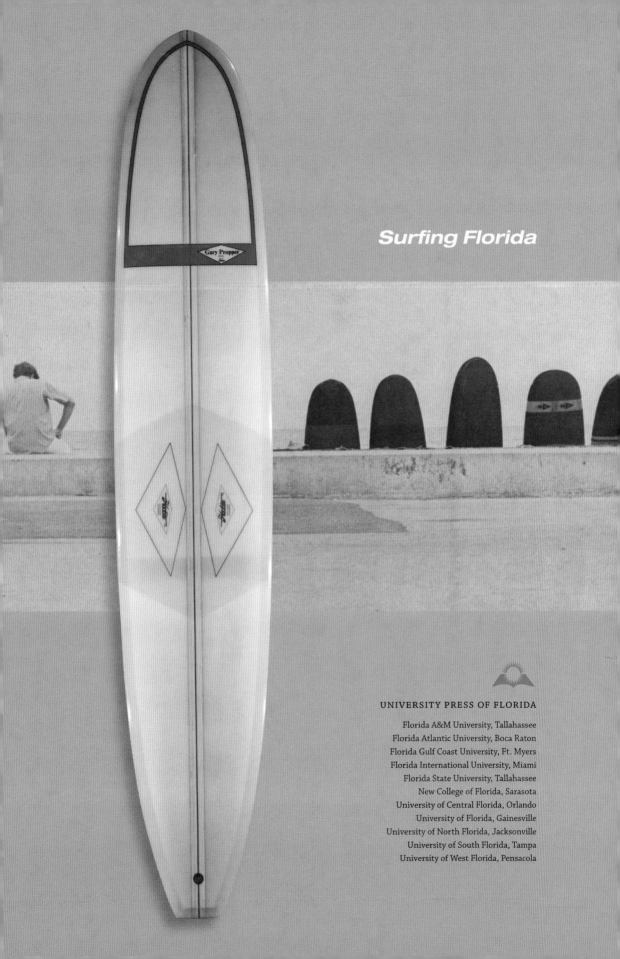

Surfing Florida

UNIVERSITY PRESS OF FLORIDA

Florida A&M University, Tallahassee
Florida Atlantic University, Boca Raton
Florida Gulf Coast University, Ft. Myers
Florida International University, Miami
Florida State University, Tallahassee
New College of Florida, Sarasota
University of Central Florida, Orlando
University of Florida, Gainesville
University of North Florida, Jacksonville
University of South Florida, Tampa
University of West Florida, Pensacola

University Press of Florida

Gainesville · Tallahassee · Tampa · Boca Raton · Pensacola · Orlando · Miami · Jacksonville · Ft. Myers · Sarasot

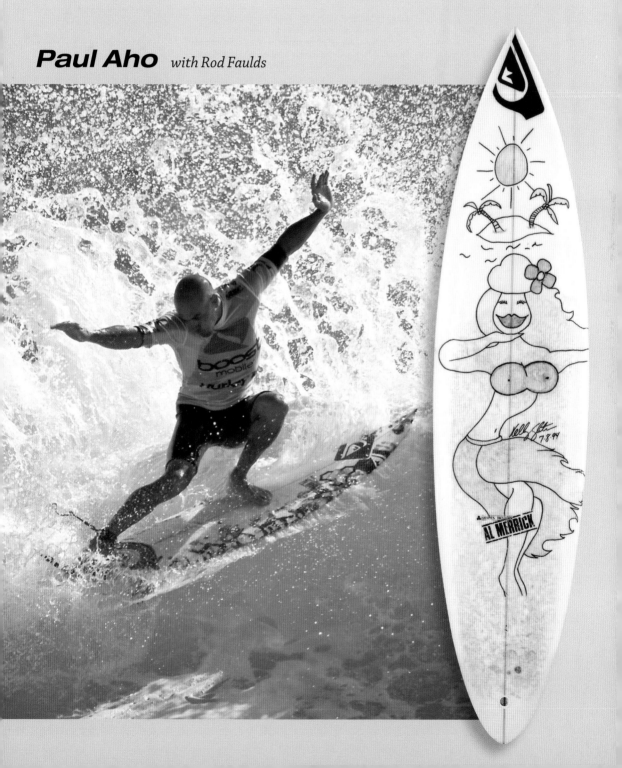

Surfing Florida

A Photographic History

Paul Aho with Rod Faulds

A Florida Quincentennial Book

Page i, Hobie Surfboards, 10'2". Collection of John Parton.
Page ii, One of the first hollow paddle boards to be built in
Florida. Collection of International Swimming Hall of Fame.
Page iii and 151, Channel Islands Surfboards, 6'4". Ridden
by Kelly Slater in ASP WCT events. Artwork by Kelly Slater.
Collection of George Trosset.
Page iv, left, O'Hare Surfboards, 9'7". Collection of Pat
O'Hare.
Page iv, right, Holmesy Sidewinder Model, 10'. Collection of
Cheyne Cottrell/Island Water Sports.
Page v, Balsa wood twin-fin, 1939, 10'6". Simmons Spoon
design. Collection of Palm Beach County Surfing History
Project.
Page vi, left, Con Surfboards, Claude Codgen Minipin, 8'9".
Collection of George Trosset.
Page vi, right, Con Surfboards, Claude Codgen Butterfly
Model, 8'3". Collection of Cheyne Cottrell/Island Water
Sports.
Page 7, Bud Gardner Surfboards, 9'8". Collection of John and
Steve Moynahan.
Page 27, Surfboards by Miller/Daytona Beach Surf Shop, 9'4".
Collection of Cheyne Cottrell/Island Water Sports.

Copyright 2014 by Paul Aho
All rights reserved
Printed in China on acid-free paper

19 18 17 16 15 14 6 5 4 3 2 1

Library of Congress Cataloging-in-Publication Data
Aho, Paul.
Surfing Florida : a photographic history / Paul Aho ;
with Rod Faulds.
pages cm
Includes index.
ISBN 978-0-8130-4948-9
 1. Surfing—Florida—Pictorial works. 2. Surfers—Florida—
Pictorial works. 3. Surfer photography—Florida. 4. Florida—
Pictorial works. I. Faulds, W. Rod. II. Title.
GV839.65.F5A46 2014
797.3'209759—dc23 2013045079

The University Press of Florida is the scholarly publishing
agency for the State University System of Florida, comprising
Florida A&M University, Florida Atlantic University, Florida
Gulf Coast University, Florida International University,
Florida State University, New College of Florida, University
of Central Florida, University of Florida, University of North
Florida, University of South Florida, and University of West
Florida.

University Press of Florida
15 Northwest 15th Street
Gainesville, FL 32611-2079
http://www.upf.com

HOLMESY

Contents

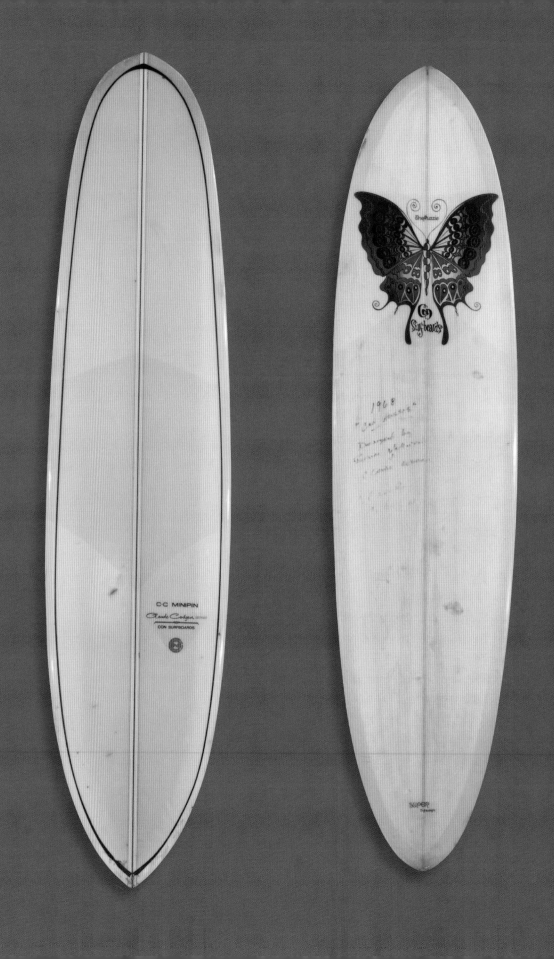

Preface

Surfing Florida: A Photographic History, which started as an exhi-
bition project at Florida Atlantic University in March 2012 and
traveled Florida through 2013, takes pride in documenting the
participants and events at the core of Florida's surf history and cul-
ture—weighing what is historically significant, what is likely to be
lost, and what needs to be told about the people and circumstances
that contributed to this remarkable story.

Recognizing the impossibility of the task at hand, we regret the
necessary omissions and inadvertent oversights within a project
of this scope. On the other hand, we are totally "stoked" to have
expanded the exhibition's narrative content with this book's pub-
lication and to recognize the extraordinarily large community of
surfers and photographers inherent or connected to Florida.

Surfing Florida would be impossible without the work of its
historic image makers, including many of the world's best surf
photographers. Through a combination of skill and artistry, they
captured the moments and movements as they unfolded. Not
surprisingly, most of the photographers were, or are, accomplished
surfers as well.

Surfing Florida documents newly discovered reports of stand-
up surfing within the state as early as 1906, but surfing in Florida
found its first serious practitioners in Miami Beach in the early
1930s. We begin our historical journey from there and make our
way up the coast to the Palm Beaches and Treasure Coast; to cen-
tral Florida's Space Coast and Sebastian Inlet; northward to New
Smyrna and Daytona Beach; farther north yet to "The Beaches" and
the communities of northeast Florida; across to the Panhandle;
and then south again to the southern Gulf of Mexico.

We have traveled to each of these regions, recruiting the con-
tributions of hundreds of advocates within the state, as well as
individuals and organizations elsewhere willing to assist in docu-
menting the adventures and accomplishments of Florida surfers.
We have also collaborated with the University of Central Florida in
conducting oral histories and interviews with dozens of Florida's
early surfers. Additionally, we have sought to extend our value by
including scholarly investigations into other dimensions of the
sport—surfing's spiritual aspects, Florida's maritime history, the

state's emergence as a seaside tourist destination, and environmental issues focused on Florida but relevant to all Americans.

Surfing Florida also looks at the history of surf music and musicians within Florida, surf movies, surfing competitions, surf travel, and other related topics. Movie screenings and public presentations on these topics accompanied the original exhibition as it toured the state, along with displays of surf memorabilia, vintage surfboards, and other artifacts—complementing media stations featuring vintage film clips and interviews with notable surfers.

Surfing Florida: A Photographic History is the stuff of a Hollywood movie. It includes the modern world's most notorious jewelry heist, a legion of serious industry interests, and the emergence of a culture of competition and personal ambitions that pitted east against west and north against south. It is a tale of triumph and tragedy; rites of passage; camaraderie, collusion, and competition; personal accomplishments; and collective accolades.

Surfing Florida is grateful for the support of its many participants and contributors in bringing this documentation of surfing history to new and larger audiences.

Paul Aho and Rod Faulds

The "Mayday Swell," Palm Beach, May 8, 2007. Photo by Tony Arruza.

There have been a number of truly historic surf events on the Atlantic Coast over the decades. The monumental swell in April 1963, the Halloween Swell of 1991, the early May swell of 2007, and Hurricane Sandy in October 2013 all come to mind. The "Mayday Swell" in 2007 resulted when an extraordinary mix of high and low pressure systems joined forces with Tropical Storm Alberto in the North Atlantic, sending record-setting swells to Florida. South Florida was particularly well positioned to receive massive surf.

Introduction

Florida has enjoyed a multitude of real estate booms and busts since the earliest developers, speculators, and profiteers made their way south from northern soil, but none reshaped the state as dramatically as the boom that began in the mid-1950s and lasted until the early 1970s. Driving the growth were a number of factors—affordable air-conditioning, rising affluence, large numbers of retirees looking for warmer climates, and the interstate highway system. Despite the state's image as a retiree haven, younger families moved to Florida for jobs in construction, service industries, tourism, and even the space industry, and the youth population consequently grew enormously. From 1950 to 1980, the overall population of Florida grew from 2.7 to 9.74 million, with only 11 percent of that 250 percent increase being composed of individuals over the age of 65. In fact, in 1970, the state's largest age group was among 10–14 year olds, a population that had grown from just under 2.8 million in 1950 to almost 6.7 million by 1970. Today, the number of people under 18 years old still outnumbers those over 65, despite the fact that Florida has the highest proportion of residents over age 65 than any other in the nation.

The impact of Florida's youth population upon the state's early surfing culture was significant, yet population alone did not fuel Florida's surfing boom. Pop culture also played a significant role. The 1959 release of *Gidget*, a Columbia Pictures film based on the surf culture of Malibu and its real-life protagonist Kathy Kohner, the "Beach Blanket" films of teen idols Annette Funicello and Frankie Avalon, and Bruce Brown's legitimate full-screen surf film *Endless Summer,* featuring real surfers Robert August and Mike Hynson, conveyed surfing images to new audiences, while the birth of surf music by Dick Dale and the Del-Tones and its

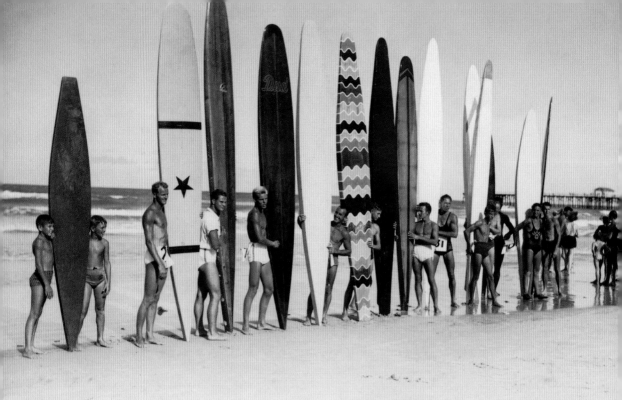

↑ Florida's first surfing competition, Daytona Beach, 1938. Courtesy of Patty Light, Gaulden Reed Archive.

This is one of several photos documenting the first Florida Surfing Championships in Daytona Beach and is among the earliest known images of surfing in Florida. Included are Dudley, Stanley, and Bill Whitman (*third–fifth from the left*) as well as other pioneers from among the forty known surfers in Daytona at the time. Paul "Bitsy" Hart (*ninth from the left*) won the event.

→ Twin Silo Surfing Association, Eleuthera, Bahamas, mid-1960s. Courtesy of Dick Catri.

As a trained aviator, Dudley Whitman, along with his family and friends, had easy access to the once-remote waves in the Bahamas. The Whitmans had a Comanche twin-engine plane and a private retreat at the break known as Twin Silos on Eleuthera. Pictured here (*left to right*) are Dick Catri, Gaulden Reed, and Bill Whitman and his son Christopher. Dudley wrote a feature story on their adventures in a 1969 issue of *International Surfing* magazine titled "Comanche to an Out Island."

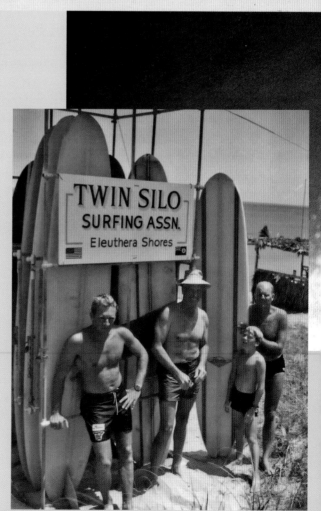

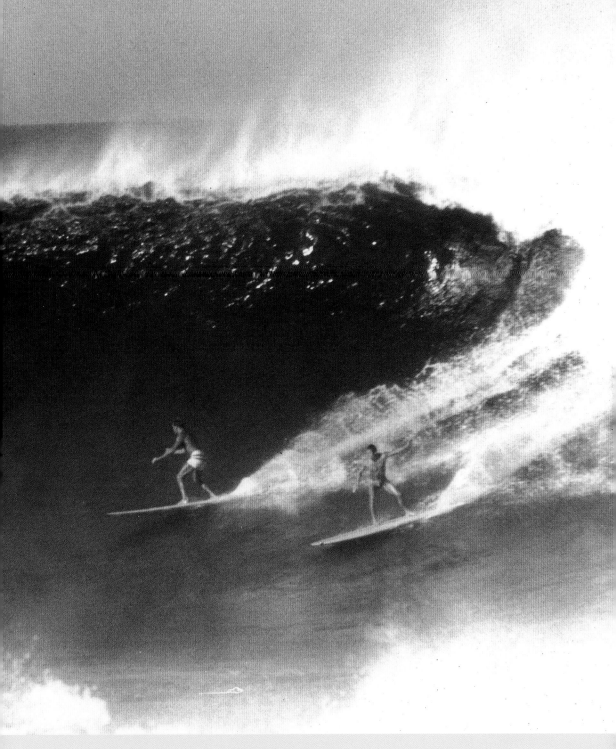

Dick Catri, Waimea Bay, Hawaii, 1964. Photo by LeRoy Grannis.

Dick Catri put his skills into play in Hawaii between 1960 and '64. He earned credibility as the first East Coaster to surf Pipeline, Sunset, and Waimea Bay, securing an invitation to the 1967 Duke Kahanamoku Invitational at Sunset Beach. In 1965, he founded the contest that became the Cocoa Beach Easter Contest and helped launch professional surfing in Florida with his creation of the Florida Pro Contest and the American Professional Surfers tour in 1972. Described as a "swashbuckling surfer/organizer/board manufacturer from Miami Beach" by Matt Warshaw in his *Encyclopedia of Surfing*, Catri is a true impresario and a leading figure in the history of East Coast surfing. Catri is pictured here to the left.

Jack "Murf the Surf" Murphy. Daytona Beach Surfing Championships, 1962. Courtesy of Neil Harrington.

Los Angeles–born Jack Murphy arrived in Miami Beach in 1955. Murphy is pictured here receiving the winner's trophy from Gaulden Reed at the Daytona Beach Surfing Championships in 1962. After decades of trouble, including jail time for the largest jewel heist in American history, Murphy was inducted into the East Coast Surf Legends Hall of Fame in 1996. He still surfs.

Daytona Beach, 1962. Photo by Walker Fischer.

"Dawn patrol" is a term surfers use to describe surfing at daybreak before the crowds arrive. While crowds were not an issue for the surfers in this vintage shot of Daytona Beach, it was still a matter of timing to catch some clean waves before work or the inevitable sea breeze.

Mimi Munro, Ormond Beach, 1965. Courtesy of Mimi Munro.

Florida's first female surf star, Mimi Munro, was born in Daytona Beach but grew up in Ormond Beach, where this photo was taken when she was thirteen. Mimi was a member of Dick Catri's stellar Hobie team and won the Florida State Championships at Ormond Pier in 1962. In 1965 and '66 she won the East Coast Surfing Championships in Virginia Beach and took third place in the 1966 World Championships in San Diego. She quit surfing in 1968 at sixteen but came back to the sport at age forty. Today she runs Mimi Munro Surf Camps in her hometown.

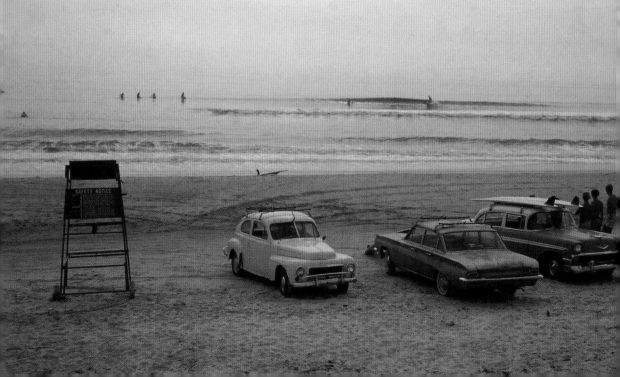

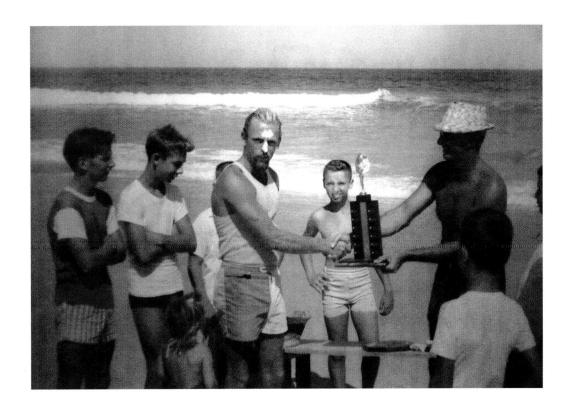

popularization by groups like the Beach Boys and Jan and Dean (among others) provided a soundtrack for the sport. Revolutionary changes in surfboard construction, especially the development of mass-produced foam and fiberglass boards, made it possible for nonsurfers anywhere with a beach to pick up the sport easily. While Florida's surf population had all but vanished during World War II, by the 1960s thousands flocked to the beaches, board in hand, for the pure joy of riding waves. Soon Florida even had its own pioneer surf movies. *Surfers Rule,* a color film narrated by Satellite Beach surfer and lifeguard Artie Styers, premiered a week before the April 1965 Cape Kennedy Surferama and "Shark Pit" Invitational Surf Meet; a few months later, David Silver's *The Enchanted Sea* debuted at the Utika Surf Club in Jacksonville Beach.

Yet long before surfing's rebirth in the '60s, the arrival of stand-up surfing and bellyboarding on wooden boards had taken root on Florida's beaches. Surfing's earliest documentation on the Atlantic Coast is found in a 1907 postcard of bellyboarding from Wrightsville Beach, while the *Daytona Gazette-News* described efforts by Eugene Johnson and his wife to ride their homemade stand-up board as early as August 28, 1909. The *St. Augustine Record* describes local bellyboarding in 1914, and a family photo from Jupiter documents pioneer Floridians at water's edge with bellyboards

in 1915. Legendary California surfer and surf photographer Leroy Grannis bellyboarded in Florida as a child in the early 1920s. Dudley and Bill Whitman, the state's first true stand-up surfers, began in 1932 as bellyboarders in Miami Beach before meeting visiting Virginia Beach lifeguards and surfers Babe Braithwait and John Smith, who inspired them to make their and the state's first Hawaiian-style surfboards in the early 1930s.

With the advent of stand-up boards and especially the hollow-style boards introduced to the Whitmans in the mid-1930s by Californian Tom Blake, and then, significantly to Gaulden Reed and others in Daytona Beach, Florida's first community of surfers was soon firmly established in Daytona. However, due to the large number of young men who joined the war effort and its demands on the civilian population, surfing all but disappeared during World War II. Reed and Brewster Shaw were among the few remaining surfers who continued to surf in Daytona. In the Palm Beaches, David Aaron had also started in the 1930s, and farther south yet, though decades after the Whitmans, Jack "Murf the Surf" Murphy and Dick Catri were to make waves of their own. The two did comedy routines and gave diving demonstrations poolside at Miami Beach resorts while surfing throughout Florida years before the 1960s boom and Catri's first visit to Hawaii in 1958. John "Chummer" McCranels built his own board and began surfing at Lake Worth Pier in 1958, joining others who were discovering the sport up and down the Atlantic Coast.

As surfing hit its early boom years, the entire notion of surfing in Florida was disparaged by the perception that there was no surf in the state and that its surfers were underqualified by global standards, particularly in "real" waves. Despite photographic evidence and competition results, it would take the West Coast manufacturers' interest in East Coast markets and a record of repeat men's and women's world champions from Florida to finally open eyes and minds to the quality of surf and surfers to be found in the nation's southernmost state. While it can certainly be argued that the success of early competitors like Gary Propper, Claude Codgen, Mike Tabeling, Bruce Valluzzi, Mimi Munro, Joe Roland, and Yancy Spencer, as well as world champions Frieda Zamba, Lisa Andersen, CJ Hobgood, and Kelly Slater, are anomalies of individual accomplishment, the truth is that they are all the result of the collective culture and pursuits of thousands of participants from throughout the state. This is their story as well.

Wave Sliding
to Wave Riding

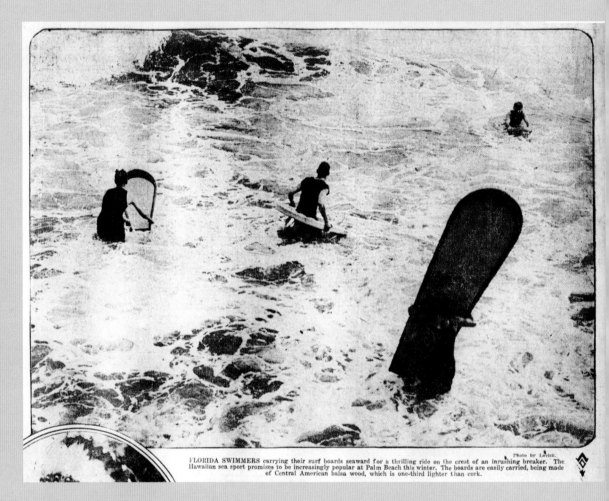

FLORIDA SWIMMERS carrying their surf boards seaward for a thrilling ride on the crest of an inrushing breaker. The Hawaiian sea sport promises to be increasingly popular at Palm Beach this winter. The boards are easily carried, being made of Central American balsa wood, which is one-third lighter than cork.

Photo by Levick.

Surfboarding, Palm Beach, Florida, 1919. Photo by Levick. Library of Congress, Chronicling America Collection. Courtesy of the Florida Department of State Division of Historical Resources.

Discovered in September 2013, this newspaper photograph, titled "Hawaiian Aquatics at Florida" from Philadelphia's *Evening Public Ledger*, represents the earliest known image of surfing and of bona fide surfboards in Florida.

CHAPTER 1

Florida Surfing Origins

SCOTT EDWARDS

In the late 1800s and early 1900s, the beach was becoming a major center of activity for cities and towns along Florida's coast. People migrated to the shores to escape the heat and humidity and find enjoyment. Florida's beaches became destinations for tourists, and hotels began to promote the beach experience as well.

With the influx of visitors to the beaches, Florida's coastal communities began to build bathing pavilions, casinos, boardwalks, and piers to provide amenities to bathers. Hotels began to promote their beach facilities and introduce their guests to new recreational activities. One of the most popular beach activities was surf bathing, which was promoted as a healthy sport. People would wade out into the breaking waves and do their best not to get knocked over. Their heavy wool bathing suits made this a challenge and a thrill. In areas with stronger currents, lifelines—ropes attached to pilings—were provided for the bathers' safety. This naturally led to bodysurfing and eventually to bellyboarding.

Bellyboarding (lying prone on a wooden board) would become popular during this period, as evidenced by a 1914 *St. Augustine Record* article describing a local who rode on a wooden plank covered in painted canvas. A 1915 photograph shows the Dubois family at the beach in Jupiter with their homemade bellyboards. Dudley and Bill Whitman, who are largely credited as Florida's earliest stand-up surfers, began as bellyboarders in Miami Beach in 1930. This was not stand-up surfing. Many early newspaper articles describe people "riding the waves" but do not give details as to whether it involved standing up or a surfboard. However, there is written evidence of people riding waves on surfboards, as a number of

articles describing stand-up surfing have been found in newspaper archives. The earliest documented record of stand-up surfing in Florida comes from Daytona Beach.

In 1909, Hawaii's Alexander Hume Ford wrote an article for *Collier's National Weekly* titled "Riding the Surf in Hawaii," in which he described Hawaii's surfing culture through words and photographs. This article introduced the sport of surfing to many Americans from coast to coast. Mr. Eugene (Gene) Johnson was one of them. Johnson owned a bicycle shop and later a sporting goods and tackle shop in Daytona Beach. Just weeks after the article appeared in *Collier's,* Johnson built a surfboard as he had seen in the article, and he and his wife rode the waves. This was such a novel event that the local newspaper, the *Daytona Gazette-News,* described their efforts in its August 28, 1909, edition, hinting that the activity was gaining followers. This story was picked up by the *DeLand News* and ran in the September 3, 1909, edition.

On Florida's Gulf Coast, Miss Florence Davison was visiting Pass-a-Grille Beach near St. Petersburg in 1918. Davison was from Honolulu, Hawaii, and brought her eighty-five-pound "surf-boat" or surfboard, and demonstrated her surfing ability in the much smaller waves of the Gulf Coast.

Additionally, a 1919 photograph from the *Philadelphia Evening Public Ledger* displays surfing on full-sized boards in Palm Beach. Later in 1921 the *Panama City Pilot* reported that Mr. R. C. Wiselogel, who owned a grocery store in Panama City, was in possession of a cypress surfboard, and that a gentleman by the name of Bill Davis was attempting to ride the board. A 1925 advertisement for Palm Beach talks about surfboards being imported from Hawaii and "weirdly" painted. The city of Clearwater celebrated Labor Day in 1926 with numerous water sports activities, including "surfboard riding," and in 1929, some Lake Worth residents enjoyed their Labor Day celebrations by riding the surf in front of the Casino and Baths building.

These newspaper articles reveal that over the first few decades of the 1900s, the newly developing sport of surfing was being discovered in areas across the state. While we may never know the exact place or person who first started surfing in Florida, we do know that its roots date back to the early 1900s.

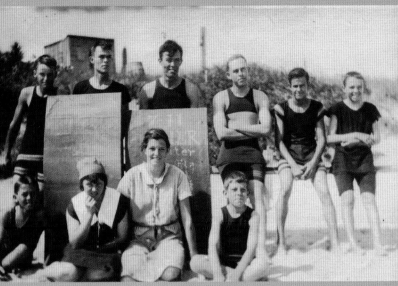

Top Row - L-R
GRAHAM KING
HENRY DU BOIS
JOHN DU BOIS
ARTHUR SIMS
BLAND FUTCH
NEIL DU BOIS
 BOTTOM ROW- L-R
JACK WILSON
BESSIE WILSON
ANNA DU BOIS
EDGAR SIMS

AT JUPITER INLET
1915

> Eugene Johnson has recently con-
> structed what is called a surf board, and
> he and his wife had fine sport at the
> beach last Thursday afternoon riding
> the waves. It is a "new wrinkle" that
> is taking well with surf bathers. Eugene
> got the idea from Collier's Weekly.

↑ Newspaper clipping, 1909. Courtesy of the Florida
Department of State Division of Historical Resources.

This recently discovered news clipping from the *Daytona
Gazette-News* of August 28, 1909, documents the earliest
known surfing and surfboard built in the state of Florida,
ten years before the first known photo of surfing in the
state, over twenty years before visiting Virginia Beach
lifeguards and surfers Babe Braithwait and John Smith
introduced stand-up surfing to the Whitman brothers in
Miami Beach, and almost twenty-five years before Tom
Blake's arrival with his new hollow board design. While this
evidence disrupts the established belief that Bill, Dudley,
and Stanley Whitman were the state's first surfers and
board builders, they remain the first "true" surfers to dedi-
cate themselves to the sport and adopt a surfer's lifestyle.

→ Newspaper clipping, 1921. Courtesy of the Florida De-
partment of State Division of Historical Resources.

This news item from the *Panama City Pilot* documents
surfing in the northern Gulf of Mexico by Hawaiian visitor
Florence Davison as early as August 1921.

↑ Jupiter, Florida, 1915. Courtesy of the Palm Beach
County Historical Society.

It remains unclear how bellyboarding came to
Florida waters, but this vintage shot of the Dubois
family and friends documents its practice as early
as 1915 at Jupiter Inlet. While this is not the earliest
record of wave riding on the Atlantic Coast, it is the
earliest in Florida archives.

> ♦ ♦ ♦
> Miss Florence M. Davison, of Hono-
> lulu, Hawaii, and a guest for the last
> three months at the Lizotte hotel,
> Pass-a-Grille, gave an interesting ex-
> hibition of surfboat riding Tuesday,
> using her big 85-pound Hawaiian surf-
> boat, in the fair sized surf which was
> rolling in. Miss Davison managed to
> have lots of fun out of it, even if it
> wasn't like the surf she is accustomed
> to in Hawaii.
> ♦ ♦ ♦

Unlikely Beginnings

With stand-up surfing in Florida making its 1930s appearance long after Floridians were "wave sliding" on bellyboards, the sport's early development was drastically interrupted by World War II. Although the entire nation was impacted by the war, Florida was likely the most radically transformed. Its proximity to the Caribbean, Atlantic shipping lanes, and the Panama Canal made it a strategic location for the nation's defense and led to a proliferation of air and naval bases. Its open landscape, ample coastline, and year-round warm weather were ideal for training troops for land and sea missions. Its population grew by 46 percent in the 1940s, largely driven by the war effort and the creation of jobs through shipbuilding and other related activities. In April 1942 in Miami Beach alone, over 70,000 hotel rooms were used to house military personnel and civilians involved in training operations. By 1943 approximately 172 military installations of varying sizes were in existence in Florida, compared to only eight in 1940. However, many of them, and certainly the largest training bases, were located in regions far from the beach or in coastal regions with no history of surfing.

Yet despite the increased numbers of residents, surfing in Florida all but disappeared during the war. With little documentation on the sport of surfing in Florida at the time, it's hard to pinpoint the causes. The surfing population was small and its participants generally of military age. Although lighter and friendlier equipment became available later, the more youthful demographic doesn't seem to have been involved during those years. Daytona's Gaulden Reed, who surfed through the war years, recalls encounters with civilian and military patrols who kept a vigilant eye on the oceans, wary of German U-boats and suspicious of

↑ Dick Catri, early 1970s. Photo by Dick "Mez" Meseroll/ESM.

After spending winters in Hawaii from 1959 to 1963, Dick Catri returned to Florida. His historic Surfboards Hawaii and Hobie surf teams dominated competitive surfing on the Atlantic Coast and beyond in the 1960s. Catri, as coach and mentor, has helped more surfing careers than any other figure in East Coast history.

↗ California, July 1967. Photo by Ron Stoner. Courtesy of *Surfer* magazine.

Long before the emergence of world-renowned surfers "MR" (Mark Richards), "PT" (Peter Townend), or "BK" (Barry Kaniapuni), there was "GP." Florida's Gary Propper is among the state's most notable surfers, and in the mid-1960s he was the most highly paid surfer on the planet.

→ Mike Tabeling, Laguna Masters, Redondo Beach, California, 1967. Photo by Dick Graham.

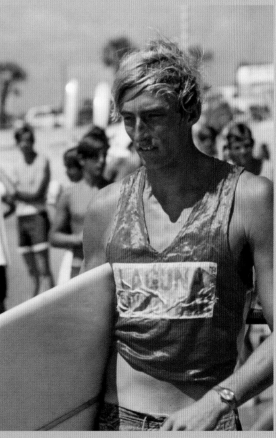

Despite having spent a good number of years living in other places, Mike Tabeling is still regarded as one of the best surfers to have ever come out of Florida. And while he and many of Cocoa Beach's other leading surfers had been members of Dick Catri's Hobie team, Tabeling cut free in 1966 with sponsorship from Dewey Weber. He went on to win the juniors division of the 1966 and 1967 East Coast Championships and the juniors of the Laguna Masters in Redondo Beach, and he took second place in the 1968 U.S. Championships Men's Division behind Hawaiian David Nuuhiwa. His win in Redondo made him the first East Coast surfer to win a West Coast event. He also competed in the 1966, 1968, and 1979 World Championships before abandoning competitions for travel and adventure. His 1970 *Surfer* magazine article, "I Love Cocoa Beach: An Erotic East Coast Confession," focused international media attention on the Space Coast.

→ Claude Codgen, 1968 World Contest, Puerto Rico. Photo by Jeff Divine.

As one of the 1960s top East Coast surfers, Claude Codgen topped the juniors division in 1966 and the men's in 1967 and 1969. He competed in the Olas Grande World Championships in Peru in 1966; the World Contests in San Diego (1966), Puerto Rico (1968), and Australia (1970); as well as the Duke Kahanamoku Invitational at Sunset Beach (1967). In 1970, he launched Sunshine Surfboards, built by West Coast manufacturer Bing Copeland and later by Codgen and others in Florida. Additionally, Codgen starred in the 1968 full-screen film *Follow Me*, modeled after *Endless Summer*; was featured in the 1978 surf film *Tales from the Tube*; and was among the first inductees into the East Coast Surfing Hall of Fame in 1996.

↘ Lisa Andersen. Photo by Dick "Mez" Meseroll/ ESM.

Florida's second multititle female world champion, Lisa Andersen, exemplified the same aggressive approach to the sport and competition as had Frieda Zamba a generation earlier. Andersen navigated a rough domestic scene in her youth, slugged her way through the challenges of women's pro surfing, and emerged a winner on many levels. As a Pro Ambassador for Roxy sportswear and women's' surfing, Andersen has assumed a role as mentor and inspiration for female surfers worldwide while deflating gender biases of the past.

→→ CJ Hobgood, Teahupoo, Tahiti, 2005. Photo by Tom Servais.

CJ Hobgood is among the world's most accomplished competitors and respected surfers. He and his brother Damien are identical twins from Satellite Beach and have risen to the top ranks of professional surfing. In his first year on the World Qualifying Tour in 1998, CJ finished the year in eleventh place and qualified for the ASP WCT. He won the World Title in 2001.

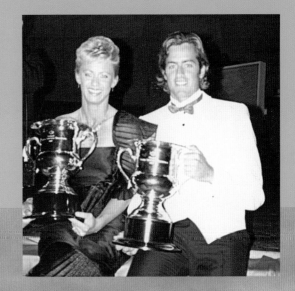

→ Frieda Zamba and Tom Curren, World Title awards ceremony, 1986. Courtesy of Frieda Zamba.

Frieda Zamba, a native of Flagler Beach, is a four-time world champion who broke the model of graceful, feminine surfing inherited from earlier generations and put herself at the top of pro surfing with a powerful approach that redefined women's surfing.

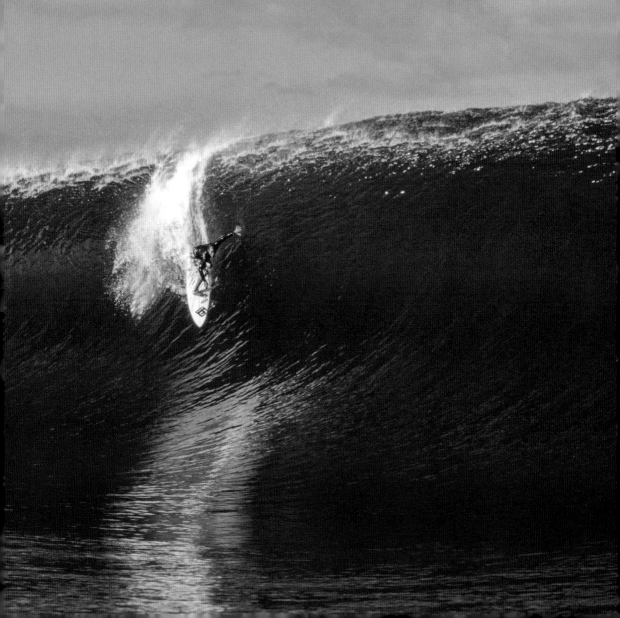

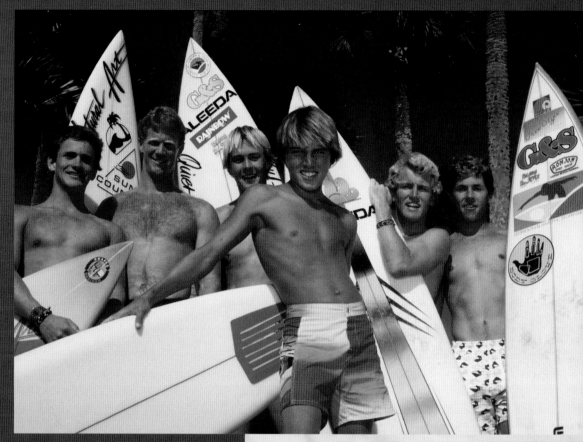

↑ Cream of the crop, king of the pack. Florida pros, 1987. Photo by Tony Arruza.

Competition is a given for surfers—at most breaks you must compete to even catch a wave—and while Florida may not host the most consistent surf in the world, it has certainly produced a lion's share of world-class talent. Centered is a young Kelly Slater, now an eleven-time world champion and one of the world's greatest sports phenoms. Kelly Slater is from Cocoa Beach and calls the Sunshine State home. Pictured with Slater are (*left to right*) Todd Holland, Scott McCranels, Rich Rudolph, Matt Kechele, and Charlie Kuhn, all among the best surfers of their day.

→ Kelly Slater, Sebastian Inlet, early 1980s. Photo by Tom Dugan.

"Half Fish, Total Dish" announced the cover of *Interview Magazine* in May 1996. As one of the world's best professional athletes, by 2011 Kelly Slater had won eleven world titles in nineteen years. His success poses the question of whether unfathomable accomplishments are driven by radical anomalies or are shaped by the summation of collective efforts.

Kelly Slater, Sebastian Inlet, early 1980s. Photo by Tom Dugan.

Kelly's dad, Steve Slater, began surfing in Daytona years earlier and led the way for oldest son Sean, and then Kelly, who began surfing in Cocoa Beach at age five on Styrofoam bellyboards. Kelly was extraordinarily talented and by 1984 had won the first of four consecutive U.S. amateur championship titles before turning pro at the age of eighteen. Slater's youngest son, Stephen, on the other hand was fifteen before he began surfing in 1993, later becoming one of the sport's most notable longboarders.

surfboarding. Rationing of almost everything, including gasoline, could also have played a role in suppressing surfing during the war. Indeed, surfing may simply have seemed frivolous to a population deeply engaged in the austerity measures brought on by the war.

Nonetheless, World War II left the state newly populous and highly prosperous, and surfing began a slow revival in the 1950s. In 1963, it would strike like lightning and become hugely popular on both sides of the coast, despite the lack of regular surf. It was for many participants a lifestyle that fit the Sunshine State and its growing youth population.

In a few short years, every coastal community with waves had a crew of hard-core surfers, and the sport continued to grow. With the bulk of its members being teenage boys, surfing remained a countercultural activity and was viewed with suspicion by an increasingly wary and conservative public.

Clubs and competitions helped to clean up surfing's image, and nationally recognized surfers came to the fore. Gary Propper, Mike Tabeling, Bruce Valluzzi, and Claude Codgen in Cocoa Beach, Mimi Munro in Ormond Beach, Bruce Clelland, Joe Roland, and Dickie Rosborough in Jacksonville, Dennis "Skinny" English from South Florida, and Yancy Spencer in the Panhandle all led the way during the 1960s.

Today, Cocoa Beach's Kelly Slater is surfing's most compelling success story ever, having won his eleventh world title in 2011. The sport itself is a mainstream activity, its lifestyle coveted across the nation and its industry brands recognized worldwide. A little like Florida itself.

Florida's Maritime History

MARK LONG

The history of Florida begins on a beach. As a transitional zone between land and sea, Native and European, and largely settled societies and rapidly expanding empires, the beach has always been a site fraught with importance, yet largely ignored by the practice of history. French, then Spanish settlers were drawn to the state because of its strategic location along the Straits of Florida, astride the Gulf Stream, through which ships laden with New World riches traveled, bound for Europe. The balance of power between those competing European empires was established on a beach, as well, as Spanish forces massacred surrendered French for daring to breach Spanish land claims (and for doing so while being Protestant), thus giving the bay upon which St. Augustine sits its name: Matanzas, or massacre. Spanish St. Augustine itself functioned mostly as a naval outpost, for the empire intended to protect the floating wealth being drawn out of New Spain from ruinous attacks from pirates and privateers.

European ships were not the first to tie the peninsula to the Caribbean via maritime connections, however. Prior to first contact, Florida's native populations traded with the indigenous populations of the islands that came to be known as the Bahamas and Cuba, and perhaps many more. They also plied the inshore waters as fishermen, whalers, and hunters of manatee and turtles. They resided near the prolific shores, which afforded both ease of transportation and material sustenance. This set a pattern that would dominate human occupation of the peninsula for the next few centuries, until the profound transformation of the state in the latter decades of the twentieth century.

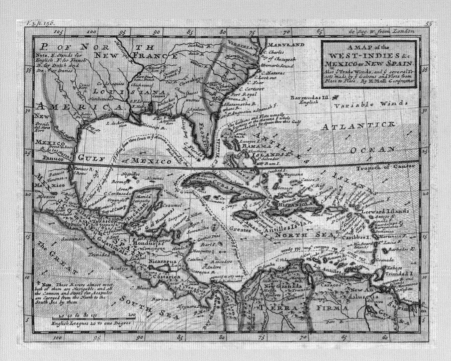

A Map of the West-Indies (1732), by Hermon Moll. From Samuel Simpson, *The Agreeable Historian*, vol. 3 (London, ca. 1740).

Hermon Moll's 1732 map emphasizes Florida's place as a key feature in the Caribbean basin.

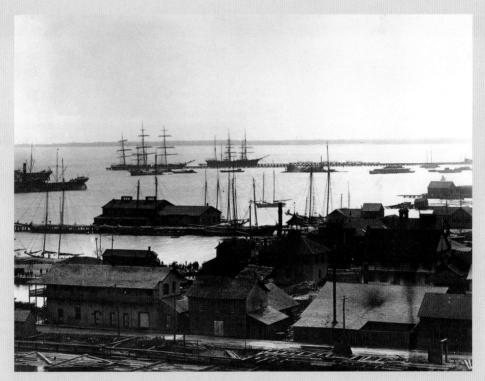

Port of Pensacola. Courtesy of the State Archives of Florida, *Florida Memory, Division of Library and Information Services*.

The Port of Pensacola is typical of the state's shallow-water ports. The geology of the region did not grace the area with any natural, deep-water ports, so the state relied on a disparate network of smaller, regional entrepôt instead.

Elliott-Van Duyn Co. Miami

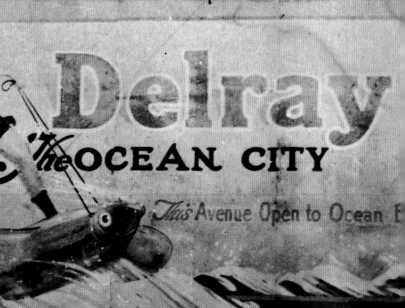

In those intervening years, life in Florida was dominated by its maritime connections to the broader world. Perhaps the most remarkable aspect of the waterfront in this period, in contrast to our own, is that it was a strictly working environment. The beach, as we know it, had yet to be invented. Interaction with marine environments was based on resource extraction and transportation. Florida's major cities were port cities engaged in the transportation of people and goods that kept the state supplied and allowed it to grow, shown by the fact that Key West was the largest city in the state in 1860, at the outbreak of the Civil War. Even that bloody conflict played out in Florida as a largely maritime affair, as the state struggled to subvert Union efforts to choke the Confederacy's supplies through a naval blockade. Blockade running and naval conflicts marked most of Florida's contribution to the war effort.

Following the war, as the state struggled to find its place in the Union, the importance of its marine environment once again asserted itself. This time, however, as a site of pleasure. Tourists and promoters began to invent the beach as they built and visited resorts along the coasts in search of recreational and leisure opportunities in mass numbers.

↖ The *Amaryllis*, 1968. Photo by M. E. Gruber, courtesy of the Palm Beach County Surfing History Project.

The juxtaposition of surfer Warren Ylitalo in the foreground with a ship hard aground behind presents a powerful reminder that the recreational beach accessed by surfers is still a transitional zone with a working ocean, and one that is often a dangerous place of employment.

← Welcome sign, Delray Beach, Florida, circa 1922. Courtesy of the Delray Beach Historical Society.

This East Atlantic Avenue billboard combines a playful image of a woman in the surf with a message about the high quality of hunting and fishing, suggesting the transition in leisure from sports and field to beach relaxation.

CHAPTER 4

Creating the Sunshine State

FRED FEJES

At the beginning of the twentieth century, Florida with its 500,000 residents had the lowest population density of all the states east of the Mississippi. Among the states of the old Confederacy, it was considered to be especially disadvantaged. It was very poorly integrated into the fast-developing national transportation system. Much of the state was not surveyed and remained undeveloped; its economy was based on cattle, lumber, and phosphate mining. The hot, humid, often swampy, mosquito-infested, nutrient-poor land was not very welcoming. As one soldier encamped in Miami during the Spanish-American War wrote home to his northern family: "If I owned both Miami and hell, I'd rent out Miami and live in hell."

Particularly uninviting were the hundreds of miles of Florida's pristine sand beaches. Prior to the twentieth century, the beaches were regarded as worthless land, good for nothing. The sandy soil was not fit for farming. The shifting dunes and unpredictable waves made any kind of building precarious. The unrelenting sun and millions of beach insects drove off the unprotected. Far more valuable were the inland rivers, the harbors and bays, and the millions of acres of swampland that could be drained.

By the mid-twentieth century, however, this "hell" was quickly becoming a heaven for winter-weary northerners. Starting in the 1890s with Henry Flagler's development of Palm Beach and, later, Carl Fisher's development of Miami Beach, the image of Florida changed from being a distant, obscure outpost of the Old South into a land of new possibilities. Made possible by a rapidly developing system of railroads, automobile highways, and air routes, along with air-conditioning and mosquito control, Florida became

22

Canaveral Pier, Cocoa Beach. Photo by Tom Dugan.

While many coastal communities built piers as recreational amenities and to enhance development, the Cocoa Beach Pier took on a life of its own as the intended tourist destination yielded to the forces of nature, creating a unique surfing destination.

Breakers Hotel, Palm Beach, Florida. Photo by Tony Arruza.

In addition to connecting Jacksonville to Key West through a railroad system developed between 1885 and 1912, Standard Oil tycoon Henry Morrison Flagler opened the Royal Poinciana, the world's largest hotel, in 1894 and the Palm Beach Inn in 1895 (renamed Breakers in 1901), which houses the landmark Alcazar Lounge with its eye-catching aquarium bar top.

a magical land of romance, relaxation, and fun. In the prosperous years following World War II, thousands came to Florida, many to vacation, some to retire, and others to start new lives.

An important part of this change was a wholesale reimagining of the beach, both as a physical and cultural space. Although upper-class seaside resorts were a feature of many western countries in the nineteenth century, only in the 1920s were beaches—with their fresh air, water, and sun—fast becoming a popular destination for America's urban dwellers. Previously deserted beachfronts such as Jones Beach in New York were built into crowded, popular working-class beach resorts. Reflecting the changing social and sexual mores of the time, unescorted young men and women, dressed in one-piece bathing suits (judged obscene only a few years earlier), sat and played in the sand together. Tanned skin, once a mark of lower-class status, was now a sign of health, youth, and vitality. Water sports, particularly swimming, quickly gained a new popularity and prominence. When the young American Gertrude Eldery swam the English Channel in 1926, she quickly became one of the heroines of the Roaring Twenties.

Florida's beaches became popular. In cities like Miami Beach, Jacksonville, Tampa, and Fort Lauderdale, large public beaches were created, making use of the previously ignored coastal areas. Particularly after World War II, with many images of the Pacific Islands filling the newsreels and the popularity of movies such as *South Pacific,* Florida's subtropical climate, flora, and fauna gave its beaches an especially alluring and exotic quality.

The growth in popularity of Florida's beach culture was amplified by the emergence in the 1950s and '60s of a pulsating American youth culture. In this culture, the beach was a particularly popular setting for romance, fun, and adventure. Although the first popular beach-centered movie, *Gidget* (1959), was set in California, Florida beaches quickly emerged as a popular location with films like *Where the Boys Are* (1960), set in Fort Lauderdale; *Follow that Dream* (1962), set in the Keys and staring Elvis Presley; and *Girl Happy* (1965), again starring Presley but set in Fort Lauderdale.

It was in the context of the new, youth-oriented beach culture that Florida's surfing scene emerged in the early 1960s.

Development came to the Panhandle like it did to every other coastal region of Florida, fast and furious. The Panhandle had the mixed blessing of broad, flat barrier islands to develop, lots of sheltered water, and regular access to the Gulf through its many natural passes. While attracting permanent residents from around the country, the region also served the vacation needs of many southerners and residents of the Midwest, earning it a reputation as America's "Redneck Riviera." It is better known as the Emerald Coast, for the color of its offshore waters.

↑ Sebastian Inlet, mid-1970s. Photo by John Tate.

Fueled by warm weather and easy living, Florida's beautiful beaches became seedbeds of cultural change in the 1960s. The surf boom of the early 1960s coincided with land development, an increasing number of young families, the sexual revolution, and a culture of peace and love. Florida was an easy sell to those hoping to share the experience.

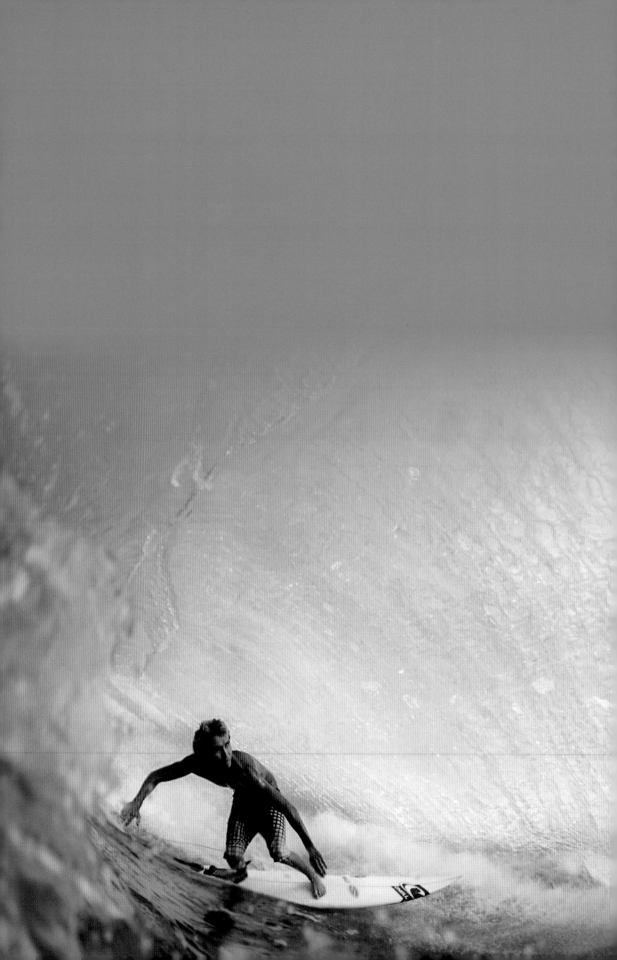

PART II

The Regions

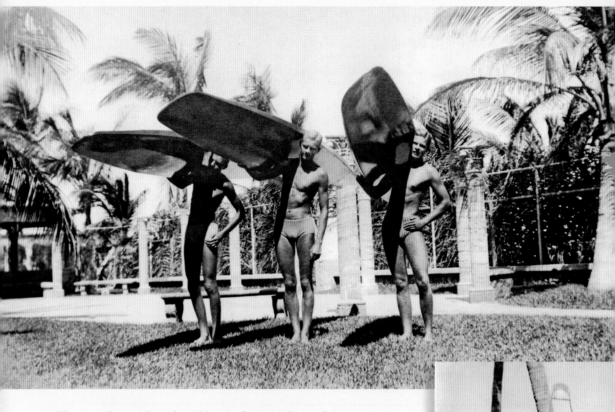

↑ **William, Dudley, and Stanley Whitman, from an album of vintage photographs dating to 1934. Courtesy of Angela Whitman.**

The three Whitman brothers (*left to right*), Dudley, William, and Stanley, sporting their new Blake-style hollow boards.

→ **Dudley Whitman, from an album of vintage photographs dating to 1934. Courtesy of Angela Whitman.**

Dudley Whitman stands on the beach of their family compound in Miami Beach, with the frame of a Blake-style hollow board, prior to the application of its plywood "skin." Abandoning the solid wood boards they had built just the year before, the three brothers were riding hollow boards of their own construction by 1934.

↘ **Bill Whitman, from an album of vintage photographs dating to 1934. Courtesy of Angela Whitman.**

Bill Whitman surfs at Miami Beach in the mid-1930s.

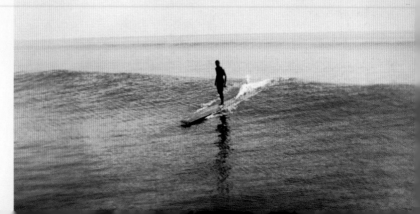

CHAPTER 5

Miami and Broward County

Surfers with origins in Miami and the state's southernmost beaches played an improbable but important role in Florida's surfing history. Despite the disadvantages of its inconsistent surf, the demographics and dynamics of the region have produced and continue to produce remarkable surfers and industry leaders.

Gone from contemporary Miami is its notorious cultural resentment, highlighted by bumper stickers proclaiming "Native Floridian" and "Will the Last American Leaving Miami, Please Bring the Flag" that plagued the relationship between immigrants and the white majority in decades past. Today we find a mix of fame and fortune and virtue and vice, driven by a cultural hybrid vigor. Hidden among the glamour of this exciting and multicultural American city is the unlikely story of the origins of surfing in the Sunshine State. Many diverse factors led to the development of Miami's surf scene, including a good number of the East Coast's first surfboard manufacturers and surf shops, occasional epic surf, the world's largest jewel theft, and many stories of illegal activities best left untold.

Regional standouts who contributed to the growth of Miami's surfing culture include Florida's original true surfers Dudley, Stanley, and Bill Whitman; 1970s Hawaii Pipeline chargers Roger Kincaid and Adam Salvio; longboard revivalist and master shaper Bill Stewart; *Surfer Magazine* photographer Darrell Jones; and East Coast legends Dick Catri and Jack "Murf the Surf" Murphy. Many others established roots in the region: veteran shapers like George Miller and Bud Gardner; industry innovators and activists like Ross Houston; and even Cocoa Beach's earliest shining star, Gary Propper, who spent his childhood in Miami. Other notables are Lewis Graves, Bruce Walker, Doug Deal, Phil Marinelli, Jeannie Chesser,

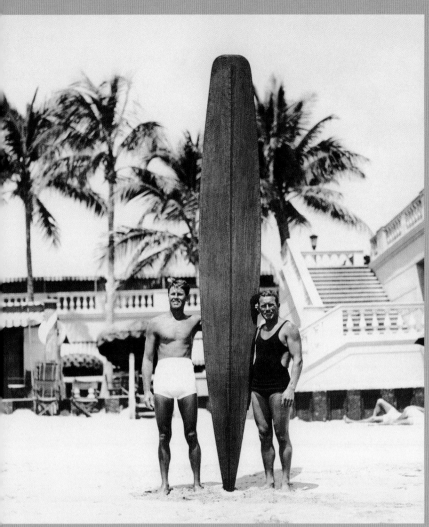

Tom Blake (*left*) revolutionized surfing technology when he built the first hollow surfboards that weighed significantly less than solid Hawaiian-style surfboards. According to Gary Lynch, coauthor of *Tom Blake: The Uncommon Journey of a Pioneer Waterman*, Blake had an unknown builder make ten of his hollow boards in Miami in 1934 as prototypes for the first of several manufacturers that would produce Blake's patented hollow paddleboards/surfboards. In the same year, Miami's Whitman brothers met Blake and began fabricating their own hollow surfboards. The Whitman family remained lifelong friends with Blake.

A day without waves is still a day in the water. Miami Beach shows its enthusiasm for the sport in the 1960s.

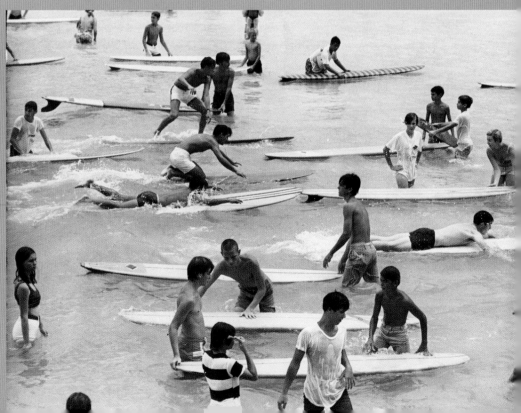

Ralph Lima, Joe Burnell, Mark Perry, Randy and David Smith, Adam Salvio, David Byrd, Gary Minervini, and Mike Beluzzi.

In the 1960s, surfing in Miami Beach was restricted to the southernmost tip of South Beach, east of the Miami Beach Kennel Club and site of the former Miami Beach Pier. Under pressure from a burgeoning surf culture and persistent advocacy of Ross Houston, then president of the Dade County Surfing Association, city officials agreed to open additional beaches in 1972. During this time, the scene was large enough to support three shops specializing in surfing gear: the Surf Shop, Factory Surfboard Outlet, and Fox Surf Shop. Miami's earliest surf shop was Dudley Whitman's Challenger Marine Showroom at 133rd Street in North Miami. The showroom was the first Hobie Surfboards distributor on the East Coast (Hobie Alter was a surf industry leader who significantly impacted global surf culture and surfboard design). Years later and further north, Bill Riedolf's Little Hawaii Surf Shop and the South Florida Surf Club would emerge as epicenters of surf culture in Hollywood.

Crossing north into Broward County, surfing started with Herb Glattli in 1960, and it was centered at Deerfield Pier, though many of its locals were from Pompano Beach and Lighthouse Point. Bob and Jack Reeves moved to Pompano Beach in the winter of 1961 from Oahu, where they had started surfing in 1960. Accomplished surfers who had ridden Oahu's North Shore, they met Glattli at Deerfield Pier, bought a Graham Surfboard from Graham Jahelka, an early board builder, and met the group of surfers that later became the Graham Surf Team.

The Wall, South Beach, Miami Beach, 1965. Courtesy of Bill Whiddon, Miami Surf Archive Project.

Like surfing beaches everywhere, Miami had its own place to hang out while waiting for waves. The wait may have been longer than on other beaches, but the "scene" was no less genuine.

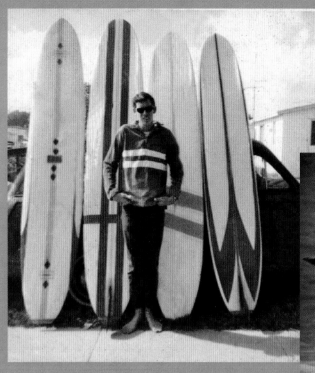

↑ Bud Gardner, Miami, 1966. Courtesy of Bud Gardner.

Among Florida's earliest and still active board builders, Bud Gardner shaped his first surfboard in Miami in May 1966. He is widely known for his skills as a shaper and for the artistic detail he brings to the process. In 2010 he was inducted into the East Coast Surfing Hall of Fame. He is pictured here with the first four boards he built in 1966.

↗ Donald Reid with his new Graham surfboard, Deerfield Beach, 1965. Courtesy of Donald Reid.

As with other surf spots up and down the coast, the crew around the Deerfield Pier formed a community of surfers who had grown up with surfing central to their lives. The area boasted talents like Tom and Donnie Reid, Jack and Bob Reeves, Bill Bringhurst, George Perkins, Marty Snow, Frank Tuppens, Greg Bernardo, and David Parsons.

→ Renee Whitman, Florida Surfing Contest, Ormond Beach, 1965. Photo by Chuck Rogers, courtesy of Mitch Kaufmann.

Following the family's enthusiasm for surfing, Dudley Whitman's daughter, Renee, was the East Coast's first women's champion, winning the Florida State Surfing Championships in Ormond Beach in 1965. Her cousin Pam Whitman, daughter of Bill Whitman, moved to Hawaii, where she surfed the North Shore and flew 737s as part of an Aloha Airlines all-female flight crew. Renee was inducted into the East Coast Surfing Legends Hall of Fame in 2004.

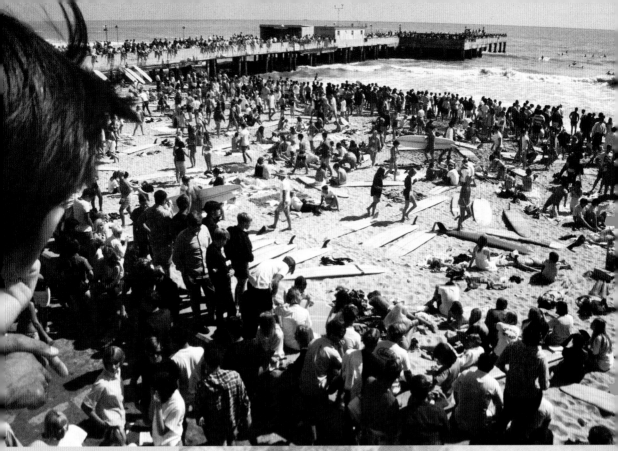

Miami Pier, 1967. Photo by Tom Hodge.

In 1967, Miami Beach and local AM radio station WQAM hosted a huge amateur competition at the Miami Beach Pier. The highly publicized surf festival featured regional bands and attracted over five thousand attendees. Radio personalities Rick Shaw and Roby "Big Kahuna" Yonge were on hand to oversee the competition, which included noted East Coasters and Jorge Machuca, Puerto Rico's national champion.

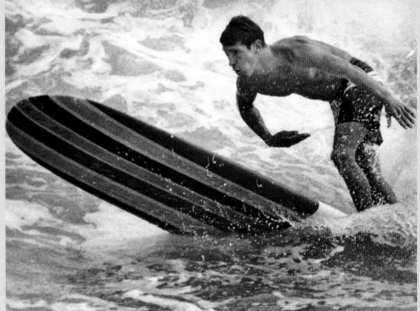

Roby Yonge, Miami Beach, 1967. Courtesy of Bill Whiddon, Miami Surf Archive Project.

In December 1967, WQAM radio's surfing disc jockey, Roby "Big Kahuna" Yonge, accepted a position with the nation's most popular radio station, Musicradio 77 WABC in NYC. Based on rumors aired elsewhere weeks earlier, Yonge broke from the station script and let on that Paul McCartney, British rock star of Beatles fame, had actually died in 1966 and been replaced by an impersonator. Yonge was directly escorted out of Studio 8-A.

→ **Groms in Miami, South Beach, Miami Beach, early 1970s. Courtesy of Bill Whiddon, Miami Surf Archive Project.**

In the 1960s, surfing in Miami Beach had been restricted to its southernmost beach, adjacent to the former Miami Beach Kennel Club. Through activism by Ross Houston and others, additional areas were opened up in the 1970s.

↓ **Miami Pier, April 21, 1964. Courtesy of Bill Whiddon, Miami Surf Archive Project.**

With the success of Hollywood's *Gidget* and Avalon/Funicello movies of the '60s, coupled with other cultural events, surfing in Florida and elsewhere in America flourished in 1964. It is estimated there were five thousand surfers worldwide in 1959; five million in the mid-1960s (though estimates vary wildly); and 17 million today.

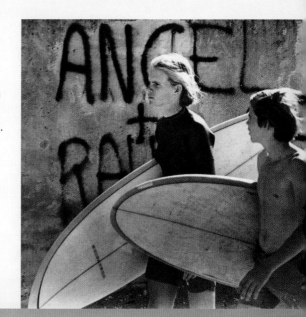

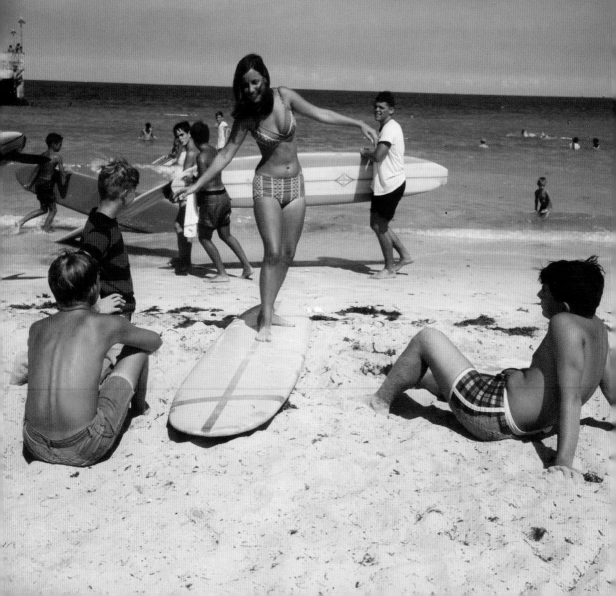

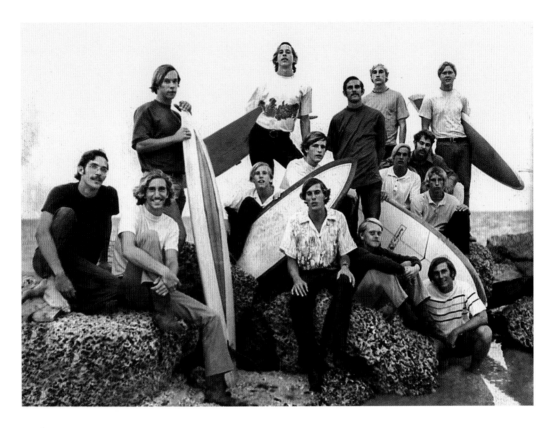

Surf clubs were the rage
beginning in the mid-
1960s. While many clubs
disappeared for various
reasons, the Greenback
Surf Club and others in
South Florida like the
South Florida Surf Club
and the Norland Surfers
(Norland High, Miami)
have continued to thrive.

Reeve's stylish Hawaiian approach to surfing quickly influ-
enced locals Bill Bringhurst, Marty Snow, Frank Tuppens, Dennis
"Skinny" English, Alan Ethier, Doug Dellenkoff, Kerry Woodruff,
David "Rat" Parsons, young Donnie Reid, and later, John Bothwell
and Chip Thompson. In 1964, Bob Reeves left for Brevard County,
while Buck and Dewey Pedrick opened Buck's Surf Shop a block
from the pier. Buck assembled his own team from a new crop of
up-and-comers, mainly from Lyons Park in Pompano—Bruce and
Rick Dygert, Greg and Guy Bernardo, Bobbie Robinson, Frank
Acitelli, Dick Altman, Tommie Willis, and Blake Ostrosser. Bruce
Dygert and Greg Bernardo were among the best. The Greenback
Surf Club gave the region a unified front in the late 1960s, but as
that decade came to a close and the longboard era ended, many,
like Greg and Guy Bernardo, never made the transition to short-
boards and walked away. Others, like the Dygerts, Bob Robinson,
Ostrosser, Frank Acitelli, and Jack and Pierce Gregory, refined their
skills on the radically new shortboards.

The Dygerts, Ostrosser, and Donnie Reid hooked up with Tomb
and Reeves Surfboards, produced in Brevard County by Bob Tomb
and Bob Reeves. George Panton arrived in Pompano Beach from
San Diego, founding Florida Surfboards in 1970, and Mike Mann

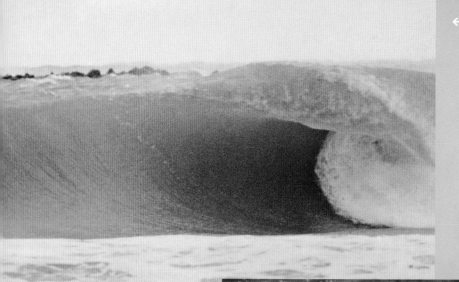

South Beach, early 1970s. Photo by Bruce Walker.

The marvel that is Miami's South Beach Jetty—thick, aquamarine, and close to the beach.

→ Ralph Lima, Miami Beach, mid-1970s. Photo by Darrell Jones.

Miami's Ralph Lima was one of the best surfers in the state during the middle '70s, and he was featured in *Surfer* magazine and Bruce Walker's 1976 movie *Free Rides*, which included footage of Miami Beach. Today Lima is professor in the School of Communications at University of Miami. His credits include writing for the television series *China Beach* and *Wiseguy*, screenplays for HBO, two documentaries for PBS, and an independent documentary, *Presidio: The Trip Back*, which he wrote and directed.

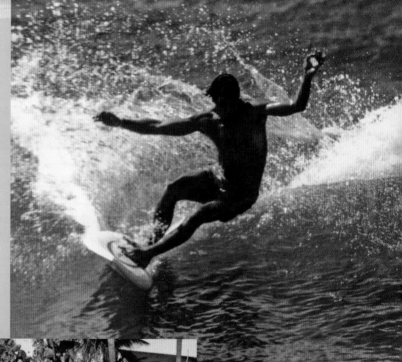

← Lewis Graves, Mark Castlow, and Phil Marinelli, Palm Beach, 1971. Photo by Darrell Jones.

Among Miami's surfing elite, Lewis Graves, Mark Castlow of Atlantis Surfboards, and Phil Marinelli during a big winter swell at Reef Road in late November 1971.

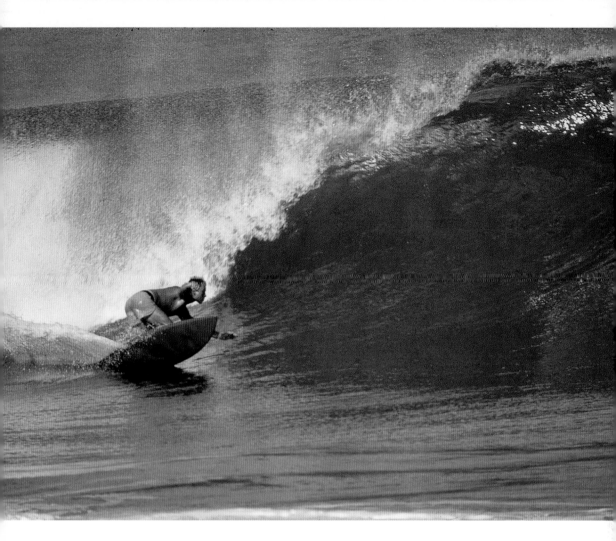

opened New Dawn Surf Shop. In 1971 Rick Dygert opened the Rock n Roll Island Surf Shop on Pompano Pier and formed a team that included himself, his brother Bruce, Blake Ostrosser, and Rick Fleury. Meanwhile, in Oahu in 1971, Bruce Dygert was featured in the iconic surf movies 5 *Summer Stories* and *Morning of the Earth*. Pierce Gregory continued his ascent and created his own team, riding Overlin and Sunset surfboards. With the tragic death of Bruce Dygert in 1976, the Rock n Roll team dissolved, and by the time Carl Beaulac opened Island Water Sports in the late '70s, new faces like Paul MaCartney, Anthony Gregory (no relation to Jack and Pierce), and Mike Polvere were making their mark as well. Deerfield's Jimbo Sampson, who was turning heads with his amazing elasticity and catlike ability, was likely the best in the early 1980s, winning the East Coast Men's Championships in 1981 and placing 104th in the 1983 World Tour results.

While the region continued to breed a remarkable collection of surfers, perhaps most legendary is Florida native Kirk Cottrell,

Phil Marinelli, Hawaii, 1977. Photo by Darrell Jones.

Phil Marinelli, one of Miami Beach's most notable surfers, blazes through a signature high-power bottom turn at Gas Chambers in 1977. Marinelli was living in Hawaii and working for legendary shaper Dick Brewer.

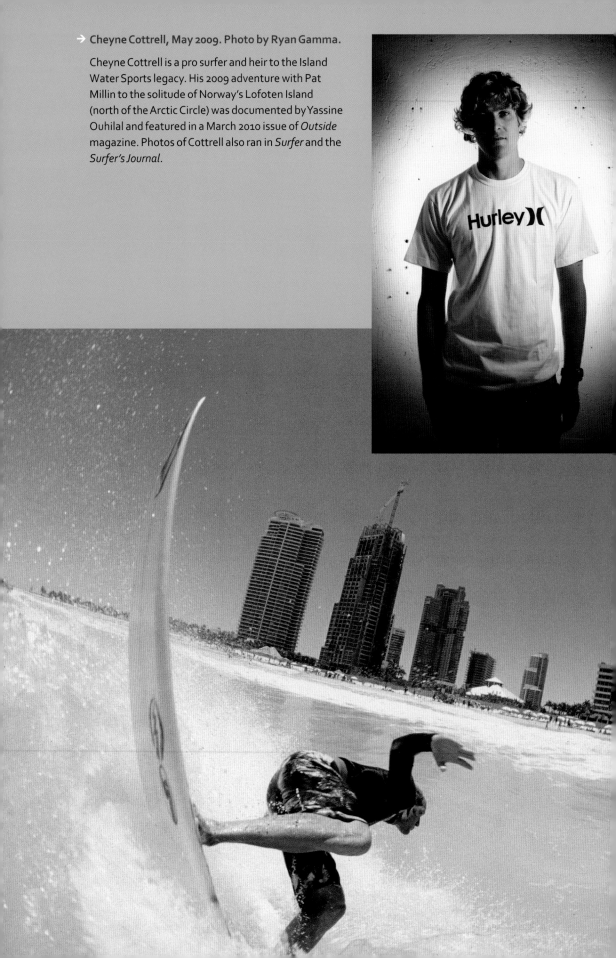

→ **Cheyne Cottrell, May 2009. Photo by Ryan Gamma.**

Cheyne Cottrell is a pro surfer and heir to the Island Water Sports legacy. His 2009 adventure with Pat Millin to the solitude of Norway's Lofoten Island (north of the Arctic Circle) was documented by Yassine Ouhilal and featured in a March 2010 issue of *Outside* magazine. Photos of Cottrell also ran in *Surfer* and the *Surfer's Journal*.

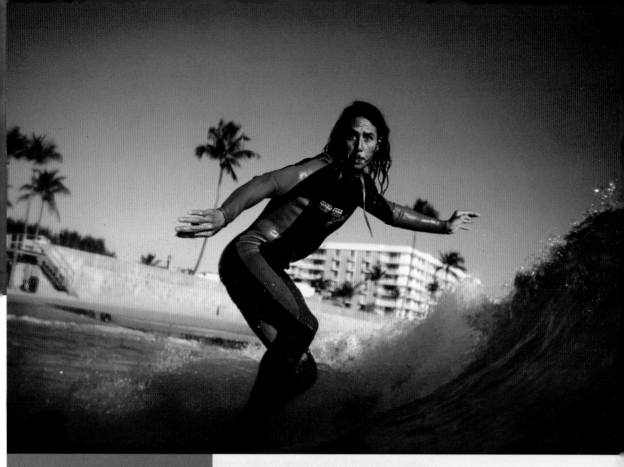

Jimbo Sampson, Palm Beach, late 1970s. Photo by John Tate.

Broward County's Jimbo Sampson surfing the metal jetty that has been known as Showers, Willougby's, and Charley's Crab, once the best of a string of man-made lefts spinning south from Palm Beach's Worth Avenue. In Palm Beach, the jetties have always been the place to be on smaller swells and higher tides.

Justin Jones, South Beach, circa 2005. Photo by Ryan Gamma.

During Florida's winters, near-shore low-pressure systems, with a combination of wind direction, fetch, and duration, often generate swells that arrive in South Florida by being redirected back toward the coast by resistance from the Gulf Stream. Known as refraction swells, they produce waves from the Palm Beaches south, with Miami's South Beach often the best spot.

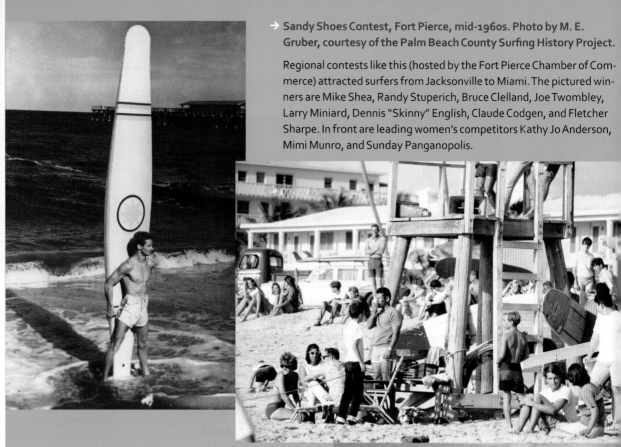

→ Sandy Shoes Contest, Fort Pierce, mid-1960s. Photo by M. E. Gruber, courtesy of the Palm Beach County Surfing History Project.

Regional contests like this (hosted by the Fort Pierce Chamber of Commerce) attracted surfers from Jacksonville to Miami. The pictured winners are Mike Shea, Randy Stuperich, Bruce Clelland, Joe Twombley, Larry Miniard, Dennis "Skinny" English, Claude Codgen, and Fletcher Sharpe. In front are leading women's competitors Kathy Jo Anderson, Mimi Munro, and Sunday Panganopolis.

↑ Tom Lawton, Palm Beach Pier, 1937. Courtesy of the Palm Beach County Surfing History Project.

Despite the recent discovery of a 1919 news photo of surfing in Palm Beach, this photo remains the oldest image of a known surfer and hollow-style surfboard in Palm Beach County. The board may be a Blake design, but this is unconfirmed. The Palm Beach Pier was at the foot of Worth Avenue and was a favorite surfing area for locals such as Tom Lawton, and then Dave Aaron, who surfed there all during the 1940s and up until 1962, when the pier was demolished by the March northeaster known as the Ash Wednesday Storm.

↗ Contest scene, Cocoa Beach Pier, mid-1960s. Photo by M. E. Gruber, courtesy of the Palm Beach County Surfing History Project.

David Aaron, one of Palm Beach County's earliest surfer, facilitated the development of competitive surfing in the entire region, along with "Chummer" McCranels, Bruce Carter, Gary Gross, Ric Nelson, David Reese, and the club of older surfers known as Surf Fossils. Aaron was also integral in creating the Palm Beach County Surfing Association, which raised money to fight antisurfing legislation.

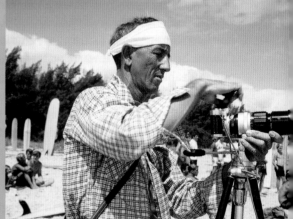

↑ M. E. Gruber, Fort Pierce, mid-1960s. Courtesy of the Gruber Archive and Palm Beach County Surfing History Project.

M. E. Gruber was among the earliest photographers in the state dedicated to documenting the sport of surfing. While based in Palm Beach County, he followed the contest scene statewide and would present slide shows of his work in conjunction with his commercial screenings of the newest surf movies at local recreational centers.

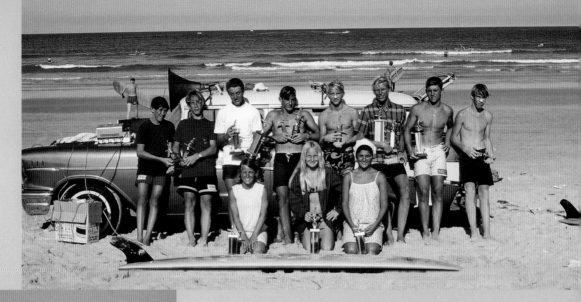

← Kim Neilson, Hobe Sound, 1966. Photo by M. E. Gruber, courtesy of the Palm Beach County Surfing History Project.

A favorite subject of surf photographer M. E. Gruber, Kim was one of the most stylish and accomplished surfers in Florida. He helped pioneer surfing in Puerto Rico and shared his home movies of PR with the crowds at the monthly meetings of the Palm Beach County Surfing Association. Kim became a renowned artist for his original watercolor designs, which include tropical fish and richly illustrated charts of Florida and the Bahamas.

↓ Chummer McCranels and Ted James, Corner's, Carlin Park, Jupiter, Florida, late 1960s. Photo by Ric Nelson, courtesy of the Palm Beach County Surfing History Project.

John "Chummer" McCranels and Ted James enjoy a beachside cookout. Doctor McCranels was among the region's earliest surfers, sailboarders, motorized paragliders, and hang gliders. Ted James was a leading surfer and shaper who founded Fox Surfboards, one of Palm Beach County's earliest and most notable manufacturers and board shops.

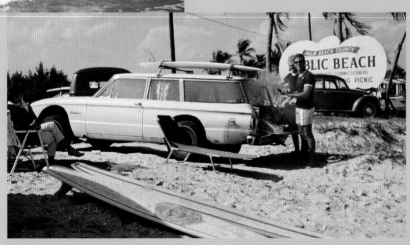

→ Stuart Public Beach, 1964. Courtesy of Bill Whiddon, Miami Surf Archive Project.

With the Treasure Coast's remarkable growth in the early 1970s, what was once a small group of longboarding locals developed into a full-blown community of hard-core surfers. Pictured here are the pioneers hanging out on the concession stand at Stuart's public beach adjacent to the Elliot Museum. With better known breaks at Fort Pierce to the north and Hobe Sound to the south, Stuart's locals and earliest visitors enjoyed extra years of solitude.

↓ Paddle Board Race, Hobe Sound, circa 1968. Photo by M. E. Gruber, courtesy of the Palm Beach County Surfing History Project.

Early surfing competitions included highly contested paddleboard races, and many of the sport's best riders excelled here as well. Cocoa Beach's Bruce Valluzzi was among the best, winning the international title in Peru in 1965. Pictured here, Chummer McCranels and his son Scott watch as Bruce Carter (black board), Mike Frantz, and others race at Hobe Sound.

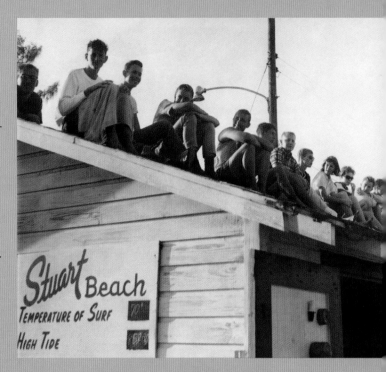

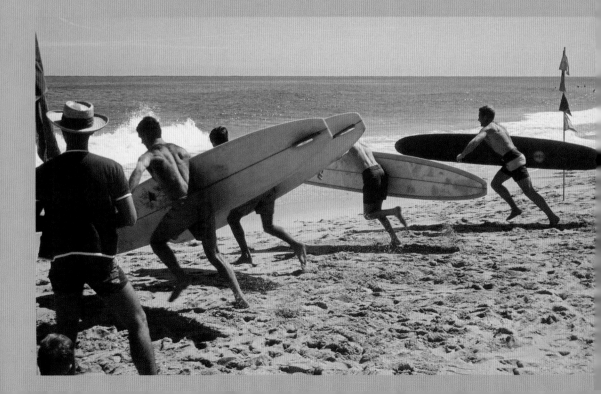

and then into Martin County and the Treasure Coast. All have their legendary days and local heroes.

Legendary as well were the two steel piers fabricated in the early 1970s by Florida Power and Light to facilitate the creation of the nuclear silos at the St. Lucie Nuclear Power Plant in southernmost St. Lucie County. While the general location remains a respectable wave today, for a number of years the power plant's jetties created what a fortunate few still consider the best waves in the state. The first of its two reactors came online in 1976, the second in 1983, and the jetties were dismantled as no longer needed. Interestingly, legal proceedings by community interests to ban the power plant went all the way to the U.S. Supreme Court twice, with construction of the second reactor finally begun well behind schedule in June 1977.

Nevertheless, the most historic event for area surfers was the wave maker produced upon the grounding of the Greek freighter *Amaryllis*, which was driven hard ashore by Hurricane Betsy in September 1965. As if ordained by the surf god Kahuna himself, the *Amaryllis* found itself permanently stuck at a perfect fifteen-degree angle in the reef just north of what is now Ocean Reef Park. The region contains several rocky outcroppings, and the *Amaryllis* was destined to create a tapering left-hander enjoyed by locals and untold others until its removal, section by section, as an early offshore artificial reef project in August 1968. "The Ship," as it was called, was home to dozens of the region's best surfers, including Mike Bowe, Kim Neilson, Doug and Mark Soverel, Alan Carlisle, Ann Woodward, Eddie Baur, and Phil Flournoy, among others.

The Treasure Coast to the north is known worldwide for its legacy of Spanish galleons shipwrecked in the seventeenth century at the height of the European conquest of the Americas. A good number of gold-laden Spanish galleons sank offshore during a single hurricane in 1715, and a serious community of amateur and professional treasure hunters continue to search for these sites and their spoils. Remarkable finds—and fortunes—have been made by Mel Fisher and others, some very close to the beach and in very shallow water. For surfers, aside from Hobe Sound and Fort Pierce, the region remained largely off the beaten path for decades, with the locals keeping their own oath of silence. Stuart Rocks remained reasonably undercover while fostering big-wave lunatics like David Ashcraft, West Palm transplants Charles and George Williams, Todd Rissacher, and Teague Taylor. Other chargers from Stuart over the years include John Smith, Frank Wacha, Thomas Cook, Scott Donelay, Charlie Wallace, Ronnie Haire, Ernesto Ayala,

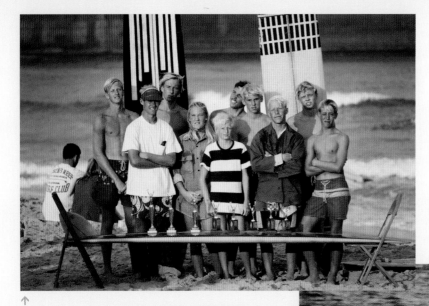

↑
Possum's Reef Surf Club. Intra club competition. Photo by M. E. Gruber, courtesy of the Palm Beach County Surfing History Project.

Surf Clubs, organized around shared surf spots and/or communities, were an integral part of East Coast surf culture. Contests, held within and between and clubs, create a competitive spirit. Pictured here at Singer Island's "Ship" (*left to right*) are Mike Frantz (seated), Mark Soverel, Kim Neilson, Eddie McCoy, Jerrie Graham, Doug "Hoy" Soverel, Bill "Holmesy" Holmes, Maury McCoy, Mike Bowe, Eddie Baur, and Phil Flournoy.

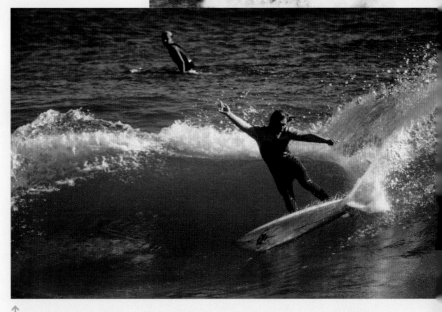

↑
Maurice "Maury" McCoy, Jungle Road, Palm Beach, 1980. Photo by Tony Arruza.

Maury McCoy, his wife, Pat, and his brother Eddie were prominent figures at the Lake Worth Pier in the 1970s and early 1980s. McCoy was a key member of the Fox team and won the Eastern Surfing Championships in 1977 and 1978, as well as the United States Surfing championships.

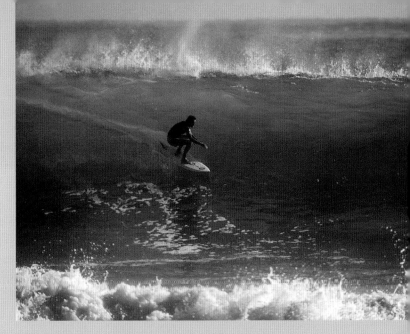

→ Hunter Joslin, Reef Road, 1980s.
Photo by Darrell Jones.

Hunter Joslin has had a hand in the surf industry and contest scene for decades, as Florida's unofficial surf impressario. Among other hats worn, he has severed as announcer for untold contests and as MC for the annual East Coast Surfing Legends Hall of Fame inductions at Surf Expo.

← Carmen Irving, St. Augustine, 1971.
Photo by Paul Aho.

Carmen Irving, of Boynton Beach, is pictured here free surfing in advance of winning the Men's Division of the Florida State Championships, first hosted in Ormond Beach in 1964. He went on to win the ESA's Eastern Surfing Championships at Cape Hatteras, North Carolina in 1972. Irving was an outstanding longboarder before joining the shortboard revolution with a Skip Frye V-bottom design purchased from Charlie Keller's shop in Boynton Beach. Later, he became a key shaper for Nomad Surfboards during its rise to East Coast fame.

↓ Fred "Deadeye" Salmon and Eddie Scozzari, "the Ship," Singer Island, mid-1960s. Photo by M. E. Gruber, courtesy of the Palm Beach County Surfing History Project.

Palm Beach County surfers were gifted with a spectacular wave on Singer Island with the grounding of the Greek freighter *Amaryllis* during Hurricane Betsy on September 8, 1965. At 441 feet, "the Ship" was firmly aground, remained in place until 1968, and is now a fishing and diving reef a half-mile from shore.

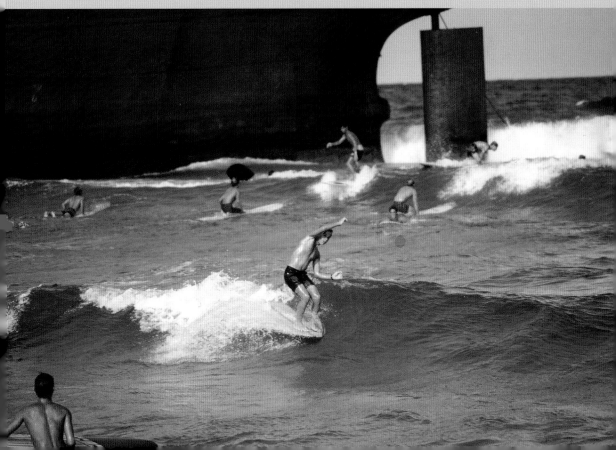

James Jolly, Larry Hehne, Brian Mitchell, Eric Ingelman, Mike Stratman, Scott Harwood, and Steve Schafer, who died of a fatal shark attack while kiteboarding off Stuart in 2010. Another loss to the community, Donny Macrae—an amazing talent from Hobe Sound—passed away at age thirty-five in 2011. The younger crew includes notables John Dillon and Kai Haire, among others.

Not far up the coast is the Fort Pierce Inlet State Park, which remains one of the region's most reliable travel destinations and was once the first spot to check on the way to the Space Coast or beyond. New discoveries took some of the pressure off, but North Jetty was always a scene of high traffic, considerable localism, and parking lot thievery. The entire scene could have come to its end as a surfers' memory and developer's dream without the intervention of surf activist Ross Houston and the Eastern Surfing Association's Beach Access and Preservation Program (ESABAP), which collectively spearheaded a campaign to save the park and other beaches for public access in the late '70s and early '80s. Since then, the Surfrider Foundation has developed regional chapters across both coasts of America to safeguard beach access and water quality issues.

Fort Pierce has its own unique history of shops, contests, and surfers. In addition to the weekend invasion from the south, it attracted its own cast of characters. John McKinney's Sol Surf Shop, the Berg brothers' North Jetty Surf Shop, and Mark Castlow's Atlantis Surfboards were all significant forces in shaping the regional scene. A good many of its earliest surfers came from elsewhere, like Deerfield's Dennis "Skinny" English and, later, Mike Polvare, Castlow, and McKinney as well. Other locals included Paul Haas and Bill and Brendon McGill. Jeff Berg would later become chairman of surfline.com, one of the surfing world's biggest Internet information providers and earliest online retail outlets.

The North Jetty has hosted a good number of contests over the decades, starting with the Sandy Shoes contests, which attracted competitors from up and down the eastern seaboard. The inlet itself was built in the early 1900s, when a storm closed the natural inlet about a mile north of its present location, and it has an interesting history that begins long before it became a surfing destination or state park. During World War II, the navy used the inlet and the surrounding land to train their landing-craft crews, and many of the 140,000 service personnel stationed in the area practiced for the D-Day invasion of Europe. It was also the birthplace

← Scott "Red" McCranels, OP America Series, Jensen Beach, Florida, 1986. Photo by Tony Arruza.

Scott, son of John "Chummer" McCranels, was one of the youngest surfers in Florida in the late 1960s. He started competing as a Menehune competitor in ESA and became a pro skateboarder at 14. As a pro surfer he split his time between the ASP World Tour and dental school. On the Natural Art Team, he surfed very large Pipeline and Waimea. In overhead surf in the 1986 Op Pro at Jensen Beach, Scott surfed brilliantly and easily outscored Shaun Tomson in the semi-final, but Shaun won by tricking Scott into an interference. Scott and his dad are the only father and son duo in the East Coast Surfing Hall of Fame. They still surf together, and they are both orthodontists. Additionally, Scott and former pro skater Bruce Walker are the only members of both the Florida Skateboarding and East Coast Surfing Hall of Fame.

↓ Shaun Abrams, Reef Road, 1989. Photo by Tony Arruza.

This shot by Tony Arruza of Shaun Abrams at Reef Road on Christmas Day 1989 graced the pages of *Surfing Magazine* as a two-page spread, opening a feature story on Reef Road and restating the facts for surfers in Florida—yes, the surf gets good; yes, the surf gets big; and yes, Tony Arruza's skills behind the lens are second to none.

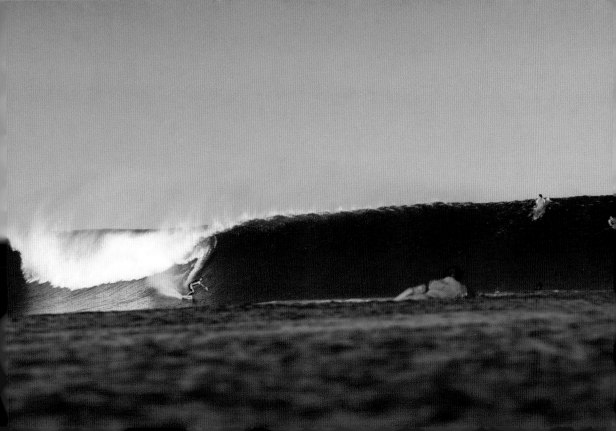

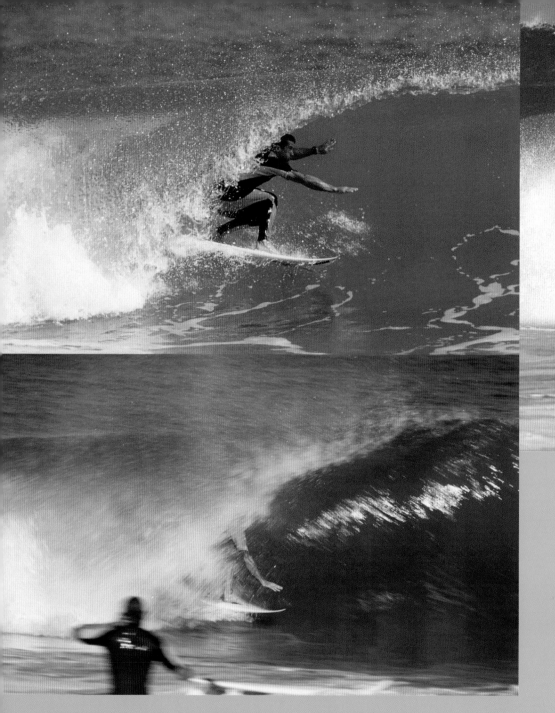

↑↑ **George Williams, Charley's Crab, Palm Beach, 1993. Photo by Tony Arruza.**

Interestingly, the Williams brothers, identical twins George and Charles, are originally from Belle Glade, well to the west of the Atlantic, as was photographer Tony Arruza. Beyond their achievements in Florida's surf, the twins are highly recognized for their exploits in big surf at mainland Mexico's Puerto Escondido.

↑ **Charles "Chuck" Williams, switch foot, Charley's Crab, Palm Beach, 1994. Photo by Tony Arruza.**

Charles Williams and twin brother George are today mainstays of the surf community in the Treasure Coast but have their origins in the Palm Beaches.

Peter Mendia, September 18, 2003, Hurricane Isabelle, Reef Road. Photo by Bill Davis.

Peter Mendia, like Cocoa Beach's Philip Watters before him, relies on his visibility as a free surfer rather than contest results to earn the benefits of sponsorship with Billabong. With a new wave of high-profile pros seeking to reinvent pro surfing outside the World Tour, Mendia seems on point as more and more surfers look for role models outside of competitive surfing.

"The Hut," Stuart Rocks. Courtesy of George Williams.

The Treasure Coast is isolated by the St. Lucie Inlet to the south, the Fort Pierce Inlet in the middle, and, until 1964, by the lack of a bridge over the Sebastian Inlet. Its core crew was highly territorial and proud of it. Pictured here, is one of many "huts" constructed over the years at Stuart Rocks, due to their periodic destruction by Martin County authorities and summer hurricanes.

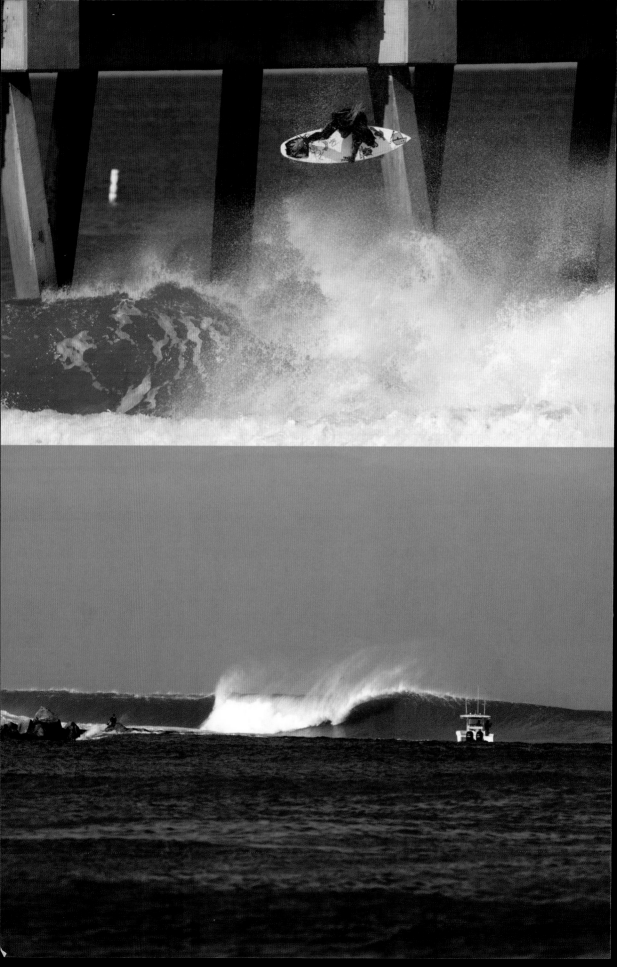

and training ground for U.S. Navy Frogmen, forerunners of today's Navy Seals, as well as the Navy Underwater Demolition Team.

Long before surfing came to the once-remote beaches of St. Lucie and Martin counties, Palm Beach County was home to a number of pre- and postwar surfing pioneers. The region's earliest stand-up surfers include Tom Lawton, an early figure in Palm Beach; David Aaron, an active contributor to the sport's regional development, who traveled to Hawaii in 1937 with California's Dorian Paskowitz; John "Chummer" McCranels, who began rafting at Lake Worth Pier in 1945 and built his first hollow board in 1952; Virginia Beach transplant Tony Stormont in Ocean Ridge; John Schmid, who returned from a trip to California with Bill Holmes in 1965; West Palm locals Ricky and Allen Laabs, who crafted a twin-fin longboard in 1966 based on a Simmons-style balsa board brought back from California by Aaron in 1945; Tom Warnke, from Boynton Beach; David Reese, son of a Palm Beach mayor and cofounder of the Eastern Surfing Association; Billy Capella, a Palm Beach resident who Reese credits with discovering Reef Road; and Kim Neilson and Paul Gingras, who were among its first regulars.

⊓⊔

The region has a litany of legendary surfers. Cocoa Beach's Gary Propper called the Palm Beaches home in the early '70s, and Puerto Rico's national champ Jorge Machuca blew minds during his extended stays at the same time. But there have been many others over the years in the Palm Beaches and points south, including Maury and Eddie McCoy, Carmen Irving, the Neumann brothers, Lenny Nichols, Scott McCranels, Clint Casey, Jimmy Miller, John and Andy Aiken, Ryan and Ronnie Heavyside, Baron Knowlton, and Peter Mendia. Jupiter's later crew includes John Scotten, Adam Ricardel, Matt Eakes, Jim and Ryan Helm, and Jensen Callaway, among many others. Standouts at the Ship, back in the day, included Mike Bowe, John Sennett, Mike Farnetti, Mike Frantz,

↖ Jensen Callaway, Juno Pier, March 18, 2010. Photo by Mark Hill.

South Florida pro Jensen Callaway won the 2011 Makka Pro in Jamaica, then the fourth stop on the circuit of the Western Atlantic Pro Surf Series founded by Mike Bloom. This shot of Callaway made the August 2010 cover of *Eastern Surf Magazine*.

← Pumphouse, Hurricane Irene, September 26, 2011. Photo by Mark Hill.

Hurricane Sandy in 2012 wasn't the first time that Pumphouse caught surfing's attention, and neither was Hurricane Irene, pictured here, but it will likely never be seen this empty again.

Bull Shark, Reef Road, Palm Beach, September 5, 2008. Photo by Tony Arruza.

While the entire East Coast experiences seasonal mullet migrations, South Florida's subtle protrusion into the Atlantic and proximity to the Gulf Stream often concentrate the bait and predators close to shore. In the late 1960s and early 1970s, schools of mullet would line the beaches for miles. This 2008 photo by Tony Arruza was shot from the hip without looking down, just wondering what was lurking below.

Baron Knowlton, Palm Beach, September 2008. Photo by Tony Arruza.

Baron Knowlton may be a local at Lake Worth Pier, but he gained respect in Hawaii, Mexico, and other heavy-wave breaks. He and fellow South Florida surfers Peter Mendia and later Ryan Helm led the East Coast Team to multiple Gold Medal wins in the Summer X Games in the early to mid-2000s.

Lake Worth Pier, May 8, 2007. Photo by Tony Arruza.

Every pier on the Atlantic Coast has its own history and legacy of early surfing legends. Cocoa Beach has Gary Propper, Mike Tabeling, Claude Codgen and Bruce Valluzzi. Jacksonville Pier has Bruce Clelland, Dick Rosborough and the Roland brothers. Lake Worth has "Chummer" McCranels, Eddie and Maury McCoy, Peter Mendia, and Baron Knowlton. Pictured here are the ruins of the pier in the middle of the biggest swell to hit Florida since the Halloween Swell of 1991—an off season event created by an Atlantic storm system that included Tropical Storm Andria and an extraordinary meteorological pressure gradient aimed directly at South Florida. Like a number of other massive storms over the decades, this swell demolished the pier and by necessity sent most surfers looking for more sheltered conditions further south.

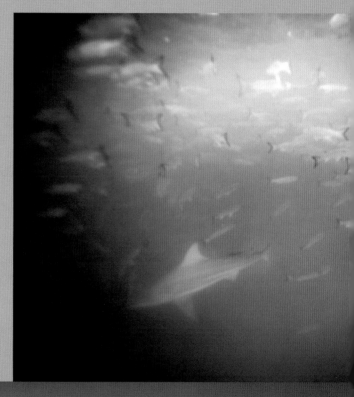

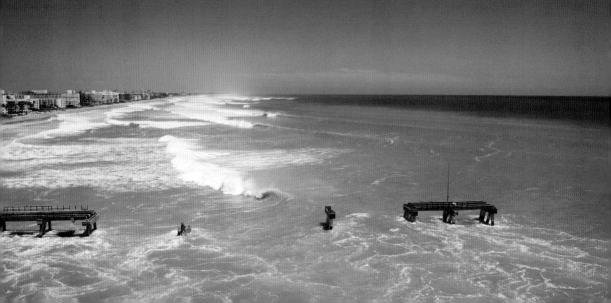

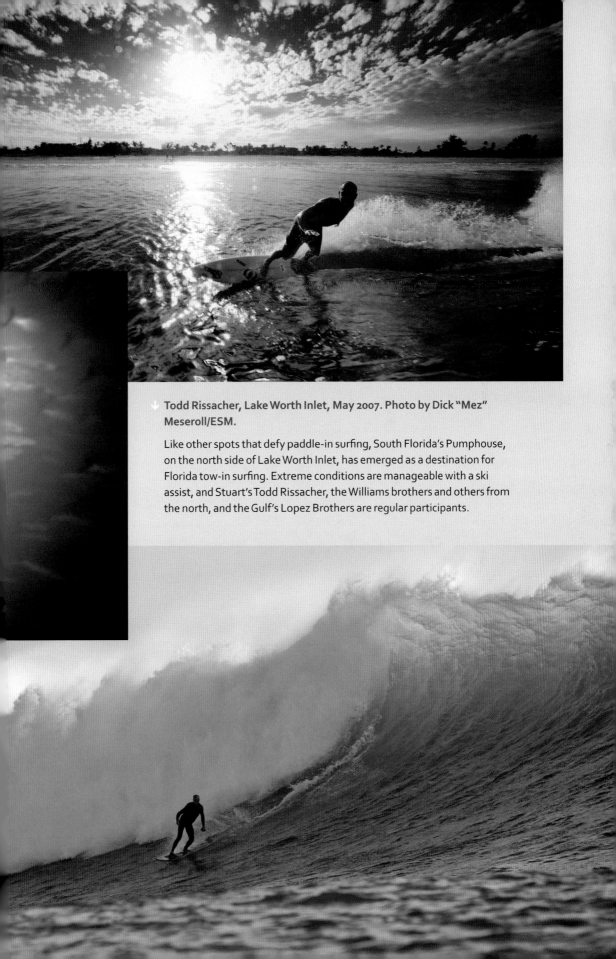

↓ Todd Rissacher, Lake Worth Inlet, May 2007. Photo by Dick "Mez" Meseroll/ESM.

Like other spots that defy paddle-in surfing, South Florida's Pumphouse, on the north side of Lake Worth Inlet, has emerged as a destination for Florida tow-in surfing. Extreme conditions are manageable with a ski assist, and Stuart's Todd Rissacher, the Williams brothers and others from the north, and the Gulf's Lopez Brothers are regular participants.

⬆ **Blue water set of waves, Lake** ⬆ **Treasure Coast. Photo by Mark Hill.**
⬆ **Worth, looking north from Lake**
Worth Pier. Photo by Tom Dugan. Don't let the crowd or the playful look of this wave fool you; both are the
exception rather than the rule at this typically heavy and highly localized
spot in Stuart.

56

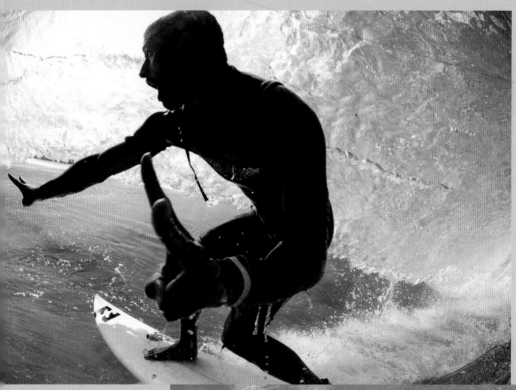

Ryan Heavyside, Reef Road, February 2010. Photo by Nic Lugo.

Florida's surfing history is filled with father-and-son stories. Among those in the Palm Beaches are Ryan and Ronnie Heavyside, whose father, Ron, was a standout longboarder and founded Nomad Surf-boards in 1968. He learned the trade while working for Delray's Caribbean Surfboards in the mid-1960s.

Cooper Brandt, Stuart, February 22, 2012. Photo by Mark Hill.

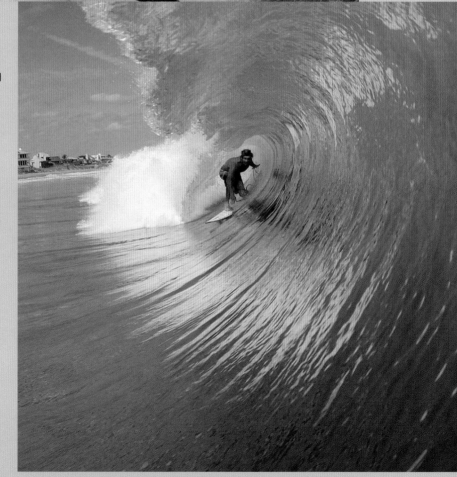

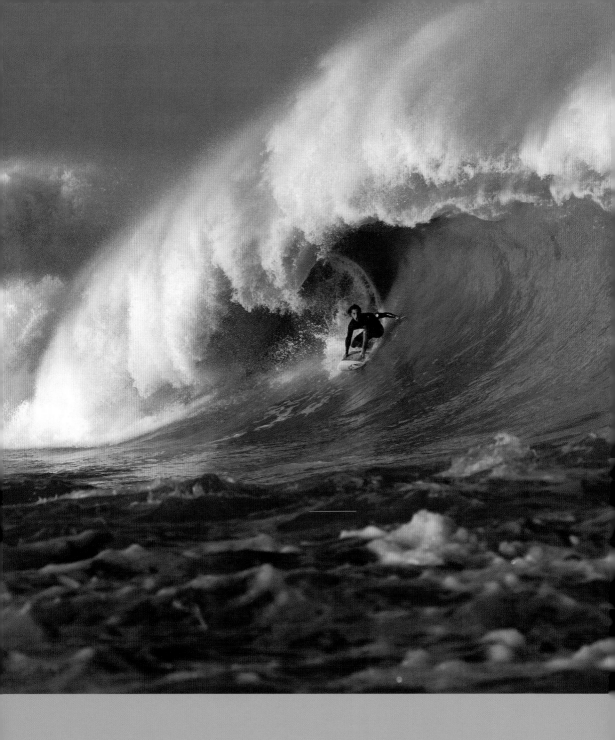

← Jesse Heilman, Hurricane Sandy, Pumphouse, October 28, 2012. Photo by Mark Hill.

Daytona Beach's Jesse Heilman won the 2010 Tommy Tant Memorial and the 2012 Kona Pro, among other victories. With a $20,000 Open Pro purse, the Kona Pro was the largest professional surfing event in the state of Florida and the third largest on the East Coast. Heilman made the trip south for "Super Storm Sandy," along with others.

↓ Peter Mendia, Hurricane Sandy, Pumphouse. Photo by Mark Hill.

South Florida's Peter Mendia, a regular among the tow crew at Pumphouse, made the most of Sandy's dredging barrels and the swarm of media attention through some epic rides caught on film and video.

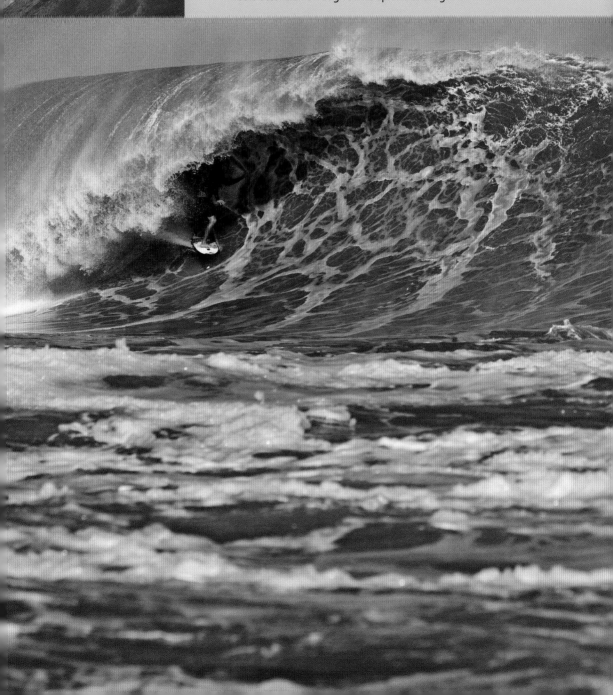

Mike Stuperich, Ed Baur, Alan Carlisle, Corky Roche, and Fred Salmon.

While this may sound like an all-boys club, the region also had its share of female talent over the decades. Early on, this included Ginny Lynn, who painted "Surfers Rule" on the side of the Ship in an act of teenage rebellion, Diane and Lorraine Rynasko, Mary Ann Church, Pat McCoy, Terry Williams, Jennifer Flanagan, Kristy Murphy (former world longboard woman's champ) and most recently Robyn Tassi-Curry and Kelly Hutchison. All hail from Palm Beach and Martin counties and represent a cadre of highly accomplished and dedicated female surfers from its early days to the present.

⌐
└⌐

Among the earliest shapers in the area were Ron Heavyside (who was with Delray's Caribbean Surfboards before founding Nomad Surfboards in 1968), Juno's California transplant Bill Holmes (Holmesy Surfboards), and Lake Worth's Ted James (Fox Surfboards). In the '70s, Carmen Irving (Nomad) and John Parton (Fox) were added to the mix, along with Keith Starling, who shaped first for Nomad and then for Fox. Dozens of others made boards in the region's shaping bays, including California's Sid Madden, who paid an early '70s visit to Nomad, author Paul Aho, and a slew of shapers and craftsmen from points north. Among the group, it is probably John Parton who has most "shaped" the local industry, being first in the region to apply advanced technology to both surfboards and sailboards and to utilize a computer-driven shaping machine to rough-shape his own and other shapers' designs. In the Treasure Coast, John McKinney and Mark Castlow were the pioneers, and later notables were Charles and George Williams, first with Rebel and then Impact Surfboards, whose reach likewise stretched well beyond the Treasure Coast.

Later labels include Gee Rainbow's Escape Surfboards, David Freidank's Blue Earth, Mike Pechonis's Bird Surfboards, and Brian Tudor's Bat Surfboards, as well as smaller operations like Jeff Surgener's Rhino Tuff. The earliest surf shops in the region included Frank "Tuppy" Tuppens's marine goods and tackle shop in Lake Worth, D&D Marine in West Palm Beach, Gunn's Patio Shop on Singer Island, and dedicated shops like Juno Surf Shop in Juno; Caribbean Surfboards at Delray Bicycle and Sporting Goods and Richwagen's Bicycle Shop and Richie's Surfboards in Delray; Buck's Surf Shop in Deerfield Beach and Charlie Keller's shop in Boynton Beach. George Evans's Aquatics Ltd., plus Nomad, Fox, Island

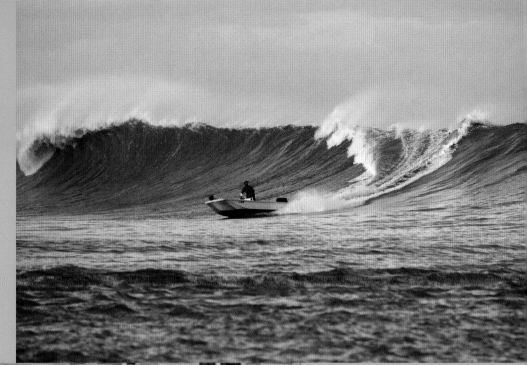

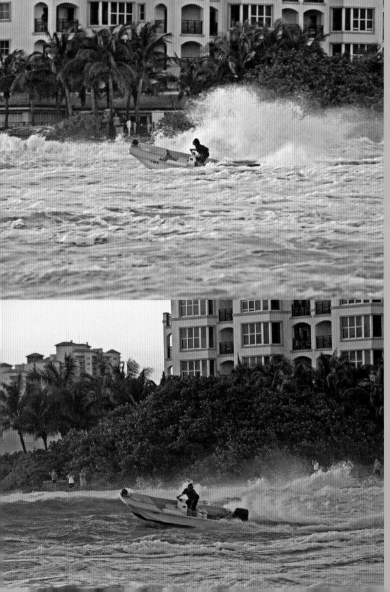

Unknown boater, Hurricane Sandy, Pumphouse. October 2012. Photos by Mark Hill.

While there were a dozen boats in the inlet, this stunt found no other takers. What could be mistaken for a drop and a race into open water was instead a bit of lunacy whose only turnaround back to sea was the washout next to shore.

Water Sports, and dozens of others would enter in the late 1960s and beyond.

As the number of surfers increased, coastal communities reacted to their prankish and occasionally bad behavior through concerted efforts to ban the sport. The quiet town of Ocean Ridge, adjacent to Boynton Inlet, sought an ordinance to ban surfing, which was defeated in part with the help of petitions circulated by a handful of its resident teenagers. North Palm Beach wrote statutes totally banning the possession of surfboards within its town limits, and in 1964 the Town of Palm Beach wrote and enforced an ordinance prohibiting surfboards in, on, or about the waters of Palm Beach. The law remained in place until 1968, when Bruce Carter was arrested and the issue was taken to court by the Palm Beach County Surfing Association. Defending surfing was a young lawyer named Joel Daves, a third-generation West Palm native who would later become the state's attorney for Palm Beach County and then mayor of West Palm Beach. The case went through four layers of judicial review before the Florida Supreme Court ruled that Palm Beach could regulate but not ban the sport. Bumper stickers saying "I Gave to Save Surfing" were sold for a dollar each, raising close to $1,500 in support of the cause. Similar legislation was attempted or implemented in communities around the state during surfing's boom years in the mid-1960s.

Today, the biggest issues facing surfers in the Palm Beaches are where to paddle out, how to find a legal place to park, and getting a wave to themselves.

CHAPTER 7

The Space Coast

While surfing in Florida developed slowly in its early modern years, the 1960s brought a confluence of events that created an explosion of new surfers in coastal communities across the state and the country. Florida's Space Coast, a collection of coastal towns stretching south from Titusville to Palm Bay, was at the center of this explosion, with Cocoa Beach its spiritual hub and Canaveral Pier its first place of worship. The growth of Patrick Air Force Base, Cape Canaveral Air Force Station, and NASA's Kennedy Space Center drew thousands of highly educated and relatively affluent workers and their families to what had been a sparsely settled stretch of coastline. By the time Neil Armstrong set foot on the moon in 1969, Space Coast towns were booming—none more than Cocoa Beach, the capital of Space Coast surfing, and arguably of the entire Atlantic Coast as well.

Yet before the '60s boom, Florida's early surfers reveled in the region's waves. Among those who came to Cocoa Beach in the late 1950s were Jack "Murf the Surf" Murphy and Dick Catri, then living in Miami Beach. Murphy introduced Catri to surfing in Miami Beach in 1957. Both were destined to play legendary roles in the sport's early development—Murphy as overachiever-gone-bad and Catri as surfer, trainer, coach, organizer, and manufacturer. Both had status as real surfers, Murphy winning the 1962 Daytona Beach Surfing Championships and the 1963 East Coast Surfing Championship while making a short appearance in Bruce Brown's film *Surfing Hollow Days*. Catri, meanwhile, was one of the East Coast's first Hawaiian big wave riders. Murphy would open one of the state's first surf shops in Indialantic before being convicted and sentenced for a historic and daring 1964 jewel heist from New York City's Museum of Natural History which included the Star of India,

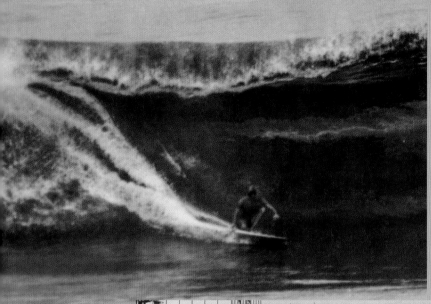

← Dick Catri, Pipeline, North Shore, Oahu, 1964. Photo by Mark Beatie, courtesy of Dick Catri.

Dick Catri put his skills he acquired traveling the beaches of Florida and California with Jack Murphy into play in Hawaii between 1960 and '64. He earned credibility as the first East Coaster to surf Pipeline, Sunset, and Waimea Bay, securing an invitation to the 1967 Duke Kahanamoku Invitational at Sunset Beach. Catri is a true impressario and a leading figure in the history of East Coast surfing.

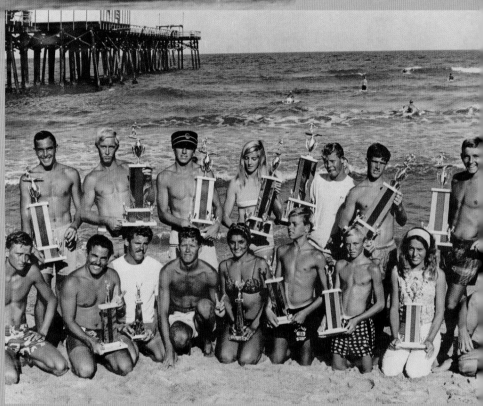

↗ Easter Surfing Festival, Cocoa Beach Pier, 1965. Courtesy of Pat Valluzzi.

The Cocoa Beach Pier, home to major events since the early 1960s, hosts the Annual Cocoa Beach Easter Surf Festival, which marked its 49th competition in 2013. Pictured here among other Floridians are (*back row*) John Eakes, Bruce Valluzzi (*in hat*), Betsy Twombly, Gary Propper (*white shirt*), Claude Codgen (*far right*); (*front row*) Sunday Panganopolis (*middle*), René Eisler, and Gary Freeman.

→ Pat and Dennis O'Hare, The Jetties, Cape Canaveral. Courtesy of Pat O'Hare.

The O'Hare brothers, from California, were early Space Coast surfers. Pat was one of the first surfboard builders in the region. They are surfing inside the jetty at Port Canaveral, an artificial cut dredged in 1951. Today, after additional dredging, it is one of North America's largest ports and the second largest cruise ship terminal in the world.

Gary Propper, Oceanside Surfing Invitational, Oceanside, California, 1967. Photo by Ron Stoner, courtesy of *Surfer* magazine.

Still hailed today as GP, Gary Propper is the Atlantic's first superstar. Propper brought international credibility to East Coast surfers and used his success to position himself for a remarkable life of multiple dimensions. Surfer, entertainment industry insider, and artist, Propper has lived a charmed life that includes taking Paloma Picasso for a day of surfing on Long Island, packaging the Ninja Turtles into a mutant merchandising gold mine, and putting comedians Gallagher and Carrot Top on top of their game, among other demonstrations of his range and confidence. Propper was born in the Bronx in 1946, moved with his family to Miami Beach, and then moved again to 13th Street in Cocoa Beach shortly afterward, where he started surfing at age 13. Within five years, he had won the 1964 East Coast Surfing Championship's juniors division and would go on to win the Men's Open in the 1966 East Coast Surfing Championships, defeating prominent Californian entrants Dewey Weber and Tom Lonardo with an amazingly intuitive ability that included converting a potential nose ride spin-out into an award winning fin-first recovery. If that doesn't sound like much relative to today's lexicon of high performance aerial maneuvers, it was a winner at the time. Propper was also the East Coast's top choice in *International Surfing* magazine's 1967 Hall of Fame Awards and was inducted into the East Coast Surfing Hall of Fame in 1996.

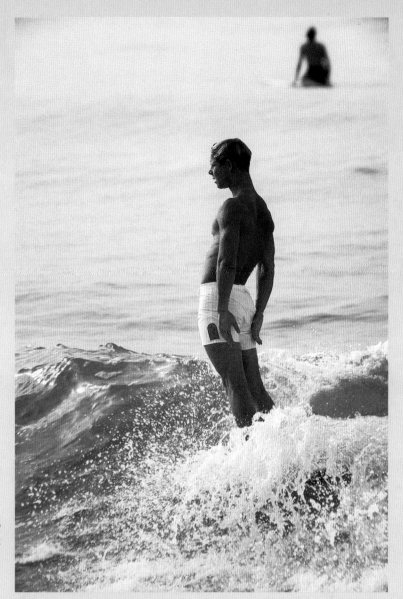

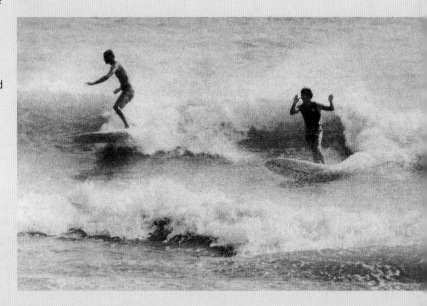

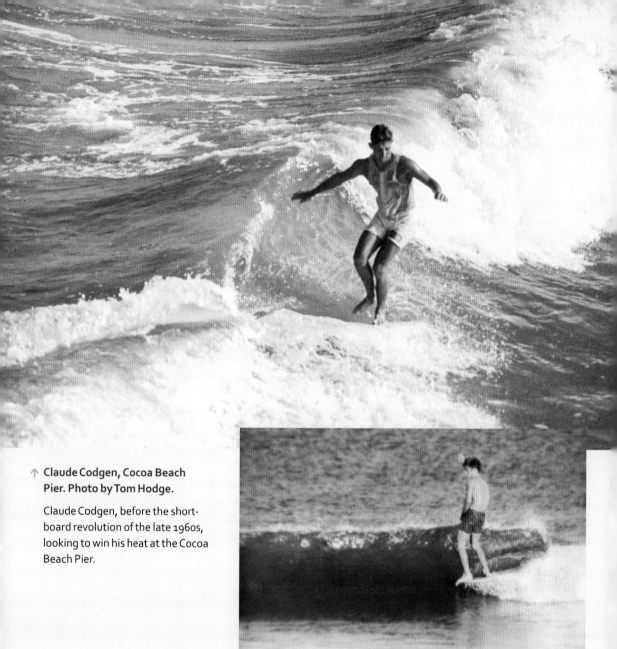

↑ **Claude Codgen, Cocoa Beach Pier. Photo by Tom Hodge.**

Claude Codgen, before the short-board revolution of the late 1960s, looking to win his heat at the Cocoa Beach Pier.

↑ **David Carson, Satellite Beach, 1967. Photo by Pete Ward, courtesy of David Carson.**

David Carson and his brother Bob were standouts in the 1960s well before making names for themselves in other aspects of the sport. Bob Carson emerged as one of the top shapers of his day before relocating to Tortola, BVI, and a career as a successful yacht broker with a home at Cane Garden Bay. While David also has a house at CGB, he got there quite differently. Following a pro surfing career and a number-eleven ranking on the world tour, he revolutionized the world of graphic design with his groundbreaking innovations and has been cited by *Newsweek* as "having changed the public face of graphic design" and by Surfrider Foundation as being "the most influential graphic designer of our times."

the world's largest sapphire. Arrested within two days, he served two years for the crime. Soon after his release, Murphy was convicted of murder and assault in additional criminal affairs. After sixteen years in prison, he was released in 1986 and today runs a mobile ministry for inmates searching for God and another way of life.

Dick Catri followed another path. By the time Murphy had been arrested for grand larceny, Catri had spent three winters in Hawaii and established himself as a player in big waves on Oahu's North Shore. He returned to Florida in the spring of 1964 as the East Coast representative for Dick Brewer's Surfboards Hawaii. He opened a shop in Satellite Beach and proceeded to put together a competitive team of the region's hottest surfers. This included Gary Propper, Mike Tabeling, Bruce Valluzzi, Fletcher Sharpe, and Mimi Munro, among others. Catri changed course in 1966, and the Surfboards Hawaii team became the East Coast Hobie Team, adding Sam Gornto, Dennis "Skinny" English, Joe Twombly, Sunday Panganopolis, and others to the mix. Among other accomplishments, Catri was inducted into *International Surfing* magazine's 1966 International Hall of Fame, surfed in the 1967 Duke Kahanamoku Invitational at Oahu's Sunset Beach, and represented the United States at the 1968 World Contest in Puerto Rico.

While there were many competitive surf teams in Florida representing West Coast manufactures within East Coast markets at the time, Catri had the lion's share of the East Coast's talent. By the mid-1960s a summer competitive circuit was in place at strategic beaches from Cocoa to Gilgo, and the Hobie Team ruled the day. The most successful surfer, competitively and financially, was Gary Propper, who was also the highest-paid professional surfer of his day. Propper declared his 1967 IRS earnings from Hobie signature board royalties, Katin surf trunks, and O'Neill wetsuits at almost $100,000 for the year. Among his other achievements, he won the Juniors Division of the 1964 East Coast Surfing Championships and the Men's Open in the 1966 East Coast Surfing Championships. With a flair for fast talk and a nose for money, Propper moved into the entertainment industry and scored big through his role in developing a single-issue East Coast comic book into one of the film industry's largest-grossing independent films ever—*Teenage Mutant Ninja Turtles*—while steering its development into a multibillion-dollar franchise. Propper also created and operated the longest-running comedy tour in the country with comedian Gallagher, and he later managed and directed the career

→ Greg Loehr, Log Cabins, Oahu, 1973. Photo by Jeff Divine.

Empowered by his youthful street cred and contest results—including his first-place finish in the Men's Division at the 1974 East Coast Championships as well as the Lacanau Pro in 1979—Greg Loehr has always been willing to speak his mind and buck the trends. Having secured invitations to the Smirnoff and Duke events in Hawaii in 1974 and 1975, he was incensed by the then prevalent maligning of East Coast surfers within an international context. The media played on his outspokenness in defense of the Right Coast, earning him considerable ink in the magazines and immense respect back home. Given the performance ratings since Floridians took to international competition, it's pretty obvious that Loehr had it right.

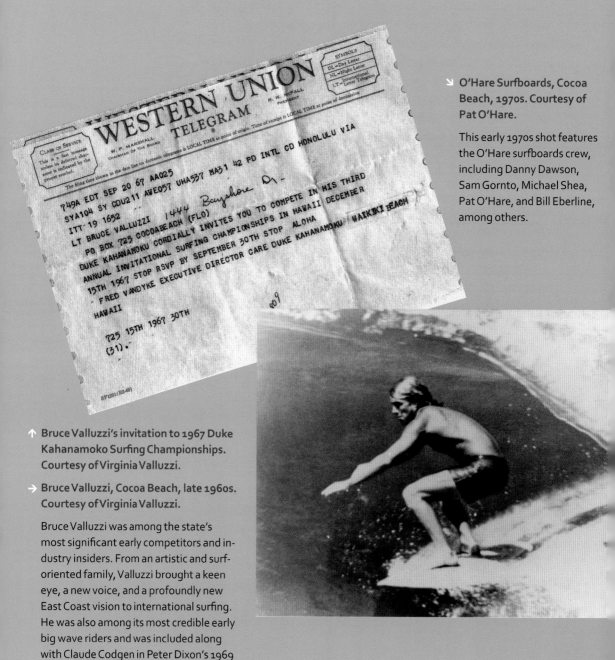

↗ O'Hare Surfboards, Cocoa Beach, 1970s. Courtesy of Pat O'Hare.

This early 1970s shot features the O'Hare surfboards crew, including Danny Dawson, Sam Gornto, Michael Shea, Pat O'Hare, and Bill Eberline, among others.

↑ Bruce Valluzzi's invitation to 1967 Duke Kahanamoko Surfing Championships. Courtesy of Virginia Valluzzi.

→ Bruce Valluzzi, Cocoa Beach, late 1960s. Courtesy of Virginia Valluzzi.

Bruce Valluzzi was among the state's most significant early competitors and in-dustry insiders. From an artistic and surf-oriented family, Valluzzi brought a keen eye, a new voice, and a profoundly new East Coast vision to international surfing. He was also among its most credible early big wave riders and was included along with Claude Codgen in Peter Dixon's 1969 Bantam Books publication, *Men Who Ride Mountains*.

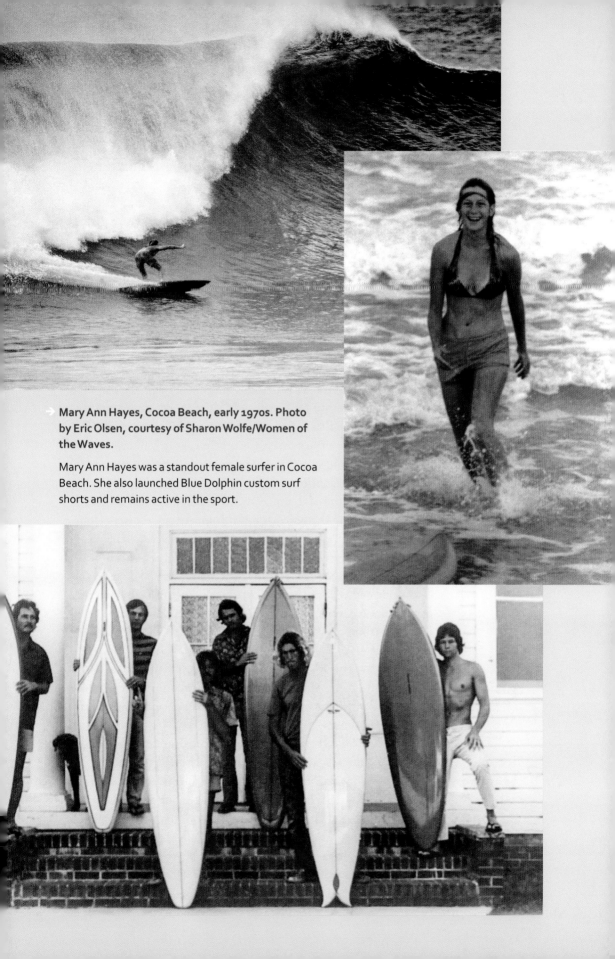

→ Mary Ann Hayes, Cocoa Beach, early 1970s. Photo by Eric Olsen, courtesy of Sharon Wolfe/Women of the Waves.

Mary Ann Hayes was a standout female surfer in Cocoa Beach. She also launched Blue Dolphin custom surf shorts and remains active in the sport.

of the comedian Carrot Top (Scott Thompson) among other super successful careers. Both Gallagher and Carrot Top are also from Florida.

As competitive surfing developed, Floridians Tabeling, Bruce Valluzzi, and Claude Codgen assumed a larger international role and positioned East Coast surfers as serious competitors in big waves. Catri had made his mark. In 1964, Tabeling competed in Lima, Peru, and became the first East Coast surfer to win an international competition; in 1965, at age seventeen, he, Valluzzi, and Codgen were invited to the World Championships at Pico Alto. During the Second Annual Duke Kahanamoko Surfing Champion-ships, Gary Propper, the event's youngest-ever surfer and then East Coast reigning champion, faced the biggest surf of the sea-son. Unprepared for the sheer scale of the surf, Propper paddled out, measured his nerve and experience, and decided against the venture.

In the same year, Valluzzi, then eighteen years old, was invited to fill in when Australia's Nat Young was unable to make the trip. Ricky Grigg, a twenty-nine-year-old California oceanography stu-dent, claimed the title from eighteen-year-old Hawaiian Jeff Hack-man, who had won the contest the previous year. Valluzzi was back the next year, alongside Claude Codgen and Dick Catri, for another go, and the three continued to build reputations in big surf.

With the coming of the 1966 World Championships, held in San Diego, among the ten East Coast competitors, six were from Brevard County. Tabeling, Propper, Valluzzi, and Fletcher Sharpe were all still representing the Surfboards Hawaii Team at the time. Claude Codgen and Tommy McRoberts were surfing for the Oceanside and O'Hare teams, respectively. The contestants were decided upon contest results at Virginia Beach's East Coast Surfing Championships and the Long Island Contest in Gilgo Beach, New York. Canaveral's Labor Day contest was not considered despite a last-minute effort by committee member Hobie Alter to factor it into the mix. Other Floridians included Mimi Munro, Renee Eisler, Bruce Clelland, and Larry Miniard. Mimi Munro took third in the Women's Division.

Two years later, the question of selecting East Coast surfers for big wave events rose to the forefront while putting together a team for the 1968 World Championships, to be held in Rincon, Puerto Rico. The Eastern Surfing Association, founded in 1967, had struc-tured a team based on East Coast contest results, which included a number of surfers likely to be out of their league in the larger surf of Rincon. In fact, that year's East Coast contest results were

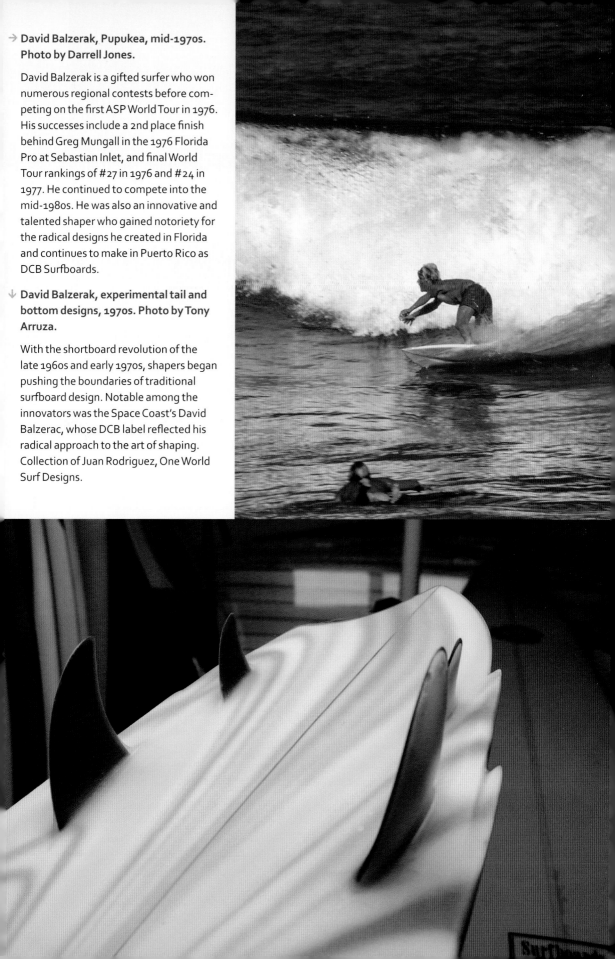

→ **David Balzerak, Pupukea, mid-1970s. Photo by Darrell Jones.**

David Balzerak is a gifted surfer who won numerous regional contests before competing on the first ASP World Tour in 1976. His successes include a 2nd place finish behind Greg Mungall in the 1976 Florida Pro at Sebastian Inlet, and final World Tour rankings of #27 in 1976 and #24 in 1977. He continued to compete into the mid-1980s. He was also an innovative and talented shaper who gained notoriety for the radical designs he created in Florida and continues to make in Puerto Rico as DCB Surfboards.

↓ **David Balzerak, experimental tail and bottom designs, 1970s. Photo by Tony Arruza.**

With the shortboard revolution of the late 1960s and early 1970s, shapers began pushing the boundaries of traditional surfboard design. Notable among the innovators was the Space Coast's David Balzerac, whose DCB label reflected his radical approach to the art of shaping. Collection of Juan Rodriguez, One World Surf Designs.

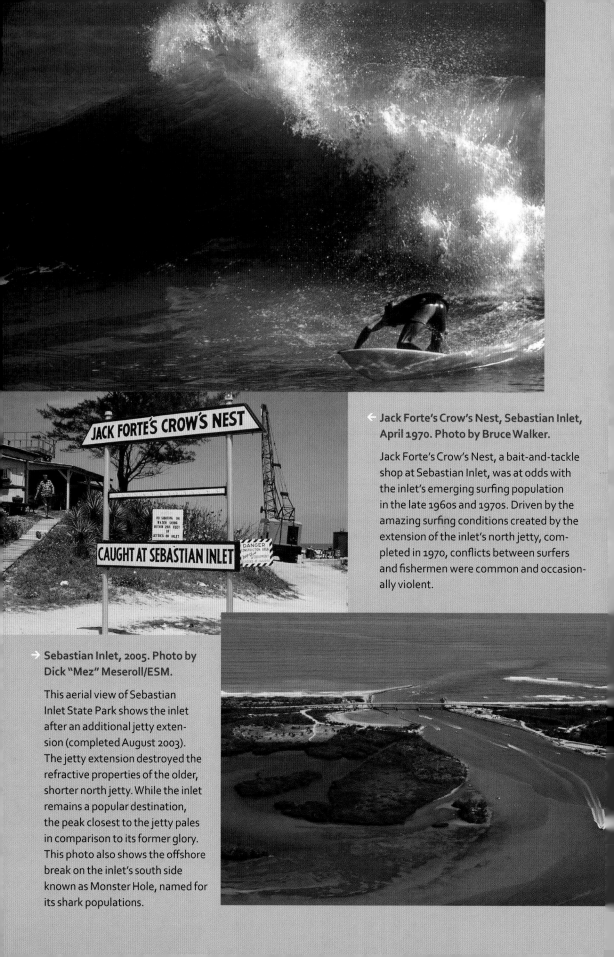

← Jack Forte's Crow's Nest, Sebastian Inlet, April 1970. Photo by Bruce Walker.

Jack Forte's Crow's Nest, a bait-and-tackle shop at Sebastian Inlet, was at odds with the inlet's emerging surfing population in the late 1960s and 1970s. Driven by the amazing surfing conditions created by the extension of the inlet's north jetty, completed in 1970, conflicts between surfers and fishermen were common and occasionally violent.

→ Sebastian Inlet, 2005. Photo by Dick "Mez" Meseroll/ESM.

This aerial view of Sebastian Inlet State Park shows the inlet after an additional jetty extension (completed August 2003). The jetty extension destroyed the refractive properties of the older, shorter north jetty. While the inlet remains a popular destination, the peak closest to the jetty pales in comparison to its former glory. This photo also shows the offshore break on the inlet's south side known as Monster Hole, named for its shark populations.

In its heyday, Sebastian Inlet's First Peak worked beautifully on waves of any size. Mike Tabeling and Dick Catri were among the first surfers to ride it in the mid-1960s. By the early 1970s, Tabeling was a regular and among the best in all conditions.

further compounded by dismally small surf at almost every event throughout the season, up and down the Atlantic Coast. Florida surfers such as Sam Gornto, Bill Bringhurst, and Fletcher Sharpe were highly vocal about their concerns. The selected team included a number of Florida's best competitors—Propper, Codgen, and Joe Roland—as well as others from within the state and points north. At the time, East Coast surfers considered to be more likely competitors for a contest in Puerto Rico included Codgen, Sharpe, Tabeling, and Valluzzi, who also voiced their concerns over the selection process. Today, this may seem a tempest in the teapot, given the success of East Coasters in big wave events around the world, but it was seriously divisive at the time.

During its heyday in the late 1960s, Cocoa Beach ruled the world of East Coast surfing. Heavily focused on competition success and promoting its own, those that competed successfully rose to the top. Among those not yet mentioned, competitors and noncompetitors alike, were Dickie Munson, Benji McRoberts, Bob Carson and later David Carson, Freddy Grosskreutz, Rusty Spech, Phil Haulk, Mike Gabreal, Betsy Twombly, and Kathy Jo Anderson. Most of these surfers made the transition to shortboards without missing a beat and led the way for the next generation of Space Coast surfers.

What was it that made the Space Coast so unique and appealing to surfers over the decades? Certainly there were waves: lots of good waves and occasionally even great waves. Among the first spots in the north end was Canaveral Inlet with its pointlike sandbar inside the inlet, Canaveral Pier, and the beach breaks from the Islander Hut at Third Street south to Sixteenth Street. Further south were the remnants of Patrick Pier, Picnic Tables, Second Light and the Officer's Club, Lums, RCs, Crescent Beach and the boardwalk at Indialantic, and finally Sharkpit. Mike Tabeling, Dick Catri, and others pioneered the breaks further south yet, which remained largely unridden due to their distance to the south from Cocoa and, until 1965, the lack of a bridge connecting traffic from the south over Sebastian Inlet. Spanish House, Sebastian Inlet, and Wabasso immediately replaced Cocoa Beach for surfers heading

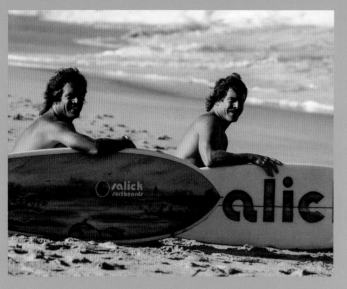

Richard and Phillip Salick, known as Space Coasters, hail from Anna Marie Island on the Gulf. They divided their time between the Gulf the East Coast, and Puerto Rico. By 1973 Rich was an established pro who competed in the U.S. Championships and the World Contest in Oceanside, California. Rich Salick overcame a major kidney disease with a donated kidney from his brother. Rich resumed surfing and was recognized as the first kidney transplant recipient to return to professional sports. In 1976 the Salick brothers launched an effort to help other kidney patients through a team competition between Salick Surfboards and Ocean Avenue, which eventually became the National Kidney Foundation Pro-Am Surfing Festival in 1985; it has raised five million dollars in support of patient programs, the largest fundraising competition of its type in the world. Rich underwent three transplants before his death following emergency surgery in July 2012. A major paddle-out memorial event in Cocoa Beach marked his passing.

↘ Pat Mulhern, Puerto Rico, March 1979. Photo by Darrell Jones.

Pat Mulhern was a standout at Sebastian Inlet and successful competitor; at eighteen, he placed twenty-second in the 1979 IPS world ratings and was top pro on the East Coast tour for five years. He became a shaper and industry leader, following his father, legendary glasser Donny Mulhern, the "M" in MTB Surfboards with Donald Takayama and Gary Brumett.

← Gary Propper, Puerto Rico, January 1980. Photo by Darrell Jones.

While best remembered for his early success during the longboard era, Propper remained a remarkable talent as the sport reinvented itself with continual refinements in equipment and shorter boards.

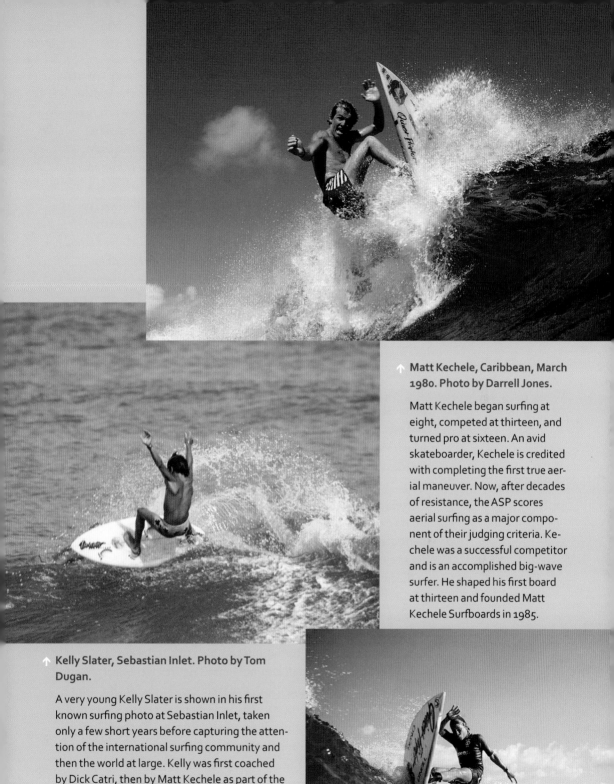

↑ Matt Kechele, Caribbean, March 1980. Photo by Darrell Jones.

Matt Kechele began surfing at eight, competed at thirteen, and turned pro at sixteen. An avid skateboarder, Kechele is credited with completing the first true aerial maneuver. Now, after decades of resistance, the ASP scores aerial surfing as a major component of their judging criteria. Kechele was a successful competitor and is an accomplished big-wave surfer. He shaped his first board at thirteen and founded Matt Kechele Surfboards in 1985.

↑ Kelly Slater, Sebastian Inlet. Photo by Tom Dugan.

A very young Kelly Slater is shown in his first known surfing photo at Sebastian Inlet, taken only a few short years before capturing the attention of the international surfing community and then the world at large. Kelly was first coached by Dick Catri, then by Matt Kechele as part of the Kechele Surfboards team, winning numerous ESA and U.S. titles.

→ Kelly Slater, Sebastian Inlet. Photo by Tom Dugan.

By the early '80s, Slater was riding for Quiet Flight surfboards, sponsored by Sundek surfwear, and turning heads wherever he went.

north as well as those in the Space Coast looking for more powerful waves to be found through deeper offshore waters to the south.

Nonetheless, Cocoa Beach had everything else to offer. It had good waves, competitions, great surfers, dozens of beachside motels, and a party atmosphere like nowhere else on the coast. It had astronauts, and there were watering holes where the space industry and surfers alike went to unwind. Cocoa Beach was a complex mix of family life, highbrow pursuits, and middle-class habits. It also harbored a unique collection of lowbrow distractions; the short list includes Lee Caron's Carnival Club, the Samoa Lounge, the Moon Hut, Pillow Talk Lounge, the Cork Lounge Go-Go, Piney's by the Pier, the Mousetrap, the Shark Lounge, and the Booby Trap, a strip club with enormous painted breasts for a roof. What more could a single male astronaut or a surfer seek in a hometown? To satisfy other needs, like food, it had restaurants like Alma's Italian Restaurant, Wolfie's, Fat Boy's BBQ, Tippy's Taco House (now Taco City), and Krystal Burgers. For temporary lodging, there was the Sea Missile, Vanguard, Polaris, and Satellite motels, all surfer hangouts bursting at the seams during major contests. For the locals, it also had affordable rental housing, driven by the periodic rise and fall of the space industry over the decades. The surf industry thrived in the Space Coast in the late 1960s, and surf notables were in abundance. Gary Propper, Warren Bolster, Bill Bringhurst, Jimbo Brothers, and New Jersey transplant Greg Mesanko all lived in the same Crescent Beach apartment complex—all haunting the same haunts, sometimes chasing the same women, and always competing for waves.

In the 1970s, surfing in the Space Coast began shifting south to Sebastian Inlet in favor of its more powerful waves. Jeff Crawford, Greg Loehr, Jim Cartland, David Balzerac, and Greg Mungall were among those making names for themselves and putting East Coast surfers back into the international scene. Within the circle of remarkably talented though less-publicized figures were Barry Wolfe, Rich and Phil Salick, Doug Deal, Pat Webber, Hunter Joslin, Tom "Troll" Black, Scott Robinson, Sam and George Drazich, Mark and Steve Sponsler, Alan Volmer, Tommy and Fletcher Sharpe, Tony Graham, Bob Rohman, Bob Rotherham, Tom Dugan, Greg Taylor, Danny Melhado, Mike Notary, Mike Neimnich, Pete Hodgson, Regis Jupinko, Les Johnson, John Randall, and female standout Dorrie Stallings, among many others.

By the early '80s, Sebastian Inlet had become the most photographed wave on the Atlantic Coast and the wave of choice for the region's best, most innovative and progressive surfers.

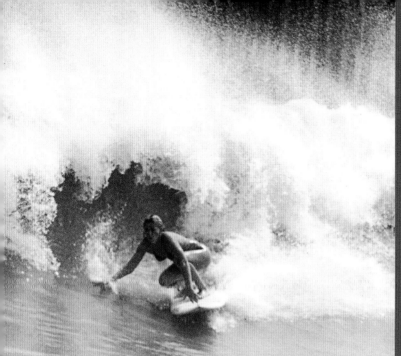

Adele Faba was among a group of accomplished and competitive female surfers, including Sharon Wolfe and Crystal Roever, making names for themselves in the late 1970s and early '80s. Faba won the Women' East Coast Championships in 1980 and 1981.

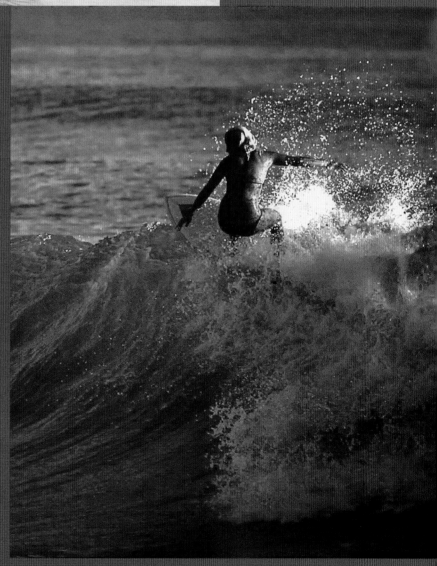

Sharon Wolfe-Cranston, Sebastian Inlet, October 1979. Photo by Bruce Walker.

With inspiration from her brother Barry Wolfe and encouragement from fellow 4th Street local Matt Kechele, Sharon Wolfe-Cranston started surfing at an early age and competing at fourteen. She won four U.S. Surfing Championships in four separate divisions on three different coasts throughout the late 1970s and '80s. She also won the Junior Women's title at Trestles and Oceanside, California, and the Women's East Coast Surfing Competition in 1982. In 1990, Sharon took the U.S. Title in the Senior Women's division at Sebastian Inlet. In 2010 she co-curated, with Marie Hughes, the Women of the Waves exhibition at the Cocoa Beach Surf Museum, recognizing 130 Florida female surfers from the 1960s to the present. Wolfe was inducted into the East Coast Surfing Hall of Fame in 2010.

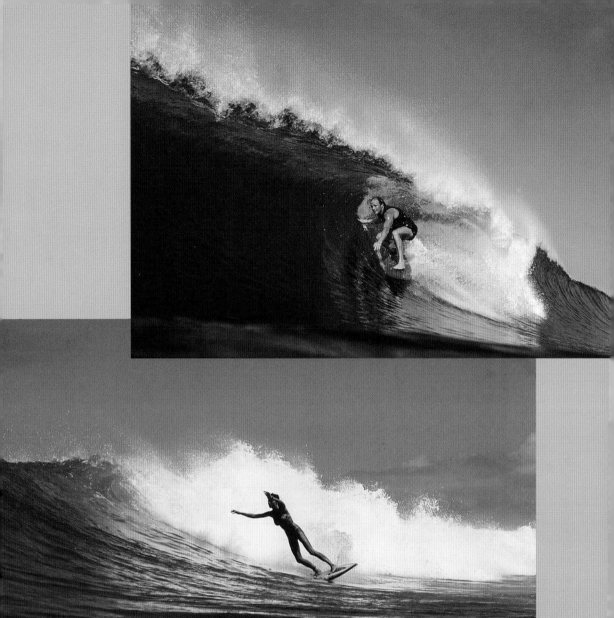

↑↑ **Lewis Graves, Mexico, 1979. Photo by Darrell Jones.**

Among the most significant members of the Miami exodus was Lewis Graves, who, with Bruce Walker, traded Miami Fox Surf Shop in South Beach for ventures in the Space Coast. Founding Ocean Avenue Surfboards in 1972, the two advanced professional surfing and skateboarding for Floridians like few others before or since.

↑ **Barbie Graves, Tortola, BVI, 1983. Photo by Darrell Jones.**

Barbie Graves, an excellent surfer by anyone's standards, married Lewis Graves and is the mother of Dylan and Josie, who are currently making names for themselves in Puerto Rico and beyond. Lewis and Barbie traveled and surfed together in the Caribbean and elsewhere.

← Jeff Crawford, 1984 Op Pro, Jensen Beach, Florida. Photo by Tony Arruza.

Formerly known as the U.S. Surfing Championships, the event was renamed the Op Pro for its sportswear sponsor, Ocean Pacific, in 1982; it was renamed again as the U.S Open of Surfing in 1994. The 1984 event was held in Jensen Beach, Florida, and was won by Tom Curren and Frieda Zamba.

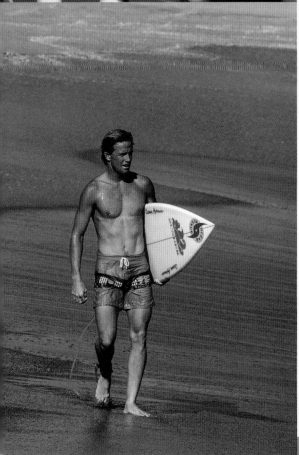

↙ Jeff Klugel. Rincón, Puerto Rico, 1985. Photo by Darrell Jones.

Jeff Klugel won the 1982 Stubbies Trials at Sebastian Inlet, which earned him entry into the Stubbies Pro at Burleigh Heads, Australia, in 1983. In 2005, Klugel was head judge for the North American region of the ASP World Qualifying Series and continues to judge for the ASP. Klugel was featured on the cover of *Surfer* magazine in September 1980 and is a highly respected shaper with experience at Rainbow and Ocean Avenue before founding his own company, Seven Seas Surfboards.

↓ Spectrum Surf Shop, 1980. Photo by Tom Dugan.

Craig Bobbit's Spectrum Shop and Spectrum Surfboards in Indialantic Beach supported many shapers over the years, including Rick Bullock, Johnny Lucas, Joe Shriver, Carl Schaper, and Bobbit himself, among others. Among Spectrum's talented team was Trip Freeman, who made the transition from Delray Beach to Sebastian Inlet to Oahu's North Shore without missing a beat.

Matt Kechele, John Holeman, Pat Mulhern, John Futch, and Jeff Klugel all applied radical skateboarding innovations to surfing at First Peak and peaks north. Kechele is credited with surfing's first successful aerial maneuver and Holeman with executing its first aerial 360-degree maneuver. Lewis Graves and Bruce Walker brought new energy to surfing as a team sport and a professional practice. Todd Holland, Bill Hartley, and Phillip Watters redefined power surfing within the context of Sebastian's first peak wedge. Geary Paul had already redefined crowd control in the '70s. Others, like Trip Freeman, Paul Reinecke, and Tim Briers, added their own contributions to the mix. Trip would prove himself in big surf at Hawaii's Waimea Bay and Backdoor. Reinecke would become the East Coast Team Manager for O'Neill, and Klugel would win the second Stubbies Trials Pro event at Sebastian Inlet, before becoming a highly respected touring ASP/WCT circuit judge. Jackie Grayson, Sharon Wolfe, Richie Rudolph, Charlie Kuhn, and Scott Busbey round out this extraordinary mix of talent, aggression, and accomplishment.

While the U.S. Army Corps of Engineers' extension of the inlets' north jetty in 2001 dealt First Peak a major blow, Sebastian Inlet continued to provide the state's most aggressive and significant surfers a high performance wave upon which to hone their skills. It has hosted innumerable contests, including the U.S. Surfing Championships in 1986, 1990, and 1994, the Stubbies Pro Trials in 1981, and the Quiksilver "King of the Peak," an annual event launched in 1995 that remains one of the most coveted titles on the Atlantic Coast. Untold numbers of surfers have defined themselves through their performance at Sebastian during the 1990s and into the present, despite the crowds and only a rare glimpse of its former First Peak magic. Todd Morcom, David Speir, Bryan Hewitson, Justin Jones, Kyle Garson, Eric Taylor, Eddie Guilbeau, Nick Guilarte, Adam Wickwire, Blake Jones, Justin Jones, Justin Brown, Jeremy Saukel, Eric Taylor, C. T. Taylor, and Tommy O'Brien were among the standouts. As the level of performance increased and the population of amateur surfers grew, so did the competition for waves, at the expense of recreational interests.

Notably absent from this list of Central Florida surfers are Kelly Slater and the Hobgood brothers, CJ and Damien, undoubtedly the most significant competitors to hail from the Space Coast, or anywhere in the world for that matter, and, in the case of Slater, throughout the entire history of the sport. Along with the southern Gulf's Lopez brothers, theirs is a different story, highlighted by competitive success and high-performance surfing in both big and

small surf and international recognition among the best surfers in the world. Slater has proven himself the best competitive surfer in the world eleven times since his first ASP/WCT World Title in 1992.

All of this supported a thriving and strongly egocentric surf community that was competitive at everything and epitomized the sport's transition from the '60s into the '70s. Cocoa Beach hosted the contests and expected to win. Contests were good for business, and there was plenty of money to be made. While the surfboard industry in the late '60s was still rooted in California, and there were plenty of players in town to "whistle a western tune," there were other locals who used the momentum to launch surfboard labels with origins in Florida. The Space Coast was a leader in the transition.

Within the Space Coast, Jack Murphy was among the first, building boards in Indialantic in the 1963, followed by Bill Feinberg with Oceanside, Pat O'Hare for others and then under his own name, and Campbell Surfboards by Jim Campbell, originally shaped by the now legendary Santa Cruz shaper Doug Haut, who shaped for Feinberg/Oceanside as well. All found markets for custom and production boards, earning huge market share at home and overseas. Oceanside was the biggest, producing five thousand boards a year at its zenith. A number of East Coast manufactures, like O'Hare, also established contracts to build boards with California labels for eastern markets, along with their own lines.

With growing demand for home-grown boards, East Coast manufactures managed to overcome West Coast efforts to thwart their survival. As demand grew, so did East Coast muscle, and the industry thrived, particularly in the Space Coast. Bob Tomb and Jack Reeves started Tomb and Reeves Surfboards, Pete Dooley and Scott Busbey launched Contact, and Bill Eberwein and Steve Holloway founded Light Wave. Claude Codgen was making Sunshine Surfboards, and David Balzerak was making DCB. George Panton launched Inspiration. Tabeling, Crawford, and Catri were all making boards under their own names, Bob Carson and the Salick brothers were making Carson/Salick Surfboards, and Ed and Jim Leisure were shaping boards in their garage in 1972 before hooking up with Regis Jupinko and Martin Thorne at Quiet Flight in 1978. Doug Wright created Rainbow Surfboards, George Robinson created GR Designs, Bruce Walker and Lewis Graves transitioned from Fox to Ocean Avenue, Craig Bobbit created Spectrum, and Tom Neilson founded Creative Visions before rebranding years later under his own name. Pete Dooley's Natural Art label emerged as one of the biggest manufactures on the Atlantic Coast, launching

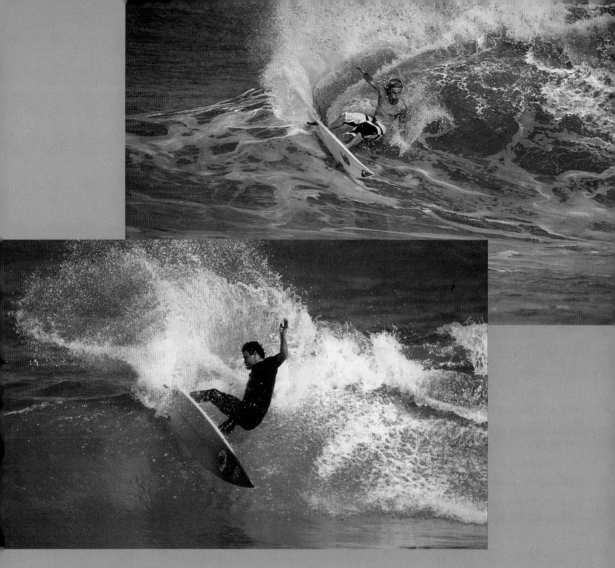

↑ Todd Holland, Sebastian Inlet, 1980s. Photo by Donald Cresitello/ESM.

A fierce and determined competitor, Todd Holland qualified for the world tour with a rank of twenty-seven and was rookie of the year in 1987. In the 1990–91 season, he finished eighth in the world year-end ratings, the highest total points by an East Coaster to that date. Winning that season's Op Pro, Holland defeated world champ Martin Potter and then points leader Tom Curren. Despite a slide in his ratings during the following years, in 1993 he won back-to-back victories in Australia, earning $36,000, and a badly needed boost in points. Nonetheless, later in the year, a legal but edgy strategy to even the playing field by forcing a paddling-interference call on a top Brazilian competitor during a WQC event outside São Paulo led to spectator violence in the water and on the beach. While Holland was escorted to safety by armed police and smuggled to the airport by a friend, the episode prevented him from returning to Brazil in the future, compromising his ability to requalify for the world tour. The bankruptcy of his major sponsor and a marriage gone bad made things worse before they got better, but today Holland is happily remarried and is running a surf school with his wife, Lauren, an East Coast Women's Champion, and with Skippy Slater. He was inducted into the East Coast Hall of Fame and is competing again, having won the Slater Brothers Invitational in 2010. His mother, Carol Holland, has served as a judge and with NSSA and ASP for many years, while running Surf Express, a travel agency for surfers, since 1986.

↑ Phillip Watters, Sebastian Inlet, late 1990s. Photo by Donald Cresitello/ESM.

By the time he was thirteen, Phillip Watters was hailed as the first super grom and featured in a pullout poster in *Surfing Magazine*. More inclined to chase photo incentives than contests, Watters compared the waves at Sebastian Inlet to a skate park and was instrumental in pushing the sport in that direction. He is credited with inventing the alley-oop varial, a maneuver he pulled off in the 2000 King of the Peak competition at Sebastian.

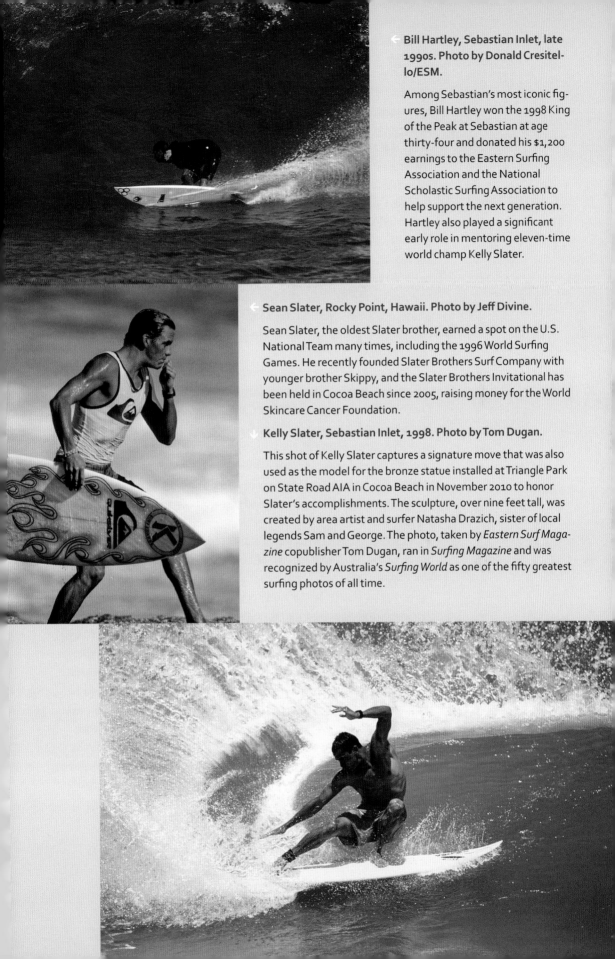

Bill Hartley, Sebastian Inlet, late 1990s. Photo by Donald Cresitello/ESM.

Among Sebastian's most iconic figures, Bill Hartley won the 1998 King of the Peak at Sebastian at age thirty-four and donated his $1,200 earnings to the Eastern Surfing Association and the National Scholastic Surfing Association to help support the next generation. Hartley also played a significant early role in mentoring eleven-time world champ Kelly Slater.

Sean Slater, Rocky Point, Hawaii. Photo by Jeff Divine.

Sean Slater, the oldest Slater brother, earned a spot on the U.S. National Team many times, including the 1996 World Surfing Games. He recently founded Slater Brothers Surf Company with younger brother Skippy, and the Slater Brothers Invitational has been held in Cocoa Beach since 2005, raising money for the World Skincare Cancer Foundation.

Kelly Slater, Sebastian Inlet, 1998. Photo by Tom Dugan.

This shot of Kelly Slater captures a signature move that was also used as the model for the bronze statue installed at Triangle Park on State Road AIA in Cocoa Beach in November 2010 to honor Slater's accomplishments. The sculpture, over nine feet tall, was created by area artist and surfer Natasha Drazich, sister of local legends Sam and George. The photo, taken by *Eastern Surf Magazine* copublisher Tom Dugan, ran in *Surfing Magazine* and was recognized by Australia's *Surfing World* as one of the fifty greatest surfing photos of all time.

the careers of pro surfers and shapers alike. Greg Loehr shaped for himself, Natural Art, Fox, and Ocean Avenue before finding his calling as an EPS/epoxy revolutionary, seeking to improve the materials of surfboard manufacturing. Joe Shriver shaped for both MTB and Spectrum surfboards during their respective reigns as major East Coast manufacturers. Other notable shapers of the day included Santa Cruz's Joey Tomas and Johnny Rice, who shaped for Catri, as well as Richard Price and Tommy Maus, who acquired their skills at Natural Art. Price launched his own label, and Maus is a legendary East Coast craftsman who puts his energies into the legendary West Coast Takayama label. An East Coast anomaly, Larry Pope is certainly the surfboard industry's sander emeritus, having put the final touches on tens of thousands of boards under numerous labels coming out of the Space Coast from decades past. Pope is also regarded as the godfather of East Coast surf photography.

More recent Space Coast manufacturers and shapers continue this impressive list, including Jeff Klugel, Bill Johnson, Matt Kechele, Chris Birch, and Ricky Carroll, who is one of the finest craftsmen and shapers in the industry's history. Others, like Pat Mulhern, Greg Mungall, and Jim Phillips, took their East Coast skills to West Coast markets, while Greg Loehr carried the flag for alternative technologies to new heights by working through the challenges of epoxy construction by reengineering the materials themselves.

Along with the boards came the shops to sell them, and the Space Coast has had its share of beloved surf shops over the years. The gamut runs from Murf's first shop in Indialantic in the early 1960s to the tourist attractions created by Ron DiMenna at Ron Jon Surf Shop and Bob Baugher at Cocoa Beach Surf Company. Among the earliest shops were Oceanside, owned by Bill and Marjane Feinberg, and Little Hawaii, owned by Bill Volmar. Over the decades, other shops have come and gone as well, the most prominent being Surfing World, a Weber shop run by Mike Tabeling's father, Roy Tabeling; Primo; Carson/Salick; Shagg's on the pier and in Indialantic; and Gary Propper's Lightning Bolt East and Ocean Avenue. Others, like Spectrum, Natural Art, Quiet Flight, and the Longboard House, have survived everything from global recessions to devastating hurricanes. A lot of lives have been shaped hanging out in shops throughout the region, and each has cultivated its own culture and history as well.

CHAPTER 8

Daytona and New Smyrna Beach

While Florida's surfing history began with the Whitman Brothers in Miami Beach, and others slightly before, it is indisputably Daytona Beach that became Florida's first Surf City. Tom Blake's visit to Florida in 1933 included a trip to Miami in search of the Whitmans and later to Daytona, where he was photographed at Harvey Street, according to Dick Every, one of the region's first surfers. Blake's introducing his hollow surfboard reinvented the sport in Miami and Daytona, although the Whitmans were already riding highly crafted Hawaiian-style boards at the time of Blake's visit.

Despite their modest lead as the state's earliest surfers, by the time the Whitmans drove into Daytona to catch a hurricane swell in 1934, towing their boards behind their white convertible, they weren't the only surfers in town. Nonetheless, they were the most visible, best-equipped, and most experienced surfers in the state.

Daytona bred its own crew of pioneers in the 1930s. By the time its earliest surfers reached high school age, almost ninety Blake-style hollow boards had been built in shop classes at Mainland and Seabreeze High Schools. The beaches of Daytona boasted as many as fifty regulars in the years leading up to World War II, who rode the region's sloping waves on boards that measured upwards of sixteen feet. Among the area's pioneers, Gaulden Reed, who died in 2007, is likely the first and certainly the most memorable, but he shared the moment with many others.

Daytona had other pioneers, including Dick and Don Avery, Paul Hart, James Nelson, Bill Wohlhuter, Brewster Shaw, Oscar Clairholme, George Doerr, Tom Porter, Buster MacFarland, Nelson Rippey, "Nudder" Wilcox, Charles Spano, Carlisle "Boop" Odum, Earnest Johnson, George Boone, and George Jeffcoat. Gualden Reed and Dick Avery, like the Whitmans before them, made early

85

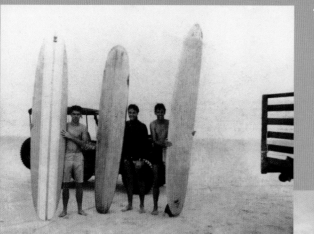

Skipper Eppelin, Mickey Boucher, and Buddy Wright, New Smyrna Beach, 1962. Photo by Beth Anne Wright, courtesy of Buddy Wright.

In the oldest known photo documenting surfing in New Smyrna Beach, its earliest surfers stand with their boards south of Ponce Inlet. The truck (*far right*), owned by Wright's father, served as a work truck and the region's first surf wagon. Wright and Skipper Eppelin are still active in the sport, and Wright still owns the Willys Jeep just behind them. Mickey Boucher passed away in 2009.

→ Gaulden Reed, Ormond Beach Pier under construction, 1959. Courtesy of Patty Light and the Gaulden Reed Estate.

Gaulden Reed, who began surfing in Daytona Beach in the early 1930s, was a true waterman—surfing, fishing, sailing, and lifeguarding for many years in Daytona. His desire to provide access to the ocean also influenced him to build the Ormond Beach fishing pier. The pier was damaged by storms in 1964 and 1984, before being demolished for safety reasons in the early 1990s.

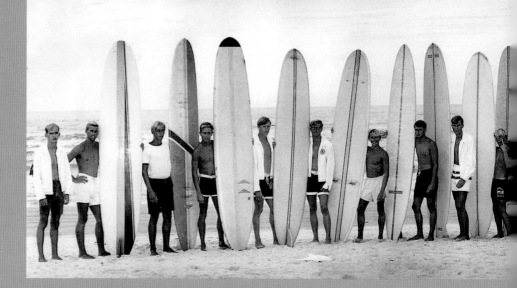

Skipper Eppelin, summer 1967. Photo by Mickey Boucher, courtesy of Skipper Eppelin.

Skipper Eppelin shared the limelight as one of New Smyrna's first surfers with a close group of friends—Buddy Wright, Gordon Smith, and Mickey Boucher. Following their example, Mike Martin, David "Tick" Parker, Kem McNair, and Mike Clancy were among the region's first and youngest surfers. All were surfing by 1963.

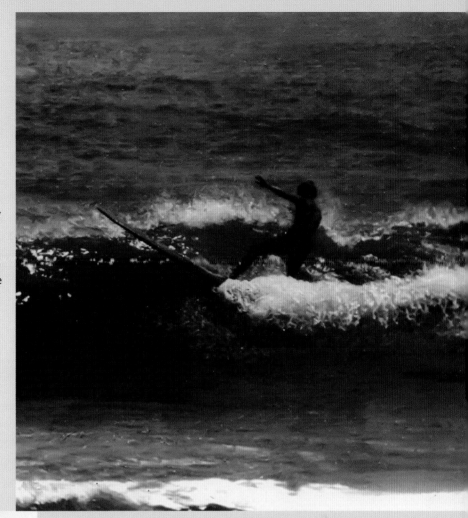

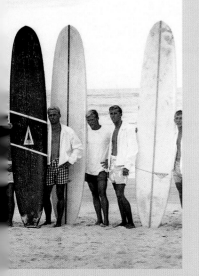

Smyrna Surf Club, mid-1960s. Photo by Savey Photography, courtesy of the Smyrna Surfari Club.

This historic shot of the Smyrna Surf Club includes members (*left to right*) Ed Vogt, Buddy Wright, Richard Parker, Robert Wolfe, Bruce Harris, Charlie Lyons, Billy Johnston, Pete Blanchet, Eugene Facey, David "Tick" Parker, John Harvey, Lloyd Dreggors, Jim Smith, Bob Kade, Skip Eppelin, Ron Dreggors, Gordon Smith, and Don Jolly. Competitive surfing began in New Smyrna in the same year but found its real feet through the Coronado Open, presented by the Coronado Surf Club in 1967. In 1979, former Smyrna Surf Club members Buddy Wright, Gordon Smith, and others reinvented the club as the Smyrna Surfari Club, a nonprofit organization that mixes surf and community service interests. The oldest extant surf club in the state, the Surfari Club remains vital by putting purpose into practice, providing scholarship support for local youth through events and competitions, mentoring the development of its own, and positioning New Smyrna Beach as a player in the state's surf hierarchy.

pilgrimages to Hawaii, likely by steamship. They surfed alongside legendary Hawaiian Duke Kahanamoku and rode Makaha on Oahu's western coast, enjoying a golden moment in time. Yet golden moments are fleeting. .

With the advent of World War II, surfing in Florida all but came to an end, and Daytona's community of surfers saw their lives rearranged in ways previously unimaginable. While most were called away to service, those who remained faced a coastline on high alert for German submarines and foreign subversion. Gaulden Reed, who remained in Daytona, relates, "Brewster [Shaw] and I were in front of the Boardwalk, and we came in after dark because the waves were so good; and we were reported to the police—that two men had come in on torpedoes." Other encounters occurred, and by the war's end in 1945, according to Dick Every, "there was no surfing at all."

Yet surfing in Florida survived and was reborn in Daytona Beach. After the war, with the arrival of foam and fiberglass surfboards, Hollywood's proliferation of beach-blanket movies, the postwar euphoria in America, and changing demographic factors, surfing captured the imagination of America like never before. Dick Avery was the first in town to own a foam board. Richard and Dana Brown, Steve Slater (Kelly's father), and others followed, creating a new generation of modern surfers. Beginning in 1962, Daytona Beach presented the Florida State Surfing Competition, with Jack Murphy winning the men's event. Other notables from the early 1960s included Jim Brill, Jeff Gearhart, and Barry and Renee Eissler. Considered among the best of his generation, Barry Eissler died in a tragic car accident at nineteen. Renee was a successful competitor and a member of the East Coast Hobie Team.

Today, it is New Smyrna Beach (NSB), just across the inlet from Daytona Shores, that is on a roll. This is its second roll, actually, for it had been a center of high-performance surfing in the middle to late seventies, back when "Shark Shallows" was among the best waves on America's East Coast and its locals among its best surfers. (Shark Shallows was a zone of shifting sandbars outside the south side of Ponce Inlet that was created by Army Corps of Engineers efforts to improve the inlet.) Were it not for the surf media's interest in Sebastian Inlet, New Smyrna Beach would have been Florida's most prized, accessible, and visible inlet (with its own version of Shark Shallows, "Monster Hole"), and would easily have been center stage as the sport developed in the early 1970s.

Early ventures to surf the more compelling waves found south of Ponce Inlet in New Smyrna Beach were thwarted by encounters

→ **Mike Clancy, 1965. Courtesy of Mike Clancy.**

Mike Clancy was one of New Smyrna's most notable pioneers. He is pictured with an early Jim Campbell surfboard shaped by Doug Haut and purchased in 1965. After winning the first competitive event in New Smyrna in 1966, Clancy joined George Miller's Daytona Beach Surf Shop Team and continued to compete successfully until he left for college in 1969. He continues to surf in northern California and is a noted meteorologist and filmmaker.

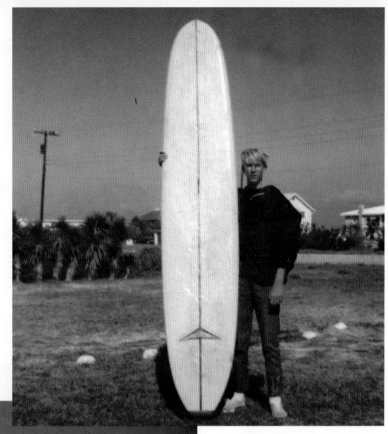

← **Mike Clancy, New Smyrna Beach, 1970. Courtesy of Mike Clancy.**

Since the sport's beginnings, surfers around the world have taken to lifeguarding for employment, sport, and satisfaction. Mike Clancy was a lifeguard in New Smyrna from 1970 through 1973, during which time he made over a hundred rescues. In September 1972, he was honored as Lifeguard of the Year for Volusia County, which includes both New Smyrna Beach and Daytona Beach, among the most heavily populated beaches on the coast.

Jack Reilly and Peter Kerv
relocated to New Smyrna
Beach from Clearwater in
1971, bringing their Creat
shop and label to the East
Coast. Creation joined th
with Dan and Dave Nicho
who were already buildin
boards and had opened t
town's oldest surviving s
Creation had an impressi
early team that included
Charley Baldwin, Bobby
Owens, and Conrad Cand
among a score of other lo
Reilly ("Capt. Ono") brou
creative flair to Creation
would go on to be chair o
Art Department at UC Ch
nel Islands and a success
Los Angeles painter.

In 1964, Linda Baron Gro
was introduced to surfin
Daytona Beach by her da
Gene Baron, who had su
in New York during the 1
Supportive of the surf bo
hitting the Atlantic Coast
in the early 1960s, Gene
bought Linda her first bo
from George Miller at the
Daytona Beach Surf Sho
1964. Linda went on to s
for the Daytona shop an
was a successful compet
alongside Mimi Munro, I
Jo Anderson, and other r
female surfers of the tim
Gene Baron documente
those early days; much o
collection appears in a re
East Coast Surf Docume
by Will Lucas, *Surfing at*
mer's End: Stories by and
a Generation of Surfers.

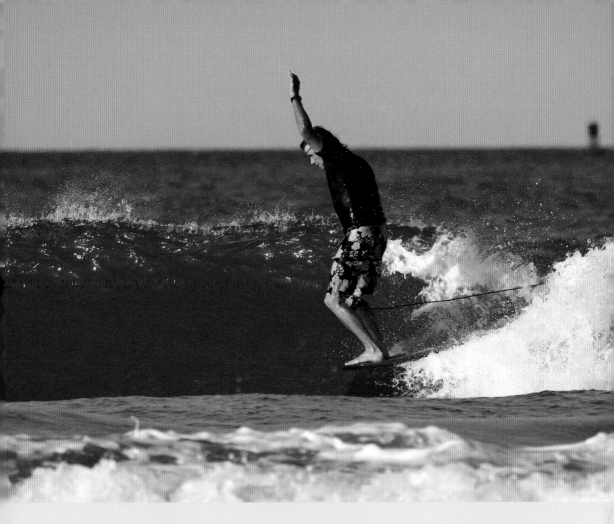

Kem McNair, Ponce Inlet, New Smyrna Beach, June 2009. Photo by Chad Shindoll.

Kem McNair was one of the region's youngest surfers. He won the midget's division in the 1967 Coronado Contest, the juniors division of the East Coast Surfing Championships in Virginia Beach in 1969, and was a member of the East Coast team at the U.S. Championships in 1970–1972 and the World Championships in Ocean Beach, California, in 1972.

→ Southwire, early 1970s.

Among New Smyrna's best surfers of their day, Kem McNair and David Coffee were also members of the rock band Southwire. Pictured (*left to right*) are David Coffee, Carl Van Cluney, Larry Delk, Mike Delk, Billy Chapin, and Kem McNair. All but Larry Delk surfed. McNair, Coffee, and Chapin are still avid surfers.

→ Isabel McLaughlin, New Smyrna Beach, early 1980s. Photo by Pat Altes.

Isabel and Cathy McLaughlin are true sisters of the Florida surf. Isabel won first place victories at the East Coast and U.S. Surfing Championships in 1974 and finished twenty-third in the 1982 American Professional Surfers circuit. Cathy earned sixth in the U.S. championships and third on the East Coast while still in high school.

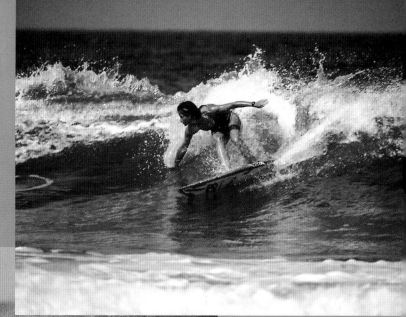

← Bernie Crouch, Ledges, Australia, early 1980s. Photo by Darrell Jones.

Bernie Crouch, like a good number of the region's legends, was from the north side of the inlet, growing up in Daytona Shores but enhancing his skills while Shark Shallows was still a NSB attraction. Crouch still commands respect in the water and in the shaping bay, building Mad Dog surfboards and running Mad Dog Surf Shop.

→ Charley Baldwin, New Smyrna Beach, early 1970s. Photo by Pat Altes.

Charley Baldwin won the open division of the 1967 Coronado Open Competition in NSB, taking top honors over Gary Propper and Mike Tabeling. Baldwin would go on to win the ESA Eastern Surfing Championships at Cape Hatteras in 1971, the inaugural year at the lighthouse. He also became a well-respected shaper and owner of CB Surfboards in 1976.

with significant shark populations, which continues to put Ponce Inlet on the map and in the world's annual registry of global shark attacks to this day. If, as once advertised, New Smyrna Beach was in fact the world's safest bathing beach, it could only have been because no one went in the water. Early surf ventures to Smyrna were not repeated, and it was not until the early 1960s, late even for Florida standards, that the area generated its own pioneers, and surfing in New Smyrna Beach took off with a feeding frenzy of its own.

Most notable as its first surfers are "Skipper" Eppelin, "Buddy" Wright, Gordon Smith, Art Christensen, David Meck, Mickey Boucher, Mike Clancy, and Mike Martin. Eppelin and Wright were perhaps the first and launched the sport within the dimensions of a relatively isolated stretch of coastline. Among other NSB surfers in the early 1960s were Bill Johnston, Pete Blanchet, David "Tick" Parker, Charlie Lyons, John Biddle, David Meck, Ed Vogt, Ron Dreggors, Robert Wolfe, and Ron Galbreath. Among the few women to surf in NSB at the time was Suzanne Hunter.

Of the pioneers, Clancy and Martin have made distinct contributions to the sport and to their community, Clancy as one of America's most notable lifeguards and Martin as one of surfing's most experienced judges of professional surfing competitions. Christensen became New Smyrna's first surfer to ride in Hawaii, having enlisted in the navy to avoid the draft and being assigned to Oahu. He served a week of his duty in Honolulu as one of five U.S. servicemen representing the armed forces in Hawaii's 1966 Makaha International Surfing Competition.

By the early 1970s New Smyrna Beach was Florida's surfing underground, with dozens of extraordinary surfers sharing what little light the surf industry and media would shine their way. Sebastian Inlet continued to rule as the East Coast's high-performance epicenter and proving grounds for Florida's surfing elite. Yet behind the scenes—isolated and inconvenient to reach—was New Smyrna Beach and its "Ponce" inlet, known to tourists as Ponce De Leon Inlet. "The other inlet," as Smyrna came to be known, remained in the shadow of the more pervasive industry interests focused on and in Central Florida. Interestingly, as the decades have rolled by, New Smyrna's surfers have also distanced themselves from the community of surfers living north of the inlet as a means of protecting their turf and building upon their own identity. In a display of internal politics shared by its younger participants, NSB dark horse and unfolding shining star Jeremy Johnston has stated, "That inlet might as well be a brick freakin' wall. We will never let

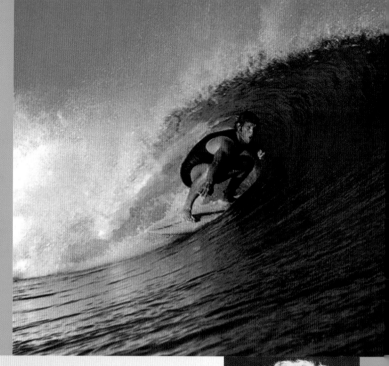

→ Randy Richenberg, Elbow Cay, Bahamas, February 1981. Photo by Pat Altes.

Randy Richenberg is a key member of New Smyrna's surfing elite. Owner of Richenberg Surfboards, he is a formidable surfer and shaper who has served as commissioner and vice mayor for New Smyrna Beach. This classic shot appeared as a double-page spread in a *Wave Rider* magazine travel feature, "It's Better in the Bahamas," photographed and written by Pat Altes. The article also featured photos of Flea Shaw, John Crouch, and Ronnie Rannie. *Wave Rider* magazine was among a number of East Coast–based publications that made a run for the money in the early 1980s.

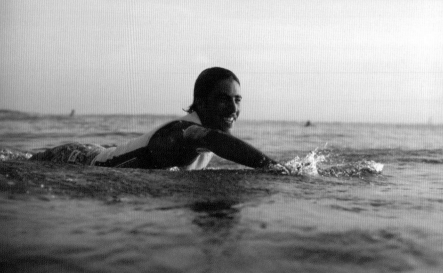

↑ Greg Geiselman, New Smyrna, early 1980s. Photo by Pat Altes.

Greg Geiselman earned a place in the lineup at Smyrna and recognition as a top East Coast pro in the early 1980s. On the ASP East Coast circuit, he ranked as high as fourth. Later, he turned to building boards and launched Orion Surfboards in 1985. His wife Gina, was the East Coast Champion in 1990, and their sons, Eric and Evan, are internationally recognized competitors.

↗ Mike Martin, Australia 1982. Courtesy of Mike Martin.

Mike Martin was among New Smyrna's first groms, riding on borrowed boards until purchasing his first board from Skipper Eppelin in 1965. Martin was instrumental in the development of competitive surfing on the Atlantic and beyond, eventually serving as head judge (1984) and North American Regional Tour Manager (2005) for the Association of Surfing Professionals. In 1988, he developed the ASP-East, a regional precursor to the World Qualifying System of the ASP, and in 1988 and '89 he and Sonny Yambor organized the Aloe Up Tour events in New Smyrna Beach, the last World Championship Tour Events on the East Coast until the Quicksilver Pro New York in 2011.

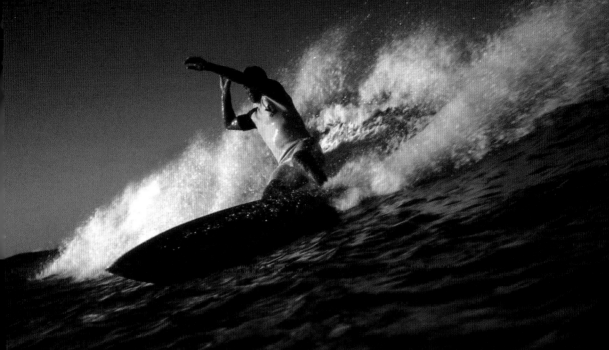

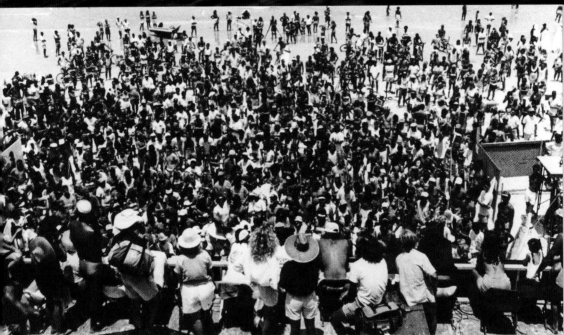

Terry Pressley, New Smyrna Beach. Photo by Pat Altes.

While Terry Pressley is not among New Smyrna's first surfers, he wasn't far behind, making a name for himself as he and others of his generation made the transition from the '60s to the '70s. Pressley, Charlie Baldwin, and McNair led the way for Tony Hume, Ross Pell, and Jimmy Lane, as pro surfing found its feet on the Atlantic Coast in the late 1970s.

↑ The Aloe Up Cup, New Smyrna Beach, 1988. Photo by Sonny Yambor, Courtesy of Smyrna Surfari Club.

The Aloe Up Cup was the most lucrative ASP contest of its day with a purse of $35,000. World champion Damien Hardman won in 1988 and John Shimooka won in 1989. While Sonny Yambor, Mike Martin, and others would outdo themselves by presenting the Aloe Up Cup in 1988 and 1989, disenfranchisement for East Coast pro surfing occurred at the highest levels of support and no WCT event occurred on America's Atlantic coast until the Quiksilver Pro Long Beach, New York, in 2011. That event offered a purse of $1 million, the largest in competitive surfing's history. Australian Owen Wright won the competition and an equally unprecedented $300,000 prize.

ourselves be lumped in with Daytona." Still, like any other surfers would, they do make the most of the Daytona side of the inlet when long-period southerly swells light up the place.

Despite the shared interface, New Smyrna has had its own community, culture, and photographers since its beginnings. In the '70s, Pat Altes captured the era on film. Today it's Pat Eichstaedt, Ryan Gamma, Kris Kerr, Casey Colins, John Perkins, Joaquin Garcia, and David Taylor, among other photographers capturing the action and innovations. While the surf industry has finally turned its attention to this new generation of NSB locals, there was a crew of competitive and radical surfers pushing the limits at the inlet. They were there decades before Aaron Cormican landed his first "Gorkin Flip," or Eric Geiselman won his 2007 *Surfer* magazine Surfer Poll Award for Most Radical Maneuver, or Evan Geiselman won the Triple Crown Rookie of the Year award in 2011.

While Gorkin established the region's current ticket to ride, he credits his rapid success to his industry sponsors and to local mentor Dave Chambers. While that acknowledgment is fitting, Gorkin and his contemporaries have roots in deeper water—the realm of earlier surfers like his father, Dale Cormican, and his peers. On the heels of the region's earliest pioneers, there exists a dynamic mix of legendary locals and successful pros who have led the way from generation to generation. Starting in the 1970s, it was Bernie and John Crouch, Steve Massfeller, Pat Altes, Kevin Ogden, Bobby Owens, Tim Gilley, Randy Richenberg, Ronnie Rannie, Mike Kitaif, the Sagraves, and Tony Hume from the Daytona Beach side of the inlet. From the Smyrna side, it was Charley Baldwin, Terry Pressley, Kem McNair, Ross Pell, Clay Lyles, Jimmy Lane, Leon and Jimmy Johnston, and Conrad Cancelmi. Following them in the '80s was Clyde Rogers, Steve Anest, Joe Surbaugh, Evan Magee, Randy Schwoerer, Greg Geiselman, Isabel McLaughlin, Jeff Buhler, Reese Lewis, Ron Hope, and many others, setting the stage for the 1990s, and then again the next and current pool of talent.

Today, New Smyrna Beach has replaced Brevard County's Sebastian and Spanish House as the arena of high-performance surfing in Florida and arguably the entire East Coast. After all, it has the most consistent surf on the East Coast outside of North Carolina's Outer Banks, and while it is cold in the winter, it is outright tropical compared to the Carolinas. Aside from an abundance of waves, the surfers who call New Smyrna home look after their own in a way that fortifies the emergence of the ever-present next crop of talent. This of course includes media stars like Eric and Evan Geiselman and Aaron Cormican, as well as high-profile figures

like Jeremy and Caleb Johnston, Nils and Noah Schweizer, Devon Tresher, Amy Nicholl, Lindsey Baldwin, Nathan Colburn, Wes Cich, Justin Ellingham, Shannon "Hopper" Eichstaedt, and Eric Templeton. As a community that behaves like a community, made of individuals who stayed in town because they liked it, NSB values its past while promoting its future. Stakeholders from decades past still hold court, but they engender respect rather than resentment among the new generation of notables.

The weekend invasion of inland surfers from Deland, Ocala, and Orlando has little in common with the concentrated takeoff zones at Sebastian Inlet during its former glory days. New Smyrna Inlet is always crowded, but it's never crowded in quite the same way or with the same aggressive energy that once defined Sebastian. This is not to say that the locals didn't or don't protect their interests, or that they weren't capable of intimidating outsiders, or that fights didn't happen in the water. Nor is this to say that the inlet was the only wave in town, as there were other notable breaks that have come and gone over the years—27th Street and Bethune Beach at the town's southern end are classic examples. Yet it is only the inlet that ultimately matters, and yet even with its substantial jetties, the inlet is subject to change. Its former ultra-outside break "Shark Shallows" is but a memory for those who rode there in the early 1970s, and the south jetty itself is facing a thousand-foot extension that could change the surf for decades to come.

Sebastian Inlet's heyday as one of the best waves on America's East Coast was largely brought to an end by the U.S. Army Corps of Engineers and its 2003 extension of the inlet's north jetty. The surf zone south of Ponce de Leon Inlet currently faces a potentially similar fate, with a proposed, and highly contested, extension of its southern jetty, which could have an equally disastrous impact upon the primary wave zone of New Smyrna Beach. Beyond the loss of a significant recreational resource for Floridians from across the state, the negative socioeconomic impact to New Smyrna Beach as a recreational destination would weigh against the speculative benefits for boating interests traversing the inlet, as defined in studies by the U.S. Army Corps of Engineers in 1999.

Unlike other regions in the state, and Miami in particular, NSB has roots and community because its pioneers remain. The Smyrna Surfari Club, the consistent surf, and the region's isolation (disconnected from the north by Ponce Inlet and from the south by Port Canaveral), are at least partly responsible for the culture and community that ranked the town ninth on *Surfer* magazine's 2009 list of top U.S. surf towns. But maybe it's also because you can drive

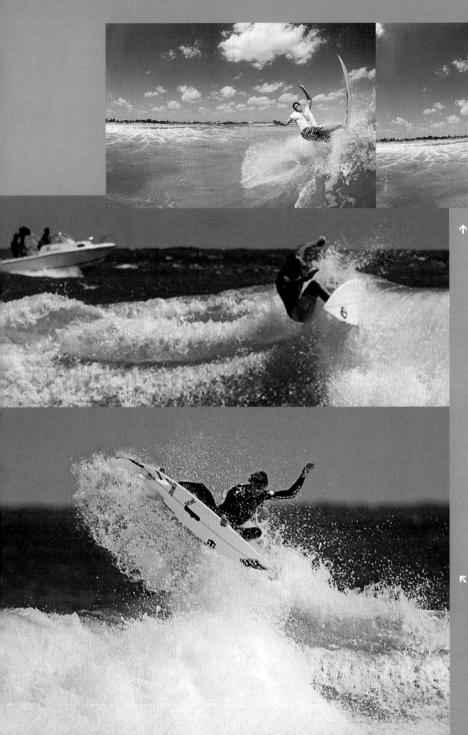

↑ Jeremy Johnston, New Smyrna Beach, September 2010. Photos by Kris Kerr.

Jeremy Johnston's early promise as the Juniors Silver Meda Winner at the 2004 ISA Cham pionships was sidetracked by the loss of a key sponsorship during the 2008 financial cris He persisted and by 2010 wa recognized as one of the bes surfers on the Atlantic Coast, winning the Coastal Edge Ea Coast Surfing Championship in Virginia Beach. Johnston also won the 2010 East Coas Scholastic Surfing Champion ships Open Shortboard Title New Smyrna Beach Inlet, ca ing himself a sober, competi tive career destroyer.

↖ Lindsey Baldwin, New Smyrna Beach. Courtesy of Sharon Wolfe.

Lindsey Baldwin started surfing at age four, competing at twelve, and went pro seventeen. She and her siste Marcie took first and second respectively, in the 1996 Eas Coast Championships. Linds is a surf instructor and active member of the Florida Surfi Association, a service-based organization that hosts regional contests and ment aspiring competitors.

↑ Eric Geiselman, New Smyrna Beach, February 2009. Photo by David Taylor.

Eric Geiselman, son of Greg and Gina and older brother to media darling Evan, is among a new crew of New Smyrna Beach talents. Among other accolades, Eric is a three-time ESA East Coast Champion, five-time NSSA East Coast Champion, and the 2007 Surfer Poll Award Recipient/Winner of Most Radical Maneuver Award. Eric also won the Huntington Beach Ezekial Junior Pro in 2007, long before appearing on the cover of *TransWorld Surf* magazine and securing a second-place finish in the O'Neill Cold Water Classic in Canada in 2010.

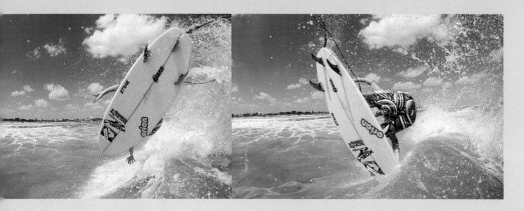

Evan Geiselman. Photo by Jimmy "Jimmicane" Wilson.

At eighteen, Evan Geiselman became the first East Coaster to win the 2011 Hawaiian Triple Crown "Rookie of the Year" Award. Other results include a win at the Seaside Pro Junior in April 2011, ESA All-Star, a dozen East Coast Championships, a $50,000 Pro Junior win at Huntington Beach in the 2010 U.S. Open of Surfing, and a record-breaking fifteen NSSA regional titles. He was also featured on the cover of the January 2011 issue of *Surfing Magazine* and in Kai Neville's 2011 film *Lost Atlas*.

Aaron Cormican, January 2009. Photo by Ryan Gamma.

An innovative and outspoken advocate of alternative approaches to a pro career, Aaron Cormican has earned international stature for his radical ways. His competitive history includes four East Coast Surfing Championships, winning the 2002 $10,000 Progression Five-Air Challenge, the 2003 Vans/SMAS Airshow World Championships, the 2009 LandShark Pro, the 2010 King of the Peak, and almost every WQS competition on the East Coast in between and after. He is also a 2003 and 2004 X Games Gold Medalist and 2003 East Coast Team MVP. He is credited with the first legitimate aerial flip ever landed, a backside double grab inverted 360 air, now known as the Gorkin Flip, which he executed in a contest in 2000.

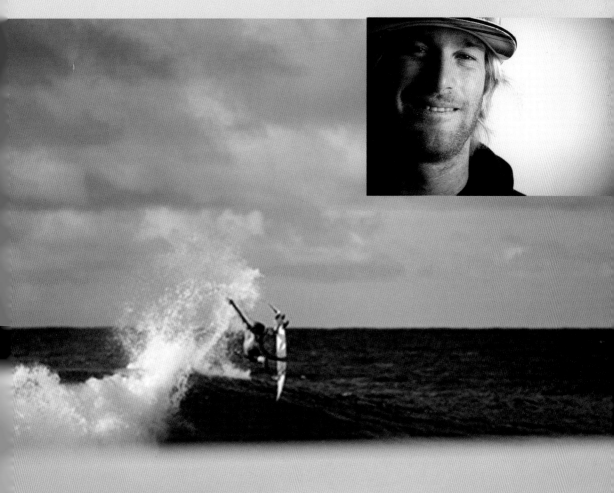

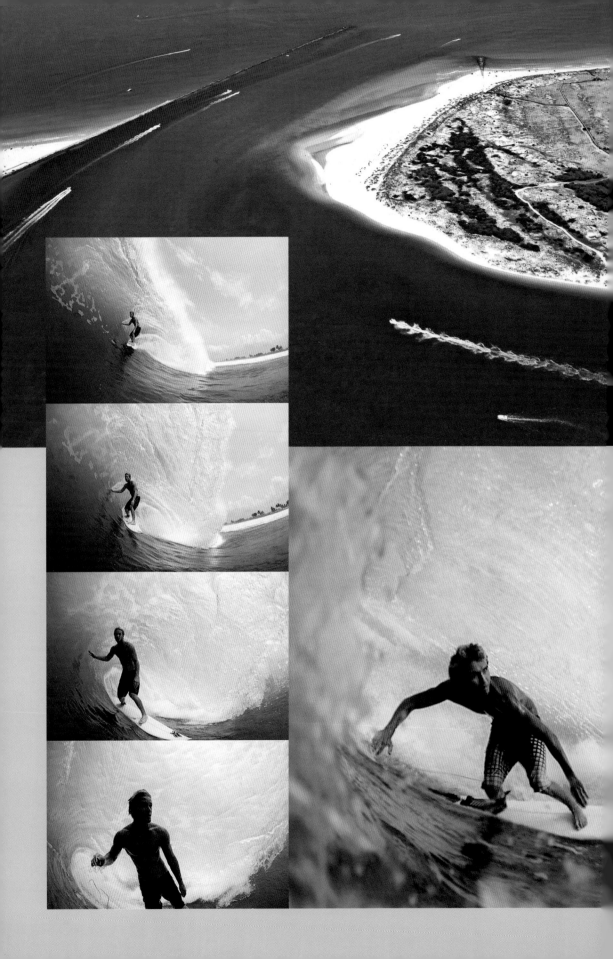

New Smyrna Inlet, 2011. Photo by Kem McNair.

Originally called Mosquito Inlet, Ponce de Leon Inlet was renamed in 1928 for the Spanish explorer. One of few natural inlets connecting the Halifax River to the Atlantic Ocean, the inlet's history is remarkable: It has been under Spanish, British, Seminole Indian, and U.S. control. In 1968 and 1972, the Army Corps of Engineers constructed and extended the north and south jetties to stabilize the inlet and, in 2011, sought to extend the south jetty again. Fearing a negative impact on the surfing zone and the surf-driven local economy, regional surfers successfully rallied to defeat the plan, for the moment at least.

Devon Tresher, Mexico, August 2010. Photos by Kris Kerr

Devon Thresher, son of Rick, an earlier generation's standout, is pictured here in an epic Mexican beach break barrel. Along with peers Taylor Brothers, Nils Schweizer, and Eric Templeton, Tresher is no stranger to powerful waves and has proven himself in serious conditions at the Pipeline Monster Energy Pro 2008 and the Five-Star WQS Volcom Pipeline Pro in 2010.

Nils Schweizer, Mexico, 2010. Photo by Kris Kerr.

Nils Schweizer, a serious competitor in small waves, has also earned international respect as a standout in heavy barrels by putting in a lot of time at Mexico's pounding beachbreaks. He applied that experience in Hawaii to make a respectable showing in the 2010 Volcom Pipe Pro and earn the highest single wave score at the 2010 Da Hui Sponsor Me Sunset Open.

and park on the beach. Maybe it's the hundred thousand dollars the Surfari Club has raised over the years for college scholarships supporting regional surfers. Or maybe it's just the underdog drive to succeed that has thrust NSB into the international limelight. Nevertheless, New Smyrna Beach has never been an easy town to break into, and while there are three hundred days per year with rideable waves, the region also recorded nineteen of the world's forty-eight documented shark bites in 2008.

With backed-up traffic leading to both communities over the past thirty years, Daytona and New Smyrna have supported a litany of historic shops and shapers over the decades. By 1963, George Miller moved from Miami to Ormond Beach and then to Daytona, setting up the Daytona Beach Surf Shop on Main Street. He also set up a factory on the mainland, where he and a crew of twenty employees built up to thirty custom boards and fifty "pop-outs" a week. The custom boards carried the new logo of "Daytona Beach Surf Shop—Custom Boards by Miller." He and Miami's Jack Murphy were among the first manufacturers in Florida, and Miller's label in particular was on a roll. The Smyrna Surf Shack owned by Janie O'Hara and later by her brother Bill O'Hara was New Smyrna's first board shop, originally selling Gordon and Smith imports from California. In 1969, Dan and Dave Nichols launched Nichols Surfboards and the region's oldest board shop. Jack "Capt. Ono" Reilly, and Peter "The Professor" Erwin, relocated Creation Surfboards to Smyrna from Clearwater on the Gulf Coast, advancing the shortboard revolution in Florida with an eye to artistic outcomes. Kem McNair, David Coffee, and Bill Geiger also opened M.C.G.'s Surfboards and Surf Shop on Flagler Avenue in 1971. Bob and Ron Condon sold a ton of Nomad Surfboards and other labels before establishing careers as major filmmakers. Local legend Charley Baldwin launched CB Surf Designs and Inlet Charley's Surf Shop in the late '70s, and Bernie Crouch started making Mad Dog Surfboards in the mid-1970s in Daytona. Dave Sokoll and Mark Klosky launched Red Dog Surf Shop in 1989 in NSB. Others would follow.

Along with the shapers already mentioned were Ronnie Rannie, Randy Richenberg, and Greg Geiselman (of Orion Surfboards) and, more recently, Erie Peeples, Wayne "Ninja" West, and Chris Coyle, who have all left their mark on the sport's development. Richenberg and Geiselman are truly historic figures as shapers of boards and as shapers of their community.

For better or worse, the most likely way for an aspiring surfer to claim fame or fortune is through competitions. While Florida's first

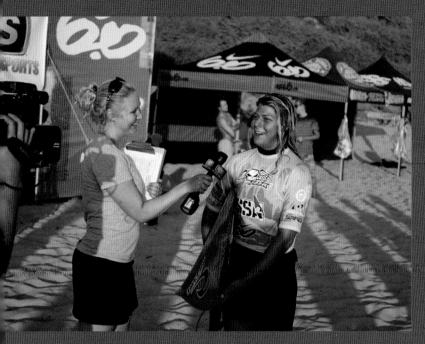

↑ Amy Nicholl, U.S. Women's Championships, July 2009. Photo by Kris Kerr.

Before age sixteen, Amy Nicholl was an ESA Eastern's Champion, a three-time consecutive ESA Southeast Regional champ, a three-time consecutive ESA Scholastic champ, and the 2006 Women's U.S. Surfing Champion. She has also been Rip Curl National Grom Search Champion and a three-year member of the ESA All-Star Team and USA Surf Team. More recently, she has been recognized as National Scholastic Surfing Association Captain of the Year for her years coaching University of Central Florida surfers for amateur and professional events.

↓ Ponce Inlet, August 22, 2009. Photo by Dick "Mez" Meseroli/ESM.

When tropical weather systems make their annual march up the Atlantic, only the breaks above the shadow the Bahamas casts upon Florida's coast will receive waves. Within Florida, the north side of Ponce Inlet and Playalinda on the Canaveral National Seashore tend to offer the best. This summer swell, courtesy of Hurricane Bill, speaks for itself.

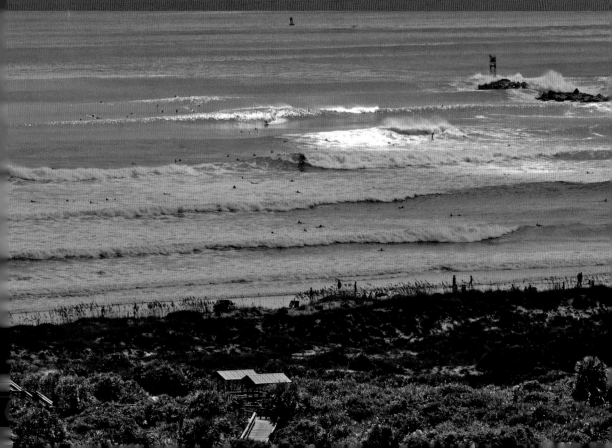

surfing competition may have taken place at Daytona Beach, New Smyrna has played a far larger role in the development of amateur and pro surfing in Florida since the mid-1960s. Amateur competition in New Smyrna began in 1966 at Flagler Avenue, but it was the Coronado Surf Club that created the first locally organized contest in 1967. It attracted a who's who of East Coast surfers and secured for NSB surfers like Kem McNair (midgets division winner) an invitation to the East Coast Hobie Team, and future East Coast and U.S. National Champion Charley Baldwin a first-place finish in the Men's Open Division. While it would be decades before professional surfing on the East Coast began with contests sanctioned by the Eastern Professional Surfers' Association (EPS), which ran its last competitive event in 1977, early competitions would set the stage for the sport's future.

⊡

At a 1978 general meeting, the EPS circuit faced growing pressure to expand its reach and opted to include competitors from within the continental United States while changing its name to American Professional Surfers (APS). Its first contest was hosted on the spot, and the Florida Pro World Small Wave Championships became the 1978 Florida Pro at New Smyrna Beach. The APS's next contest, the First Jax Beach Surf Festival, was hosted two weeks later. The APS would continue to run contests on the East Coast until its collapse under pressure from the International Professional Surfing Association (ISP), before it, too, fell to pressure from the Association of Surfing Professionals in 1983. The ASP embraced an ASP–East Circuit in 1988, led by NSB native Mike Martin, before it was deemed unsustainable in the mid-1990s.

During these years, New Smyrna Beach hosted a slew of Surf Classic and Spring Classic competitions, and since 1979 the Smyrna Surfari Club has hosted well over fifty surf contests and awarded over $100,000 in scholarship monies to regional surfers. It also hosted two World Tour Events, the 1988 and 1989 Aloe Up Cup, and the last World Championship Tour (WCT) events on the East Coast of America until the Quiksilver New York Pro in September 2011.

A decade after the Aloe Up Cup, with its record-setting $35,000 purse and international competitors, the 2009 LandShark Spring Surfari Pro revived pro surfing in New Smyrna Beach. On a roll from one victory to the next, hometown favorite Aaron Cormican took the event while crediting the unique and local culture of NSB for his success. In 2010, as the competition moved into its

second year, it saw many changes. It allowed women to compete among men in the open pro and junior pro events, and it saw the LandShark Pro become the inaugural event of the newly formed Western Atlantic Pro Surf Series. Whether loss of local control will be a plus or minus remains to be seen. As a newly sanctioned East Coast pro tour event, opportunity abounds.

In March 2011, the LandShark Pro officially became the Kona Pro, kicking off the 2011 circuit of Atlantic competitions sanctioned by the Western Atlantic Pro Surfing Series. The Smyrna Surfari Club stepped up to sponsor a Women's Pro Event and a Tadpoles division at the Kona Pro and its June Seaside Fiesta. The Western Atlantic Pro Surf Series also includes the East Coast Surfing Championships in Virginia Beach, the Belmar Pro in New Jersey, the Makka Pro in Jamaica, the OBX Pro in the Outer Banks of North Carolina, and the Jupiter Fall Classic in Jupiter, Florida. With marginal surf for its first competitions in 2011, the circuit's organizer, Mike Bloom, and major sponsors like Kona Brewing Company face the same challenges as had previous attempts to sustain a pro circuit on the East Coast. For now, the East Coast is back on the map of World Tour events, and New Smyrna is once again hosting sanctioned pro contests.

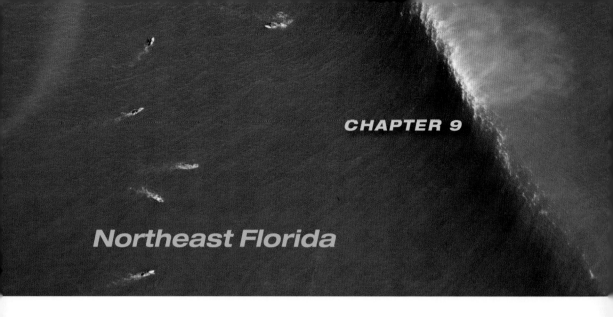

Northeast Florida

Surfing in Northeast Florida dates back to the 1930s, but few participated until the 1960s. The region's earliest surfer and surfboard maker was Jim Jarboe, who built a hollow board out of materials from a local lumberyard with plans he bought through the mail. Other pioneers included Stan Holtsinger and Dick Stratton, lifeguards at the Ponte Vedra Surf Club in the 1940s.

During the 1940s and '50s, surfing declined throughout the state, and as late as 1963, only a handful of surfers lived in North Florida. Among them were Randy Tucker, who began in 1961, and, slightly later, George Grandy, Bubba Mullis, David Stearns, Bill Longenecker, Kenny Walsh, Bruce Clelland, and David Silver, who also captured the sport's development on film and movie footage.

In 1964, the surf boom hit Jacksonville like a fever, and the number of surfers grew to several hundred. It spread throughout the region but was concentrated at the Jacksonville Beach and Atlantic Beach piers. While these numbers pale compared to those who now share the same waters, they gained the attention of the Jacksonville Beach City Council, which, like other coastal communities, tried to deal with the perceived threat surfing posed to the community. When their effort to completely ban surfing failed, they relegated the sport to a tiny area south of the pier at Sixth Avenue.

Surf clubs and teams emerged and competed in events up and down the coast. Among the earliest and largest clubs in the region were the Oceanside Club, founded in 1964 by surfers from South Jacksonville Beach, and its rival, the Utika Club in Atlantic Beach. Today the WaveMaster Society has transformed these friendly foes into a cadre of like-minded surf enthusiasts dedicated to creating positive outcomes through the sport and regional competitions.

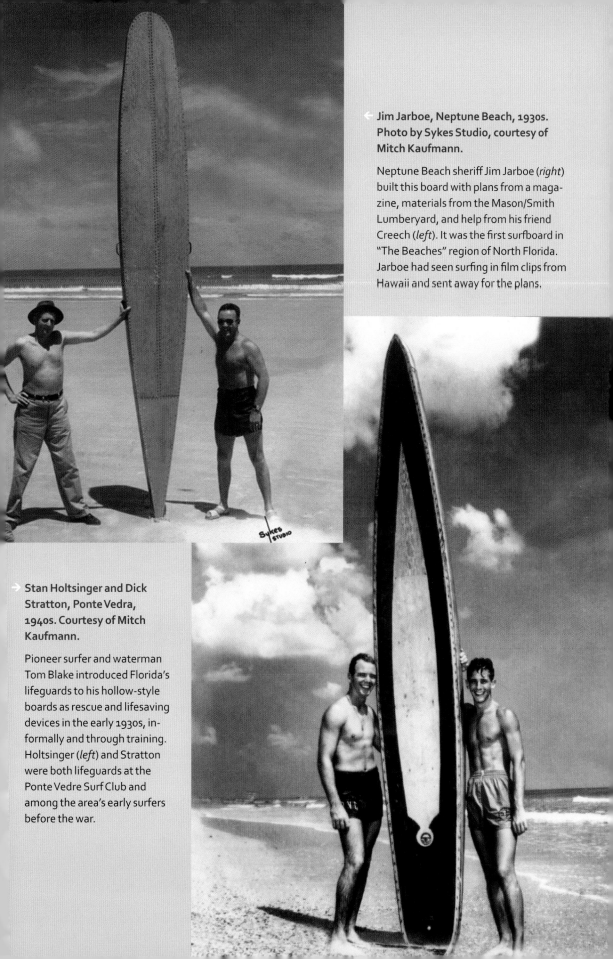

← Jim Jarboe, Neptune Beach, 1930s. Photo by Sykes Studio, courtesy of Mitch Kaufmann.

Neptune Beach sheriff Jim Jarboe (*right*) built this board with plans from a magazine, materials from the Mason/Smith Lumberyard, and help from his friend Creech (*left*). It was the first surfboard in "The Beaches" region of North Florida. Jarboe had seen surfing in film clips from Hawaii and sent away for the plans.

→ Stan Holtsinger and Dick Stratton, Ponte Vedra, 1940s. Courtesy of Mitch Kaufmann.

Pioneer surfer and waterman Tom Blake introduced Florida's lifeguards to his hollow-style boards as rescue and lifesaving devices in the early 1930s, informally and through training. Holtsinger (*left*) and Stratton were both lifeguards at the Ponte Vedre Surf Club and among the area's early surfers before the war.

↓ Jax Pier, 1965. Photo by David Silver, Courtesy of Mitch Kaufmann.

The Jax Pier was to Jacksonville what the Canaveral Pier was to Cocoa Beach. It overshadowed other breaks such as Access 5 (Poles) and the Grease Pit, north of the Holiday Inn. The pier was also frequented by a large hammerhead shark, known as Kerosene Joe or Oil Can Charley, that would patrol the beaches from Mayport to Ponte Vedra Beach. Legend has it he lived in a shipwreck off Ponte Vedra. Years later, the shark was caught off the pier and hung from a rope in a disgusting display, having never harmed anyone.

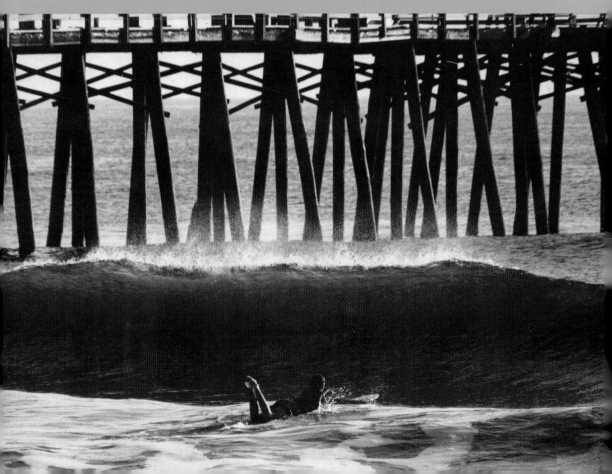

The Oceanside Surf Club, south Jacksonville Beach, 1964. Courtesy of Mitch Kaufmann.

Surf clubs were prevalent in surf communities in the mid- to late 1960s. The Oceanside Club predated Surfside and Utika. Clubs competed internally and with other clubs, and helped advance the growth of competition along the East Coast. Pictured left to right are Johnny Mobley, Rick Shore, Ricky Hale, unknown, Mark Keisus, Steve Cissel, Bruce Clelland, and unknown.

Mimi Munro, 1966 World Contest, San Diego, California. Photo by LeRoy Grannis.

Ormond Beach's Mimi Munro was the East Coast's most successful female competitor of her day. She placed third at the 1966 World Contest and first in the Florida State Surfing Championships in Ormond Beach in 1967. Other top Florida women included Kathy Jo Anderson, Kathy LaCroix, and Linda Baron. In 2007, Munro was inducted into Huntington Beach's Surfing Walk of Fame.

Bruce Clelland, Jacksonville Beach, 1966. Photo by David Silver.

Bruce Clelland was a natural talent who earned serious recognition as a leader among other world-class talents to emerge from North Florida. He rode for Surfboards Hawaii and Hobie before launching his own signature model with California's Greek Surfboards, the Bruce Clelland East Coast Special, which was released in 1965 and rereleased in 2007.

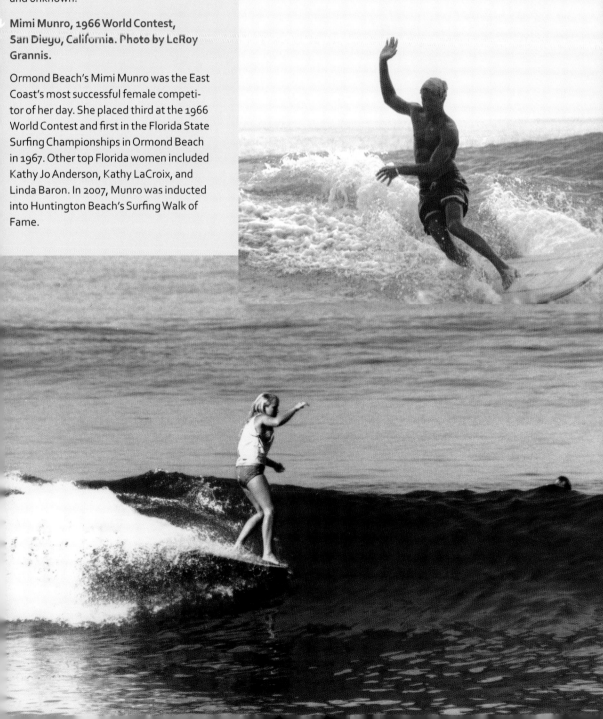

← Hixon's Surf Shop, late 1960s. Courtesy of Mitch Kaufmann.

Bill Hixon's shop in Neptune Beach has been a North Florida powerhouse since its founding in 1964 as a Weber shop. It was best known for Water Weapons surfboards crafted by the region's leading shapers. Hixon's early '80s circle of surfers included Ray Pimental, Mark Cooper, Bruce Clelland, Chuck Utter, Sean Mattison, Chris Wooter and Mitch Kaufmann.

↓ Joe Roland, Jacksonville Pier, mid-1960s. Photo by David Silver.

Joe Roland won the ESA's first men's 4A championship in 1968, won third place in an early Peruvian International Big Wave competition, had his own models with Hansen and Rick surfboards, and competed in the 1968 and 1970 World Contests. He started shaping boards in 1972 under the Roland-Miniard-Rosborough label. His brother Vince was also an accomplished surfer.

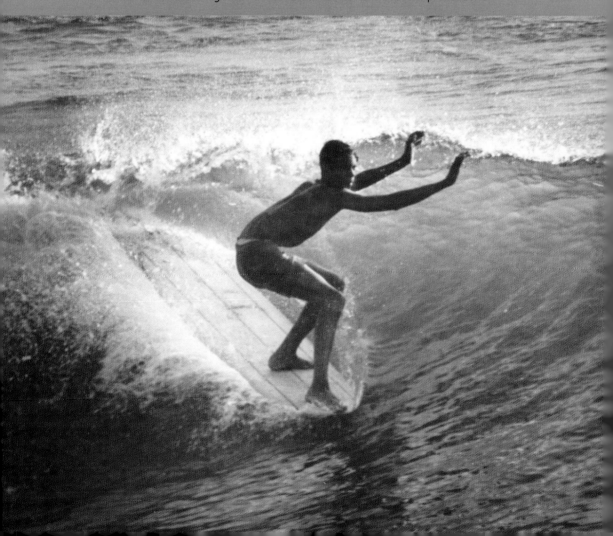

Among the region's earliest notables, Bruce Clelland, Dick Rosborough, Joe Roland, and Larry Miniard led the way between 1963 and 1970, earning media attention and sponsorships with California manufacturers. Other early figures included Harry Dickenson, Jim "Chips" McClurg, Tim and Tom Ellis, George Nobbs, Ricky Hale, Glen "Gordo" Guthrie, Mike "Fox" Holtsinger, Paul Marino, Randy Hjelm, Bill Longenecker, and Vincent Roland.

By the late '60s and into the late '70s, new surfers were gaining recognition—Clay Bennett, Terry Deloach, "Danny Mac" McDaniel, Ray "Taco" Hinson, Roger Wood, Chris Gardner, John Tully, Erik Lundgren, Danny Sibley, Lloyd Wilson, Brad Santora, Scott Worthley, and others Alvin Farmer, Skipper Brooker, and, much later, Mitch Kaufmann would bring to the region organizational skills and an eye for something bigger than themselves. In 1973 Farmer established North Florida as its own district within the Eastern Surfing Association and became its first director. Brooker assumed the mantle next, and Kaufmann then ran the largest amateur competitive surfing district on the Atlantic Coast. He has also taken the lead role in documenting the region's rich surfing history.

Into the '80s, the talent included Terry Strumpf, a former pro and now president of Excel Wetsuits; Kenny Sanderford, a 1982 invitee to the World Contest in Australia; and Richard Thompson, who chose a life of travel and adventure over competition. Among the standouts in the '90s were three-time East Coast champ Charley Hajek, Matt Albert, Jason Hoey, Alan Riik, Jason Motes, Buddy Evans, and Jed Davis. Other notables to the south in St. Augustine and Fernandina Beach include Burgess and Josh Autrey, Bill Eichols, Kevin Leary, and Eric Hatton, representing an older generation of surfers still going strong.

Today, it's Kyle McCarthy, Ryan Briggs, Cody and Evan Thompson, and Wayne Satterwhite who are raising the bar, but it's Gabe Kling of St. Augustine, and Asher Nolan and Karina Petroni of Atlantic Beach, who have made Northeast Florida's most recent international impact. Kling is a serious WCT competitor who has distinguished himself among the top surfers in the ASP. Nolan traded a competitor's jersey for a position with Billabong sportswear but remains a WQT competitor, winning the 2011 Unsound Pro in New York City. Petroni is a multidimensional success story and was the top-ranked American female surfer in 2007.

Nolan and Petroni live within "The Beaches," a collection of communities from Mayport and Vilano Beach occupying an island created by dredging a ten-mile canal between Palm Valley Bridge

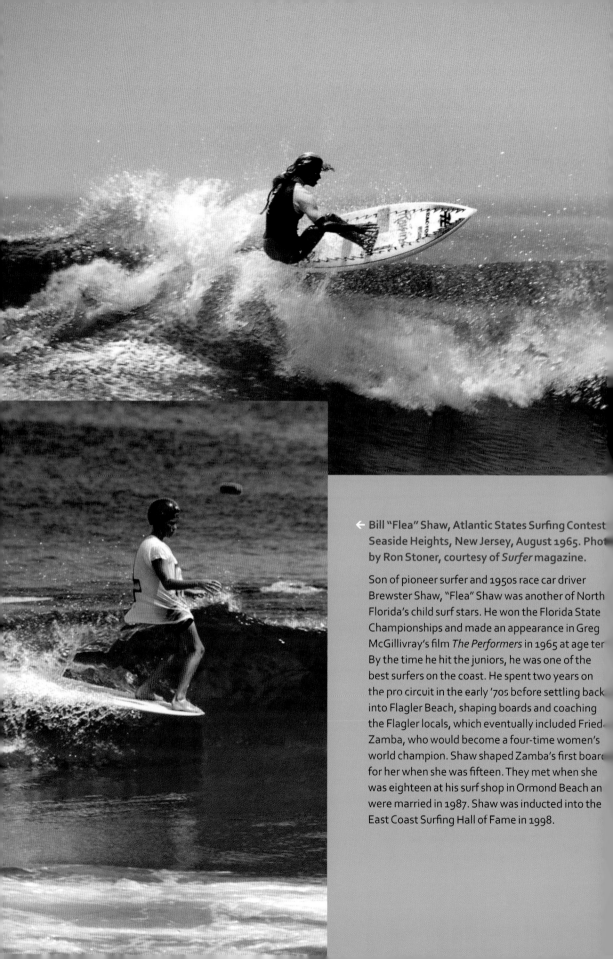

← Bill "Flea" Shaw, Atlantic States Surfing Contest Seaside Heights, New Jersey, August 1965. Phot by Ron Stoner, courtesy of *Surfer* magazine.

Son of pioneer surfer and 1950s race car driver Brewster Shaw, "Flea" Shaw was another of North Florida's child surf stars. He won the Florida State Championships and made an appearance in Greg McGillivray's film *The Performers* in 1965 at age ter By the time he hit the juniors, he was one of the best surfers on the coast. He spent two years on the pro circuit in the early '70s before settling back into Flagler Beach, shaping boards and coaching the Flagler locals, which eventually included Fried Zamba, who would become a four-time women's world champion. Shaw shaped Zamba's first board for her when she was fifteen. They met when she was eighteen at his surf shop in Ormond Beach an were married in 1987. Shaw was inducted into the East Coast Surfing Hall of Fame in 1998.

Frieda Zamba, OP Pro, Huntington Beach, 1988. Courtesy of Frieda Zamba. Photo by Simone Reddingius.

At nineteen years old, Frieda Zamba was the first Floridian and youngest competitor to earn the World Title. In total, she won three consecutive titles between 1984 and 1986 and reclaimed the top spot in 1988. Zamba's radical approach to surfing narrowed the gap between the sexes in performance and perception.

Wave Masters Society, Jacksonville Beach, 1982. Courtesy of Mitch Kaufmann.

In 1982, Bill Hixon and some of North Florida's first surfers created the Wave Masters Society, a not-for-profit organization. Today, the group is a diverse mix of surfers and hosts the Wave Masters Surf Contest and other Wave Master programs, which raise serious money for local charities and youth-oriented programs.

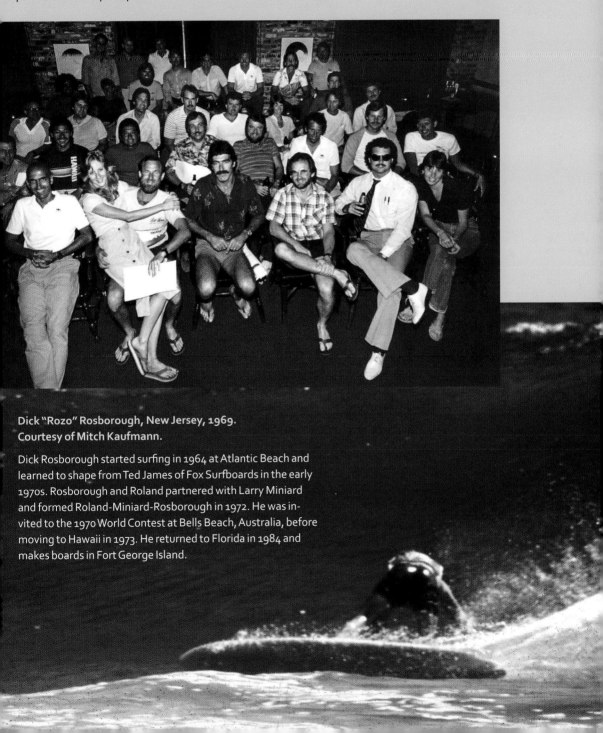

Dick "Rozo" Rosborough, New Jersey, 1969. Courtesy of Mitch Kaufmann.

Dick Rosborough started surfing in 1964 at Atlantic Beach and learned to shape from Ted James of Fox Surfboards in the early 1970s. Rosborough and Roland partnered with Larry Miniard and formed Roland-Miniard-Rosborough in 1972. He was invited to the 1970 World Contest at Bells Beach, Australia, before moving to Hawaii in 1973. He returned to Florida in 1984 and makes boards in Fort George Island.

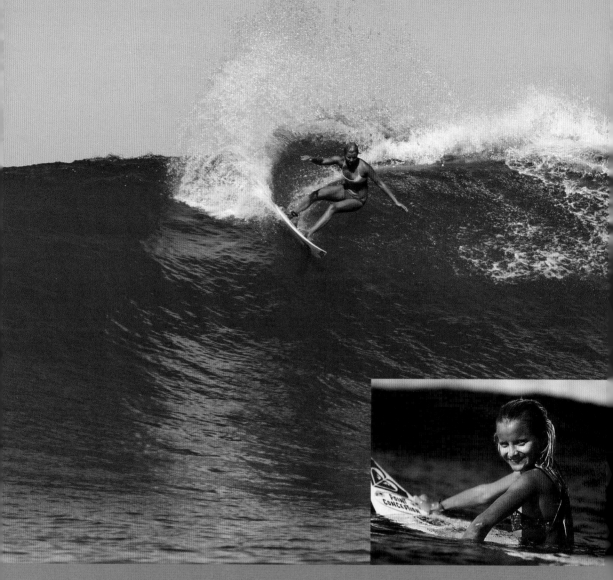

↑ Karina Petroni, Indonesia, circa 2005. Courtesy of Karina Petroni.

↗ Karina Petroni, Panama, late 1990s. Courtesy of Karina Petroni.

In 2006, Karina Petroni took time off from the world tour to assist her father in recovering from a brain aneurism. Gerard Petroni died on December 31, 2009. By September 2011, Petroni was back on track, winning the Presidente Light Women's Pro competition at the Jacksonville Beach Pier. She is also dedicated to marine issues, joining forces with noted dolphin trainer Richard "Ric" O'Barry in producing *The Cove*, which won the Academy Award for Best Documentary of 2009. The film exposed the routine slaughter in the Japanese town of Taiji of thousands of captured dolphins unsuited for "swim with dolphin" attractions worldwide.

Born in the American Canal Zone of Panama, Karina Petroni began surfing with her father and brother at the age of two. With the United States transferring ownership of the canal to Panama in 2000, her family moved to Atlantic Beach, Florida, when Karina was twelve. Petroni would go on to win the Eastern, U.S., and National Scholastic Surfing Championship titles in 2002 and back-to-back silver medals in the World Junior Games. She was the most recent female from America's East Coast to qualify for the ASP World Championship Tour and the only North American female on the 2008 tour.

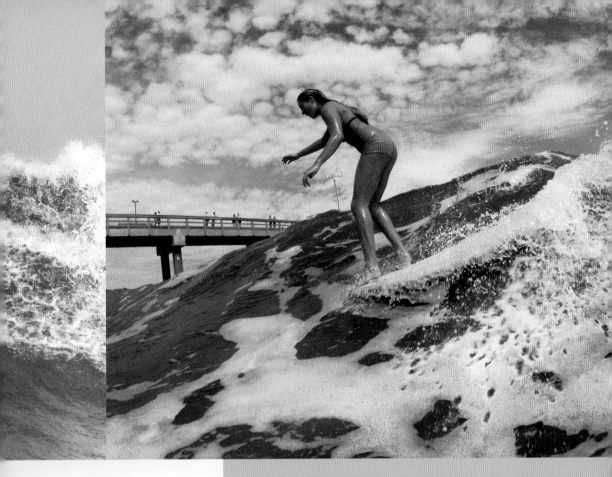

↑ **Lauren Hill, St. Augustine Pier. Photo by Jimmy "Jimmicane" Wilson.**

Now living in Australia, St. Augustine's Lauren Hill started surfing at age thirteen in Crescent Beach and began competing within a year. In 2001 she won the U.S. Women's Longboard Championship in Malibu, California, and in 2002, she won the East Coast Wahine Championships Pro Women's Longboard division in Wrightsville Beach, North Carolina.

← **Lisa Andersen, Sebastian Inlet, 1989. Photo by Tom Dugan.**

Lisa Andersen, Florida's second four-time women's world champion, arrived in Ormond Beach, Florida, with her family at age thirteen. Her step-father's disapproval of her surfing and poor school performance led to Lisa's running away at sixteen to Huntington Beach, California. She won four consecutive titles beginning in 1994. Plagued by back pain, Andersen abandoned the 1998 tour in midseason and returned to Ormond Beach with her daughter. But by late 1999 she was back in action, winning the Billabong Pro in Anglet, France, and finishing the 2000 season in fourth place. After settling back again in Florida for the birth of her second child in 2001, she surfed her final year on the WCT in 2002. Then she retired from competition and moved to California to assume a leadership role in Quiksilver's Roxy sportswear line.

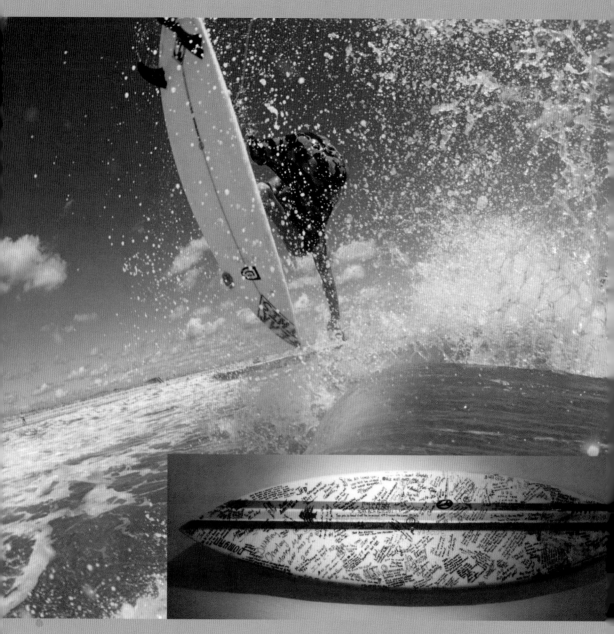

↑ Jonny Barclay, St. Augustine. Photo by Jimmy "Jimmicane" Wilson.

In the summer of 2006, Jonny Barclay knocked his eye out of its socket during a missed aerial known as a Gorkin Flip. Luckily, he reinserted his eye before the socket swelled shut. With major surgery and help from friends Jimmy Wilson, Tory Strange, and others, he recovered and remains one of the region's best surfers.

↑ Jax Beach remembers Jed Davis, deceased 2007. Photo by Rod Faulds.

The signatures on Jed Davis's board commemorate loss of one of Jacksonville Beach's favorite sons. Davis was struck by a car while riding his bike and died in December 2007 at age thirty-seven. Jed was nicknamed "Money Man" due to consistent placing in both long- and short-board divisions. Surfers honor their own through a variety of ceremonies, but the "paddle out" ceremony has risen to the top. Whether the deceased is a local or global figure, surfers will come together, join hands, and spread flowers on the waters to honor and remember one of their own.

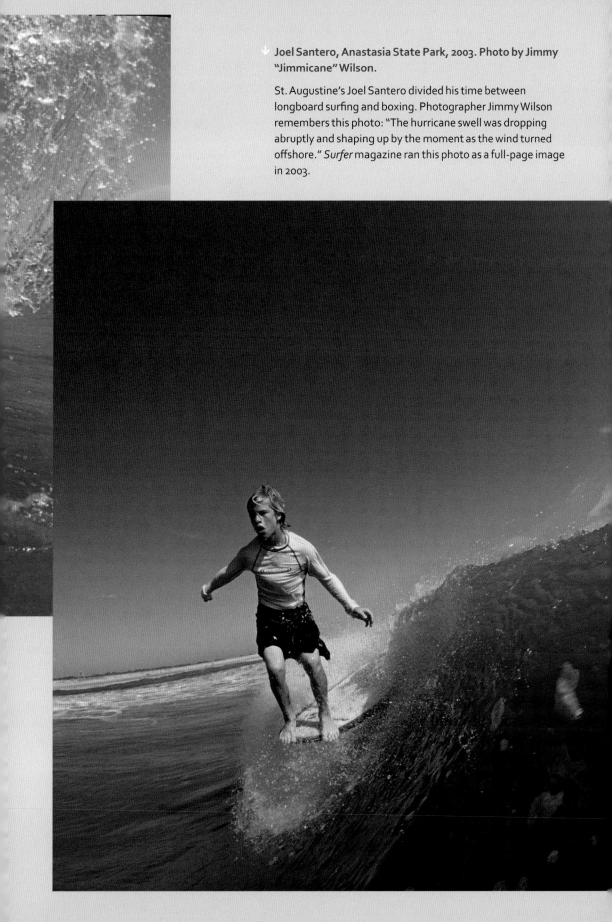

Joel Santero, Anastasia State Park, 2003. Photo by Jimmy "Jimmicane" Wilson.

St. Augustine's Joel Santero divided his time between longboard surfing and boxing. Photographer Jimmy Wilson remembers this photo: "The hurricane swell was dropping abruptly and shaping up by the moment as the wind turned offshore." *Surfer* magazine ran this photo as a full-page image in 2003.

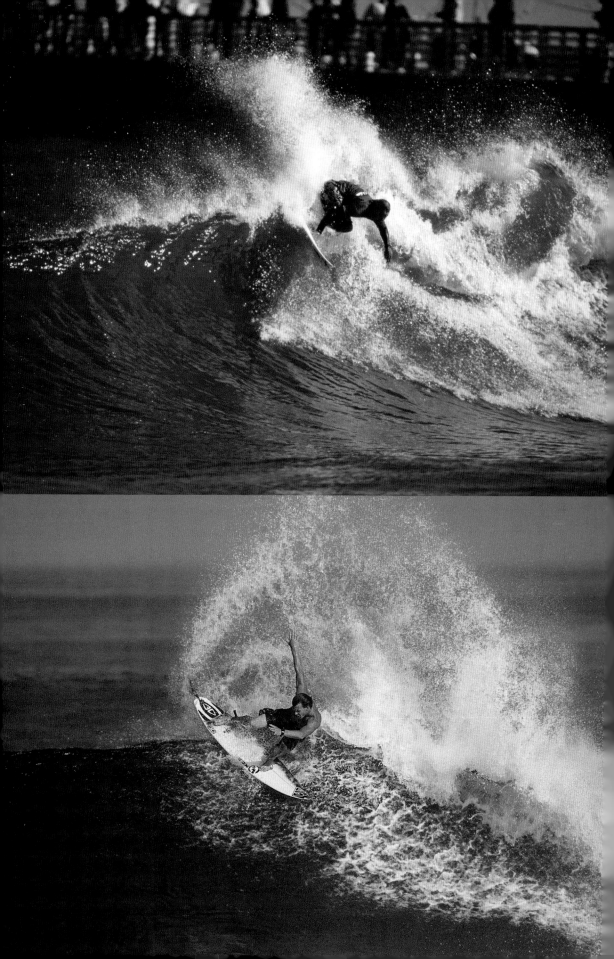

and Marsh Landing. While this area has generated the largest share of surfing talent in North Florida, it is the communities just to the south that have produced its most famous surfers—Mimi Munro in the early '60s and multiple World Title champions Frieda Zamba and Lisa Andersen in the 1980s and 1990s.

While one might speculate on the dynamics that would create such a confluence of notable female surfers from this largely isolated, testosterone-laden stretch of beach, all of these women speak of the support they received from the then almost exclusively male surf population. Their success is particularly notable within a sport, culture, and industry that has failed to provide the same level of support for its female professionals as for its men. Pointedly, Zamba's dismay with this disparity, and her genuine reluctance to face the limelight as world champion, fueled an early departure from international competition, but not before making a comeback to win her final World Title in 1988.

Lisa Andersen is a different story. In an overt display of teenage rebellion, she ran away from home, leaving a note to her mother stating she was going to California to become the women's world surfing champion, while later admitting to not really knowing that such a thing existed. Andersen eventually found her tack-sharp focus and is today the ultimate role model for female surfers around the world as both surfer and Pro Ambassador for Roxy, Quiksilver's line of women's sportswear.

Looking back again at the women, North Florida has generated far more talent than those already mentioned. Among the most notable are Chris Snyder (Frosio), a star performer bridging the '60s and '70s; Holly Rubin; Julz Arnold; Debbie Swaney; Annette Stuart, U.S. Champion in 1978; Adelle Faba, East Coast Champion

⬉ **Asher Nolan, Sebastian Inlet. Photo by Tom Dugan.**

Atlantic Beach's Asher Nolan is a former ASP North America Men's Champion and two-time East Coast Champion. He finished third at the Globe Sebastian Inlet Pro, second at the Body Glove Surfout, first at the Sweetwater Pro, and first at the 2011 Unsound Pro, the Quiksilver Pro Trials at New York City.

⬅ **Gabe Kling, Rocky Point, Oahu, Hawaii, 2005. Photo by Jimmy "Jimmicane" Wilson.**

St. Augustine's Gabe Kling has been a formidable world tour competitor over the past decade. While competing at Pipeline in 2009, he suffered a severe knee injury, but worked his way back up the ladder with consistent results and a win at the ultracompetitive 2010 ASP Prime 6.0 Lowers Pro at Trestles in Southern California, finishing the season as the 2010 ASP North American Champion.

in 1979; and Lyn Singelton and Nancy Macri, who moved east from St. Petersburg in 1979. Newer names include 2003 U.S. Champion Molli Miller, Tiffany Layton, Kayla Beckman, Jesse Carnes, Nastassja Gwizdak, Piper Austin, and Kayla Durden, among others.

In the early '60s, surfboards were hard to come by in North Florida, with boards available mostly through retail sources like Sears and Western Auto. By 1965, demand was sufficient to support dedicated surf shops, prompting Bill Hixon to launch Hixon's Surf Shop in Neptune Beach, which ran strong for twenty-five years.

Today, roughly a hundred regional board shops are making a run for the money. Aqua East (1973) and Sunrise (1976) have led the pack and are valuable assets in the region. Others of particular note include Austin's, the oldest shop in the region, and Hart's, which lasted for thirty-five years. Early shops also included North Florida, the Surf Beast, Glory, and Strickland's Factory Showroom. In St. Augustine, Blue Sky has served the region since 1979, and Tory Strange's Surf Station has grown into a landmark from its unlikely beginning as an Amoco gas station in 1984.

Other assets came on the scene as well. Skateboard parks were springing up across the state, and Northeast Florida built great parks while breeding a talented community of surfer/skaters. George Wilson, Mitch Kaufmann, Zach Ness, and Jimmy Plummer led the way at Kona, Marina Del Rey, and Landalee skateparks throughout the '70s. Wilson and Plumer moved to California in 1977 and became the only Floridians to be included in the legendary Dogtown Z-Boys team.

The Emerald Coast, Florida's Panhandle

Surfing in the northern Gulf of Mexico has enjoyed enormous popularity from the early 1960s forward, producing generation after generation of notable surfers. While this may seem surprising to audiences outside the region, more surprising yet is the history of surfing in the Panhandle well before the 1960s and even the sport's commonly held earliest beginnings within the state. While the earliest record of Floridians surfing on stand-up boards now dates back to Daytona Beach in 1909, the Panhandle had its own curious cabinet of individual surfers within the 1920s and 1930s—with Panama City appearing to have had the earliest records of surf-sliding in the Gulf, according to newspaper articles.

The first newspaper account of surfing in Florida's Gulf documents Bill Davis of Panama City attempting to ride R. C. Wiselogel's cypress wood surfboard in 1921. This evidence, along with documentation supporting even earlier origins with Gene Johnson in Daytona Beach in 1909, disrupts the long-held belief that Miami's Bill and Dudley Whitman were Florida's first stand-up surfers. Another Panama City newspaper article documents the return of Del and Betty Wood, who arrived home from an around-the-world trip with a surfboard acquired while in Hawaii. Yet another news item documents Bert Butler, along with his eleven-year-old son Bobbie, surfing in the late 1930s on a twelve-foot surfboard made of "fir ply-wood and covered with canvas set in glue"—also in Panama City. Elsewhere in the Panhandle, Fort Walton's E. C. Work Jr., an airplane pilot and designer, built a fifteen-foot hollow surfboard, gave a public demonstration on its use, and then presented the board to the local coast guard crew in 1937.

While these early pioneers exposed the sport of surfing to this region long before the boom of the 1960s, no one defined the

← Yancy Spencer III, early 1970s. Photo by Bruce Walker.

In late 1966, Yancy Spencer emerged as the top competitor from Florida's Panhandle, winning the Navarre Beach Gulf Coast Championship and the Fiesta Five Flags juniors division. His success continued, and by 1968, California-based Challenger Surfboards was paying Yancy twenty-five dollars a week (good money then) plus free boards and travel expenses to represent their label. In the fall of 1969, Spencer signed on with Greg Noll Surfboards, which released a Yancy Spencer model to court the market on the Gulf Coast. At the time, the Gulf Coast Surfing Association was the largest competitive surfing organization in the world. Following a number of similar career moves, Spencer launched a chain of Innerlight surf and skate shops, still serving the Gulf.

→ Fort Walton Beach, September 10, 1974. Photo by Brad McCann.

Fort Walton Beach (pictured here prior to Hurricane Carmen) is a thriving surf town with a history of shops, shapers, and surfers. Notable surfers include Greg Ammons, Dave Guin, Brad McCann, Stacey Lea, Fred Cheney, Mike Koran, Steve Shipley, Rich Price, Steve Horner, Terry Kerr, Rick and Dave Buehrig, Kelly Newsom, and Rod Dreyer.

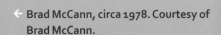

← Brad McCann, circa 1978. Courtesy of Brad McCann.

A top Gulf competitor and avid traveler, Brad McCann has been a Gulf Coast fixture since the late 1960s. Like other Gulf Coasters, McCann regularly surfed Florida's East Coast as well, making friends early on with Donnie Fisher and other noted surfers in New Smyrna Beach. McCann also spent two years studying photography at Daytona Beach Community College and was one of the few Florida surfers of the era to own a 650mm Century lens. He ran the North Gulf Coast region of the ESA in the early 1980s before passing the baton to Kathy Hughes Griffith. He is pictured here at Cape Hatteras, North Carolina, in 1978, riding a favorite board shaped by Daytona's Bernie Crouch.

Pete Lege, Okaloosa Island, mid-1980s. Photo by Kathy Hughes Griffith.

Pete Lege and his brother were among the original core group in the waters of Destin and Fort Walton Beach. Like a good number of the region's early and best surfers, Lege and many of his peers moved to Hawaii or elsewhere after honing their skills in the Gulf. Lege now lives on Kauai, while Marc Seibmann, Darin Auger, and Jimmy Lacroix are all on Maui.

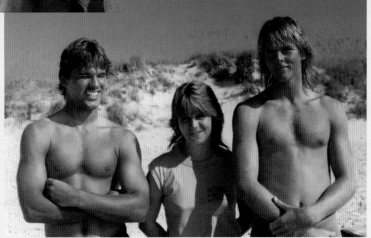

James Estes, Kathy Hughes Griffith, and Mike Gilmore, Okaloosa Island, Fort Walton Beach, 1983. Photo by Brad McCann, courtesy of Kathy Hughes Griffith.

When the United States Surfing Association foundered in 1967, the Gulf Coast Surfing Association, along with other regional associations, filled the void. In 1978 the Gulf Coast joined the Eastern Surfing Association. Since then, it has thrived under various directors and volunteers. Kathy Hughes Griffith served as director from 1984 to 1987.

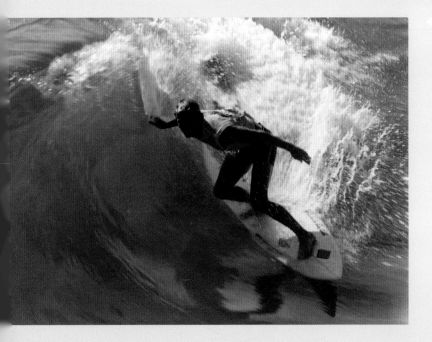

Dave Guin, Okaloosa Pier, 1984. Photo by Kathy Hughes Griffith.

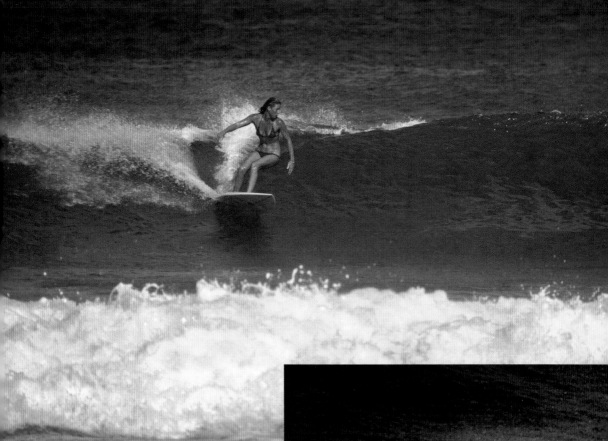

↑ **Lisa Muir Wakley, Rincon, Puerto Rico, 1976. Photo by Lance Trout.**

Lisa Muir, who learned to surf at Ramey Air Force Base in Puerto Rico, moved to Florida and became one of the top female competitors on the East Coast Pro Circuit. She was inducted into the East Coast Surfing Hall of Fame in 2002. In 2004, she hosted the first all-female surfing competition on the Gulf Coast.

↘ **John Gaynor Green, Marc Seibmann, and Darrin Auger, Cape Hatteras, North Carolina, 1986. Photo by Kathy Hughes Griffith.**

While John Green was an established surfer by the time this shot was taken, Siebmann and Auger were just beginning their ascent. Both moved to Maui, where Auger remains, having taken to big surf, deepwater free diving, and spearfishing in pursuit of very large fish.

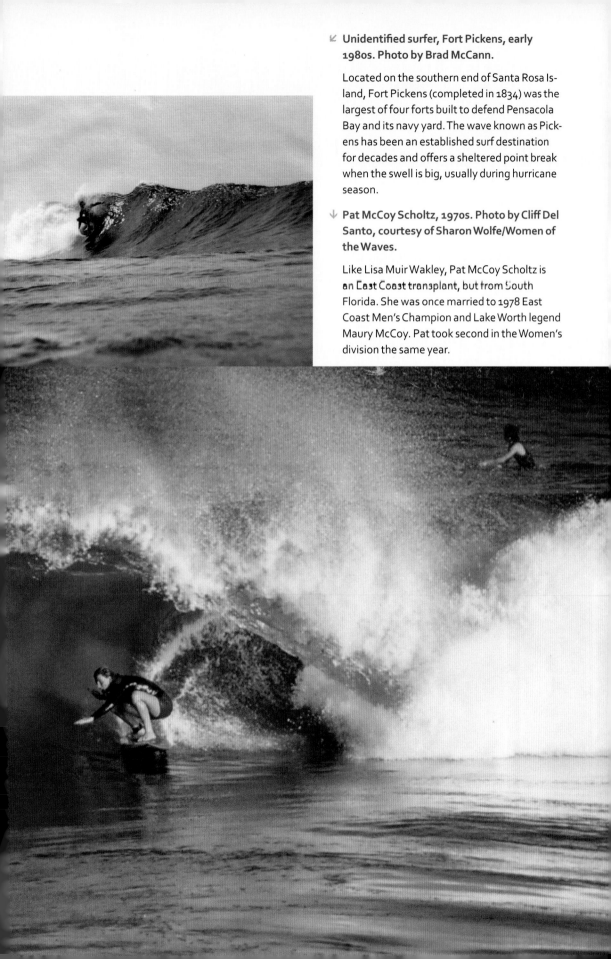

↙ Unidentified surfer, Fort Pickens, early
1980s. Photo by Brad McCann.

Located on the southern end of Santa Rosa Is-
land, Fort Pickens (completed in 1834) was the
largest of four forts built to defend Pensacola
Bay and its navy yard. The wave known as Pick-
ens has been an established surf destination
for decades and offers a sheltered point break
when the swell is big, usually during hurricane
season.

↓ Pat McCoy Scholtz, 1970s. Photo by Cliff Del
Santo, courtesy of Sharon Wolfe/Women of
the Waves.

Like Lisa Muir Wakley, Pat McCoy Scholtz is
an East Coast transplant, but from South
Florida. She was once married to 1978 East
Coast Men's Champion and Lake Worth legend
Maury McCoy. Pat took second in the Women's
division the same year.

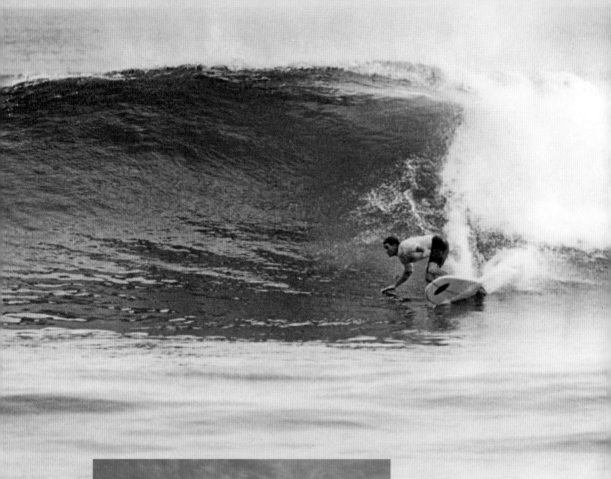

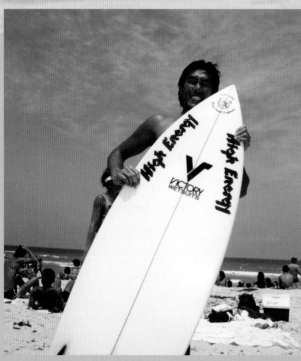

↑ **Stacey Lea, Playa Negra, Costa Rica. Photo by Brad McCann.**

Florida surfers have been traveling to Costa Rica for decades, and many have established permanent or second home While there are many waves and region choose from, Playa Negra in Guanacast one of the best and was featured in Bru Brown's 1994 *Endless Summer II*, a sequ to the iconic 1960s film.

← **Mark Foo, Wave Wizards Pro, Jensen Beach, 1983. Photo by Tony Arruza.**

Future Hawaiian big wave star Mark Fo spent his high school years in Pensacola and competed in regional contests befo leaving for Hawaii in 1978. One of the fe pros to secure sponsorship outside the industry, Foo signed a modest deal wit Anheuser-Busch in 1981. He was also th first surfer to ride a tri-fin at Waimea an the first to use a leash in big surf. Foo's ended tragically when he drowned whi surfing Mavericks, a renowned big-wav location in Northern California.

Panhandle surfing scene with as much success or influence over the decades as Yancy Spencer III. While still a teenager, Spencer was the Panhandle's first surf star, winning the Gulf Coast Surfing Championships in 1970 and the first East Coast Pro in 1972, and placing second in the 1975 U.S. Championships. He had his own signature model with Greg Noll Surfboards; he opened Innerlight Surf and Sport, one of the region's first shops, in 1972; and he was among the first inductees in the East Coast Surfing Hall of Fame in 1996. Like others in the sport, Spencer found new beginnings through Christian beliefs, discovered while battling drugs and alcohol early in his career. Throughout his adult life, he championed a spiritual alternative for countless surfers in search of a path, until his untimely death at age sixty by heart attack while surfing Malibu in 2011.

Chief among those in the Gulf sharing the limelight with Spencer in the early '70s were Beaser Turner, a stylish and serious competitor, and surfer/photographer Tony Caruso. Adding to the mix, though slightly later, were Freddy Esposito, who was also one of the earliest pro skateboarders in the state, Greg Ammons, Brad McCann, Rod Dreyer, Mike Bencivenga, Stacey Lea, Pete Lege, Buddy Capel, Mark Rush, Mark Forsman, Tim Quigley, Rick Beurig, Cliff Ray, and Ray Smith. Later yet, Marc Seibmann, Darrin Auger, and others would rise as local stars before proving themselves as serious watermen in Hawaii. Also in the mix was Mark Foo, a young Maryland transplant who found himself on the Gulf Coast with aspirations to excel in Hawaii's biggest waves, which he established before his tragic and highly publicized drowning at California's big wave magnet Mavericks in 1994.

The female surfers include Sharon Cain in the 1960s, followed by Brenda Stokes, Kathy Hughes Griffith, and East Coast transplants Lisa Muir Wakley and Pat (Scholtz) McCoy Wilcox. Wakley and Wilcox both reside in Navarre Beach, and along with Yancy Spencer III are the only Gulf surfers included in the East Coast Surfing Hall of Fame.

Today, the story returns full circle to Yancy's two sons, Yancy IV and Sterling, who both hold court as recognized pros in the Gulf, with Sterling making a name for himself internationally—whether you like his approach or not. Others, like Chuck Taylor and, more recently, Michael Peyton, are standouts among of the enormous number of talented surfers that surfaced in the northern Gulf.

All of the region's better breaks—from Pickens Point and Pensacola Pier in the west to Panama City's St. Andrews State Park and Shell Island in the east—benefit from deeper water offshore,

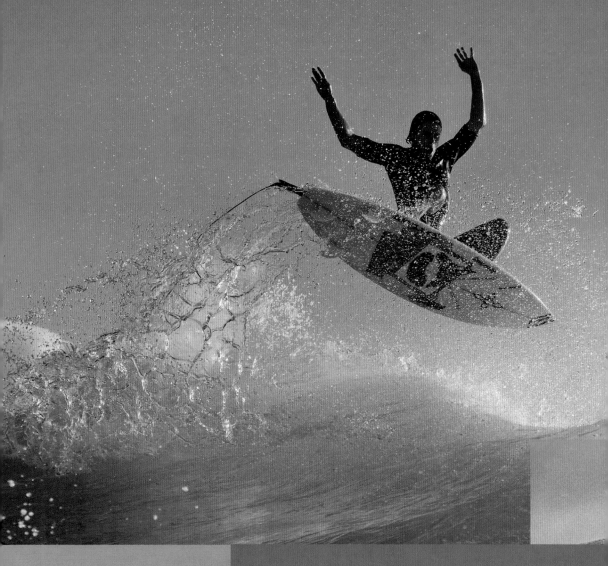

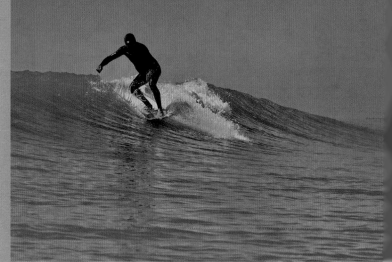

→ Yancy Spencer III, Pensacola Beach, April 2008. Photo by Nic McCue.

Yancy Spencer (pictured here in 2008 at age fifty-seven) was a Gulf Coast legend and dedicated Christian. Three years later, after getting out of the water with chest pains at Malibu, he died of a massive heart attack on the beach. Later that week, the west side of Pensacola Pier, an established "no surf" zone, was opened to host the Yancy Spencer III Paddle Out Memorial, with thousands turning out to celebrate the life of one of Florida's most notable surfers.

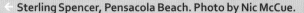 Sterling Spencer, Pensacola Beach. Photo by Nic McCue.

Sterling Spencer has transitioned from the northern Gulf's heir apparent to international surf star since joining the Billabong team decades ago at age eight. Sterling has earned impressive competitive results, which include four consecutive East Coast Championships and placing within the top five on the U.S. Pro Junior tour in 2006. He was the subject of an Internet rage in 2010 over an incident known as "the human boardslide" in which Spencer landed an aerial maneuver on the back of a surfer who had dropped in on him in Southern California. Spencer defended the move as the lesser of other more dangerous outcomes, but not without weathering a storm of derision and reported death threats. He is also on the record as having seen a Centaur in his backyard and has capitalized on the experience as surfing's "Centaur," putting himself and his pinchmysalt.tv on the Internet chatterbox, which won *Surfer* magazine's 2011 Battle of the Blogs. Sterling is also unique among contemporary pros in securing out-of-market sponsorship with Verizon Wireless. He was featured in a lengthy *Surfer* magazine feature "The Spencer Legacy" in June 2013.

↓ Sterling Spencer, Destin Beach, January 17, 2008. Photo by Nic McCue.

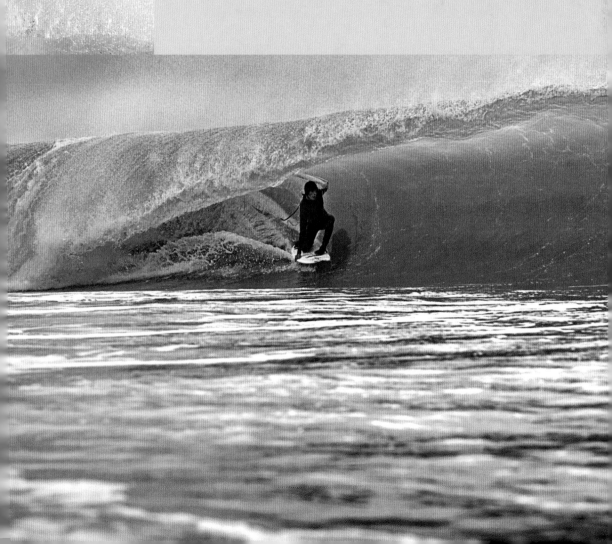

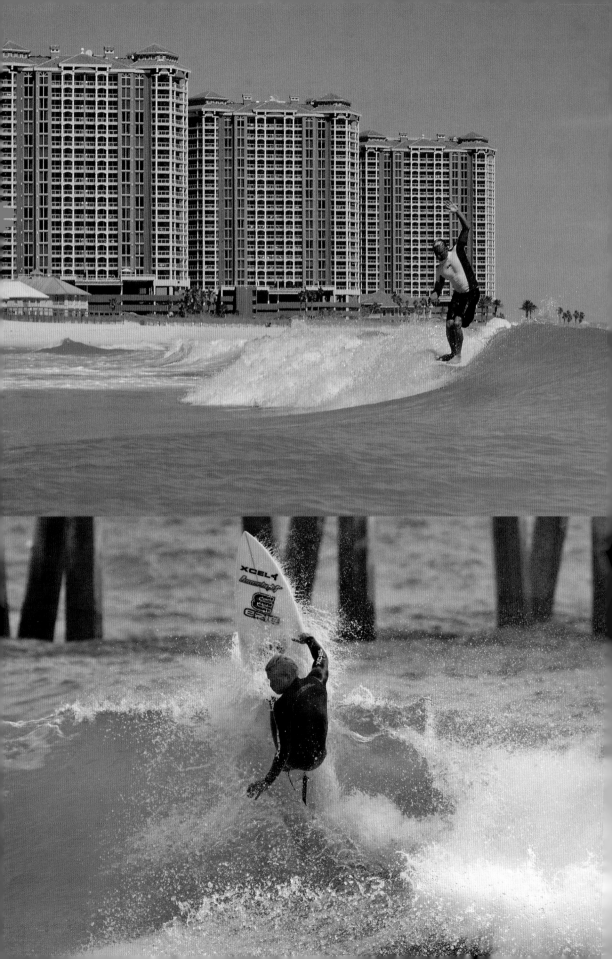

even if only by Gulf Coast standards. Between them, Navarre Pier, Okaloosa Island, Destin, and Fort Walton Beach have all produced epic surf over the decades.

Each community had and has its crew of hardcore surfers, mixed with a regular rotation of military personnel stationed at major naval and air force bases in the region. As one heads east past Panama City, beautiful waves can be found at Mexico Beach, and, on occasion, at Cape San Blas. East of Apalachicola, barrier islands such as St. George Island and Dog Island come alive on serious swells but are seriously inconsistent. The region's offshore islands protrude well into the Gulf, compromising the coastal saltwater marshes that receive no surf at all until deeper water reappears offshore again hundreds of miles to the south, from Clearwater to Naples.

Like other regions in the state, the Panhandle has a rich history of shapers and surf shops. Among the earliest players were Scott Bush, a pioneer shaper who also promoted California's Challenger Surfboards in Pensacola; Hutson Surfboards, which were made and sold through Hutson's hardware store and surf shop; and Brian Waters, whose parents ran Hutson's. In the early 1970s, Waters abandoned the hardware counter for the shaping bay, launching Islander Surfboards. He was instrumental in training other regional shapers, including Rick Bullock, who later moved to the Space Coast to shape for Tabeling, Spectrum, and Creative Shaping Company before moving to Hawaii. Bullock returned to Pensacola and joined forces with Sean Fell at Waterboyz Surfboards six years after its founding in 1988. Fred Cheeny founded Eastwinds Surfboards in Fort Walton in 1973. Rich Price and Steve Forstall, now East Coast icons, also began in the Gulf before relocating in the late 1970s.

In 1979, Steve Forstall drove over to compete in the Stubbies Pro Trials and decided to stay, launching his career as an airbrusher for Mike Tabeling and then shaping for Spectrum, Ocean Image, Action Surfboards, Hawaiian Island Creations, Nirvana, and Alekai in Florida and Hawaii before launching his own line of Coda

↖ **Yancy Spencer IV, Pensacola Beach, April 2008. Photo by Nic McCue.**

Yancy Spencer IV is the oldest of the Spencer children, which includes pro surfer Sterling and actress Abigail Spencer Pruett. Yancy IV calls the Gulf Coast home and is equally adept at styling on a longboard and shortboard performance. He has introduced many Gulf Coast youngsters to surfing through Innerlight Surf and Skate's Summer Surf Camps.

← **Yancy Spencer IV, Pensacola Beach, April 2008. Photo by Nic McCue.**

Surfboards. Today he runs Steve Forstall Designs in Indialantic and is recognized for his work in epoxy fabrication and for creating his own epoxy-compatible blanks. Rich Price ran Seadreams Surf Shop in Fort Walton Beach before heading to the Space Coast in the early '70s. He learned to shape at Natural Art Surfboards before founding his own label, Rich Price Designs, also based in Indialantic.

Today, established surf shops in the Panhandle include Waterboyz and Innerlight Surf and Skate shops in Pensacola, Gulf Breeze, and Destin; Fluid Surf Shop in Fort Walton Beach, and Mr. Surfs in Panama City. Tony Johnson, owner of Mr. Surfs, also served as the Eastern Surfing Association's director of the North Gulf Florida Chapter between 1998 and 2008, the largest amateur surfing association in the world. Long before him, Kathy Hughes Griffith, Brad McCann, and others directed the region's competitions and helped launch the careers of early Gulf competitors. In 2011 the ESA and Tim Carr's Fluid Surf Shop hosted the first Pro-Am Stand-Up-Paddle (SUP) and surf contest in the region at Navarre Beach. Given the characteristically smaller surf in the region and its remarkably diverse coastal zone, it is no surprise that SUP surfing has also proven enormously popular in the Panhandle.

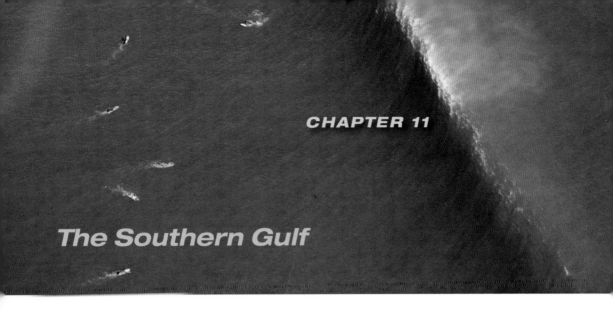

The Southern Gulf

When the conditions come together, Venice Jetties, Siesta Key, Lido Beach, Bradenton, and Indian Rocks are each capable of producing exceptional surf, and they are widely known outside the region by East Coast surfers who chase hurricane surf in the Gulf of Mexico during the summer months. And while it is also widely known that the internationally recognized Lopez brothers—Cory and Shea—grew up and found their feet in the Gulf, the area has a deeper history of great surfers and watermen. This includes an older generation of notables that includes Chris Lundy, Juan Rodriguez, Bruce Hansel, Kevin Stecher, Lance Trout, Phil and Rich Salick, Bob Webber, Jim Brady, Harry Donner, Pete Dooley, George Panton, Jack Reiley, and Pete Lopez, father of Shea, Cory, Ashley, and Matt. While a good number of these surfers no longer call the Gulf Coast home, all of their stories began near or under the Sarasotian sun.

While there were relatively few surfers in the region in 1963 or '64, there were a handful at each of the primary waves close to Sarasota—Crescent, Siesta, Lido, and Holmes beaches. According to Juan Rodriguez, "the Holmes Beach crew were on top of the game early on." Among all the region's pioneers, those of greatest note started young—Lundy at the age of nine, Rodriguez at thirteen, and Pete Lopez at eleven. All looked to Florida's east coast for consistent surf and all traveled extensively, far and wide, for world-class waves. Chris Lundy and Juan Rodriguez, arguably the kingpins among early Gulf Coast groms, remain or have returned to the region through a combination of shaping skills and creative endeavors. Bruce Hansel established himself in Hawaii but has long since repositioned himself among the leading surfers and shapers to reset their roots in Bali.

→ David Stahl, Palm Island off Siesta Key, Sarasota, 1968. Photo by Bill Koplitz, courtesy of David Stahl.

David Stahl was among the first generation of younger surfers within the region, and he had an equally early talent and eye for photography. His father was a noted painter, and David brought more than a touch of inherited artistry to both pursuits.

↘ Rich Salick, Jim Drawdy, and Phil Salick, Puerto Rico, mid-1960s. Courtesy of East Coast Surfing Hall of Fame.

The Salick brothers and Jim Drawdy were among the earliest surfers from the region and early travelers as well. Puerto Rico was still relatively uncrowded and reasonably easy to get to for Florida surfers. This shot of an early trip was given to the Salicks by East Coast legend Mike Tabeling twenty years after the trip.

↑ Phil Salick, mid-1960s, Lido Beach. Courtesy of Phil and Rich Salick.

Phil and his brother Rich grew up on Anna Maria Island, learned to surf in the Gulf, and traveled regularly to the East Coast to compete in the 1960s. Both moved to the Space Coast in the early '70s and started Salick Surfboards. In 1985, they cofounded what is now the National Kidney Foundation Rich Salick Pro-Am Surfing Festival. Rich battled a rare kidney disease for decades and ultimately died from its ravages in 2012.

→ David Stahl, Siesta Key, 1966. Courtesy of David Stahl.

David Stahl and his 9' 10" Moyer, purchased from Dick Catri at Shagg's Surfshop on the East Coast. The board was soon traded for a 9' 6" Surfboard's Hawaii noserider, which he took to Hawaii in 1966, a trip that began by bus from Sarasota to Los Angeles with Art Elek and Willy Coleman. Elek, one of the first surfers in Sarasota and a noted lifeguard at Siesta Beach, remained in Hawaii.

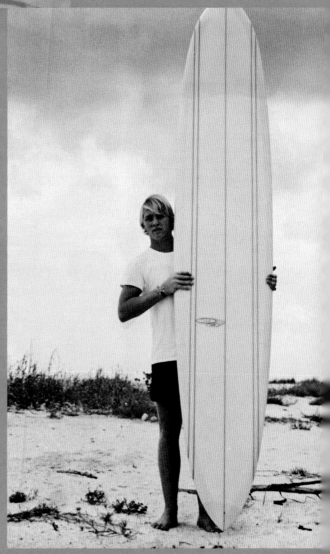

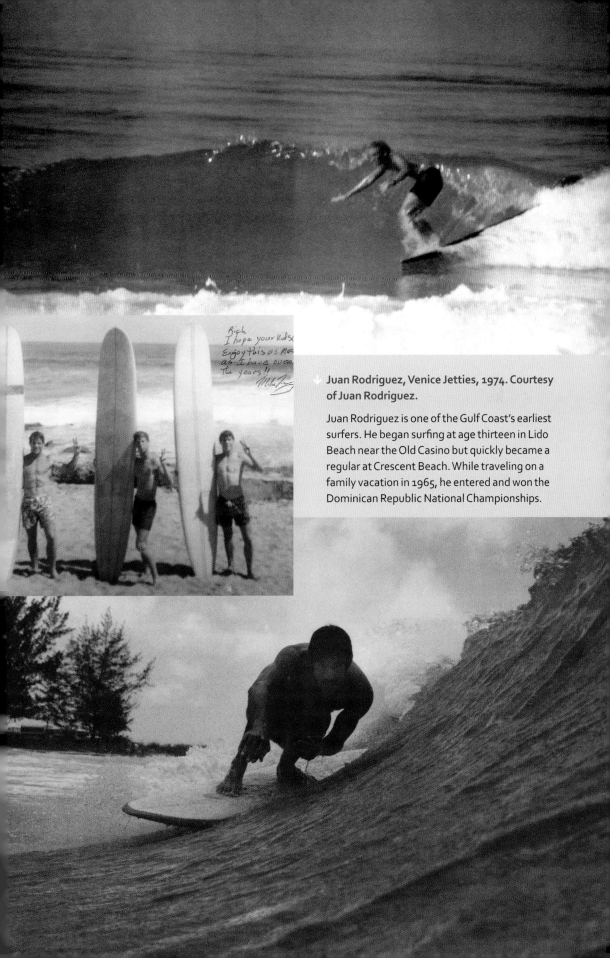

Rich
I hope your kids
Enjoy this as much
as I have over
the years!!
Mike [signature]

Juan Rodriguez, Venice Jetties, 1974. Courtesy of Juan Rodriguez.

Juan Rodriguez is one of the Gulf Coast's earliest surfers. He began surfing at age thirteen in Lido Beach near the Old Casino but quickly became a regular at Crescent Beach. While traveling on a family vacation in 1965, he entered and won the Dominican Republic National Championships.

Chris Lundy, likewise, set his vision on distant targets. Lundy bought his first board, a 9' 6" Dextra pop-out from Economy Fishing Tackle in Sarasota, where Rodriguez was working and repairing dings. In the spring of 1974, Lundy made the move to Oahu's North Shore following a stay in Santa Cruz, where he earned recognition for himself as both a surfer and shaper. In 1979 *Surfer* magazine did a series of articles on what it called the Pipeline Underground, featuring legendary boogieboarder Phylis Dameron, Californian Brian Buckley, Miami transplant Adam Salvio, fellow Sarasotian Bruce Hansel, and Lundy, among others. Lundy would go on to compete in the 1982 and '83 Pipeline Masters and to shape the first Thruster-style tri-fin surfboard to be ridden at Waimea. Retrofitted in 1982 from a single fin to a tri-fin, and tested during the El Niño spring of 1983, the infamous 9' 1" Tiger Stripe Thruster would later be ridden by Tom Curren in the 1983 Billabong Waimea Contest and by Mitch Thorson, Eric Merlander, and Don "Hoey" Johnston as well.

Chris Lundy left Hawaii in 1984 for art school in Los Angeles and has since earned an international following for his creative work, designing event posters for the 1995 Twenty-fifth Anniversary Rip Curl Cup, Sunset Beach; the 1996 and 1997 Quiksilver in Memory of Eddie Aikau competitions; the 1997 Quiksilver Pro in G-Land; and the 1994 Honolulu Marathon Race for Nike. Lundy's relationship with Nike led to a number of notable projects, including a 2003 Lundy design for Nike's coveted Dunk Laser Low series, establishing a market for Nike's collectable footwear.

Rodriguez remains a Gulf Coast icon. His One World Surf Designs represents a unique blend of artistry and handcrafted production work. Spanning the years from his line of Western Flyer skimboards to the current demand for stand-up paddleboards, Juan continues to be one of the best shapers in the business and one of the best surfers with origins in the Gulf.

Among others to leave the region, George Panton moved to California in 1967, launching Inspiration Surfboards and the retail shop that George Draper would later convert into a Huntington Beach legacy, George's Surf Shop. Panton would relocate his factory to Cocoa Beach in 1972. Pete and Debbie Dooley created Natural Art Surfboards and Surf Shop in the Space Coast, Lance Trout became a staff photographer for *Surfing Magazine*, and Jack Reilly would take his Clearwater-based Creation Surfboards to New Smyrna Beach before establishing himself as a Los Angeles artist and art department chair at UC Channel Islands.

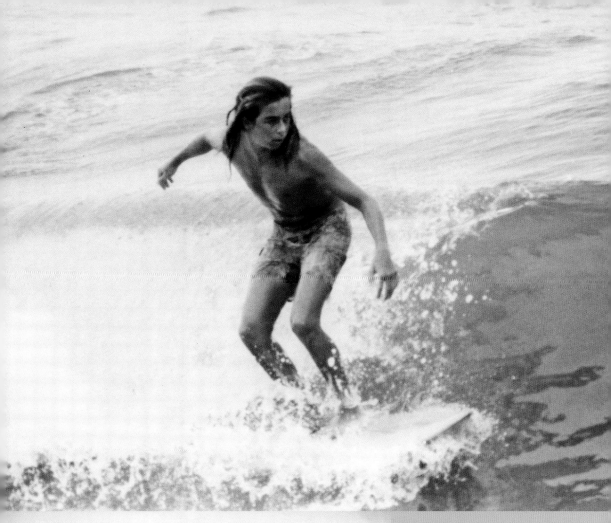

↑ Chris Lundy, Sarasota, early 1970s. Courtesy of Juan Rodriguez.

← Dwight Meyers, John Johnson, "The 'Capt,'" and Allen Johnson, 1970s. Courtesy of Juan Rodriguez.

This photo of Siesta Key locals reinforces the need to live for the moment, as three of the four are deceased—only Allen Johnson can remember this moment. Today, Allen Johnson is European general manager for sportswear giant Hurley.

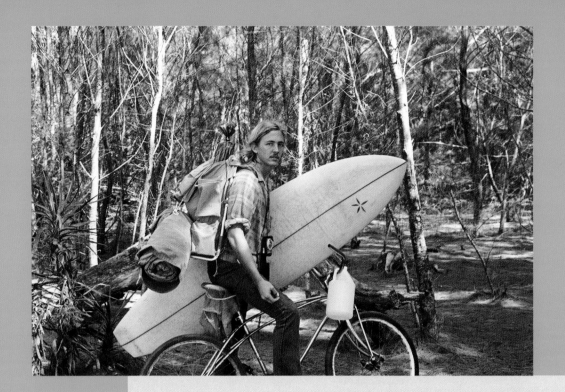

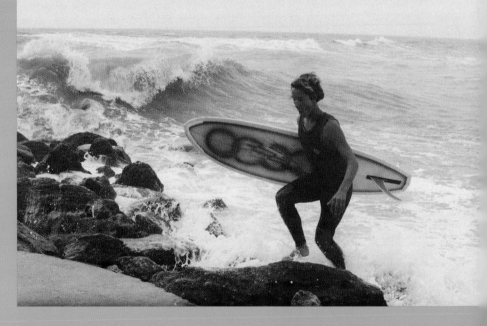

↑ Unknown surfer, North Venice Jetty, 1980s. Photo by David Stahl.

"North Jetty" was first surfed by Steve Arbuckle and David Stahl in the early 1960s. Both were riding Malibu Customs, one of the legitimate surfboard brands to show up on the southern Gulf Coast. Stahl's "other board" at the time was an early wakeboard given to him by Dick Pope Sr., public relations genius, founder of Cypress Gardens, and driving force behind the development of waterskiing and wakeboarding.

→ Turtle Beach, Siesta Key, Sarasota, 1970. Photo by David Stahl, courtesy of Juan Rodriguez.

The Southern Gulf has a wide variety of inlets, piers, and beach breaks. Turtle Beach on the southern end of Siesta Key was an exception to the region's gradual sloping beaches and produced hollow waves from deeper water and steeper rise.

David Stahl, Siesta Key, early 1970s. Photo by Dwight Meyer.

With the approach of a cold front in the early 1970s, Dwight Meyer and David Stahl took off on bicycles from Siesta Key to the north end of Casey Key (before Midnight Pass closed) to catch the coming swell at the sandbars off the south side of the pass during a three-day camping adventure. The fresh buildup of sand in the salt marsh forest pictured here was brought in during an eight-foot tidal wave several months earlier.

Juan Rodriguez, Panama, 1968. Courtesy of Juan Rodriguez.

Among his other world travels, Juan Rodriguez was in Panama in the early 1970s as it prepared for the Pan-American Games in Mexico City. With an eye for opportunity, Rodriguez put the training track for the men's bicycle races to other purposes.

Juan Rodriguez, Panama, 1968. Courtesy of Juan Rodriguez.

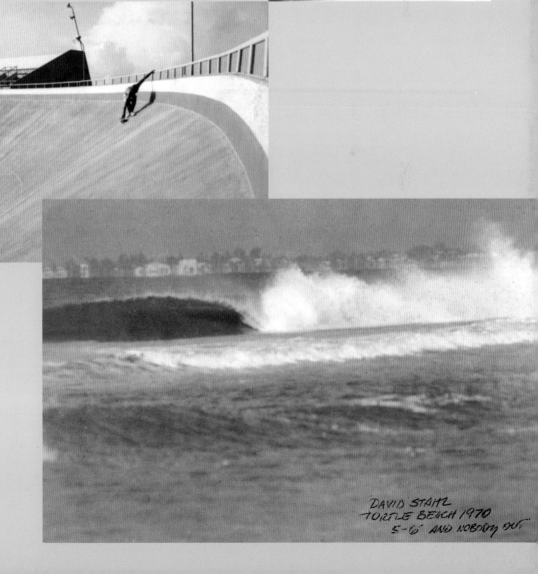

DAVID STAHL
TURTLE BEACH 1970
5-6' AND NOBODY OUT

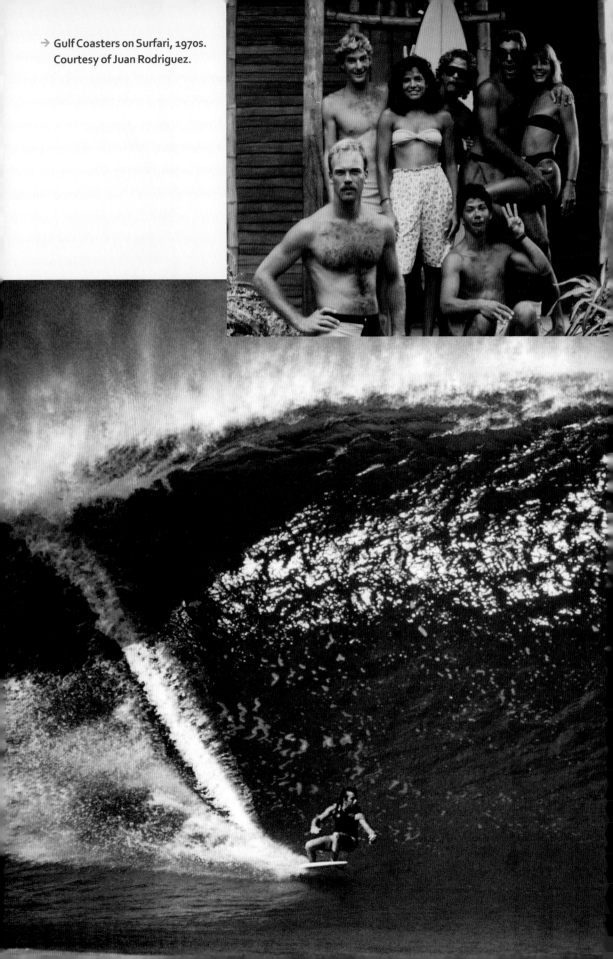

→ Gulf Coasters on Surfari, 1970s.
Courtesy of Juan Rodriguez.

↑ **Competition and Event Posters by Chris Lundy. Courtesy of Chris Lundy.**

A Gulf Coast legend and member of the Pipeline Underground celebrated by *Surfer* magazine in 1979, Chris Lundy left Hawaii in 1984 to study art at the prestigious Art Center College of Design in Los Angeles. He has since earned an international following for his creative work, designing event posters for the Twenty-fifth Anniversary Rip Curl Cup, the Quiksilver in Memory of Eddie Aikau competitions, the Quiksilver Pro in G-Land, and the 1994 Honolulu Marathon Race for Nike. Lundy's relationship with Nike led to a number of notable projects, including a 2003 Lundy design for Nike's coveted Dunk Laser Low series, establishing a market for Nike's collectable footwear.

← **Chris Lundy, Pipeline, 1978. Photo by Lance Trout, courtesy of Chris Lundy.**

While in Hawaii, Lundy became good friends with Australians Mitch Thorson and Jim Banks and earned recognition for himself as both a surfer and shaper. In 1979 *Surfer* magazine did a series of small articles on what it called the "Pipeline Underground," featuring legendary boogieboarder Phyllis Dameron, Californian Brian Buckley, Miami transplant Adam Salvio, Sarasota's Bruce Hansel, and Lundy, among others. Lundy would go on to compete in the 1982 and '83 Pipeline Masters and to shape the first Thruster to be ridden at Waimea. Retrofitted in 1982 from a single fin to a tri-fin and debuting during the El Niño spring of 1983, the infamous 9' 1" Tiger Stripe Thruster would later be ridden by Tom Curren in the Billabong Contest and by Mitch Thorson, Eric Merlander, and Don "Hoey" Johnston as well. Martin Potter also rode a 7' 11" Lundy.

↑ David Stahl, Weeki Wachee Springs, Weeki Wachee, Florida. Courtesy of David Stahl.

This photo shows David Stahl testing his underwater 8" × 10" film camera at Weeki Wachee Springs, a noted tourist destination on Florida's Gulf Coast. After their underwater show, the mermaids swam over to help in the testing, as models for Stahl's new camera. This camera, designed and built by Stahl, was the first of its kind created to shoot underwater scenes on large-format film. The mermaid shows have been a feature of the state park since 1947.

↓ Juan Rodriguez and friend. Courtesy of Juan Rodriguez.

← Juan Rodriguez, Siesta Key, early 1980s. Photo by Augustine McCarthy, courtesy of Juan Rodriguez.

In the early 1980s, Juan Rodriguez was king of the skimboarding industry, manufacturing over five thousand Western Flyers annually out of his Sarasota factory. He also ran competitions in the early days of the sport. He is pictured here with megaphone in hand, directing the action.

↓ Chris Lundy, Maalaea, Hawaii, 1976. Photo by Lance Trout.

Chris Lundy bought his first board, a 9' 6" Dextra pop-out from Economy Fishing Tackle in Sarasota, where Juan Rodriguez was working and repairing dings. Five days out of high school, he and future big wave charger Bruce Hansel headed to Santa Cruz, where they met up with Rodriguez. In the spring of 1974 Lundy made the move to Oahu's North Shore with a group from Santa Cruz, including a young shaper named Curt Goin. Lundy picked up work laminating for Island Surfboards and Surfboards Haleiwa, where Goin had found work shaping for owner Nick Benusco. Lundy rode Curt Goin's shapes for five years, before he began shaping under his own label.

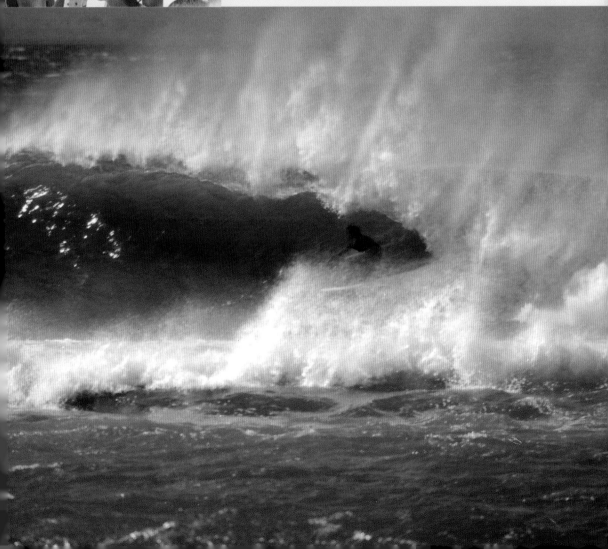

On the rise among surfers at the moment are newer names gaining recognition. Chief among them is Taylor Brothers, who shares with Cory and Shea Lopez an angler's addiction, acquired perhaps by the abundant fisheries of the Gulf Coast and a good deal of idle time between surf sessions at home.

There were other distractions as well. If the Gulf Coast couldn't provide regular waves for its surfers, it could feed the need for speed with a slew of notable skateboard parks. Some, like Kit and Linda Traverso's Rainbow Wave Park in Tampa, were designed with surfing in mind. Other parks met other needs, including the Clearwater Skate Park; the "Bro Bowl" (1979) in Tampa, a public park which distinctly mismatched its mostly white skaters with the surrounding black community; and the historic Skate Park of Tampa (SPot), which opened in 1993 and featured indoor and outdoor components redesigned each year. Early pro skaters from the region include Mike McGill, inventor of the McTwist; George MClelland; Ed Womble; and Ray Diaz—none of whom surfed but contributed to surfing's skate-related transition in the early 1980s.

In the early 1960s, before the advent of dedicated surf shops, it was common for surfboards to be sold in sports and tackle shops. The earliest true surf shops on the Gulf Coast include two that remain in business, Joe Nuzzo's Suncoast Surf Shop, launched in 1966 at the former Lido Casino and now based in Treasure Island, and West Coast Surf Shop in Holmes Beach, Florida's oldest surf shop, founded in 1963 by Jim Brady and Jim Dawdy, who were age sixteen and twenty-one, respectively, at the time. Newer additions to the mix include the Lopez family shop, Nekton, in Indian Rocks, and Surf Shack in St. Pete Beach.

→ Bruce Hansel, Pipeline, 1979. Photo by Lance Trout.

Gulf Coast expatriate Bruce Hansel started surfing in 1964 at age nine in Siesta Key. Along with Chris Lundy, he left the Gulf for California, before traveling to El Salvador and then Hawaii, where he earned media attention as a member of the original Pipeline Underground. Hansel competed in the Pipeline Masters as an alternate in 1979, before earning an invitation as a full-fledged competitor in 1981. As misfortune would have it, Hansel mistimed his third wave of the event, took a punishing wipeout, and broke his ankle in three places. After twenty-three years in Hawaii, Hansel moved to Indonesia, where he is an internationally recognized surfer, shaper, and artist based in Bukit, Bali.

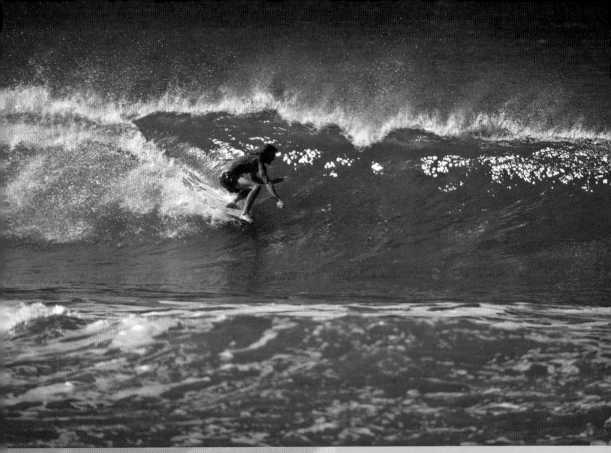

↑ Robert Hartlieb, Maria's, Puerto Rico, 1976. Photo by Lance Trout.

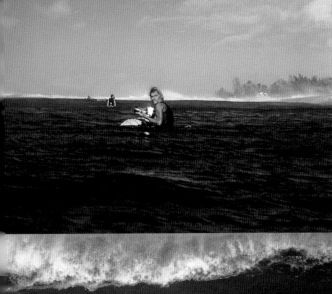

← Lance Trout, Sunset Beach, Hawaii, late-1970s. Photo by Bernie Baker, courtesy of Lance Trout.

Lance Trout, who spent time in Hawaii in the mid- to late 1970s, grew up among and has since returned to the beaches of Sarasota. In Hawaii, he was a freelance photographer before making the staff at *Surfing Magazine* in 1977. Pictured here, Lance floats on a raft between sets at Sunset Beach, Oahu.

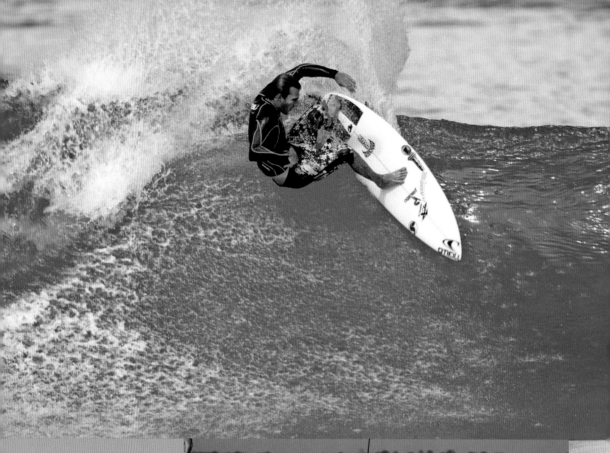

↑ Cory Lopez, Ehukai, Hawaii, 2005. Photo by Jeff Divine.

Like other leading Florida pros, Cory Lopez has proven himself a major talent in surf of all sizes. He has appeared in over thirty videos, including the 1996 classic *What's Really Goin' Wrong*.

↑ Evan Geiselman (*left*) and Taylor Brothers, August 2009. Photo by Kris Kerr.

New Smyrna's Evan Geiselman and current Gulf Coast standout Taylor Brothers share a talent for catching fish as well as waves. Both regions support major fisheries, and both surfers know how to put fish in the boat. The Gulf Coast's Lopez brothers are pretty handy with a rod and reel as well.

← Cory Lopez, 1986. Photo by Tom Dugan.

Among Florida's most successful competitors, Cory and Shea Lopez are more remarkable yet as surfers raised on Florida's Gulf Coast. As the number-three world-ranked ASP surfer in 2001, Cory Lopez is certainly the most accomplished. Following a slew of youthful victories that included placing first in the boys' division of the U.S. Championships in 1991, he qualified for the World Tour in 1997.

↓ Cory Lopez, Gotcha Tahiti Pro Teahupoo, Tahiti, 1999. Photo by Tom Servais.

Just two years into his WCT career, Indian Rocks Beach resident and Gulf Coast superstar Cory Lopez raised the bar in big wave competitions by pushing the limits at Teahupoo. While he didn't advance from his heat, he would come back to win the Billabong Tahiti Pro in 2011, surfing in the final against fellow Floridian CJ Hobgood. Lopez claimed his first WCT victory and finished the year third on the World Tour.

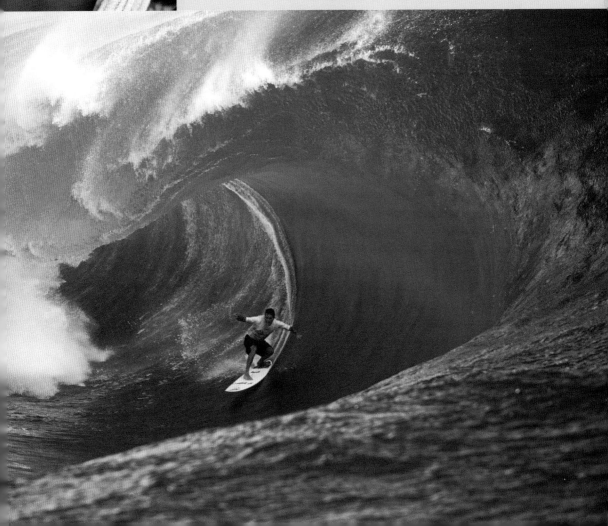

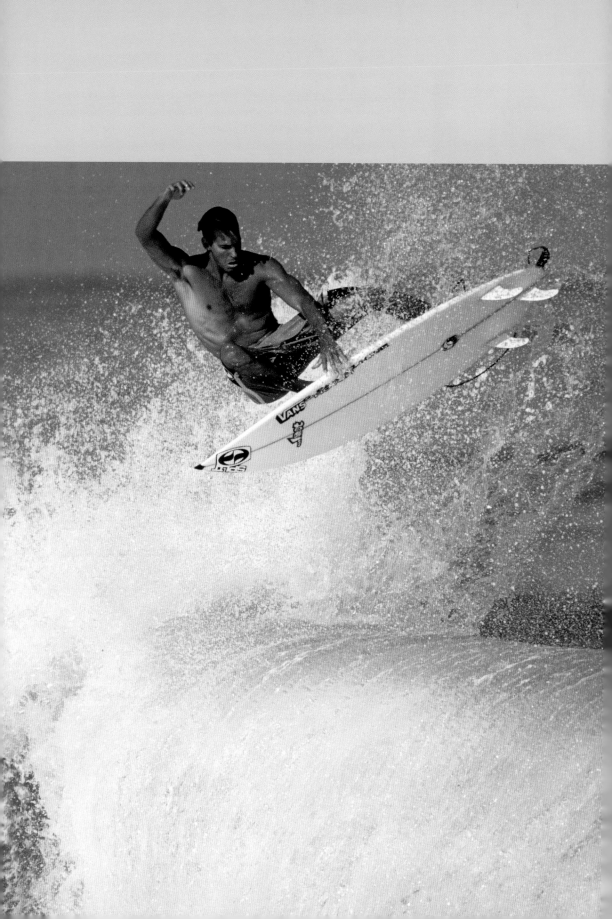

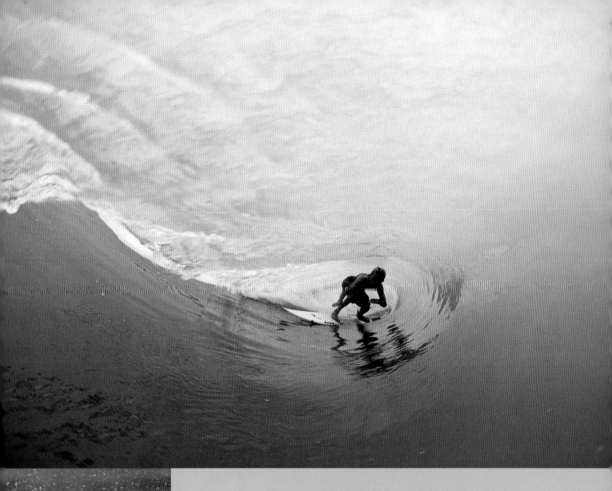

↑ **Taylor Brothers, New Smyrna Beach. Photo by Ryan Gamma.**

Taylor Brothers has roots in the southern Gulf but has earned his place within the East Coast's pecking order. Competing locally as a young grom on the Gulf Coast prepared him for bigger things, including a place among Florida's best surfers.

← **Shea Lopez, Hawaii, 2005. Photo by Jeff Divine.**

The oldest son of Gulf Coast surfer Pete Lopez and brother of Cory, Matt, and Ashley, Shea Lopez spent ten years on the WCT earning a year-end ranking of eleven in both 2000 and 2002. Following an injury during the Pipe Masters in 2003, major knee surgery kept him out of the water for the 2004 season. He managed to regain a ranking of twenty-seven on the WQS in 2007 and took top honors at the Red Bull Tow-At, during the O'Neil Sebastian Inlet Pro in 2008. Before turning pro, he won the juniors division in the 1992 U.S. Open in Huntington. Today he lives in Daytona Beach, where he runs a surf camp and serves as a WCT expert for *Surfer* magazine.

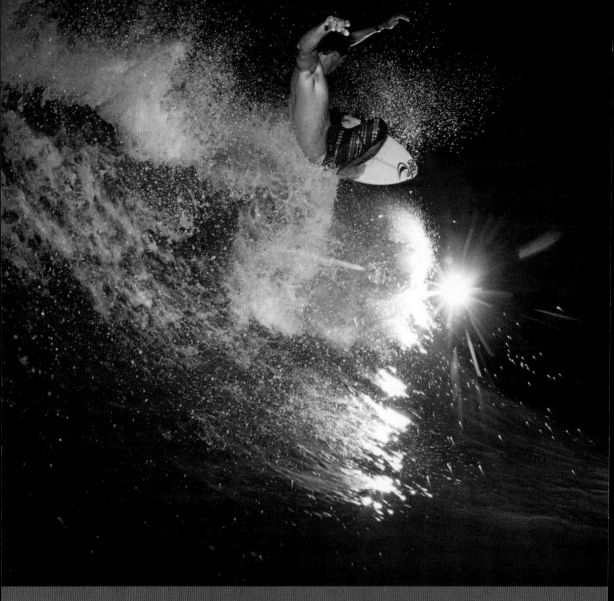

Night surfing and night surf photography emerged
in the '70s on both coasts of America. In this
shot of Cory Lopez, photographer Jimmy Wilson
captured the moment as Chris Wilson (no relation,
though one of the state's best shooters) provided
a synchronized secondary flash via radio signal.

Florida and Surfing's International Dimensions

Bruce Valluzzi, Salt Creek, California, early 1970s. Photo by Jeff Divine.

Cocoa Beach's Bruce Valluzzi was among the sport's most avid early travelers and competitors. In the 1970s, he and Mike Tabeling surfed in Morocco and other locations in Africa, France, and Portugal, often documenting their adventures for *Surfer* magazine. Valluzzi made his way to East Coast editor of *Surfer* magazine and, upon revisiting Morocco in 1982, wrote a controversial tale of travel, adventure, and miscreant behavior for *Surfer* that spanned almost twenty pages. Tabeling would follow with "Cruisin' the Caribbean," a *Surfer* feature that pulled back the curtain on lesser-known waves outside of Puerto Rico. Photographer Darrell Jones was on hand to capture the surfing and flavor of the Lesser Antilles.

Travel and Wanderlust

Since the early 1920s, surfers have been taking to the road, sea, or air to find bigger, better, or newer waves to ride, with Hawaii the destination of first choice. From the earliest days, Florida's surfers have been equally prone to surfing wanderlust. Bill and Dudley Whitman made their first pilgrimage to Hawaii in 1937, gaining introductions to the prestigious Outrigger Canoe Club with the help of a letter from Tom Blake, and earning acceptance through the craftsmanship of their self-made surfboards, unwrapped before an audience of over a hundred spectators. Dave Aaron also went to Hawaii in 1937 with California's Dorian "Doc" Paskowitz. Gaulden Reed followed in the early '40s, and Dick Catri in the late '50s. Florida competitors Bruce Valluzzi and Claude Codgen tested their big wave skills in Peru in 1965 and 1966, before making their way to Hawaii's North Shore, but this was travel by invitation to compete.

On the side of pure adventure, Bruce Brown's epic *Endless Summer*, released in 1966, captured the imaginations of surfers and mainstream audiences alike with the universal appeal of adventure in search for the world's perfect wave. Its impact was enormous, and the impulse to discover new horizons was launched into full motion. East Coasters explored Puerto Rico and locations further south. South Florida's George Robinson was introduced to Ecuador through family connections in 1966, and the Whitmans were flying their own plane to their own surf camp in the Bahamas, later documenting their adventures in a 1969 issue of *International Surfing* magazine.

As surfing left the 1960s, self-discovery and global travel became surfing imperatives. *Surfer* magazine chronicled the exploits of Californians Kevin Naughton and Craig Peterson in thirteen articles between 1972 and 1984, while Larry and Roger Yates's 1974 film,

→ Greg Loehr, Mission Jetty, California, 1971. Photo by Jeff Divine.

In summer, surfers from Florida hit the road. Jeff Crawford, Greg Loehr, and a carload of Space Coast surfers made the journey to Southern California in the summer of '71. They arrived in Laguna Beach with an appetite for waves and a car full of fast-food wrappers. Photographer Jeff Divine remembers their arrival and their performance as impressive.

↘ Jackie Grayson, Punta Roca, La Libertad, El Salvador, 1983. Photo by Darrell Jones.

Jackie Grayson, Lewis Graves, Rafael Lima, Freddie Grosskreutz, and photographer Darrell Jones followed the 1970 trail blazed by Kevin Naughton, Craig Peterson, and photographer Bernie Baker to El Salvador. At this time, the country was mired in civil war, but the waves were firing as well, and Jones's camera work appeared in the *Surfer* magazine feature "Combat Surf." Florida expat Bob Rotherham established a restaurant at the beach early on and today provides travel packages for those with a sense of adventure and an appetite for one of the best waves in Central America.

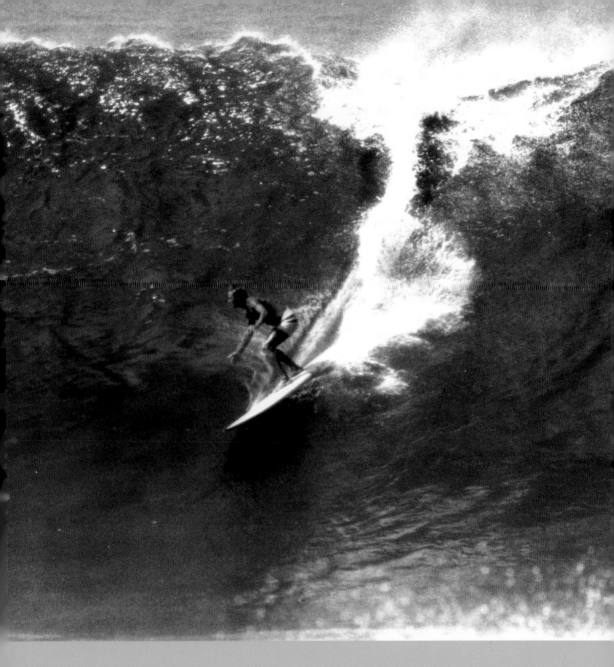

← Mike Tabeling, southern France, early 1970s. Photo by Darrell Jones.

Mike Tabeling has lived a life worthy of this salute from southern France. A decade earlier in 1965, Dick Catri secured Tabeling's participation in a contest in Peru, where he became the first East Coast surfer to win an international event. Later, Tabeling and his traveling companion Bruce Valluzzi abandoned contests altogether in favor of a life of adventure, long before surfers were lining up at international airports.

↑ Dick Catri, Sunset Beach, 1960. Photo by LeRoy Grannis, courtesy of Dick Catri.

For surfers, the first destination of choice has always been Hawaii, and the North Shore of Oahu remains the ultimate proving grounds for serious surfers. Dick Catri was among the first of Florida's postwar surfers to travel extensively—to California with Jack Murphy in 1959, and then to Hawaii in 1960–1964. While earlier Floridians Dudley and Bill Whitman, David Aaron, and Gaulden Reed made the venture as early as the late 1930s, Catri is the first East Coast surfer to ride Pipeline and Waimea, earning respect among the big wave riders of the day.

Forgotten Island of Santosha, transformed the dream of perfect surf into a spiritual quest. Floridians Mike Tabeling and Bruce Valluzzi were on a parallel track, searching out new waves in Morocco and other parts of Africa, France, and Portugal, but with little regard for documenting their discoveries.

With regional beginnings, Valluzzi rose among the ranks of surf journalists and made his way upward to East Coast editor of *Surfer* magazine. Following an impressive list of articles over the previous decade, he revisited Morocco in 1982 with Hawaiian Pipe Master Rory Russell and photographer Art Brewer, returning with a controversial tale of travel, adventure, and miscreant behavior for *Surfer* that spanned almost twenty pages. Tabeling would follow with "Cruisin' the Caribbean," a *Surfer* feature that pulled back the curtain, without naming names, on lesser-known waves outside of Puerto Rico. The surfers were Greg Loehr, Phil Marinelli, Lewis Graves, Pat Mulhern, Doug Soverel, and others. Photographer Darrell Jones was on hand for the task of capturing the waves and spirit of the Lesser Antilles.

More radical were the travels of Florida surfers venturing into Central America's war zones. In 1983, Lewis Graves, Jackie Grayson, Rafael Lima, Freddie Grosskreutz, and photographer Darrell Jones followed the trail blazed by Naughton, Peterson, and photographer Bernie Baker in 1970, replanting El Salvador in the imagination of surfers everywhere. The country was in the middle of a full-scale civil war, and mortar fire and mayhem were everyday occurrences. Jones's camera work appeared in the *Surfer* magazine feature "Combat Surf." Later, the region would face other challenges at the hands of street gangs returning from urban lives in America.

While every surfer has his or her home break, rare today is the surfer who is content with that experience. The surf trip, or "surfari," is common ground for surfers everywhere, whatever their origin or destination. Surfers are likely the most widely traveled sport population on the planet. Yet for better or worse, surfing's appetite for world-class waves has also reshaped many once-remote and

Jim Cartland, Cloudbreak, Tavarua, Fiji, 2006. Photo by Scott Winer, courtesy of Jim Cartland.

The Space Coast's Jim Cartland passed on the opportunity to participate in the emerging World Tour while attending college on Oahu in 1976, choosing instead to stick to the books. Today he is a radiologist living in California, with the resources to travel. Tavarua and its remarkable Cloudbreak are on the top of his list of favorite destinations.

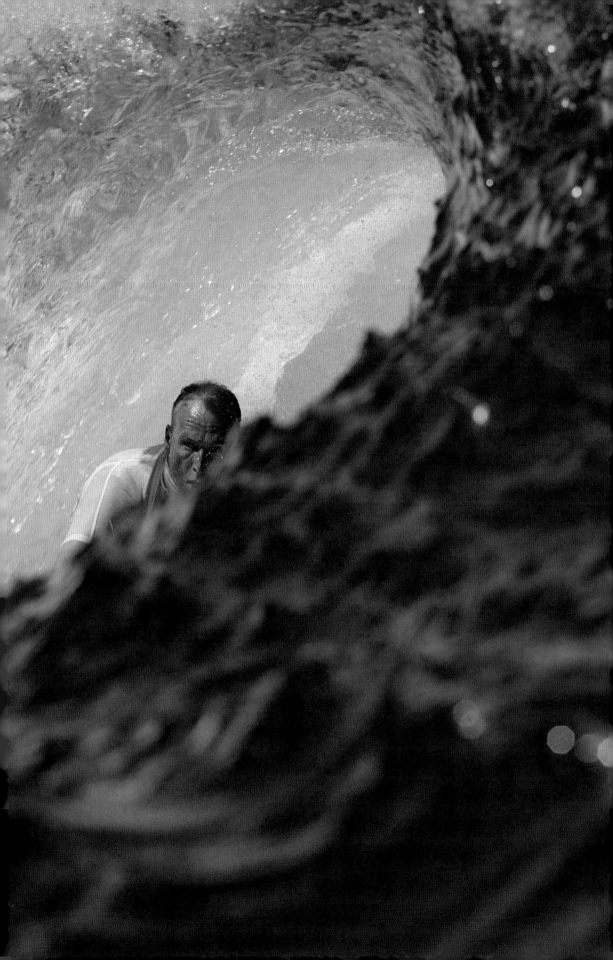

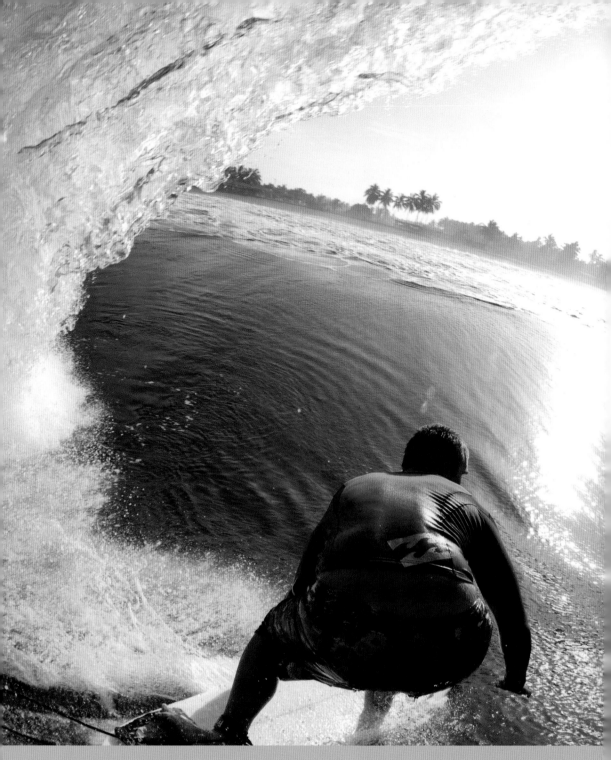

↑ Peter Mendia, mainland Mexico, April 2010. Photo by
Nic Lugo.

Captured with an ultra-wide lens, this shot of Palm Beach
County's Peter Mendia reflects a broader appreciation of
Mexico's many offerings than that of Puerto Escondido
alone, despite its major media attention. From Salinas Cruz
north to Nexpa and beyond, Mexico is the best bet for seri-
ous summer surf and is an easy trip for Florida surfers.

→ Hotel Santa Fe, Puerto Escondido, Mexico, 1982.
Photo by Paul Aho.

Like the Caribbean, mainland Mexico has always bee[n]
go-to destination for Florida surfers. As a summer w[ave]
magnet, Puerto Escondido has emerged as an interr[na-]
tional destination for global travelers seeking seri-
ously big wave experiences. As the region first gaine[d]
renown, the Hotel Santa Fe was the comfort zone fo[r]
those with deeper pockets or girlfriends in tow. Flori[da]
surfers were in the know.

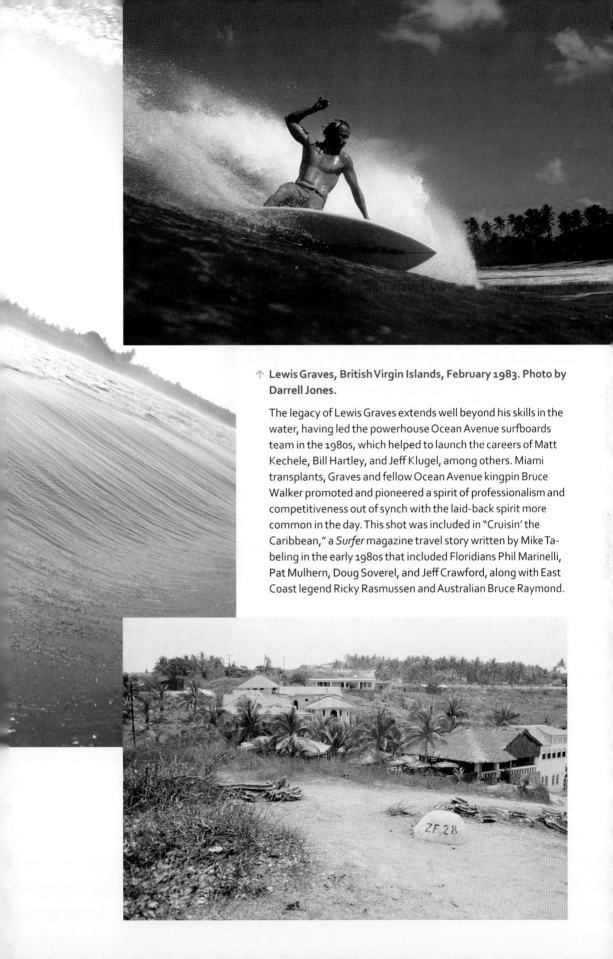

↑ Lewis Graves, British Virgin Islands, February 1983. Photo by Darrell Jones.

The legacy of Lewis Graves extends well beyond his skills in the water, having led the powerhouse Ocean Avenue surfboards team in the 1980s, which helped to launch the careers of Matt Kechele, Bill Hartley, and Jeff Klugel, among others. Miami transplants, Graves and fellow Ocean Avenue kingpin Bruce Walker promoted and pioneered a spirit of professionalism and competitiveness out of synch with the laid-back spirit more common in the day. This shot was included in "Cruisin' the Caribbean," a *Surfer* magazine travel story written by Mike Tabeling in the early 1980s that included Floridians Phil Marinelli, Pat Mulhern, Doug Soverel, and Jeff Crawford, along with East Coast legend Ricky Rasmussen and Australian Bruce Raymond.

→ George Williams, Puerto Escondido, 1989.
Photo by Terry Williams.

The best big wave surfers from around the world come to Puerto Escondido, which replaced Pascuales as the "Mexican Pipeline," for its serious challenges. "Puerto" has emerged as the world's heaviest beach break, and twins George and Charles Williams, Todd Morcom, David Ashcraft, Ryan Helm, and Baron Knowlton are a select group of Florida surfers who have distinguished themselves at the break for decades.

↑ Tari Village, North Malé Atoll, Maldives, 2000.
Photo by Paul Aho.

In the early '70s, while shipwrecked in the Maldives archipelago, Australian Tony Hinde discovered surfing potential and set up Atoll Adventures on Tari Village, now known as Chaaya Island Dhonveli. The island features private access to Pasta Point, and the region includes Jail Break, Sultan's, Honkey's, and other reef passes. A dhoni, pictured, is the surfmobile of choice.

↓ Matt Kechele, Tres Palmas, Puerto Rico, March 27, 2009. Photo by Osiris Torres.

With Puerto Rico, the Bahamas, and the Caribbean easily accessible and affordable, it's common practice for East Coast surfers to put together a last-minute trip, then score as conditions come together. East Coast team captain for Quiksilver and the East Coast X-Games team, Matt Kechele was among dozens of Floridians to head to Puerto Rico for an epic, late-season swell in 2009. Kechele made the most of the occasion with help from tow partner Ricardo Villanueva.

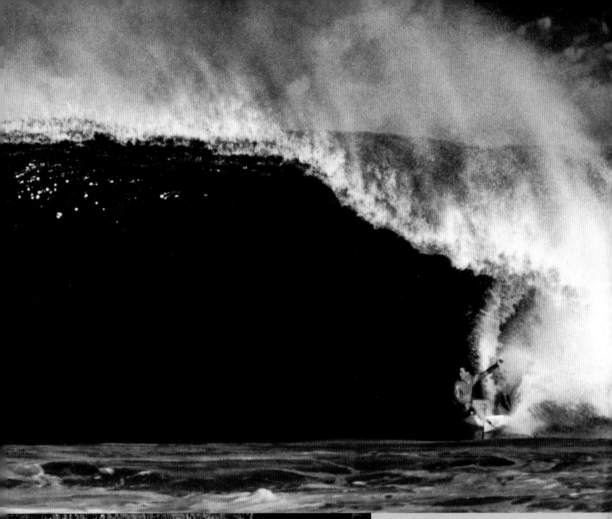

← Chile, Puertocillo, 1998. Photo by Paul Aho.

Though Chile has been known as a surf destination for decades, economic, political, and civilian strife kept it off most travel lists. With reforms in the 1990s, surfers began to explore a coastline greater in length than that from Alaska to Baja. In 1998, former Florida snowbird Kevin Grondin, then U.S. Amateur Team coach, along with author Paul Aho, Stan Chew, and their wives, made the venture in this roving campsite. Their guide, Nick, is at the wheel. Destinations included Puertocillo, Pichilemu, Topocalma, and Ponta do Lobos.

unique destinations according to its own interests. Among socially aware surfers, the questions are, What to do, how to give back, and how to go forward?

The sheer numbers of traveling surfers and the disparities between native populations can generate negative outcomes. Communities are transformed, expatriate surfers become territorial, and media attention converts unknown waves into "must surf" destinations, all of which contributes to the unyielding law of diminishing value. Alternatively, a number of models have surfaced to channel surf travel as a sustainable practice through managed access. Pasta Point in the Maldives shares the Tavarua practice of limited access for resort guests. Papua New Guinea has a surfing management plan limiting crowds, and the Mentawais have begun to regulate charter boat traffic and surf camps to protect the industry and quality of the experience. Heated opinions fill the debate between open markets and limited accessibility. Only time will tell where the future lies. Yet without question, after surfing's second major boom in the mid-1980s, the sport shows no sign of retraction, and the demand on the world's best waves will only continue to rise.

Nonetheless, good things happen in the exchange as well. Surfers leave boards behind, tourism vitalizes local economies, relationships develop on every level, lives are transformed, and alternative support systems for native populations are established. Notable among the last category are initiatives implemented by the surfing resort on Tavarua in the Fijian archipelago. Each year over a million dollars in donated medical assistance and supplies are distributed into Fijian communities. The Loloma Foundation, formed by doctors visiting Tavarua, and the Scripps Health–Fiji Medical Alliance donates crucial medical assistance, training, and surgical care to Fijians who otherwise lack access to costly medical care—all arranged through the Tavarua surf camp. Beyond these initiatives, organizations like SurfAid International bring resources and aid to surfing destinations globally when tragedy strikes, as in the 2010–2011 tsunamis in Indonesia and Japan.

Expatriates

Along with the impulse to explore exotic surfing destinations came the realization that there were other possibilities for Florida surfers looking for lives and careers where the surf was far better than that of the Sunshine State. Many of Florida's best surfers grew impatient waiting for waves, became dismayed by the increasing numbers of surfers competing for those same waves, or simply preferred to be closer to the surf industry based in California, Hawaii, or elsewhere. Some simply hungered for truly big waves, a thrill rarely satisfied in Florida.

The most significant of those who left are undoubtedly Lisa Andersen and Kelly Slater, world champions who hail from Florida and now reside in California. Andersen fled from home and the state with the youthful delusion of becoming a world champ, an accomplishment she nonetheless achieved four times through strength of character and sheer ability, while Florida's other four-time women's world champion, Frieda Zamba, chose to abandon the competitive circuit and develop a life and career closer to home. Slater, despite his current West Coast address and honorary keys to the City of Huntington Beach, continues to consider Cocoa Beach his hometown.

Others have left, made their mark, and returned to follow their path at its origins. Sarasota's Chris Lundy and Lance Trout, North Florida's Dick Rosborough, New Smyrna's Mike Martin, and the Space Coast's Gary Propper, George Panton, and Freddy Grosskreutz all come to mind.

Others found new beginnings as expatriates outside of Florida and remained at chosen locations to establish lives and careers elsewhere. Among the many who moved to Hawaii are 2012 Triple Crown Champion Sebastian Zietz of Fort Pierce, Bobby Owens of

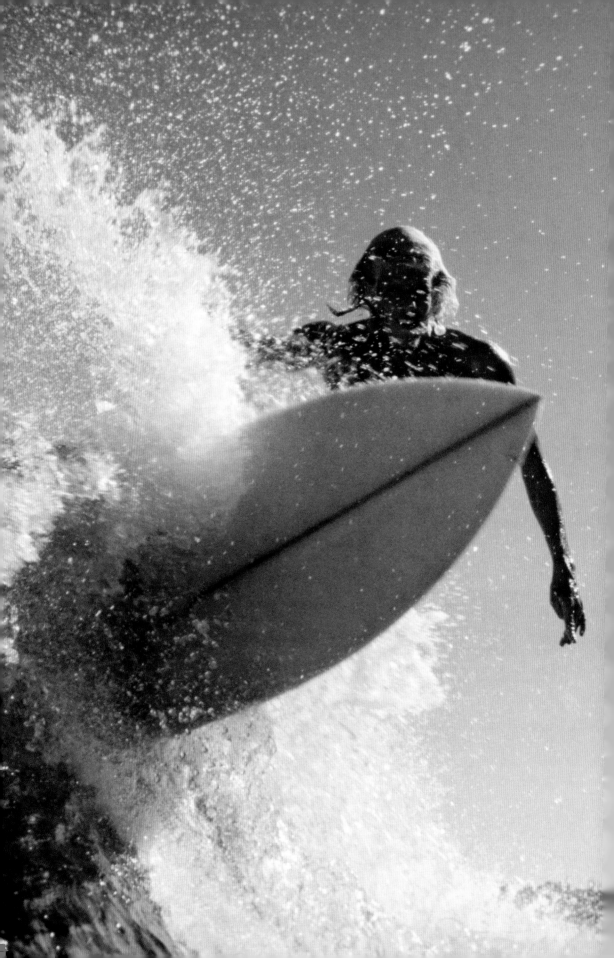

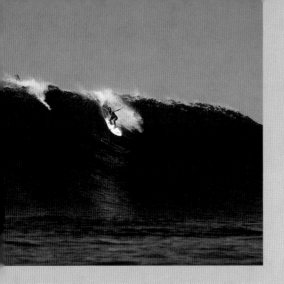

Originally from Miami Beach, "Banzai" Betty Depolito is a Hawaiian icon who helped pioneer women's big wave surfing on Oahu's North Shore in the late 1970s and early '80s. She was honored for her prowess in the lineup at Waimea by posing with the male big wave invitees to the Eddie Aikau contest. A noted videographer, media producer, and contest organizer, Depolito remains a relentless advocate for the sport and its female athletes.

Jeannie Chesser—surfer, artist, and mother of pro surfer Todd Chesser—was born in Miami, started surfing at Miami Beach in 1961, and won her first contest in 1963. She married David Chesser in 1967, and their son, Todd, was born in 1968. When David died in a 1970 car crash, Jeannie and Todd moved to Hawaii in 1971. In Hawaii, Jeannie and Todd surfed and competed in amateur contests. Todd was the NSSA and HASA Junior and Men's Champion in 1985–1986. Jeannie won many contests in the women's division and was named Senior Female Athlete of the year in '86. She was U.S. Champ in '92. Named 1989 Rookie of the Year on the Bud Pro tour and known for his pursuit of big waves at remote breaks, Todd Chesser died while surfing at Alligators on February 13, 1997, far removed from the crowds and the cameras that had gathered elsewhere for this monstrous swell.

Known widely as DCB, David Balzerak was among the most formidable competitors and shapers within Florida's elite as the shortboard revolution found its feet in the late 1960s. He competed on the ASP World Tour, finishing twenty-seventh in 1976, and placed second behind Floridian Greg Mungall in the Wave Rider Florida Pro during the same year, before relocating to Puerto Rico.

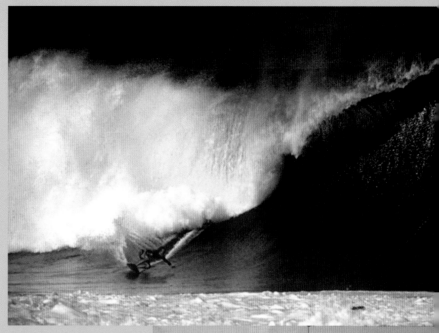

→ Bruce Hansel and Mark Foo, Waimea Bay, Hawaii, 1984. Photo by Darrell Jones.

Sarasota's Bruce Hansel watches as Pensacola transplant Mark Foo rides out a helicopter rescue during one of the biggest swells of the decade. The bay can hold its form during huge winter swells, but when conditions push toward forty feet, sets can break across the channel. The most famous of Waimea's tales is that of seventeen-year-old Hawaiian Dickie Cross, who drowned at Waimea in 1943. He and thirty-one-year-old Woody Brown of New York had paddled out at Sunset Beach only to face a rapidly escalating swell, leaving them no choice but to seek a way to the beach through Waimea's channel. After making the long paddle, they found it breaking across the bay. Cross made a desperate paddle for the beach, never to be seen again. Brown kept his head and lived, washing onto the beach unconscious. Waimea remained unridden until 1957. Florida's Dick Catri was the first Floridian to surf Waimea in the early 1960s.

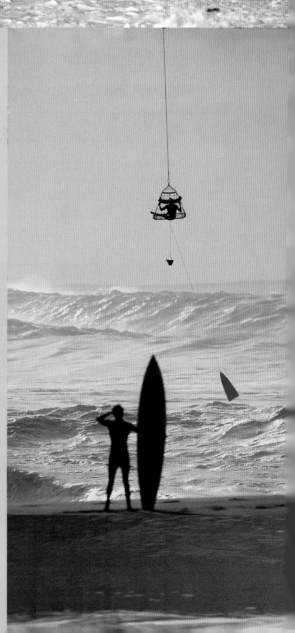

← Jim Cartland, Pipeline, circa 1976. Photo by Larry Pierce, courtesy of Jim Cartland.

Jim Cartland moved from Miami to Cocoa in 1953 at age five and began surfing at twelve. He won his first contest at fourteen, was the East Coast Junior Champion in 1970, the ESA State Champion two years running in the same period, and took second place in the ECSC and USSC Men's division in 1974. Moving to Hawaii in 1976, Cartland was invited to join the budding World Tour but declined, sticking to his studies at UH. Today he is a radiologist living in California.

↓ Greg Mungall, Sebastian Inlet. Photo by Lance Trout.

Greg Mungall began surfing in Cocoa Beach at age nine, won the Wave Rider Florida Pro, his first pro event, in 1976, and, following his win at the 1979 Katin Team Challenge in Huntington Beach, moved to California. Mungall shaped for Natural Art and Nectar Surfboards before launching Altra Surfboards in 1985. Along with fellow Floridians Greg Loehr, Steve Forstall, and John Parton, Mungall is a leading proponent and innovator of EPS (expanded polystyrene) and epoxy boards. He was also an accomplished skateboarder who accompanied Bruce Walker, Jackie Grayson, and Jeff Klugel on an illegal skate session at SkatBoard City, in Port Orange, the first skateboard park in the country, while the park was still under construction.

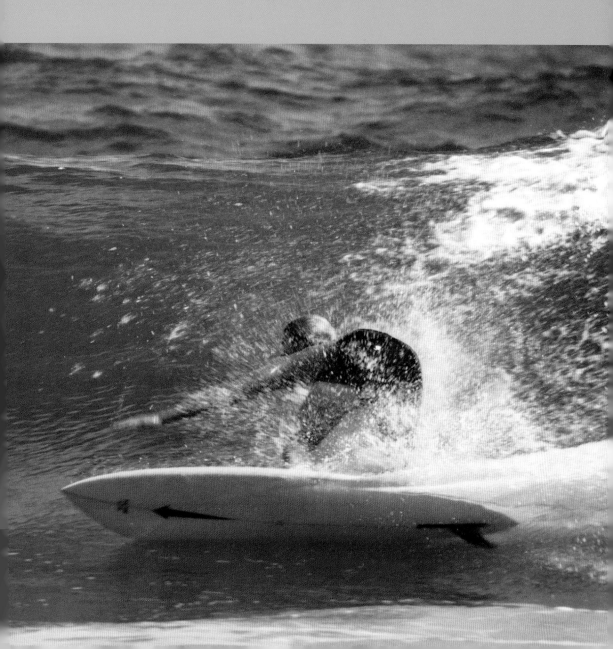

Daytona Shores, and Mark Foo, who attended high school while living with a friend in Pensacola before rejoining his family in Hawaii in 1975. Both earned international reputations as big wave competitors.

Owens moved with parents to Hawaii while he was still in his early teens, becoming a top-ten WCT competitor in the mid-1970s and earning the nickname "Mr. Sunset" for his intuitive relationship with Sunset Beach's fickle ways. Among Hawaiian circles, this was serious recognition for an outsider, particularly one from Florida. Mark Foo became one of the world's most revered big wave surfers, at times publicly at odds with others aspiring to the same accolades. He abandoned the WCT in 1981 and applied himself instead to big wave performances, surf journalism, and a North Shore cable TV show called *H2O*, before drowning at California's notorious Mavericks in 1994.

Among other surfers who began as Florida standouts before earning international credibility elsewhere are Doug Deal (Miami, Space Coast, Hawaii), Pete Hodgson (Space Coast, Hawaii), Bruce Hansel (Southwest Florida, Hawaii, Bali), Adam Salvio (Miami, Hawaii), Roger Kincaid (Miami, Hawaii, Bali), Greg Mungall (Space Coast, Southern California), David Ashcraft (Treasure Coast, Northern California), David Balzerak (Space Coast, Puerto Rico), Scott Busbey (Space Coast, Australia), Jim Cartland (Space Coast, Hawaii, California), Mike Clancy (New Smyrna Beach, Northern California), Steve Massfeller (Daytona, Hawaii), Bob Rotherham (Space Coast, El Salvador), Pat Mulhern (California, Space Coast, California again), Charlie Kuhn (Space Coast, Costa Rica), Kenneth Hurlburt (Space Coast, Hawaii), Rick Yeomans (Space Coast, California), Pat Webber (Space Coast, California), Pete Lege (Panhandle, Hawaii), Jim Vaughn (Palm Beach, Nags Head), and Marc Seibman (Panhandle, Hawaii).

Among the women, Betty Depolitto (Miami, Hawaii), Jeannie Chesser (Miami, Space Coast, Hawaii), April Grover (Space Coast, Hawaii), Kristy Murphy (Palm Beach County, California), and Jennifer Flanigan (Palm Beach County, California) are all recognized for their competitive success and contributions beyond their beginnings and respective histories in Florida.

→ Pat Mulhern, October 2010. Photo by Jesse Sinclair.

California born and Florida bred, Pat "Mulley" Mulhern returned to California following a successful early pro career on the East Coast and a leadership role at Sebastian Inlet in the 1970s. Son of legendary glassier Donny Mulhern, Pat is a recognized shaper who currently favors the right-hand points of southern Mexico.

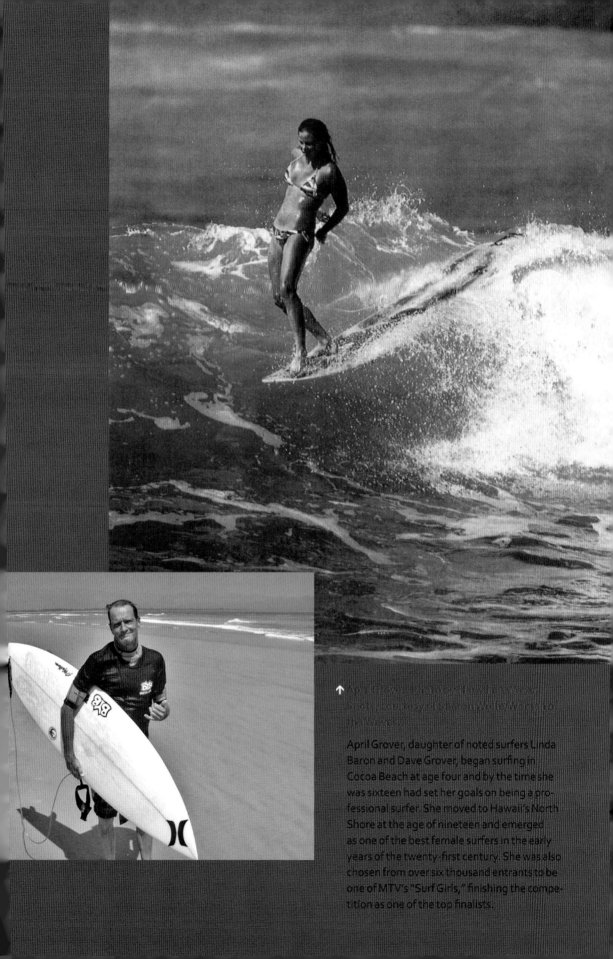

April Grover, daughter of noted surfers Linda Baron and Dave Grover, began surfing in Cocoa Beach at age four and by the time she was sixteen had set her goals on being a professional surfer. She moved to Hawaii's North Shore at the age of nineteen and emerged as one of the best female surfers in the early years of the twenty-first century. She was also chosen from over six thousand entrants to be one of MTV's "Surf Girls," finishing the competition as one of the top finalists.

↑ Kristy Murphy. Photo by Cat Slatinsky.

Jupiter's Kristy Murphy wa
East Coast Women's Long-
board Champion in 2001 ar
Women's World Longboard
Champion in 2005. Today,
she and fellow Floridian Je
nifer Flanigan run Siren Su
Adventures, specializing ir
surfing retreats to Zihua-
tanejo, Mexico, and Stand
Up Paddle retreats to the
Bahamas and Caribbean.

↑ Pete Hodgson, Space Coast. Photo by Lance Trout.

With origins in Cocoa Beach's surfing elite, former firefighter and surfer-turned-
professional-photographer Pete Hodgson is a North Shore fixture. Trading his
still camera for video in 1990 and assuming a role as shooter, coproducer, and
editor of Hawaii's *H2O* surfing TV show, Hodgson helped the show become one
of the most viewed surf TV shows ever. Hodgson returned to shooting stills,
and his stunning 2009 two-page spread of Andy Irons in *Surfer* magazine ranks
among his most memorable still images. Today he runs HodgsonHawaii, shoot-
ing action sports primarily with GoPro HD video cameras.

CHAPTER 14

Shapers and the Surfboard Industry

The surf industry today is a complex mix of international sports-wear brands, media interests, and board makers primarily based in California and marketed to consumers worldwide. The East Coast of America has always been a major market for West Coast companies, and California has always been able to secure riders, representatives, and customers for its goods among East Coast surfers. While the strength and persuasiveness of West Coast brands continues to provide the means of survival and support for most of the east's best surfers, a good number of others have benefited from the efforts of individuals and entities closer to home.

While surfing's appetite for the marketing strategies of corporate entities has never been greater, the sport's overt commercialization has also had its detractors over the decades. Surfing's counterculture movements of the late '60s, early '70s, and some might even say late 2010s, led many of the best surfers worldwide to seek rewards other than contest results, corporate paychecks, and sponsorship deals. A free board in exchange for surfing well was the goal, and contests were simply not cool in many circles. While this was true in Florida as well, many of the state's most historic surfers have kept an eye on the money and are likely more aligned with the self-promotional initiatives of the Bronzed Aussies, Australia's pioneering professionals, than with the spiritual goals of the Hawaiian soul surfer. Those who were there can remember Space Coast surfers shoving one another off of waves during early competitions, before interference rules and wave priority regulations were put into place.

Early on, for surfers living in Florida, there were very few means to make a living as surfers. Most of them required West Coast interests as a team rider or sales representative. Yet, despite the

marketing appeal of Californian goods from the boom years of the 1960s to the present, surfing's entrepreneurial aspects were displayed among Florida's early surfers as well. Without doubt, the earliest was Tom Blake, the pioneering waterman and surfer who was also a relentless inventor and innovator. While visiting Florida in 1934, Blake prototyped ten hollow boards for production by the Mitchell Furniture Company of Cincinnati, Ohio, before later turning over production to the Los Angeles Ladder Company. Among the first commercial board builders in the state were Jack "Murf the Surf" Murphy, George Miller, and Jim Campbell. Murphy had learned to shape in California and made boards in Indialantic before ending up in prison for grand larceny and worse.

<div align="center">⌐⌐</div>

George Miller, who arrived in Florida after military service in Hawaii, set up a factory in Miami in the early '60s, before relocating to northern Florida in 1962 and establishing himself as one of Florida's first board shops and one of the first major manufacturers in the state. Unlike Murphy and Campbell, who made a relatively small number of custom boards, Miller created a major factory producing upwards of eighty custom boards and pop-outs a week under various labels, while launching Daytona Beach Surf Shop—Custom Boards by Miller.

In the winter of 1963, Californians Jim Campbell, Doug and Dan Haut, and Jimmy Hoffman drove to Florida in Campbell's 1950s Jaguar MK sedan from Santa Cruz and established Campbell Surfboards near the Melbourne airport. By the late summer of 1964, the Hauts and Hoffman were back in California, but Campbell remained, moving to a smaller shop in West Melbourne, where Bob Reeves worked for him as glasser, sander, and fin maker until Campbell moved to Long Island in early 1965. According to Reeves, Campbell created the first sponsored surf team on the East Coast—the Campbell Competition Team—and many of the sixties' hottest East Coast surfers got their start on this team.

In South Florida, Dick Catri shaped boards for Surfboards Miami, Graham Jahelka started Surfboards by Graham, and Bud Gardner launched Surfboards by Gardner. In the Space Coast, Pat O'Hare, a California-trained transplant, began Surfboards by O'Hare, and would make the best of both worlds by shaping his own boards and East Coast models for West Coast giant Greg Noll. Bill And Marjane Feinberg created Oceanside Surfboards in the early '60s, with a factory in Rockledge and then a retail shop at the location later occupied by Natural Art in south Cocoa Beach.

Considerably further south, Bill Holmes arrived from California and started Holmesy Surfboards in Juno Beach in 1964.

Like West Coast labels, East Coast manufacturers had their own signature board models, a practice that is back in vogue again today. Holmesy had the Sidewinder, Oceanside the Spoiler and the Javelin, and O'Hare the Tommy McRoberts Model and the Duke Kahanamoku East Coast Noserider, designed by Bruce Valluzzi and built under Greg Noll's label. Contemporary manufacturers differentiate their respective products in much the same way, profiling boards according to outlines, function, and purpose.

Early on in South Florida, Bob and Jack Reeves learned to make boards with South Florida's Graham Jahelka, before moving on to other goals. Bob Reeves relocated to Melbourne and launched Tomb and Reeves Surfboards with Bob Tomb, and Jack Reeves began work at age fifteen for Delray Bicycle and Sporting Goods, building Caribbean Surfboards, and he eventually ended up glassing for Dick Brewer in Oahu, one of Hawaii's most renowned shapers; there, he earned a reputation as one of the world's best laminators. Ron Heavyside also started shaping at Caribbean in 1964–1965, learning the trade before launching Nomad Surfboards in 1968. Ted James founded Fox Surfboards in Lantana at the same time, and the two labels competed for riders and market share within the state and beyond. John Parton joined forces with Ted James at Fox in West Palm Beach, became his partner in 1975, and continued to build surfboards and sailboards under the Fox label beyond James's sudden death in 2004. Carmen Irving shared the shaping duties at Nomad with Heavyside, beginning in the early 1970s, as did Keith Starling and Paul Aho. Elsewhere, Miami's Mark Castlow rounded up the mix with Atlantis Surfboards in Fort Pierce. Mike Pachonis of Bird Surfboards, Bobby Z's glassing shop, Blue Earth, Viking, and, once again, Surfboards by Miller are current additions to the historic mix in South Florida.

Nevertheless, the Space Coast knew the ropes and did its best to stay a step ahead in every way and in every game. Some manufacturers within Florida chose to level the field by relocating to Central Florida. George Panton, founder of George's Surfshops in California, had earlier set up a factory in Pompano, building Florida Surfboards, then later relocated to the Space Coast, launching Inspiration Surfboards and then, later yet, Sea Oats swimwear. Mike Mann, who had set up New Dawn Surf Shop in Deerfield Beach in the early '70s, headed north to launch a franchise clothing chain called Kick in the Pants with photographer Alan Margolis, before opening the Longboard House in Indialantic. Rich and Phil

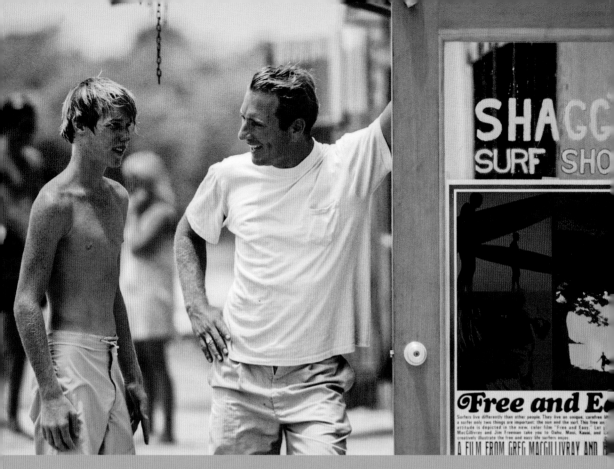

Another Hobie Winner
ready for you now!

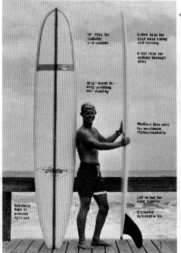

Gary Propper
EAST COAST MODEL

Here's the brand new board from Hobie especially designed for East Coast surf conditions. It's the same board that Gary Propper uses with such fantastic success in East Coast surf, large and small.

And here's what Gary, who helped design the board, says. "This surfboard is designed for top performance by both experts and beginners in East Coast surf. The board is stable and easy to paddle with excellent control and maneuverability at all times. The tip of the nose is lifted and flattened for excellent nose riding and easy nose turning. The rails are slightly dropped for added lift and maximum edge control. The laps are narrower so the board can be ridden in large or small waves, and will not spin out in critical nose rides. And, of course, the board has Hobie's renowned speed fin for ultimate personal trimming."

Step in and see the new Gary Propper East Coast Model at your Hobie Dealer soon.

← Gary Propper Model, Hobie Surfboards ad, circa 1966.

In 1966, Dick Catri reached an agreement with Californian industry giant Hobie Alter to make the switch from leading an East Coast team representing Dick Brewer's Surfboards Hawaii to one promoting Hobie Surfboards. Gary Propper, the East Coast's number-one competitor, was uniquely positioned to capitalize on his success and became the highest-paid surfer of his day. The Gary Propper East Coast Model was the East Coast's top-selling surfboard of its time and was ridden by the first-place surfer in every division of the 1967 East Coast Championships. Of the estimated six thousand surfboards Hobie made in 1967, nearly half were Propper Signature Models.

Dick Catri, Shagg's Surf Shop Indialantic, 1967–1968. Photo by Jeff Divine.

In 1966 Dick Catri and then wife Shagg opened a shop on the Cocoa Beach Pier and another in Indialantic next door to the former site of Jack Murphy's pioneer shop of the early 1960s. Shagg's Surf and Sport was a classic and remained in business long after the two parted ways. In the door is a poster for *Free and Easy*, the groundbreaking surf film produced by partners Greg McGillivray and Jim Freeman in 1967 that opened doors for the two to major careers in the film industry and IMAX productions.

Bill Stewart, San Clemente, California, summer 2010. Photo by Rod Faulds.

Bill Stewart grew up in Hollywood, Florida, began surfing in 1963, and began shaping in 1967. He moved to Southern California in 1971, opened Stewart Surfboards in 1978, and emerged as an innovator in longboarding's rebirth and refinement. He is an accomplished airbrush artist, and his mural on the Stewart Surfboards Shop in San Clemente is a landmark.

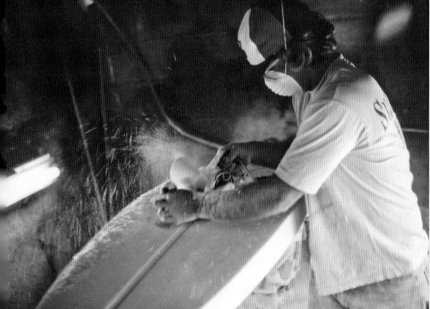

Ted James, December 1971. Photo by Bruce Walker.

Ted James founded Fox Surfboards in the late 1960s, about the same time Nomad Surfboards got its start but three years behind Bill Holmes and Holmesy Surfboards, which opened in 1964 in Juno Beach. In 1975 John Parton became a partner in Fox, developing its products and an international demand for its surfboards and sailboards through his initiatives in new technology. Ted James died unexpectedly in 2004.

Salick founded Salick/Carson with renowned Cocoa Beach shaper Bob Carson, while Pete Dooley, Scott Busbey, and George Easley founded Natural Art. Rich Price launched Rich Price Designs after honing his skills with Natural Art, and Steve Forstall shaped thousands of boards for Spectrum and other labels before setting out on his own.

Dooley and the Salicks were both from the southwestern Gulf, and Price and Forstall hailed from the Panhandle. Forstall has a long and varied career, having shaped for Mike Tabeling, Doug Deal's Alekai label in Melbourne Beach, Hixon's Wave Weapons out of Jacksonville, and Spectrum in Indialantic, before putting his own labels, Coda Surfboards and then Steve Forstall Designs, on the map. Spectrum Surfboards, founded in 1980, made a major mark during the years that followed. Ed and Jim Leasure began building Leasure Surfboards in 1978, before founding Quiet Flight in 1979. Since their modest beginnings, Quiet Flight has emerged as an industry leader, and along the way it sponsored many of the top surfers in the state, including Kelly Slater, Damien Hobgood, Matt Kechele, Rich Rudolph, Bill Johnson, and Gabe Kling. In 2012, they continue to build boards for CJ Hobgood, Bryan Hewitson, and Jody Davis.

With the shaping talent of Rich Price, Dooley's Natural Art likely made the biggest impact on the sport's development in Florida, embracing Greg Loehr, Chris Birch, Buddy Pelletier, Mike Nemnich, Mike Notary, Bob Rohmann, Richard Cram (Australian, World Tour), Ricky Carroll, Scott McCranels (World Tour), Todd Holland (U.S. and OP Pro Champ World Tour), Steve Anest, Danny Melhado (World Tour and three-time ASP East Coast champ), and Todd Morcom. Natural Art also sponsors renowned power surfers Peter Mendia and Baron Knowlton, along with hundreds of other surfers and pro surfing events from North Carolina to Barbados over the years.

Congruent with the shortboard revolution in the late 1960s came new supply chains and new opportunities for surfers up and down the coast to support themselves by making boards for others or launching their own labels. Ross Houston's then Miami-based Atlantic Surfing Materials would supply large and small factories alike with the required materials and latest products. In addition, Houston was an effective and active political advocate for surfing, and he would later provide new marketing and sales opportunities for the industry by creating Surf Expo, a major trade event linking wholesalers and retailers.

Surf Expo began during a 1975 board meeting of the Eastern Surf Association, when a small group of sales reps presented a hotel show displaying products to attendees at the Virginia Beach meeting. The following year, Houston, an ESA board member, ran with the concept and launched the first Surf Expo at Cocoa Beach's Cape Colony Inn. In July of the next year, Fantasma Productions presented Van Surf and Skateboard Expo at the West Palm Beach Auditorium, featuring innovative skateboarding demonstrations and voluptuous young women modeling the latest fashions in swimwear. By its fifth year, Surf Expo moved into Orlando's Tupperware Auditorium with 150 booths, and in 2011, hosted 2,400 booths for industry interests during January and September. The event attracts over 15,000 attendees at the Orange County Convention Center in Orlando. Other events, like the Board and Wave's Expo in Melbourne, take place on a retail level, but Surf Expo stands alone as either the best (or worst) example of the sport's commercial dimensions.

The state has also produced an enormous list of additional shapers and craftsmen. Within the Space Coast, Bob Carson, Tommy Maus, Greg Loehr, and Larry Pope are undeniably at the top of that list. A top competitor, Loehr was a 1970s shaper for Natural Art before launching his own label and then putting his mind to alternative technologies for the surfboard industry. An avid supporter of EPS/Epoxy construction, Loehr's Resin Research company worked out the challenges inherent to extruded polystyrene cores and epoxy-based coatings within the market for custom surfboards, offering manufacturers a compelling alternative to polyurethane foam cores and polyester-based coatings, which involve higher levels of industrial toxicity.

Larry Pope is an iconic figure with ties to almost everyone who had their hands in Florida's surfboard industry. As the world's most notable sander—sanding being a finishing process in surfboard production—Pope has put the final edges on tens of thousands of boards for multiple labels over multiple decades. He also ran Clark Foam's Melbourne-based distribution center and helped launch the careers of Central Florida's best surfers of the '70s and early '80s through his photographic skills and dedication to capturing those formative years on film.

Among other major shapers not already mentioned are Johnny Rice, Wayne Land, Richard Munson, Tom Neilson, Chris Birch, Skip Ledingham, Stu Sharpe, Bill Eberwein, George Robinson, Bob Strickland, Joe Shriver, Pat Mulhern, Glen Klugel, Jeff Klugel,

↘ Claude Codgen, Sunshine Surfboards, early 1970s. Photo by Dick Graham.

Claude Codgen was a top East Coast competitor and was among the East Coast's first big wave competitors, competing in the Olas Grande World Championships in Peru in 1966, the Duke Kahanamoku Invitational Surfing Competition at Sunset Beach in 1967, and the World Contests in Puerto Rico in 1968 and in Bells Beach, Australia, in 1970. In 1970, he started Sunshine Surfboards with Sam Gornto and others in the Space Coast, which he continues to operate today.

→ Larry Miniard, mid-1970s. Photo by Bruce Walker.

Bruce Clelland, Dick Rosborough, Larry Miniard, and Joe Roland were among the top Florida shapers of their day, launching Roland-Miniard-Rosborough Surfboards in 1972. Miniard, an exceptional surfer, also shaped for Bill Hixon's Fluid Visions as well as Ted James's Fox label out of Palm Beach County. All have remained in or returned to North Florida.

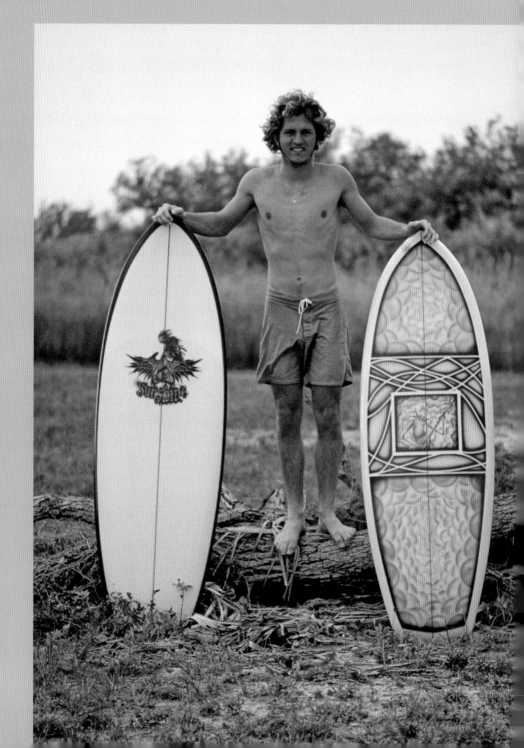

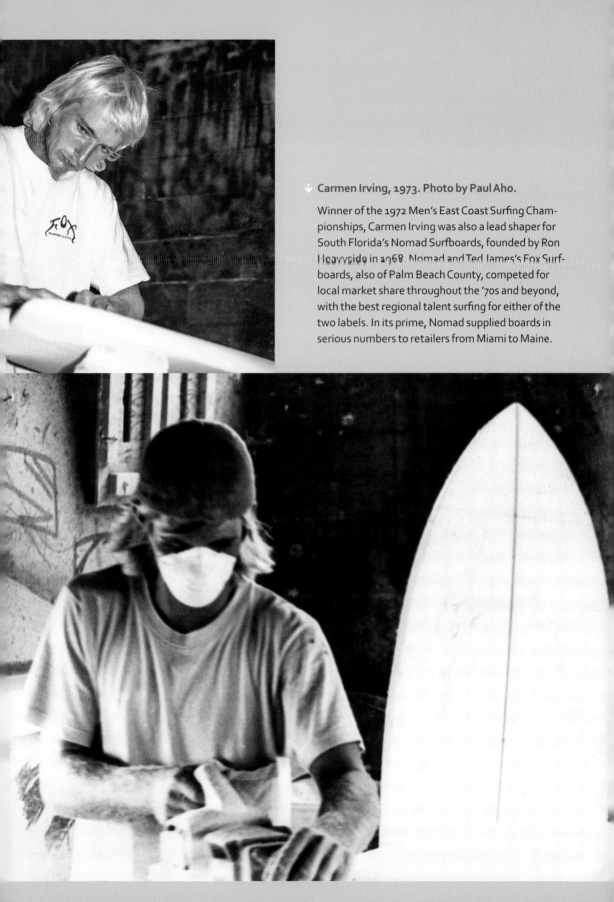

↓ Carmen Irving, 1973. Photo by Paul Aho.

Winner of the 1972 Men's East Coast Surfing Cham-
pionships, Carmen Irving was also a lead shaper for
South Florida's Nomad Surfboards, founded by Ron
Heavyside in 1968. Nomad and Ted James's Fox Surf-
boards, also of Palm Beach County, competed for
local market share throughout the '70s and beyond,
with the best regional talent surfing for either of the
two labels. In its prime, Nomad supplied boards in
serious numbers to retailers from Miami to Maine.

Bob Rohman, Pat Madden, Paulo Christo, Dave "Davo" Dedrick, Scott Busbey, Bill Johnson, "Balsa Bill" Yerkes, Sean Slater, and Jesse Villareal. Freddy Grosskreutz earned recognition glassing for almost everyone.

Other Space Coast labels included Dick Catri's short-lived Primo, Bruce Walker and Lewis Graves's legacy Ocean Avenue, David Balzerak's DCB, Doug Wright's Rainbow, Donny Mulhern's MTB, and Matt Kechele Surfboards. Kechele would mentor Kelly Slater and introduce untold numbers of others to the sport as he "launched" his own career as Florida's pioneer aerialist and one of the East Coast's most notable surfers and manufacturers.

The Space Coast's Ricky Carroll has earned similar accolades for his skills and craftsmanship at his R&D Surf Designs, where he makes boards under his own label and for legendary names like Takayama, Velzy, Rawson, and Surfboards Hawaii. Carroll is undoubtedly among the best shapers in the business, as demonstrated by his winning the prestigious "Tribute to the Masters Shape-Off" in 2007, 2008, and 2012, at the Sacred Craft Surfboard Expo in Del Mar, California.

In the Panhandle, Rick Bullock, whose riders once included Shea and Cory Lopez, spent years in the Space Coast at Spectrum after returning from Hawaii and before returning to his native Pensacola Beach. Tom Stack has maintained an independent and unique presence in the Panhandle for decades. Brian Waters's Islander Surfboards and his family's pioneer surf shop inspired local surfers and shapers alike, and Yancy Spencer, a Gulf Coast legend, designed boards for Greg Noll, Blue Cheer, Sunshine, and Hobie surfboards, as well as his own line of Innerlight Surfboards.

In North Florida, Bruce Clelland, Dick Rosborough, Larry Miniard, and Joe Roland were among the top shapers of their day, launching their careers with Roland-Miniard-Rosborough Surfboards in 1972. All had traveled to compete and put those experiences to use in the shaping room. Clelland had the opportunity to exchange ideas with Wayne Lynch in Australia, and Rosborough spent over a decade in Hawaii surfing and shaping on the North Shore from 1973 to 1985. Miniard shaped for Bill Hixon's Fluid Visions and became one of North Florida's most sought-after shapers. All have remained or returned to North Florida, and Rosborough continues to shape out of his St. George Island retreat. Clay Bennett, a legendary shaper and 1968 East Coast Champion who disappeared on customers in 2007, made his return in 2009 to set things straight and put his affairs back in order.

In Sarasota, Juan Rodriguez has been an industry mainstay for

over forty-five years with his One World Surf Designs. His range of skills and level of craftsmanship position him as one of the best in the business. Beyond his talent as a shaper, Rodriguez helped to popularize the sport of skimboarding, as manufacturer of the Western Flyers brand, making close to five thousand per year during the sport's popularization and promoting skimboarding competitions on the Gulf Coast. As a shaper specializing in custom longboards, Rodriguez also won the First Annual Florida Shape-Off at Surf Expo in 2007.

In the battle for bigger is better, a number of surf shops have grown to significant proportions over the decades. Island Water Sports had dozens of shops during the late '80s, and Quiet Flight has grown to a half dozen shops or retail outlets around the state. Nonetheless, when it comes to sheer bulk and industry muscle, it's Ron Dimenna's Ron Jon Surf Shop and Bob Baugher's Cocoa Beach Surf Company that reign supreme. The two empires occupy adjacent properties near the historic Canaveral Pier and share overlapping histories as well. At one point in time, Baugher was a high-level executive for Ron Jon, only to have the relationship end abruptly and in court. Baugher struck out on his own and opened the Cocoa Beach Surf Company, occupying a three-story monolith that also houses a Sheraton Four Points Hotel, a Starbucks, and a surf-themed restaurant with a shark tank and daily in-tank feedings by willing staff members.

Ron Dimenna began Ron Jon Surf Shop in New Jersey and set up a small shop in downtown Cocoa Beach in the mid-1960s before relocating to its current location. Dimenna gradually expanded the original shop, then purchased the property and later built the Ron Jon store that exists today. In the early 1960s, he also had a small shop on Canaveral Pier that was run by Willy Hickman and later by Bob Freeman. Dimenna, Ted Lund, and Bill Volmar ran the larger store. Fueled by its own success, Ron Jon Surf Shop has since licensed its brand to Ron Jon Surf Shop locations in Orlando, Tampa, Cozumel, and Grand Turk, as well as Miami and JFK international airports. The Cape Caribe Resort in Cape Canaveral, which includes the Ron Jon Surf Grill restaurant, as well as the Ron Jon Surf School run by Cocoa's historic surfer Craig Carroll, are also extensions of the Ron Jon brand. Needless to say, Dimenna and Baugher are driven and dynamic personalities cut from different cloth, but once joined at the hip.

Surf attire and sportswear companies have always been major profit centers seeking hardcore and lifestyle markets among coastal populations. Early brands like Catalina, Jantzen, Hang Ten, Ocean

Juan Rodriguez, One World Surf Designs, Sarasota. Courtesy of Juan Rodriguez.

In the first decade of the new millennium, Florida Power and Light launched a national campaign aimed at educating consumers about their energy consumption. Among other industry figures, Gulf Coast surfboard manufacturer Juan Rodriguez was featured in the campaign.

Larry Pope, LP Glassing Shop, December 19, 2006. Photo by Dick "Mez" Meseroll/ESM.

Larry Pope has ties throughout Florida's surfboard industry. In addition to managing Clark Foam's distribution center in Melbourne before Gordon "Grubby" Clark closed his factory in 2005, Pope is recognized as the surf industry's most prolific sander and a key figure in capturing Florida surfing on film as a staff photographer for *Surfer* magazine. Today, he owns LP Glassing Shop in Indian Harbor Beach.

↑ Greg Loehr, early 1980s. Photo by Bruce Walker.

An outspoken defender of East Coast interests, Greg Loehr's more recent battles occur within industry circles. Loehr pioneered the development of epoxy resin and EPS Foam as environmentally superior replacements for the polyester and polyurethane-based surfboard industry, which has changed little since the 1950s. While not the only shaper to see value in the crisis that ensued in 2005 when Gordon "Grubbie" Clark closed and destroyed his Clark Foam empire, he was certainly among the most vocal to express the opportunities. Clark Foam had been producing 1,000–1,500 blanks a day and had almost monopolistically fueled the surfboard industry for half a century. With Clark's closure catching the entire industry off-guard, Loehr and a few others envisioned an immediate adoption of environmentally safer materials circumventing the toxicities of glassing with polyester resins and the isocyanides inherent in polyurethane blanks. Despite the opportunity for change, other forces filled the void, and little has changed. Loehr began his career as a laminator for Pete Dooley's Natural Art Surfboards and quickly became its major shaper in 1974. By 1982 he was shaping for Ted James and John Parton at Fox in Palm Beach County, which was also developing cutting-edge epoxy-based sailboards. He also shaped for Lewis Graves and Bruce Walker's Ocean Avenue Surfboards in the early 1980s, as they launched the careers of Jeff Klugel, Matt Kechele, and others. Loehr has spent the last thirty years solving the problems inherent to early epoxy technologies, refining the materials and opening minds in the face of established interests. Today he is a partner in Resin Research, founded in Indian Harbor Beach in 1982 but now manufacturing epoxy resins out of Tucson, Arizona.

Pacific (Op), and others have come and gone over the decades. Today it's Quiksilver, Roxy, Billabong, Hurley, and others who command consumption of branded surfwear and have expanded the market to every possible location. While remembered as an East Coast brand making it big in the late '70s and early '80s, Sundek had its origins in California during the late 1960s. The company focused its energies on the East Coast when Jim Jenks quit to start Op in 1972. Bill Yerkes, from New Jersey, was recruited to build Sundek's brand on the East Coast, and upon moving to Cocoa Beach decided he liked the Space Coast and would call it home. Yerkes has pointed out that Sundek made as many sales in Hawaii and California as it did in the east, but the brand struck home with East Coasters in particular. Sundek sponsored the leading pro surfers in Florida and hosted the Sundek Classic, a huge and unruly early pro event in Melbourne Beach in May 1983 that coincided with the traditional college spring break festivities in the Space Coast. By that point in time, spring break was no longer focused upon Fort Lauderdale and was a mixed blessing for other coastal communities throughout Florida.

Attention from the international surf media has been intermittent but responsive to the markets for goods advertised in its publications. Florida surfers have regularly made the pages of publications still in existence and those long gone. *Surfing International* changed ownership and was renamed *Surfing*, with a short and stormy stay in New York before finding its feet again under different ownership in San Clemente in 1976. Others like *Competition Surf* and *Peterson's Surfing Magazine* would have short runs as international publications. Others yet, like *Atlantic Surfing* (1960s), *Surf'in East* (1975), *Wave Rider,* and *U.S. Surf* (1980s), took a regional view with an eye on outside events, yet they disappeared despite the best of efforts.

Alone in the field of East Coast publications, *Eastern Surf Magazine* (*ESM*) has managed to thrive as a publication championing surfers on and from the Atlantic Coast. Founded by Tom Dugan and Dick Meseroll, *ESM* celebrated its twentieth anniversary in 2011. Until the recent past, West Coast publications like *Surfer* and *Surfing Magazine* have traditionally recognized East Coast talent solely as a nod to the marketplace. Yet Bruce Valluzzi was a *Surfer* correspondent and East Coast editor for years in the early 1980s, and numerous Floridians have made the covers of international publications. Florida photographers David Silver, Roger Scruggs, Allan Margolis, Larry Pope, Pat Altes, Darrell Jones, Lance Trout,

Tom Servais, Doug Waters, Thanos Paulos, Tom Dugan, Dick Meseroll, Kevin Welsh, Pete Frieden, and others—as staff photographers or independent shooters—helped put many Florida surfers on the map, as well as those from other locations. Darrell Jones has had more *Surfer* cover shots than any other photographer in the publication's history. More recently Pete Hodgson, Donald Cressitello, Chris Wilson, Mark Hill, Ryan Gamma, Patrick "Tupat" Eichstaedt, and Patrick Ruddy have all made significant names for themselves as surf photographers from Florida. Jimmy "Jimmicane" Wilson, associate photo editor for *Surfing Magazine*, is from North Florida and is a hardcore champion of East Coast surfing.

Surfer magazine actually ran a January 1972 cover shot by legendary California photographer Ron Stoner of boat wake in the Banana River, which was taken in the backyard of Bob and David Carson's family home in Cocoa Beach. Despite the acknowledged scale, it was a fantasy shot that connected with readers around the world.

CHAPTER 15

Religion and
Surfing's Spiritual Core

BRON TAYLOR

Surfers often say that surfing is more than a sport—it is a way of
life. It is also a way of life that in which nature becomes deeply in-
tertwined with religion, if by *religion* we mean beliefs and practices
related to God or other divine beings, and involving religious or-
ganizations of some kind. Surfing and nature are also often inter-
twined with what people call spirituality, if by *spirituality* we mean
powerful and transformative experiences that take place outside of
the world's conventional religions, which provide a meaning and a
sense of one's place on earth and in the cosmos.

In the United States, Christian and Jewish surfers often find in
the beauty and power of the ocean a reflection of God's power and
goodness. Some of these individuals consider it a religious duty to
protect God-given marine ecosystems. Evangelical Christians, who
sometimes share such environmental concerns, nevertheless tend
to put a priority on converting the surfing legions, whom they con-
sider to be in spiritual peril. Their passion has led to the Christian
Surfers organization and other surfing-related missionary efforts.
Since Florida has many such Christians, it has a larger population
of such surfing evangelicals than most other surfing regions, with
the possible exception of Southern California.

Meditating surfer and dog, North Shore, Hawaii, 1976. Photo by
Jeff Divine.

Throughout surfing's history, it has divided upon personal practice—is surfing
an art form, a spiritual practice, or a sport? Despite the realities of its global
commodification, surfing has remained a spiritual practice for many.

→ *Surfing Magazine cover, circa 2009*

While many incorporate surfing into well-known and longstanding religious systems, for a significant subset of the global surfing community, surfing is itself a religion as recognized by *Surfing*, the world's largest-distribution surfing magazine.

TOO LEGIT TO QUIT PG. 92

SEE TH

SURFING
MAGAZI

NATURE = GOD*

IT'S OFFICIAL:

SURFING IS A RELIGION

WHAT NOW?

Tom Blake, "Voice of the Wave," SURFING magazine, 1969.

Blake once scrawled "Nature=God" on the cliffs at Santa Monica, California, in an effort to express his surfing-inspired feeling that all nature's energies flow, somehow, from a divine source. Such thoughts he eventually published in "Voice of the Wave," an article published in *Surfing Magazine* in 1969, in which he wrote, "nature is synonymous with God." It was almost forty years later that the same magazine put "Nature=God" on its cover, reflecting on surfing as religion.

Mike Pechonis, owner/shaper of Bird Surfboards in Broward County, is a longstanding leader among South Florida Christian Surfers, a movement that first gained traction internationally in the late '70s. According to the Space Coast's Pete Dooley, several core central coast surfers turned to Jesus in the seventies to moderate aspects of their lives, including adopting less confrontational attitudes toward other surfers at crowded surf spots.

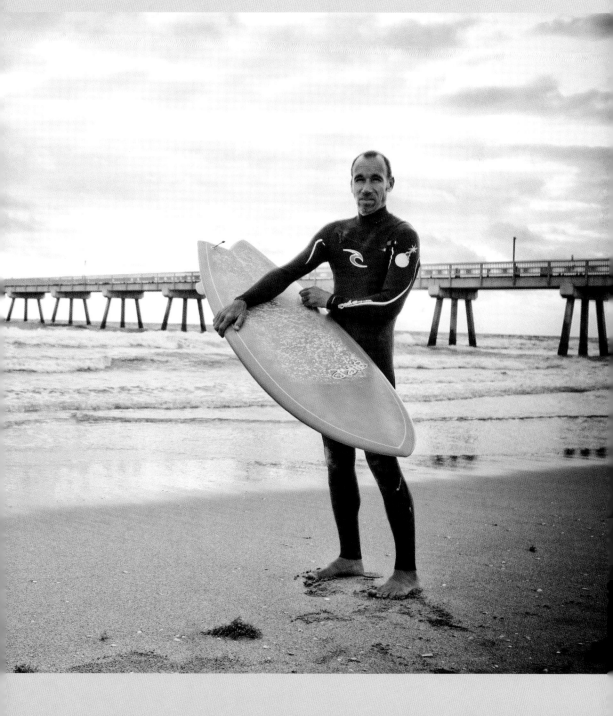

Like the rest of the United States, Florida is increasingly diverse religiously. As a result it is easy to find surfers who practice religions originating in Asia, such as Buddhism and Hinduism. They also fuse their surfing and religious experiences and beliefs. The artist, musician, and Tibetan Buddhist Chris Harazada provides but one example from Florida. He was a practitioner of acupuncture and other healing arts, and some surfers considered him to be enlightened being. He died from a heart attack in 2007 after surfing at Jupiter Beach, after which hundreds who knew him participated in a "paddle out" for him, one of the rituals now common among surfers, whatever their religious orientations, to mark their passage from earthly life.

While many incorporate surfing into well-known and long-standing religious systems, for a significant subset of the global surfing community, surfing is itself a religion. This was recognized when *Surfing*, the world's largest-distribution surfing magazine, declared in its cover story in July 2008, "Nature=God," that "It's Official: Surfing Is a Religion." The preceding year the British surfing magazine *Drift* published a similar cover story on surfing as an "aquatic nature religion." In both cases, the editors wrote that they personally understood that surfing provides profound, transformative, and even healing experiences, which can also provide spiritual meaning and ethical guidance.

Surfing is indeed, for some, a form of nature religion. Many people have what could be called nature religion or spirituality, whether through surfing, hiking, fishing, hunting, gardening, or other activities in which people spend extended time observing and interacting with ecosystems and their inhabitants. In general, with nature religions, people understand natural environmental systems as sacred and develop feelings of belonging and connection to nature, humility about the place of humans on earth and in the universe, and kinship with nonhuman life forms. Through their own regular surfing practice and experiences, many come to deeply respect, if not also love and have reverence for, the diverse species they regularly encounter in these coastal environments. One example of such a perspective is the respect that surfers generally have for sharks, recognizing that such predators are an important part of the web of marine life.

That increasing numbers of surfers consider their practice to be spiritually meaningful, and discuss this openly, is significant. Since the resurrection of the Hawaiian "sport of kings" by Duke Kahanamoku early in the twentieth century, there have been

many ambassadors of the sport who have spread it around the world; some of these understand and portray surfing as a spiritual practice. Surfing writers commonly assert, for example, that for traditional Hawaiians, surfing involved a deep, spiritual respect for nature. This can be seen, they say, in the ritualized respect paid to the trees that were cut down to make the boards, but also in the communion between people and the rest of the living world that can be evoked through the practice. This sort of communion is in part reflected the word *aloha*, which has a deeper spiritual meaning in traditional Hawaiian culture than its simple use as a salutation. Aloha has been adopted by some surfers as having to do with the exchange of breath between people and other beings, which is viewed as a sacred exchange, related to the mysterious breath of life itself. Therefore, to some surfers, the aloha spirit symbolizes connection and communion among humans as well as reverence for the sources of existence itself.

Tom Blake is often called the greatest surfing ambassador ever, second only to Kahanamoku, who was his mentor and friend. Born in northern Wisconsin in 1902, Blake saw a newsreel about surfing a decade later and met Duke Kahanamoku in the lobby of a Michigan movie theater at age eighteen. He soon moved to Los Angeles to pursue the sport. He eventually became a lifeguard as well, while revolutionizing surfing by inventing lighter, hollow surfboards, which made surfing easier and more popular. Less well-known is the extent to which he traveled, spreading surfing and a spirituality-infused aloha spirit along the way. This included regular trips to Florida beginning in the early 1930s.

Blake once scrawled "Nature=God" on the cliffs at Santa Monica, California, in an effort to express his surfing-inspired feeling that all nature's energies flow, somehow, from a divine source. Such thoughts he eventually published in "Voice of the Wave," an article published in *Surfing Magazine* in 1969, in which he wrote, "nature is synonymous with God." It was almost forty years later that the same magazine put "Nature=God" on its cover, reflecting on surfing as religion.

When Christian missionaries first encountered surfing and recognized a religiosity to it at variance to their own, they suppressed it as spiritually dangerous, and surfing was forced into secret. Today, those who find meaning and spiritual truth directly in nature through their surfing experiences, and those who see God's goodness in nature during their surfing experiences, are no closer to agreeing on whether nature is God or points to God. This reflects

a longstanding, global religious contest between those who find the sacred above and beyond this world, and those who see themselves part of, and surrounded by, an entire world they consider sacred. But however differently surfers understand the sacred and construe the meaning of surfing, it is clear that the rituals of this practice are an important wellspring of the spiritual understandings and ethical commitments of many surfers.

CHAPTER 16

The Right to Surf

TOM ANKERSON

Older surfers remember when getting to the beach was not a matter of where you could park, but whether you would get stuck in the loose sand between the hard road and the dunes. Then the peninsula filled up. Those sand roads turned into gated entries for homes and condos. Beach access today is a highly regulated enterprise. Today's surfers must stuff money in a parking meter and leave when the sun sets. In this new century of accelerated sea level rise, access has taken on an additional meaning as the waves crash on sea walls and revetments, eliminating access along the shoreline.

Basic water quality is a growing and serious concern. Surfers never used to think twice before paddling out. Florida's near-shore coastal waters were clear and clean—arguably, they were "healing" waters. But the peninsula filled up, and the ocean became a con-venient dumping ground, true to the quintessential expression of waste management, "dilution is the solution to pollution." Now, in addition to checking the surf conditions, the twenty-first-century surfer must monitor bacteria counts and be on the lookout for the dreaded red tide. Increasingly, storms bring not just waves but also the flotsam and jetsam of our consumer culture.

Additionally, Florida surfers face strong competition on beaches, jetties, and piers. The competition for waves is increas-ing, even as the waves themselves may be increasingly hard to find. What passes for point breaks in Florida are jetties and piers, which force waves to break before they reach the beach. In the "old days," competition for the first peak was among only surfers, in a

↑ Cover of *U.S. Surf* magazine, early 1980s.

Because most piers cause sand bars that enhance waves for surfing, pier fishermen and surfers have often been at odds, as the article "Pier Wars" by Tom Ankerson describes. Fights have even broken out, such as at the Sebastian Inlet State Park jetty and the Juno Pier. In both cases the surfers won and the fishermen were restricted. At Sebastian Inlet, the park brochure soon had a surfer on the cover.

↗ Surfrider Foundation environmental awareness sign. Photo by Tom Warnke.

Public awareness is often all that is needed to make a difference. Surfrider Foundation's reputation for guerrilla marketing includes creative tactics such as branding public toilets with a direct message, calling attention to the archaic and harmful practice of flushing partially treated human sewage into the ocean, or injecting it into aquifers that flow there.

Surf the Sewer

the

Delray Beach
All American City

← *Surf the Sewer*. Art by Ed Tichnor.

Reef Rescue, a Delray Beach diving organization, spearheaded efforts that were supported by Surfrider Foundation's nine Florida chapters, resulting in the closure of the Delray Beach Ocean Outfall. This stopped thirteen million gallons of sewage from being dumped there each day, only a mile from a prime surf spot. In 2014, other South Florida utilities are still dumping almost 400,000 gallons per day of minimally treated human sewage directly into the surf zone in Dade and Broward Counties. Billions of gallons are also dumped daily into South Florida aquifers that drain to the ocean. The resulting "death by fertilization" causes coral death, toxic algal blooms, beach closures, and unprecedented jellyfish invasions.

↓ *Hazmat surfer, Broward County. U.S. Surf* magazine [1982?]. Courtesy of Tom Ankerson.

Brevard County, Florida, has coastal pollution traced to human sewage feeding algae at surf spots. Coastal dune location of sewage injection wells is one possible source, but so are the many large cruise ships that are based at or visit Port Canaveral. Those ships dump their waste just a few miles offshore, where it drifts into the surf zone. Protests and lobbying by Surfrider Foundation have caused legislation to be drafted that requires the ships to pump out while in port, rather than dump at sea. This shot accompanied a *U.S. Surf* article by Ankerson on polluted beaches and was shot on the Cape Canaveral National Seashore with the help of a NASA contractor who provided the suit.

culturally evolved pecking order. But as the population of Florida grew, the term "pier wars" entered the surfer's lexicon. In the twenty-first century, the break nearest piers and jetties has become contested space, as anglers, swimmers, and Jet Skiers vie for the recreational opportunities that these manmade point breaks provide. Even beach breaks are now threatened, as coastal engineers seek structural solutions, such as offshore breakwaters, to dissipate wave action before it reaches the backyards of the homes and condos that line the modern Florida coast.

As water quality, surfable waves, and beach access have diminished, surfers have risen to the challenge. In the last century, the only dark suit a surfer would wear was made of neoprene. But now surfers are donning those other suits and participating in the political and legal processes that ensure their beaches can be accessed, their waters are surfable, and their breaks are protected. Surfers found their collective voice with the Surfrider Foundation, a national ocean and coastal advocacy group that has won impressive victories in Florida protecting beach access and the quality of coastal waters—which is the essence of the right to surf.

Dave Hyde's Trashy Cutback. Art by Dave Hyde.

As more and more plastic and other garbage enters the ocean, surfers are among the first to feel the impacts. This image was used by Surfrider Foundation's Miami chapter to convince the City of Miami Beach to enforce its beach litter ordinances. Thousands of volunteers are also staging beach cleanups around Florida. In 2010, extreme athlete Tom Jones completed his record-setting Key West–to–New York paddle to call attention to plastics polluting the ocean. Plastics kill marine life and cause long-term endocrine disruption in marine animals and humans. With groups such as Plastic Free Ocean and Surfrider Foundation's Rise Above Plastics (RAP) campaign providing political clout, ordinances are beginning to regulate single-use plastics.

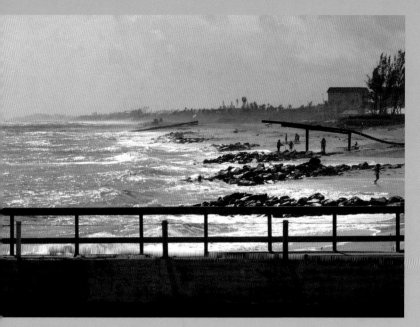

Coastal Armoring, Ocean Ridge, Florida. Photo by Tom Warnke.

Inlets, seawalls, and jetties are coastal armoring projects that have caused Florida's treasure of native beach sand to be washed out to sea or kept from moving naturally. Since 1970, dredge and fill has been used statewide in a futile attempt to cover those mistakes, even in the face of a rising ocean. In 2010, the Palm Beach County chapter of Surfrider Foundation won the first case challenging the use of poor material for beach fill, with the judge ruling against the Town of Palm Beach on all fifteen counts.

Smyrna Dunes Park, New Smyrna Beach. Photo by Dick "Mez" Meseroll/ESM.

Among the many premium waves at state and local parks across Florida, Smyrna Dunes Park, located on the south side of Ponce Inlet, is a remarkable resource that offers access to miles of walking trails through the region's pristine ecosystem and foot access to the beach when driving isn't permitted.

CHAPTER 17

Competitions

With the origins of surfing competitions rooted in Hawaiian surf festivals, surfing was slow to adopt the professional practices of other sports. Though Hawaii's earliest contests were an occasion to party, the competitions were definitely serious events. While modern surfing and the 1950s brought higher performance equipment and an emphasis on maneuverability as the new criteria for judging, it did little to mediate the "Surf, Suds, and Sex" spirit of most events.

In an effort to head off negative reactions, the California-based United States Surfing Association (USSA) was created "to make the sport more serious and respectable." In the early '60s, it began sanctioning contests, and by 1965, competitions used standardized scoring and a panel of judges. An individual's competitive advancement was established through a series of elimination heats. The 1963 United States Surfing Championships ushered in the beginning of spectator numbers reaching as high as 10,000, and by 2002, over 450 competitors. Despite a huge increase in its membership—required to compete locally, nationally, and internationally—questions about the USSA's operations and its California-centric culture within a broader context led to its collapse in 1967, and to the formation of the Eastern, Western, Gulf Coast, and Hawaiian surfing associations.

The United States Surfing Championships would come under the management of the newly formed United States Surfing Federation (USSF), and the emerging international contest scene came under International Professional Surfers (IPS), and then, with a name change, to International Professional Surfing (in an attempt by organizer and 1968 World Champion Fred Hemmings) to downplay the appearance of a surfer's union. Nonetheless, by 1983,

→ East Coast Hobie Team, 1966, East Coast Surfing Championships, Virginia Beach, Virginia. Courtesy of East Coast Surfing Hall of Fame.

This early Hobie team photo features Dick Catri (*center*) Mike Tabeling, Gary Propper, Bruce Valluzzi, Mimi Munro, Joe Twombly, and Sunday Panganopoulis, among others. Florida surfers won twenty-six trophies, and Gary Propper claimed an East Coast first by beating top Californians Dewey Weber and Tom Lonardo in the West Coast Open. The event also determined the East Coast World Contest Team that would consist of Propper, Valluzzi, Tabeling, Tommy McRoberts, Fletcher Sharpe, Mimi Munro, Kathy LaCroix, and Renee Eisler. Bruce Valluzzi took second in the Men's Event and won the All Events Trophy. Mike Tabeling won the Juniors Division, Mimi Munro the Girls.' The events judges included Hobie Alter, Greg Noll, Reynolds Yater, and John Hannon, among others.

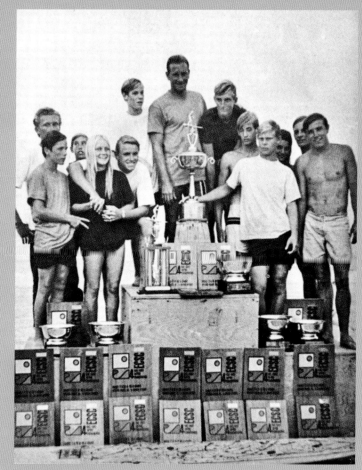

← Florida State Surfing Championships, Daytona Beach, 1964. Photo by Gene Baron.

Early women's competitors included Linda Baron, Mimi Munro, Kathy Jo Anderson, Cici Camp, Jerrie Graham, and Kathy LaCroix, among others. Helmets were required by the competitive sanctioning agency of the time, the United States Surfing Association.

international pro surfers Ian Cairns, Wayne "Rabbit" Bartholomew, Mark Richards, Shaun Tomson, and others, fed up with the International Professional Surfing tour, rebelled and created the Association of Surfing Professionals (ASP).

In an effort to crush the IPS, Ian Cairns, by then the head of the ASP, forbade ASP surfers from competing in any IPS-sanctioned events. By this time, the ISP was only in control of Hawaii's Triple Crown events, usually held at Pipeline, Sunset, Haleiwa, or Waimea Bay. Demonstrative of the politics involved, top Hawaiian pros Bobby Owens, formerly of Daytona Shores, and Hawaii's Dane Kealoha competed nonetheless. Kealoha won the 1983 Pipe Masters but forfeited his 1983 ASP ranking. The IPS continued to lose authority, and by 1984 the Pipe Masters was an ASP event as well.

Today the APS runs a wide variety of qualifying competitions under a system known as the World Qualifying Series (WQS), from which surfers advance to the World Championship Tour (WCT), where the world's top thirty-four surfers compete for ratings, sponsorships, and earnings on the world title circuit.

While Florida's first surfing contest was hosted in Daytona Beach in 1938, and the Florida State Surfing Association held its first contest in Daytona Beach in 1962, Cocoa Beach was destined to become Florida's competitive epicenter. Early contests in Virginia and Cocoa Beach attracted surfers from across the nation. Cocoa Beach's Gary Propper, Mike Tabeling, Bruce Valluzzi, and Claude Codgen, as well as North Florida's Mimi Munro, Flea Shaw, Bruce Clelland, Dick Rosborough, and Joe Roland, put the state on the map. Contest organizers Dick Catri, David Reese, John McCranels, David Aaron, and others established the systems. Important 1960s contests included Cocoa Beach's Easter, Labor Day, and Memorial Day contests; New Smyrna's Coronado Surf Club Contest; North Florida's Florida State Surfing Championships; Miami's huge WQAM radio event in 1965; and Fort Pierce's Sandy Shoes contests.

In the late '60s, competition exploded. The Eastern Surfing Association (ESA) held district and regional contests; clubs hosted weekly competitions; and the East Coast Surfing Championships (ECSC) came to prominence. As the oldest contest on the East Coast (2012 marked its fiftieth year) and the second oldest in America (predated only by California's Brooks Street Surf Classic), the East Coast Surfing Championships continues to attract amateur and professional contestants alike, as documented by its winners over the years. Gary Propper won the first Junior's division in 1964, and in 1966 the Men's and Junior's, beating legendary

Californians Dewey Weber and Tom Leonardo. In 1965, at the age of thirteen, Ormond Beach's Mimi Munro won the Women's event, repeating her victory in 1966 and '67. Other winners include Jack Murphy (1963), Californians Steve Bigler and "Corky" Carroll (1967 and '68 respectively); and Joe Roland (1969). Florida's "Jimbo" Brothers won the first pro competition in 1972, as did Yancy Spencer (1973), Matt Kechele (1983), Jon Futch (1984), Tim Gilley (1985), Rich Rudolph (1985, 1986), Scott McCranels (1987, 1988), Asher Nolan (2008), Aaron Cormican (2009), and Jeremy Johnston (2010). In 2011, the 49th Annual (Coastal Edge) East Coast Surfing Championships were presented by the United States Surfing Federation as a Four Star event sanctioned by the ASP, reestablishing the competition among the biggest pro-am events in East Coast competitive history.

On other fronts, with the creation of the ESA in 1967, amateur competitive surfing on the East Coast took a giant step forward. Gary Propper was declared the first ESA East Coast Champion by prior contest results, and in 1968, Joe Roland of Jacksonville Beach was declared the ESA's first East Coast Champion through accumulated contest points. Cocoa Beach's Claude Codgen would follow in 1969.

The first ESA Eastern Surfing Championship Competition ("the Easterns"), hosted at Picnic Tables in Cocoa Beach in 1970, failed to finish due to divisions between the organizers and Florida's surfers, but its relaunch the next year in Cape Hatteras saw New Smyrna's Charley Baldwin take the ESA's first one-event title. In 1972, South Florida's Carmen Irving won the Men's division. The Space Coast's Greg Loehr took the East Coast title in 1974, alongside the Women's winner, New Smyrna's Isabel McLaughlin, who also won the Women's event at the U.S. Championships, hosted that year in Cape Hatteras. Cocoa's Mary Ann Hayes and Lake Worth's Maury McCoy won the "Easterns" Women's and Men's divisions respectively and back-to-back in 1977 and 1978. Dozens of other Floridians have claimed the ESA East Coast title over the following years, many going on to careers as professional competitors.

Yet long before the world's first pro contest, Floridians Catri, Tabeling, Codgen, Propper, Valluzzi, and others surfed contests in Hawaii and Peru in the mid-1960s. As professional surfing developed, Daytona's Bobby Owens left Florida for Hawaii, placed in the top sixteen for four years in a row on the ISP Tour, and ended 1980 ranked tenth in the world. Following a 1973 third-place finish at Hawaii's prestigious Duke Classic at Sunset Beach, Jeff Crawford, of Cocoa Beach, became the first East Coast surfer to win the

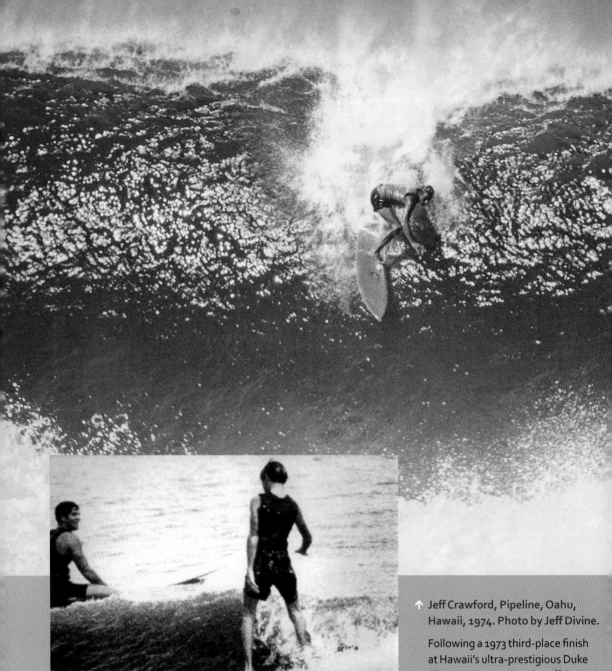

↑ Jeff Crawford, Pipeline, Oahu, Hawaii, 1974. Photo by Jeff Divine.

Following a 1973 third-place finish at Hawaii's ultra-prestigious Duke Classic at Sunset Beach, Jeff Crawford, of Cocoa Beach, became the first non-Hawaiian and East Coast surfer to win the Pipeline Masters in 1974, an honor still shared among East Coasters only with Cocoa Beach's Kelly Slater. In 1976, Crawford also became the first USA mainlander to make the top sixteen in the IPS's inaugural year, and in 1977, he won the *Wave Rider* magazine Florida Pro, the first IPS East Coast event at Sebastian Inlet.

↑ Fletcher Sharpe, Cocoa Beach, mid-1960s. Courtesy of East Coast Surfing Hall of Fame.

Fletcher Sharpe won the Junior Men's division at the 1965 Florida State Championships, plus a third- and first-place finish in the 1966 and 1967 East Coast Championships. He was among the best short-boarders of his generation as well, sharing the limelight at Sebastian Inlet with Mike Tabeling and few others when conditions got serious.

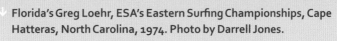
Florida's Greg Loehr, ESA's Eastern Surfing Championships, Cape Hatteras, North Carolina, 1974. Photo by Darrell Jones.

Following a forced move south to Frisco to get out of the wind, "The Easterns" 1974 competition moved back to the Hatteras Lighthouse for the finals, where Greg Loehr won the title over fellow Space Coaster Jim Cartland in epic, overhead conditions. ESA, now the largest surfing association in the world, has been crowning East Coast Champions for forty-five years, almost always in the shadow of the Cape Hatteras Lighthouse.

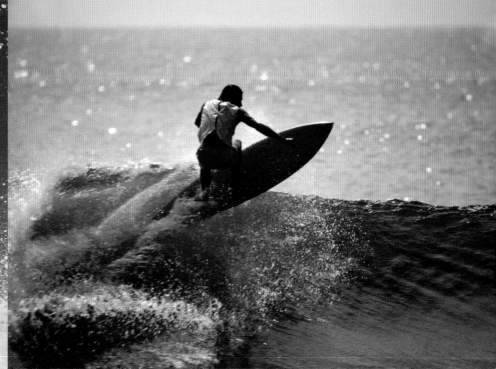

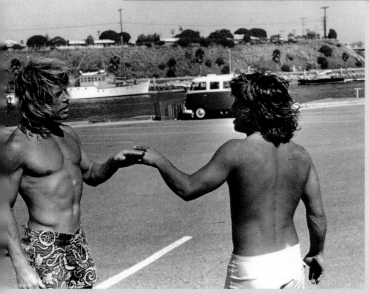

Rich Salick and Dru Harrison, 1973 World Contest, Oceanside, California. Courtesy of Doug Walker, thelostandfoundcollection.com.

Californian Dru Harrison (right) misjudges Florida's Rich Salick for the second time in a row. Rated the number-one surfer in the world going into the contest, Harrison lost his early-round heat to Salick by 20 points and was eliminated from the heat. The photo ran in Surfer magazine in 1973.

Pipeline Masters in 1974, an honor still shared among East Coasters only with Cocoa Beach virtuoso Kelly Slater. Slater won the event in 1994, 1995, 1996, and 1999. In 1976, Crawford also became the first U.S. mainlander to make the top sixteen in the IPS's inaugural year, and in 1977, he won the *Wave Rider Magazine* Florida Pro, the first IPS East Coast event at Sebastian Inlet. Kelly Slater would continue to dominate the world of competitive surfing into the present and earn a reputation as one of the world's most notable athletes.

By 1984 Florida had hosted numerous pro events, including the Sun Country Pro Am in Deerfield Beach and the Sundek Classic at the Holiday Inn in Cocoa Beach. Drawing huge audiences, both events drew unruly crowds, and the Sundek Classic was bad enough to be a setback for pro surfing in Florida. But that was a weekend of teenage antics compared to the Op Pro in Huntington Beach, California, in 1986, where spectators turned a pro surfing event into the "Op Pro Riot," overturning and burning police cars and more.

Nonetheless professional surfing continued to develop, and so did a broad talent pool of serious competitors and winners from within the state. Interestingly, upon the bona fide emergence of professional surfing in the 1980s, Florida's surfers were conspicuously at odds with the largely laid-back culture of California, as well as Hawaii's "soul surfing" elite. Being more aligned with the middle '70s agro/competitive culture of the Australians and South Africans, as portrayed in the 2008 documentary film *Bustin' Down the Door*, a new group of surfers emerged. Younger faces like Pat Mulhern, Matt Kechele, and Jeff Klugel competed alongside established names like Greg Loehr, Jeff Crawford, Greg Mungall, Flea Shaw, Mike Kitaiff, and David Balzerak, as the sport went pro and the number of Florida-based and international events exploded.

Greg Mungall won his first pro event, the 1976 Waverider Florida Pro, and the Katin Pro Am in Huntington Beach in 1979. Greg Loehr, of Cocoa Beach, won the French Lacanau Pro in 1979, the first time an East Coast surfer would claim an international pro victory. Much later, fellow Cocoa Beacher Charlie Kuhn would win the Lacanau Pro in 1985. Matt Kechele and Pat Mulhern took first and second, respectively, in the 1981 Stubbies Trials at Sebastian Inlet; and former Cocoa Beacher David Carson placed ninth on the world tour in 1989, before achieving international fame as one of the most innovative graphic designers of the century. In 1998, CJ Hobgood won the Buondi Sintra Pro in Portugal, qualifying for the World Championship Tour along with fellow Cocoa Beacher Bryan

Hewitson. In 2000 Satellite Beach's Damien Hobgood was named WCT Rookie of the Year at number ten on the World Tour, and in 2001, twin brother CJ Hobgood won the WCT World Title. In 2002, Jacksonville Beach's Karina Petroni won the National Championships and in 2008 was the only North American female to qualify for the World Tour.

In 1984, Flagler Beach native Frieda Zamba won the first of four world title championships. In 1992, Kelly Slater won his first World Tour event at the Rip Curl Pro in France, his first Triple Crown Event at the Pipe Masters, and his first World Title, all while completing his first full year on the World Tour. In 1994, Slater won his second world title (incidentally, while dating celebrity Pamela Anderson), and Florida's expatriate female surf legend, Lisa Andersen, won the first of four world women's titles. In 2012, Kelly Slater claimed his eleventh world title in Puerto Rico at the age of thirty-nine, becoming both the youngest (at twenty) and the oldest world title winner in surfing's history. All of the world titlists from America's East Coast are from Florida, and in fact, since the founding of the Association of Surfing Professionals and its creation of ASP World Titlists in 1992, twenty out of thirty-two possible men's and women's world surfing titles have been won by surfers from Florida.

None of these surfers succeeded without the help of others. New Jersey's Cecil Lear and Connecticut's Rudy Huber created the Eastern Surfing Association to organize regional events. With the help of Floridians David Reese, Dick Catri, and others, the ESA established amateur surfing on the East Coast, grooming and training the emerging talent. Other Floridians shaping East Coast and international competitive surfing include Dave Aaron, Chummer McCranels, Mike Martin, Jeff Klugel, Bruce Walker, Matt Kechele, Paul West, Skipper Eppelin, Mitch Kaufmann, Kevin Grondin (a former New Hampshire snowbird), Tom Warnke, Kathy Hughes Griffith, and Carol Holland, among many others.

Since then, local organizations and surfers like Rich and Phil Salick (National Kidney Association); Kelly, Sean, and Steven Slater (National Skin Cancer Association); and the family of Tommy Tant (Tommy Tant Memorial Surf Classic/local college scholarships), the Smyrna Surfari Club (college scholarships); and many others, have created opportunities for Florida surfers to hone their competitive skills while supporting and raising money for philanthropic causes.

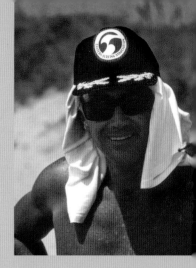

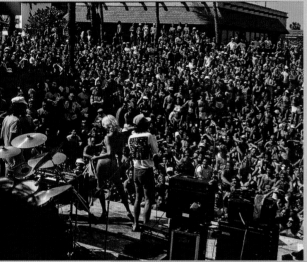

Bikini contest, Sun Country Pro-Am, Deer-field Beach, March 1983. Photo by Bruce Walker.

National Kidney Foundation Pro-Am Surf Festival. Courtesy of Rich and Phil Salick.

What began as a local team contest in 1976, raising $125 in entry fees to support regional dialysis patients, has grown into the largest surfing-related charitable event in the world, benefiting the National Kidney Foundation. Cofounded by Rich and Phil Salick, the event took on national proportions in 1985 and now bears the name NKF Rich Salick Pro-Am Surf Festival in honor of Rich, who died during emergency surgery related to his ongoing battle with kidney disease in July 2012. Now over a quarter-century old, the event raises over $125,000 in support of the National Kidney Foundation's Research Endowment Fund, which it helped to create in 1985.

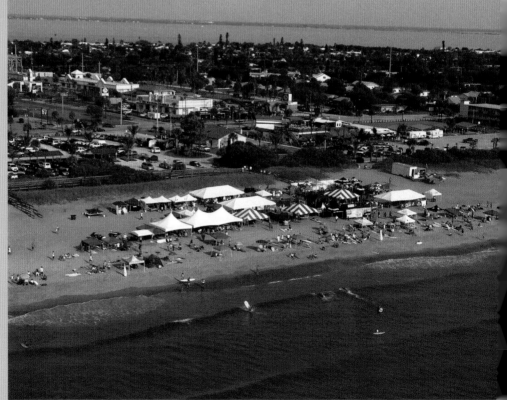

← David Reese, 1978. Photo by Darrell Jones.

Palm Beach's David Reese played a key role in establishing the Eastern Surfing Association's contest program, using the system he put in place as competition director of the Palm Beach County Surfing Association, which predated the ESA. He became ESA's competition director in its formative years. A leader in the sport's development, David was still serving on the ESA Board of Directors in 2014 with friend and ESA cofounder Cecil Lear. Reese's father was once mayor of the Town of Palm Beach, which had later sought to ban surfing altogether within its city limits in the early 1970s.

↙ Pat Mulhern, Stubbies Trials, Sebastian Inlet, 1981. Photo by Dick "Mez" Meseroll/ESM.

Then local kingpin Pat Mulhern saves time and energy returning to the lineup during the 1981 Stubbies Pro Trials at Sebastian Inlet. Mulhern placed second behind Cocoa Beach's Matt Kechele. Both later traveled to Australia to compete in the Stubbies Pro at Durleigh Head.

↓ Sundek Pro, Cocoa Beach, 1981. Photo by Bruce Walker.

In 1981 Florida hosted the Sundek Classic in Cocoa Beach and the Sun Country Pro-Am in Deerfield Beach. Held during Spring Break, the Sundek Classic drew wild spectators and became a public relations setback for pro surfing in Florida, but for competitors, it was a serious professional event hosted by a major industry sponsor with East Coast ties.

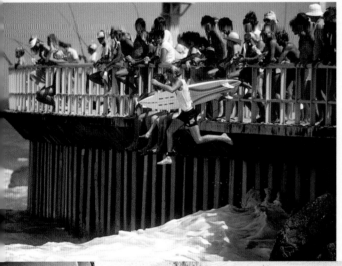

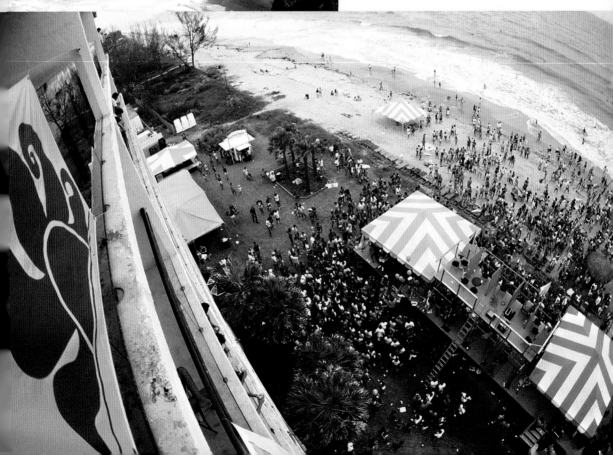

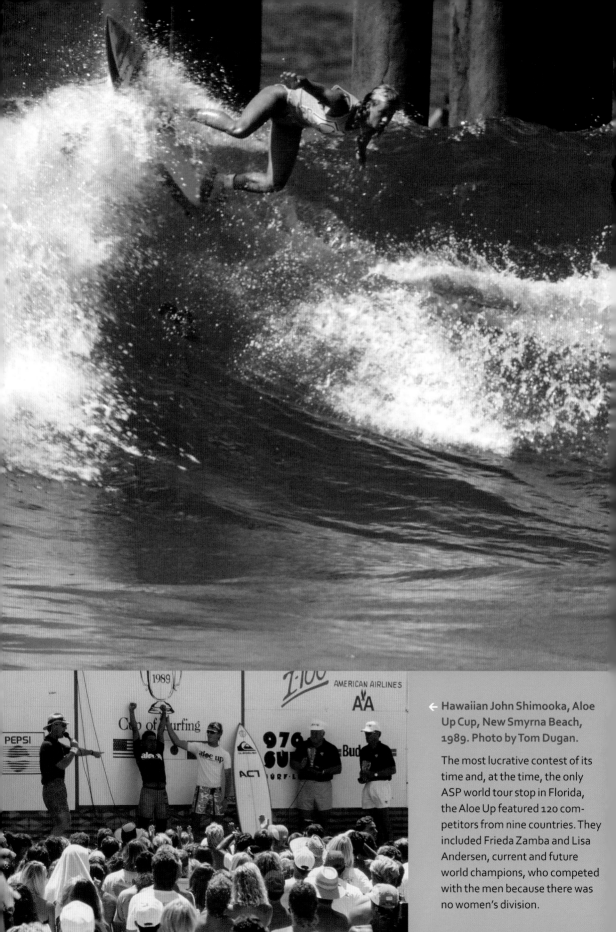

← Hawaiian John Shimooka, Aloe Up Cup, New Smyrna Beach, 1989. Photo by Tom Dugan.

The most lucrative contest of its time and, at the time, the only ASP world tour stop in Florida, the Aloe Up featured 120 competitors from nine countries. They included Frieda Zamba and Lisa Andersen, current and future world champions, who competed with the men because there was no women's division.

← Frieda Zamba, 1985 Op Pro Huntington Beach, California. Photo by Simone Reddingius.

Four-time World Champion Frieda Zamba won the Op Pro on five occasions, more than any other competitor. Sponsored by sportswear giant Ocean Pacific, the event was once California's most prestigious event. In 1986, things turned ugly when unruly spectators launched the "Op Riot," turning over vehicles and burning a police car. Now the U.S. Open of Surfing, the contest suffered a similar setback in July 2013.

↓ Bryan Hewitson, Sebastian Inlet. Photo by Dick "Mez" Meseroll/ ESM.

Indialantic's Bryan Hewitson is known for heavy moves in heavy waves. A well-established East Coast and World Tour competitor, Hewitson takes special pride in his King of the Peak win at Sebastian Inlet in 2003. Faced with strong onshore wind, ripping current, and a relentless north swell, he won by matching force with force. This shot was taken within the same year during more photogenic conditions.

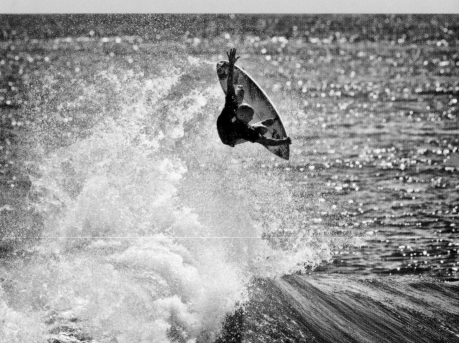

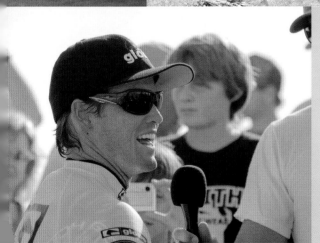

← Damien Hobgood, January 2006. Photo by Brad Styron.

Damien Hobgood wins the Globe Pro Sebastian Inlet, January 2006. Damien and CJ Hobgood are among the state's most accomplished competitors and respected surfers. Identical twins from Satellite Beach, they have risen to the top ranks of professional surfing following a multitude of wins as amateurs in the NSSA and the ESA. CJ and Damien have made reputations for themselves in small and seriously large conditions, and they have both finished in the top ten ASP end-of-the-year tour rankings together. CJ won the World Title in 2001.

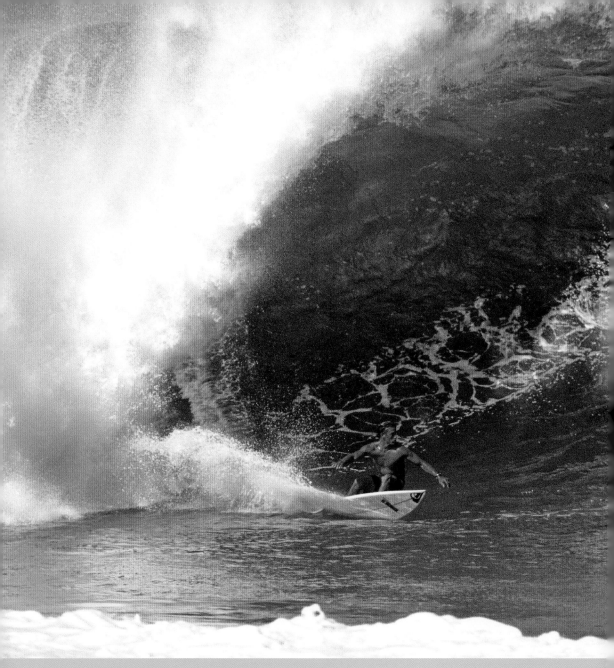

Kelly Slater, Pipeline, Hawaii, early 1990s. Photo by Jeff Divine.

Kelly Slater holds eleven WCT World Titles, a record unmatched in any sport. He has dominated his sport for longer than any other athlete in the world. While Slater won the bulk of his Pipe Masters events in the late 1990s, he won again in 2008, and in 2013 described himself as "the old lion" upon winning over Hawaii's John John Florence in epic conditions. With that win came the opportunity for a twelfth world title, and many of the millions of viewers worldwide who watched the event, claim Slater was deprived of that title through questionable quarter final wins awarded by ASP judges to earn Australia's Mick Fanning the points to take the world title. In a live, trophy stand interview, Slater joked he was pissed off enough to stick with the WCT for another year and another chance at twelve titles. With eleven WCT titles spanning nineteen years, he is the youngest and the oldest surfer to win a world title. The 2013 Pipe Masters runner-up and consecutive Triple Crown winner John John Florence was born in 1994, the same year that Kelly Slater won his first Pipe Masters competition.

→ **Kelly Slater, Awards Ceremony, Chiemsee Pipe Masters (Hawaii), Oahu, Hawaii, 1994. Photo by To Servais.**

Kelly Slater claims his first of seven Pipeline Masters titles, the only East Coaster to win this contest after Je Crawford in 1974. Slater won the 2 Billabong Pipe Masters while ridin 5' 11" board, and he finished third i 2011 on a 5' 6", pushing the preval of shorter equipment in bigger sur

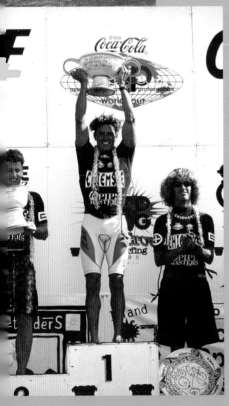

↑ Michael O'Shaughnessy, Molokai Channel, Hawaii, 2000.
Courtesy of Michael O'Shaughnessy.

On June 18, 2006, the Guinness World Record for the fastest crossing of the English Channel by paddleboard was set by Michael O'Shaughnessy, who beat the existing record set in 1994 by Hawaii's Laird Hamilton and Buzzy Kerbox. In the following week, O'Shaughnessy also set world records crossing the Irish Sea and Loch Ness, and later the Florida Straits. O'Shaughnessy, who started surfing in Cocoa Beach, is a four-time East Coast Paddleboard Champion and six-time Florida State Paddleboard Champion. He is also the only person to have completed an unescorted crossing from California to Catalina Island and back in less than twenty-four hours. Earlier in the history of paddleboarding, Mike Tabeling and Chuck Evans attempted to paddle from Bimini to Florida in 1979 to benefit the Suncoast Seabird Sanctuary; in 1983 Evans attempted the paddle again with three other Florida surfers. Two of the group made it, raising money for Greenpeace. In 1982, Lauren Baker made the first successful crossing from Bimini to Florida in twenty hours and fifteen minutes. Her board is on display in the International Swimming Hall of Fame in Fort Lauderdale.

Conceptualized in 1995 by Kelly Slater, the inaugural King of the Peak launched an annual competition for all-out performance surfing and served as a fund-raiser to draw attention to the potential closing of Cocoa Beach Junior and Senior High School, the alma mater for Kelly and generations of notable surfers from the Space Coast. King of the Peak's legacy of innovation, such as Phillip Watters's 2000 alley-oop varial, attracts current and former WCT notables and world champions. Staged in early November, the event is subject to wildly varying and often difficult conditions. Directed by Quiksilver East Coast team manager Matt Kechele, the King of the Peak is the nation's most popular skins event. Each contestant must determine what he feels will be his best wave in each heat by claiming a chosen ride to advance. When it's all over, the surfer with the most skins wins.

Iconic competitor and eleven-time world champ Kelly Slater has won the Hurley Pro at Trestles five times—the first in 2005 and the most recent in 2011. Lower Trestles is arguably one of the best high-performance waves on the planet, and the Hurley Pro has a history of amazing performances.

This February 1996 *Surfer* cover shot celebrated Lisa Andersen's second of four world titles and was only the second cover shot of a woman in the publication's then forty-year history. In 1997 she won her fourth consecutive championship. The cover shot carried a headline reading "Lisa Andersen surfs better than you."

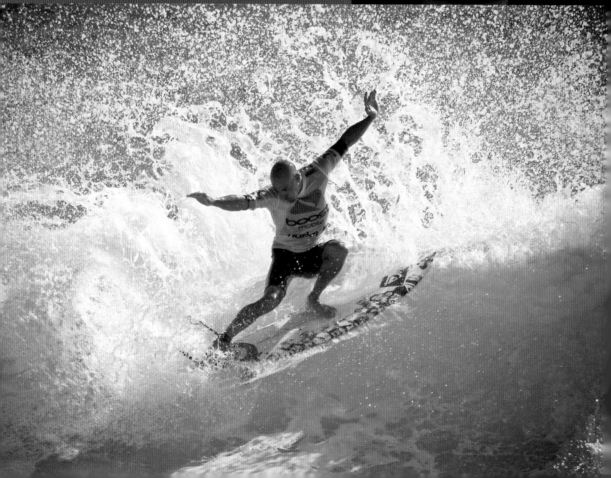

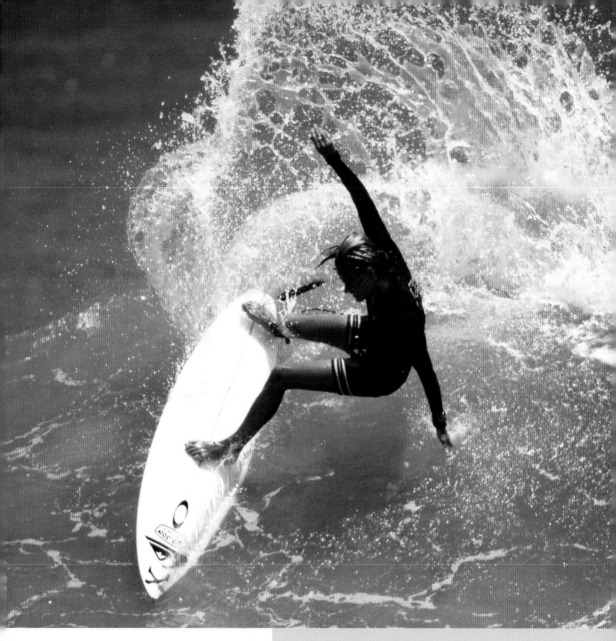

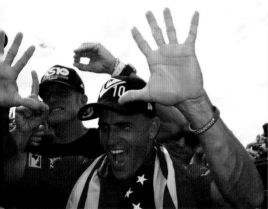

Kelly Slater, tenth World Title Win, Rip Curl Pro Search, Puerto Rico, November 6, 2010. Photo by Nathan Adams.

Kelly Slater enjoys his quarter-final win, securing his tenth World Title win in 2010 at age thirty-eight. He won his eleventh in 2011 at the Rip Curl Pro Search San Francisco, following an embarrassing situation for the Association of Surfing Professionals, which had prematurely announced his victory earlier in the contest, only to recall it due to a clerical error.

Land, Sea, and Air

CRAIG SNYDER

In the 1970s, Florida surfers and skateboarders changed their sports forever by developing the first ever no-handed aerials. But to this day, their pioneering achievements remain largely unrecognized, usually overshadowed by the accomplishments of others, as well as the usual hype and spin that can be expected from two sports that are often driven by the combined forces of ego and the marketplace. When the subject of aerial innovation in surfing comes up, most often this dialogue turns to riders from outside Florida, with Matt Kechele from Cocoa Beach and John Holeman from Satellite Beach left out of the conversation. Regardless, the first pioneers of aerials in both surfing and skateboarding were from Florida, and their revolutionary contributions and global influence cannot be denied. Skateboarding's Ollie air and surfing's Kech air maneuvers are the foundation for critical airborne maneuvers on both land and sea.

The "quest for air" began in the 1970s with skateboarding. By the late '70s, surfers, especially those of the younger generation, who skated or who followed skateboarding's rapid advancement began to see some new possibilities for surfing. Matt "Kech" Kechele, then a teenager, was one of a number of Space Coast surfers who had become interested in adapting many of skateboarding's new maneuvers to the water. In late 1978, after Kechele heard about Alan Gelfand and his miraculous Ollie air through sponsor Bruce Walker, he began to attempt to do the same in the water. By 1979, in the surf off Sebastian Inlet, Kechele successfully landed his first Ollie airs, a move he would instead refer to as a Kech air. In 1980,

Next best thing
to water skiing

Whiz along on wheels
SKEE SKATE $2³³

"Ski" or "surfboard" on your sidewalk. Push off with one
foot until you pick up speed, then put both feet on the board
and glide—using "body English" to steer. Roller skate wheels
riveted on plywood base. Red, 19x4½ in.
49 N 2453—Shipping weight 2 lbs. 8 oz......Each $2.33

← Skee-Skate, Sears catalog, Christmas 1964.

The first known commercially produced skateboard, the Skee-Skate was nothing more than a plank of plywood painted bright red with some shiny metal wheels riveted to the bottom. At the time of its release, this board seemed more closely linked to skiing than surfing, as evidenced by its name and the graphics on the top that showed slalom cones with flags. Ironically, when the Skee-Skate first came to market in 1959, the Hollywood movie *Gidget* had just hit the big screen, and by the time this Sears listing appeared in 1964, surfing had exploded in popularity across North America. The copy in this ad, in fact, suggests you could also use the Skee-Skate to "surf" the sidewalk. The connection between surfing and skateboarding would soon grow stronger.

↓ Homemade Florida skateboard, circa 1960. Collection of Craig Snyder.

An early homemade skateboard with steel wheels. Such boards were common during the 1950s and 1960s. They did not turn well and had little or no nose or tail.

fellow Space Coast surfer John Holeman took Kechele's aerial a step further, rotating the board completely around, to successfully and consistently land surfing's first known 360 aerials. In 1981, Kechele became the first surfer to win a pro surfing event using aerials. His victory at the Stubbies Pro at Sebastian Inlet that year proved to be controversial though, and as Kechele found out, his new move was decried by surfing traditionalists who considered aerials a cheap stunt.

In the 1980s, several years after Kechele began getting magazine coverage, other aerialists appeared. They included South Africa's Martin Potter and California's Kevin Reed, Davey Smith, and John McClure. These surfers, along with Hawaii's Larry Bertlemann, who scored an aerial cover with *Surfer* in March 1984, and California's Christian Fletcher, who got a *Surfer* cover in 1988, helped give the move more legitimacy. But no matter what anyone says, Matt Kechele and John Holeman were the first, and their early aerials were another pioneering moment in Florida's extraordinary surfing heritage.

Early sidewalk surfer, Jacksonville, Florida, circa 1960. Collection of Craig Snyder.

This skater, posing with a homemade board equipped with loose-bearing clay wheels, is representative of most skaters from the pre-urethane era. Many early skateboarders from the 1960s and early 1970s rode their boards in their bare feet, sometimes with street clothing like the skater pictured here, and other times in beachwear such as surf baggies. It wasn't until the 1970s, after the introduction of skateparks coupled with more difficult and dangerous maneuvers, that shoes became a necessity.

← Bobby Little, Hollywood, Florida, 1976. Photo by Craig Snyder.

Bobby Little, one of South Florida's pioneering skaters of the 1970s, getting some lift off a homemade street ramp near his house on the east side of Hollywood near North Lake. Before skateparks appeared, this was one of the more common ways for skaters to get air. Little is riding a homemade solid wood deck, Road Rider 4 urethane wheels with precision bearings, and Tracker trucks. This mid-1970s equipment was a leap from what came before it, and it allowed skaters to create moves that were never before possible.

→ Skateboard contest winners, Riviera Beach, Florida, circa 1964. Courtesy of Fred Salmon.

This is one of the earliest known contest images from the 1960s. The fact that it took place in Florida demonstrates how widespread skateboarding actually was, much like surfing. As 1950s skateboarder Ron Leiter from St. Petersburg, Florida, confided to Craig Snyder in one interview, "It was not unique to California. . . . [It was] not something I saw on the news. It happened word of mouth. It was something that got passed around the guys at my school." At contests in the 1960s, nose wheelies, endovers, and 360-degree spins were the maneuvers that won the day. Pictured left to right are Phil Salmon, Ed Baur, and George Alger. For the most part, the skate industry did not exist at this time, and many skaters, like the three riders pictured here, made and rode their own boards.

← Alan Gelfand, Ollie air. Photo by Craig Snyder.

The Ollie air was created in South Florida in 1978 on banks, flatground, and vert and named after Alan "Ollie" Gelfand, a skateboarder from Hollywood, Florida. It was a dynamic new move that helped give skateboarding an identity that set it apart from surfing. Seen here in early 1979 at the Hollywood Ramp in Pembroke Pines, Florida, is Gelfand himself, who is undisputed as the first skater to perfect the Ollie on vert and revered for doing it with a style that remains unmatched to this day. The Hollywood Ramp also holds certain celebrity status as well. Designed and built by Jeff Duerr and Kevin Peterson during the summer of 1978, it became one of the first halfpipe-style ramps to feature flatbottom, and after its exposure in *SkateBoarder* magazine during 1979, it influenced a sweeping change in ramp design around the world. Today, all halfpipes use flatbottom and most use the same dimensions, proportions, or both that the Hollywood Ramp employed back in 1978.

→ Dave Bentley, Gorilla Grip, South Beach Pier, circa 1976. Photo by Jonathan Utz.

Forms of early air, no-handed and otherwise, included the gorilla grip, a maneuver in which skaters grabbed the board with their toes to get airborne or overcome obstacles. Here, famed East Coast skater and University of Miami student Dave Bentley gorilla grips a high jump over a bar at Miami's South Beach pier in 1976.

→ Bobby Summers, North Bowl, Skateboard USA, 1977. Photo by Craig Snyder.

Considered to be the "Waimea" of skateboarding when it opened in March 1977, Skateboard USA in Hollywood, Florida, became the first skatepark in the world to have vertical. The North Bowl, with its 10 to 13 foot walls and 3 to 4 feet of vert, became the place where the first Ollie airs on vert were landed in early 1978 by Jeff Duerr. The first Ollies on banks and flatground also took place at this important proving ground, and before those, the first Ollie pops were landed by Alan "Ollie" Gelfand in the snake run of the park. Skateboard USA was demolished in 1979, as were many of the other skateparks that had been built during that era; it was unfortunate, as the '70s parks had been the critical setting where much of modern skateboarding had been born.

↓ Bro Bowl skatepark, Tampa, 2006. Photo by Craig Snyder.

Critical to skating's evolution during the 1970s were the first skateparks, many of which were strongly influenced by surfing. Names of some of the Florida's legacy parks of the 1970s were a testament to that influence. They included Solid Surf in Fort Lauderdale, the Paved Wave in Cocoa Beach and Pensacola, Concrete Surf in Miami, and Rainbow Wave in Tampa. Surfing also influenced park design. Facilities such as Kona in Jacksonville and the Bro Bowl in Tampa (two of the last surviving parks of the "skatepark era") feature snake runs, flowing courses that emulate surf and foster surf-style riding.

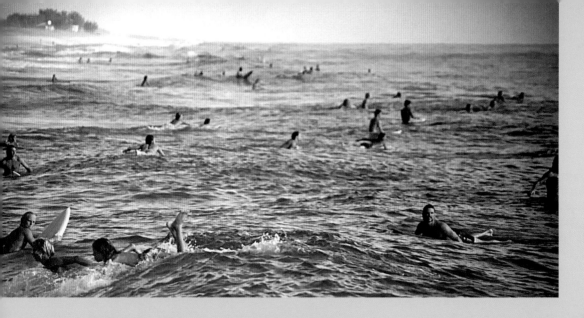

↓ **Matt Kechele "Kech air," 1979. Photo by Rich McCarey.**

This is the first known photo of Matt Kechele pulling off his landmark and revolutionary Kech air in the waters off Sebastian Inlet. Shot by friend and amateur photographer Rich McCarey, it shows a maneuver that was remarkably different from any other surf move of the time.

↘ **Matt Kechele, 1980. Photo by Bruce Walker.**

↑ **Sebastian Inlet, "a moving skate-park," 1976. Photo by Craig Snyder.**

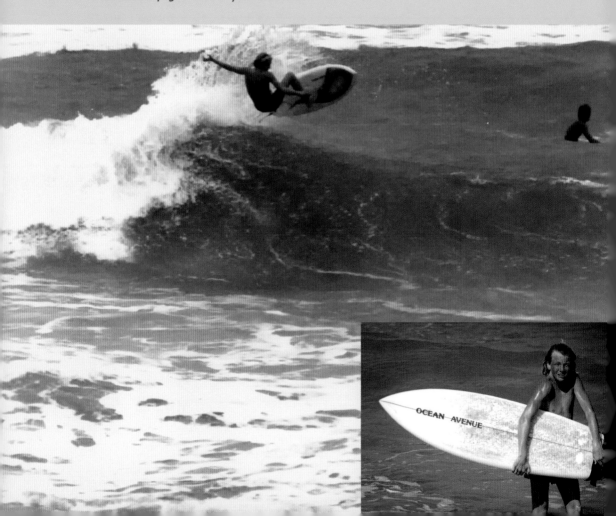

OCEAN AVENUE

↑ John Holeman, surfing 360 aerial, 1980. Photo by Greg Meischeid.

This is the first known image of the Satellite Beach surfer John Holeman performing a 360 aerial. After Holeman did his first 360 Ollie airs in 1980, he progressed by 1982 to launching doublerail-grab aerial 360s.

↗ John Holeman, April 1982. Photo by Bruce Walker.

↓ Matt Kechele and Greg Meischeid with a tow boat and two "Kech Air" models, July 1981. Photo by Bruce Walker.

Florida's shortage of quality waves has often led to improvisation. In addition to skateboarding, Florida surfers pursued wake surfing. The Whitman brothers and Tom Blake may have been the first, riding their paddleboards behind a Chris-Craft boat in the Miami region during the early 1930s. In the early 1960s, wake surfing was introduced and popularized on both coasts by Dick Pope, an innovative, world-renowned water-skier and founder of Florida's first commercial theme park, Cypress Gardens, in Winter Haven. Around 1980, Kechele (*center*) and surfer/skater Greg Meischeid (*right*) took wake surfing a step further when they introduced skateboard-based moves such as Ollies, shove-its, and frontside airs to wake surfing, and by 1981, a *Surfer* publication called *Action Now* featured the two in an article called "Freeboarding: Wakesurfing into the '80s," with a photo of Kechele in the center spread.

Florida Surf Rock, Then and Now

JAMES E. CUNNINGHAM

Florida's surf-associated rock is an offshoot of the West Coast vocal and instrumental "surf rock" genres of the early 1960s. Since that time, Florida surf rock has played a significant role in the state's popular culture. And at present, Floridian surf rock is breaking new ground in the indie rock music scene internationally.

The surf rock genre had its beginnings on the U.S. West Coast in the early 1960s. It owes its birth to the dual development of the fiberglass surfboard (longboard) and Fender electric guitar and amplifier technology. These two technological achievements were inseparably fused by the release of the Hollywood film *Gidget* in 1959, which had the effect of spreading the appeal of California beach culture throughout the United States. Above all, early surf rock was a youth movement, which actually encompassed two distinct genres, instrumental surf rock and vocal surf rock. As the name suggests, instrumental surf rock lacked vocals and featured the electric guitar, with electric bass and drum accompaniment. Most commonly associated with surf culture, it had strong county and western roots due to the influences of electric guitar pioneers such as Duane Eddy, Les Paul, and Chet Atkins. Vocal surf rock, on the other hand, had strong ties to the rock and roll of the 1950s, particularly to the bluesy guitar style of Chuck Berry and to doo-wop vocal harmonies. Musically, both genres often featured the newly introduced Farfisa electronic organ and the saxophone, which was a holdover from 1950s rhythm and blues. From its inception, surf rock existed as the sonic embodiment of technology, recreation, and youth pop culture.

THE NATION ROCKING SHADOWS

THE NATION ROCKING SHADOWS, perhaps the hottest band in Florida, have created the wildest new sounds since "Pipeline" with this their first recording - "ANESTHESIA." Realizing that the areas of surfing, hot rodding, and inter-planetary dimensions are well exploited by instrumental groups, THE SHADOWS have pioneered a new field in rock-and-roll, medicine.

"ANESTHESIA" interprets the supernatural effects of an anesthetic on the human body. The pulsing beat, portraying a heart, combined with the electronic sounds of guitars and organ, brings vividly to life the unbelieveable experiences encountered while under the influence of a powerful sleeping drug, such as ether or sodium pena-thol.

Here then, for your listening entertainment is THE SHADOWS'

"NEW CONCEPT IN ELECTRONIC ROCK - AND - ROLL !! "

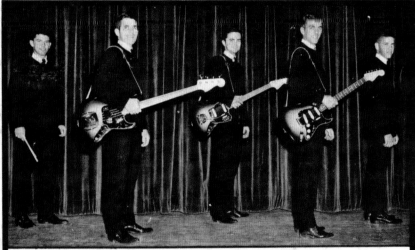

"THE NATION ROCKING SHADOWS"

David Freidman, 17, drums; Bill Thacker, 18, bass and vocals; Ron Skinner, 18, lead guitar; Sherman McGreggor, 21, rhythm guitar and vocals; Randy Boyte, 17, Organ.

↑ The Nation Rocking Shadows record sleeve. Courtesy of Jeff Lemlich.

The Nation Rocking Shadows, a band from Leesburg, had their first big surf rock classic with "Anesthesia."

→ Roby Yonge, "The Big Kahuna." Courtesy of Jeff Lemlich.

Roby Yonge, a.k.a. "The Big Kahuna," was a popular surf DJ at Miami's WQAM radio; here, he rules over a local surf contest.

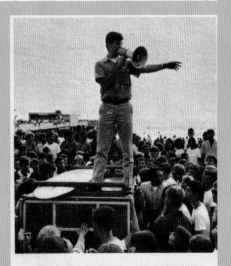

...AND NEXT YEAR YOUR KAHUNA WILL ASK FOR 10 FOOT WAVES.

The Awesome SUPER-SURFER

by Dave Holding and Jim Miller

IN THIS MONTH'S EXCITING ISSUE...
"The Birth of a Hero!"

THE AMAZING STORY OF HOW ROBY YONGE BECAME SUPER-SURFER!

ONE DAY, MANY MONTHS AGO, ROBY YONGE, MILD-MANNERED DISC-JOCKEY FOR A GREAT METROPOLITAN RADIO STATION, WAS WALKING ALONG SOUTH BEACH....

GOSH, LOOK AT THAT SHELL! IT'S GLOWING!

REALIZING WHAT A FABULOUS ADDITION THIS WOULD MAKE TO HIS COLLECTION, ROBY STARTS TO POLISH THE SHELL, WHEN SUDDENLY...

EEK!

IT'S SMOKING!

INSTANTLY, THE BILLOWING CLOUDS TAKE THE FORM OF A SURF-GENIE....

OKAY, KID! I AIN'T GOT ALL DAY! WHAT'S YOUR WISH?

A WISH? WELL....

I WANT TO HELP THE SURFERS! THAT IS, IF THEY NEED ME!

OF COURSE THE SURFERS NEED YOU....

THEY NEED ALL THE HELP THEY CAN GET!

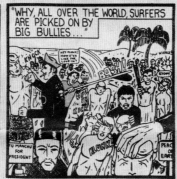

"WHY, ALL OVER THE WORLD, SURFERS ARE PICKED ON BY BIG BULLIES..."

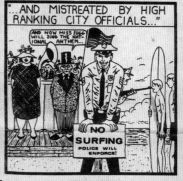

"..AND MISTREATED BY HIGH RANKING CITY OFFICIALS..."

NO SURFING POLICE WILL ENFORCE

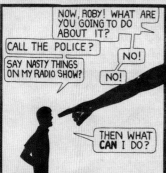

NOW, ROBY! WHAT ARE YOU GOING TO DO ABOUT IT?

CALL THE POLICE?

NO!

SAY NASTY THINGS ON MY RADIO SHOW?

NO!

THEN WHAT CAN I DO?

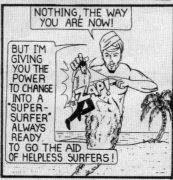

NOTHING, THE WAY YOU ARE NOW!

BUT I'M GIVING YOU THE POWER TO CHANGE INTO A "SUPER-SURFER" ALWAYS READY, TO GO THE AID OF HELPLESS SURFERS!

HIS TASK COMPLETE, THE KIND GENIE GENTLY BIDS FAREWELL TO THE GRATEFUL DISC JOCKEY....

WELL, TIME'S UP KID! GOOD LUCK!

THE NEXT DAY AT THE RADIO STATION....

AND THAT WAS THIS WEEK'S HIT..."BUCKY AND THE BUMS" SINGING "THE AKTEX THEME"!

MAOW

BUT NOW, A NEWS FLASH....

OH NO! A GIANT SQUID IS ATTACKING SOUTH BEACH!

MAOW

TAKE OVER, RICK! I'VE GOT A JOB TO DO!

I HOPE IT'S NOT SIDNEY, MY PET SQUID!

BROOM CLOSET

Drawn by Jim Miller of the Shades, the Super-Surfer cartoon illustrated how the legendary Roby Yonge became a super-hero.

The instrumental surf rock of the early 1960s was a guitar-driven genre, which featured loud volume and the clean, twangy tone produced by the Fender Stratocaster electric guitar, which was manufactured in the Southern California city of Fullerton. It is important to note that the instrumental surf guitar genre featured a very similar sound and approach as the music associated with Western, spy, and horror movies of the same time period. And due to the growing mobility of American youth via the automobile, instrumental surf rock also developed a close affinity with early 1960s car and hotrod culture. As the genre and Fender amplifier design developed in response to ever-increasing demands for volume and effects, the surf guitar sound was characterized by ever-increasing volume with disproportionate amounts of reverberation (reverb). Although early instrumental surf rock bands also hailed from the states of Washington, Arizona, and New Mexico, most music historians agree that the epicenter of instrumental surf rock was the Rendezvous Ballroom, located in Newport Beach, California, just south of Los Angeles. A former swing band hotspot in the 1930s and '40s, the Rendezvous, located on a popular surfing beach, became the scene of large dances that were frequented by young surfers and beachgoers in the early 1960s, which became known as "surfer stomps." The popularity of surfer stomps soon led to the opening of other instrumental surf rock venues such as Club Belair in nearby Redondo Beach.

The undisputed "King of the Surf Guitar" is Dick Dale. Born Richard Monsour, Dick Dale's innovative electric guitar performances at the Rendezvous Ballroom, with his group the Del-Tones, provided the impetus for the birth of instrumental surf guitar. Along with his contemporaries Eddie Bertand and Paul Johnson, of the Belairs, and fellow Del-Tone Nick O'Malley, Dick Dale pioneered the classic instrumental surf rock sound featuring both lead and rhythm guitars played at maximum volume, to a driving rock drum beat. In 1961, his hit "Let's Go Trippin'," along with the Belairs' "Mr. Moto" and the Ventures' "Walk Don't Run," are all credited as seminal surf rock tunes. In 1962, Dale released perhaps the most well-known instrumental surf tune, "Miserlou," an adaptation of a Middle Eastern oud classic, which featured a fast "wrist tremolo" picking style and full-neck slides that would mark his signature sound.

At the same time in the nearby Los Angeles suburb of Hawthorn, the Wilson brothers, Brian, Carl, and Dennis, along with their cousin Al Jardine and friend Mike Love, were developing

their own brand of vocal surf rock. As the Beach Boys, their sound melded the close vocal harmonies of 1950s groups such as the Four Freshmen and the Crew Cuts with the aggressive rock and roll style of Chuck Berry, all packaged with themes espousing the fun-in-the-sun lifestyle of Southern California youth. Their 1961 release "Surfin'" was the first of many hit songs, including "Surfer Girl," "Surfin' USA," and "Fun Fun Fun." Despite their individual stylistic differences, both instrumental surf rock and vocal surf rock would share a common association with surf and beach culture from that time to the present day.

Following the popularity of the surf scene on the West Coast, Florida, with its 663 miles of white sand beaches, was not far behind in the development of its own surf culture. Although its climate is favorable for year-round surfing, Florida has fewer surfable beaches and traditionally smaller waves with less consistent formation than those in California, due to the protective effect of the Bahamas and the Gulf of Mexico, which block the development of large ocean swells (except during hurricanes). Nevertheless, Florida developed its own surf music scene in the early 1960s. Florida's surf music scene was an offshoot of the national garage band phenomenon, which was propelled by the availability of inexpensive guitars and amplifiers. Because of its widespread geography, Florida quickly developed a number of distinct regional music scenes, in the Panhandle (Pensacola), the West Coast (Tampa Bay and St. Petersburg), Northeast Florida (Jacksonville, Daytona, and Cocoa Beach), Central Florida (Orlando), and South Florida (Fort Lauderdale and Miami). These regional music scenes were well supported by local radio stations such as WFLA in Tampa and WQAM in Miami. Disc jockey Roby Yonge, known as "the Big Kahuna" at WQAM, was particularly active in the South Florida surf and surf music scene, through the sponsorship of local surfing contests and surf music events.

Inspired by the ever-increasing number of instrumental and vocal surf recordings available from California, Florida youth in early 1960s garage bands began performing surf rock covers and beach-oriented originals at local dance halls and teen clubs throughout the state. Studies of the Florida garage band phenomenon, such as *Savage Lost,* by Florida music historian Jeff Lemlich, show that a number of bands performing surf rock were active in Florida in the early 1960s. It is important to note that the available recordings and discographies represent only a small fraction of the 1960s Florida surf music scene, since many of the surf rock bands did not

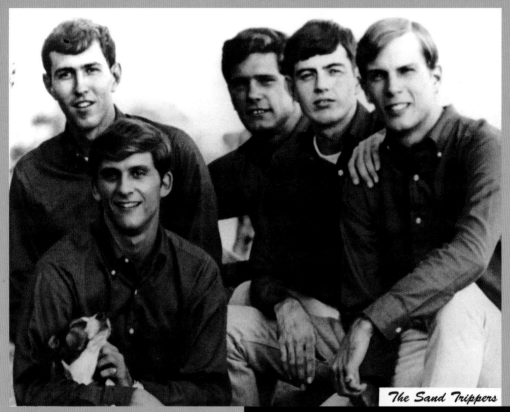

The Sand Trippers

↑ The Sand Trippers. Courtesy of Bob Melton.

The Sand Trippers were real-life surfers from Fort Pierce (*from left*): Jimmy Strange, Jon Kral (with Poo Dog), Jeff Wright, Steve Chandler, and Bob Melton.

→ Record label, "A Wave Awaits." Courtesy of Jeff Lemlich.

Miami's the Gents Five recorded the vocal surf tune "A Wave Awaits," written by rhythm guitarist Dave "Cosmo Ohms" Tubin.

MARCH
RECORDS

69A-7734

45 R. P.
2:45
PROD.
JIM SESS

A WAVE AWAITS
(Tubin)
THE GENTS FIVE
(C)

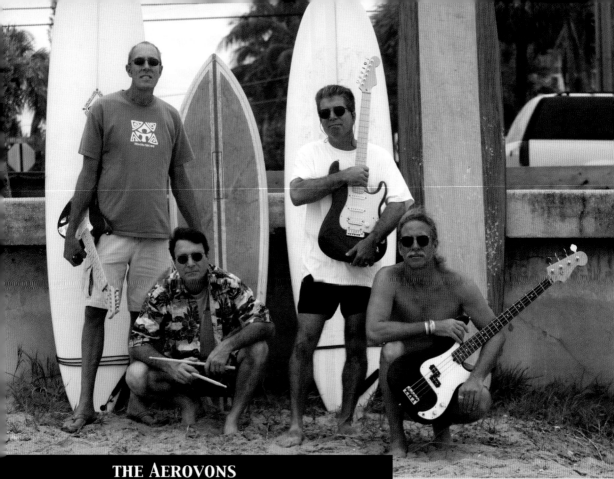

THE AEROVONS

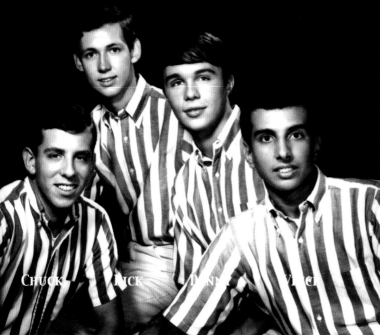

↑ Founding members of the Cutback Surf Band. Courtesy of Bob Garas Photography.

Contemporary instrumental surfers and rockers from Fort Lauderdale include Cutback Surf Band's founding members (*from left*) Rich LaVoir, Joe DiDonna, Frank Ferraro, and Nicky Ravine.

← The Aerovons. Courtesy of Chuck Kirkpatrick.

The Aerovons from Fort Lauderdale (*from left*): Chuck Kirkpatrick, Dick Cook, Denny Williams, and Vince Corrao, wearing their "Beach Boys" striped shirts.

record. Also significant is the fact that, following the national surf rock phenomenon, only a small percentage of musicians in Florida surf rock bands were actually surfers.

A few exceptions to the above trends include a popular live 1965 recording of Dick Dale's signature instrumental "Miserlou" by the the Roemans from Clearwater, and "Corkscrew," written by Chuck Kaniss of the Vanguards IV from St. Petersburg as a musical response to the Revels' 1960 surf instrumental classic "Church Key." Also noteworthy are a pair of instrumentals, "Anesthesia" and "Going Down," written by Leesburg's Ron Skinner and recorded in 1964 by his band the Nation Rocking Shadows, initially known as just the Shadows.

The single instrumental surf rock album attributed to a Florida group in this early period is *Surfers' Holiday,* released in 1963 on the Family Records label by the Nep-Tunes. However, the Nep-Tunes' Florida ties, as reported by Brian Chidester and Domenic Priore in *Pop Surf Culture,* have not been substantiated.

Other 1960s Florida instrumental surf rock bands include the Dynamics from Auburndale, who performed "garage surf versions of 'Baby Elephant Walk' and 'Summertime,'" and the Legends' "6-5-4-3-2-1," featuring Jim Stafford and a young Gram Parsons, both from Polk County in Central Florida. Following the early 1960s trend of connections between surf and car culture, Florida bands also recorded automotive-inspired instrumentals. These included the drag race songs "Drag Baby USA" and "Speed Demon," recorded by the Surftones, and "Night Drag," a reworking of "The Candy Silk Twist" with dubbed-in drag racing sound effects, recorded by the Lincolns, a studio group from Miami.

Due to the international popularity of the Beach Boys, many Florida groups followed suit by writing and recording songs with rich vocal harmonies. The Aerovons were one of the main bands in Fort Lauderdale and the South Florida area from 1964 to 1966. Bucking a national trend, they became a Beach Boys cover band after the arrival of the Beatles and played on South Beach in Miami for large crowds during local surfing contests. Few Florida vocal surf recordings actually mention surfing. Exceptions to this trend include "A Wave Awaits," a vocal surf song in the style of the Beach Boys written by Dave Tubin (a.k.a. Cosmo Ohms) of the Gents Five, and "Surfbeat USA," by the Surftones.

As reported by Ben Fong-Torres in his book *Hickory Wind*, the Shilos were a Florida folk group led by Gram Parsons, who wrote and recorded "Surfinanny" as a demo to "promote inland surfing at Cypress Gardens, and for Florida's exhibit at the 1964 World's Fair"

in New York. Although "Surfinanny" (the word is derived from folk music gatherings called hootenannies) became the "unofficial theme song for Cypress Gardens," it did not make it to the Florida World's Fair pavilion.

In Florida, the themes of 1960s vocal surf rock often focused on the state's beaches, rather than on the act of surfing itself. One such song is "Let's Go to the Beach," recorded by Larry and the Loafers from Pensacola (via Birmingham, Alabama) in 1967. Borrowing its theme from the Beach Boys' "Surfin' USA," its lyrics drop the names of several of Florida's well-known beaches. They also had an early 1960s hit with the original song "Panama City Blues," named after a popular Florida vacation destination. Likewise, the aforementioned Surftones, consisting of studio musicians Johnny Redd, Chuck Conlon, and Marshall Letter, recorded "Black Bottom Inn" about a hotspot on Daytona Beach. Musical chameleon Steve Alaimo from Miami had a local hit with his song "On the Beach," which was released on ABC Records in 1966.

As previously mentioned, many Florida "surf-rock" bands performed, but did not record, surf songs. However, their surf-oriented band names underscore the significance of 1960s Florida surf culture. Prominent among those were the Surfin' Vibrations, the Surfin' Boys, and the Stingrays, from Miami; Bobby Cash and His Surfers, and the Surfin' Tones, from Cocoa Beach; the Tropics, from St. Petersburg; the Tikis, from Fort Walton Beach; as well as the Tides, featuring Jim Miller, who went on to draw the Super Surfer comic strip.

Fort Pierce's Sand Trippers were actual surfers who initially worked out their Beach Boys–style harmonies on the beach, while waiting for the surf to build.

Other notable Florida bands reputed to have included surf rock in various forms in their repertoire include the Birdwatchers from West Palm Beach, the Candymen and the Mor-Loks from Fort Lauderdale, the Soul Searchers from Jacksonville, the Impacs from St. Petersburg, and the Torquays and the Echoes, both from Miami.

In the decades following the 1960s, interest in surf rock, instrumental and vocal, ebbed and flowed nationwide. As detailed by Kent Crowley in his 2011 book *Surf Beat,* a second wave of surf rock emerged in the late 1970s, led by surf rock guitarists and historians such as John Blair and Bob Dally, which coincided with the development of the multifinned short surfboard and intersected with the do-it-yourself (DIY) aesthetic of the punk movement in bands such as the Los Angeles–based Surf Punks. The third wave of surf rock, in the early 1990s, was propelled by Quentin Tarantino's use

"Skinny Jimmy" LeClair (*front*) and the Stingrays (*from left*), Dan "Doctor Dano" Eng, Garret "G-Man" Wood, and Chris "Savvy" Savarino, are nuevo instrumental surf rockers from Deerfield Beach

The NovaRays are (*from left*) Rob Fox, Lewis Bailey, and Geno Katko, who have been performing "Surf Music for the Masses" since "the aughts of the twenty-first century."

Russell Mofsky. Courtesy of Teajay Smith.

The founder of Miami's Gold Dust Lounge, Russell Mofsky performs "original post-surf noir . . . rock-n-roll."

The Intoxicators. Courtesy of the Intoxicators.

Serving up surf instrumental music with class, attitude, and innovation (*from left*): George Dyal, Adam Watson, Brian "Goob" Crum, and Gary Evans, the Intoxicators from Tampa.

GuyHarvey. Courtesy of Carlos Charlie Perez.

Lake Worth's GuyHarvey (*from left*), Drew Locke, Mike Nadolna, Adam Perry, and Devon Nelson, on the set for the video shoot of their beachy video *The Rope*.

of classic 1960s instrumental surf rock tunes in his film *Pulp Fiction*. The third wave was also an international phenomenon due to the increasing impact of foreign surf rock bands such as Finland's Laika and the Cosmonauts. Very little documentation of Florida surf bands exists during this time period, but it is perhaps safe to assume that, owing to the strength of the surf scene and beach culture in the state, surf rock in various forms did continue. According to Jeff Lemlich, groups such as the Randies, and the "hard core" surf band Category 5, did perform instrumental surf rock in Florida in the 1990s, but their musical legacy was limited to live performances and a few radio broadcasts.

Entering the second decade of the twenty-first century, Florida is enmeshed in what could be called a "fourth-wave surf rock movement." Unlike previous waves, the fourth wave is a contemporary Renaissance, which mixes old and new musical forms with vintage and modern equipment. It shows influences from, and it has influenced, numerous other genres, including punk, metal, country, Hawaiian, alternative, ambient, ambient rock, exotica, garage, lounge, retro, reverb rock, rockabilly, spy-fi, horror, and tiki genres. A prominent feature of the fourth wave is experimentation with new sounds and textures.

In Florida, fourth wave surf rock can be categorized into two main types, progressive instrumental surf rock and beach-oriented indie/noise-pop, which both bear some similarities and significant differences to previous surf rock styles. Currently, there is a strong contemporary instrumental movement among numerous Florida bands, with stylistically strong ties to 1960s instrumental surf rock. Musicians in instrumental groups favor either vintage or reissue Fender guitars and amplifiers and employ a wet reverb-soaked sound often provided by Fender outboard spring reverb tanks. However, contrary to the youthfulness of the 1960s musicians, Floridian fourth-wave instrumental surf rock musicians tend to be older baby boomers or thirty- to forty-year-old ex-rocker punks, many of whom were, or are, surfers. And although these groups play the standard instrumental classics such as "Pipeline," "Walk Don't Run," and "Miserlou," they also freely compose original songs in the instrumental surf rock genre.

In a similar fashion to the parallel development of instrumental surf rock and vocal surf rock in early 1960s California, a youthful contemporary rock vocal movement has established a foothold in South Florida. Although surf rock aficionados will certainly balk

at any similarities between this phenomenon and traditional surf rock, the loud volume, dense reverb-soaked texture, and emphasis on jangly guitars does suggest some sonic comparison with instrumental surf rock. Furthermore, the pop music orientation, fun-in-the-sun themes, and heavy lyric identification with beach culture are features reminiscent of vocal surf rock groups in Southern California during the early 1960s. Also, like the popularity of early instrumental surf, the music of these South Florida bands is popular within the young surfing community locally, nationally, and internationally.

Notable among South Florida's instrumental surf rock groups is the Cutback Surf Band, which has been a prominent fixture in the Fort Lauderdale surf rock scene since the earliest years of the twenty-first century. Its core members are baby-boom surfers with a history in the local rock music scene. Their repertoire includes a vast catalog of both classic and obscure surf rock instrumentals as well as more than a dozen original tunes, all featuring the dual-lead approach of guitarists Rich LaVoir and Frank Ferarro. Their surfing background, the band name "Cutback" (taken from a common surfing technique), the Florida-surf-themed titles of their original tunes, such as "Atlantico," "Shark Pit, "Secret Spot," and "Conan the Surfarian," and a between-song surf-education-banter by bassist Nicky Ravine place them in the forefront of the fourth wave of instrumental surf rock in Florida. Additionally, Cutback plays a steady gig the first Friday of every month at the Molokai Bar in the world-famous Mai-Kai restaurant, a bastion of tiki culture in Fort Lauderdale since the 1950s. As longtime surfers, their music highlights the surfing lifestyle by presenting an educational diorama of Florida surf culture, musically expressed.

Because of its consistent surf, the "Space Coast" remains a bastion of Florida surfing and surf culture. Headquartered in Satellite Beach, just south of Cape Canaveral and Cocoa Beach, "Balsa Bill" Yerkes is active in both the surfing and music scenes. Although he is best known for his surf shop and handmade balsa-wood surfboards, Balsa Bill also handcrafts ukuleles and performs his Hawaiian-inspired surf originals at local clubs. As a member of the Surf Chasers, Balsa Bill also provided the musical soundtrack for the Florida surf documentary, *The Summer of '67*.

The Haole Kats from St. Petersburg were active in the surf rock scene during the first decade of the twenty-first century. The "Kats" melded surf instrumentals with Hawaiian slide guitar and

ukuleles, which created a unique Polynesian exotica sound and highlighted the close connection between surf rock and tiki culture in Florida.

A fair number of younger musicians have also made names for themselves in the Florida instrumental surf rock scene. Perhaps a generation or so removed from the baby boomers, many of these musicians began performing rock in the 1980s, and several had their entrée into music via the South Florida punk rock scene of the 1990s. While firmly entrenched in the instrumental surf rock tradition through their performances of surf classics and an authentic reverb-soaked surf guitar sound, these younger groups also bring a punk intensity and an energetic rock spirit into both cover and original tunes.

The NovaRays are a progressive instrumental surf rock band from Orlando. Since their formation in 2003, the NovaRays, with their punk rock roots, bring an aggressive style and a DIY aesthetic with rockabilly flair to classic instrumental surf in Florida. Billed as "surf music for the masses," the NovaRays' rhythm section greatly compliments the surf instrumental lead guitar work of Lewis Bailey, a founding member of the Intoxicators, via a strong, rock-driven foundation.

Equally well-versed in the surf classics, the Intoxicators from Tampa bring a fun, worldly, and aggressive hard rock aesthetic to instrumental surf rock. Their reverb-soaked original instrumentals such as "The Goat," "I Dreamed the Best Part," and "Indira" highlight a progressive style that earned them national recognition as featured performers at the 2012 *Surf Guitar 101 Convention* in California.

Led by Jim LeClair, Skinny Jimmy and the Stingrays from Deerfield Beach is another band from the younger generation that specializes in traditional instrumental surf rock. In addition to surf rock classics like "Pipeline" and "Walk Don't Run," their repertoire includes Florida-inspired surf originals like "Hurricane Surf" and "Point Panic." Skinny Jimmy bring a strong intensity to instrumental surf because of its members' backgrounds in hard rock and punk. They have added further credibility to the South Florida instrumental surf rock scene by opening for Dick Dale in West Palm Beach in 2012 and in Fort Lauderdale in 2013.

Gold Dust Lounge (GDL) is the musical creation of Miami-born guitarist and sidewalk surfer Russell Mofsky, who began his musical journey as a puck rocker. Contrary to his punk roots, his twangy looped and reverb-laden guitar explorations, self-described as "acid surf, jazz, punk rock, spy-fi, and spaghetti western," have served

him well as a fixture of Miami's Wynwood Arts District street scene since 2009. Because of the instrumental bent of his music, Gold Dust Lounge has often been viewed as an instrumental surf rock band, as their recent opening set for Dick Dale in Miami would attest. However, the band's musical transformations caused by its revolving-door membership, combined with Russell's trippy guitar effects and spacey melodic explorations, reveal a multifaceted, highly original and innovative musical approach. As a composer of "original post-surf noir . . . rock-n-roll," Mofsky, who is currently finishing his fourth album of original material, is firmly ensconced in the avant-garde of "instrumental surf rock" worldwide.

As the popularity of Florida's surf bands and the quality of their music can attest, contemporary instrumental surf rock clearly has a strong foothold in Florida. The music resonates well with the growing number of baby boomers reliving or turning to the surf or beach lifestyle throughout the state. It also has its adherents among younger, hipster audiences with esoteric musical tastes. Florida instrumental surf rock is also linked to a growing fascination with exotica and tiki culture. The Intoxicators, the NovaRays, Skinny Jimmy and the Stingrays, and Gold Dust Lounge have all been featured performers at Fort Lauderdale's internationally renowned tiki and exotica gathering known as the Hukilau.

Yet surf rock is not the exclusive purview of instrumental surf in South Florida. At present, several indie noise-pop bands, comprising musicians in their twenties, are making waves both locally and nationally. These bands, Surfer Blood, GuyHarvey, the Jacuzzi Boys, Dr. Martino, and Beach Day among others, show some referential influence of 1960s instrumental surf rock by favoring a dominant, jangly, reverb-strewn guitar sound, as well as harmonic influences from early '60s vocal pop groups. Favoring a contemporary indie approach blended with a pop sensibility, these groups express a strong Florida beach-oriented identification. They are part of a larger surf noise-pop movement, which includes similarly inclined groups Wavves and Best Coast from California.

Hailing from West Palm Beach, Surfer Blood, led by guitarist, songwriter, and vocalist John Paul Pitts, has made a splash on the international indie rock scene since the release of their debut album *Astro Coast* in 2010. Their hometown location, surf-derived name, heavy use of guitar reverb, and beachy-themed songs such as "Swim" and "Floating Vibes" add to their immediate identification with surf culture. Since 2010, Surfer Blood has been a fixture at the SXSW (South by Southwest) music industry showcase event in Austin, Texas. Also in 2010, they headlined the Waved Out

→ **Beach Day.** Courtesy of Kimmy Drake.

Based in Hollywood ("Holly-weird"), Florida, the reverb-indie band Beach Day (*from left*), Kimmy Drake, Skyler Black, and Natalie Smallish, present an aggressive, youthful vitality and noise-pop sensibility with influences from the Ventures, the Shangri-Las, the Sonics, and the Ramones.

↘ **Dr. Martino.** Courtesy of Simone Puleo.

The members of Dr. Martino, from Boca Raton (*from left*): Michael Kaminski, Paul McBride, Steven Gula, Simone Puleo, and Pete Campbell. The band's musical performances—and fashion directions—feature "folk, prog, surf, metal, punk, rap, indie, and funk."

Music Festival in Los Angeles, along with California noise-rockers Best Coast. And in 2011, Surfer Blood played at the Nike U.S. Open of Surfing in Huntington Beach, California, the home of instrumental surf rock. Although the title of their latest album, *Pythons,* may seem to distance them from surf association, Floridians will automatically associate the name with the recent invasion of the Everglades by giant Burmese constrictors.

Guy Harvey, a band from nearby Lake Worth, shares Surfer Blood's musical approach and association with Florida aquatic culture. Their name is borrowed from an iconic Florida artist whose prints of fish adorn t-shirts and murals throughout the state. Led by Adam Perry, Guy Harvey presents loud, reverb-soaked guitar riffs and Florida-themed songs like "Never Seen Snow." In the online magazine *Impose,* Blake Gillespie describes their sound as "jangly and lo in fidelity." A review in the *New Times* by Reed Fisher notes that the video for their song "The Rope," directed by Carlos Charlie Perez, is "one of the beachiest music videos ever concocted—without ever setting foot on the sand." He continues, "Set to the robust strums of 'The Rope,' a call-and-response dandy of a jam, this clip's ready to keep the perma-summer festive here in Florida and to kick out the cobwebs anywhere else."

Rounding out the South Florida indie/noise-pop/vocal surf rock youth movement are newcomers Dr. Martino, from Boca Raton in Palm Beach County, and Beach Day, from Hollywood, Florida, in Broward County. Dr. Martino, led by guitarist and vocalist Simone Puleo, "is a rock band that embraces an eclectic mix of genres including folk, prog, surf, metal, punk, rap, indie, and funk, to name a few." They have just self-released their first album, *Right to Work*, featuring the song "Animal," with its doo-wop-inspired vocal harmonies, reminiscent of early the Beach Boys.

Hailing from the old-Florida beachfront city of Hollywood, Beach Day is an upcoming retro-surf-pop group led by Kimmy Drake (guitars and vocals) and Skyler Black (drums). Newcomers in South Florida, they released their self-titled debut single in the summer of 2012, and their first album, *Trip Trap Attack,* has just been released on Kanine Records (the same label that released Surfer Blood's debut, *Astro Coast,* in 2010). Beach Day's musical inspiration combines numerous early 1960s pop influences, including both instrumental and vocal surf genres, and mixes them with an aggressive, youthful vitality and noise-pop sensibility. Their original songs place them squarely in the South Florida and national indie music scene. As touted on Kanine Records' Web page, the music

of Beach Day is "an embodiment of their surroundings and love of '60s' girl groups. . . . Think of a female fronted Beach Boys, throw in some The Shangri-La's, The Ventures, The Sonics, Phil Spector, The Ronettes, add in contemporaries Cults, Jacuzzi Boys, Dum Dum Girls and the Black Lips and you have a soundtrack for your perfect Beach Day." Their place among other South Florida surf rock bands is expressed in a *Music Snobbery* blog review: "They [Beach Day] are like the band that sonically beats-up the resident surf rock bands."

Owing to the surf-inspired, punk/DIY, and beachy bent of contemporary Floridian bands, both instrumental and vocal, today's surf rock musicians in South Florida have created a strong regional forth-wave phenomenon. Proving the point is the recent success of South Florida "vocal surf" bands Surfer Blood and Beach Day, and the continuing popularity of cutting-edge instrumental surf rock bands the Intoxicators and Gold Dust Lounge. Perhaps most importantly, the music of these groups resonates positively among the surf culture and tiki exotica aficionados old and new within the state. The strong thematic identification with Florida surfing and beach culture (real or imagined), which is combined with loud volume, a twangy reverb-drenched guitar texture, and solid songwriting, connect these disparate bands within the regional confines of the South Florida music community. Perhaps Beach Day, which combines influences from early 1960s vocal and instrumental streams, most appropriately defines the music of the fourth-wave Florida surf rock movement.

Acknowledgments

Surfing Florida: A Photographic History began as an exhibition organized by the University Galleries, School of the Arts, Dorothy F. Schmidt College of Arts and Letters, Florida Atlantic University, Boca Raton, with Paul Aho as author/curator and Rod Faulds, director of University Galleries, as project manager.

Content contributors:

Tom Ankersen, Director, Conservation Clinic, Center for Governmental Responsibility, University of Florida, Levin College of Law; James E. Cunningham, Associate Professor of Music, Department of Music, Florida Atlantic University; Scott Edwards, Historic Preservationist, Florida Division of Historical Resources; Fred Fejes, Professor, School of Communication and Multimedia Studies, Florida Atlantic University; Mark Howard Long, Instructor, Department of History, University of Central Florida; Craig Snyder, writer, journalist, photographer, and historian of skateboarding culture; Bron Taylor, Samuel S. Hill Eminent Scholar, Graduate Program in Religion, University of Florida.

Content editors:

Evan Bennett, Assistant Professor of History, Florida Atlantic University; Jim Newell, Associate Professor of English, School of Humanities and Communication, Dayton State College.

Additional editorial assistance and fact-checking:

Pete Dooley, Scott Edwards, Jonathan Harms, Mitch Kaufmann, Mike Martin, Brad McCann, Gary Miller, Fred Salmon, Bill Whiddon. Special thanks to Tom Warnke.

Sponsors:

This project is made possible in part by grants from the Florida Humanities Council and the National Endowment for the Humanities; the Palm Beach County Cultural Council; the Roslin Family Foundation; FAU Business Services; Media Sponsor: ESM—*Eastern Surf Magazine*.

Thanks:

Barabara Groth/BigBuddhaBaba, Steve Groth, David Carson, Steve Pezman, Steve Wilkings.

Collaborators:

Bird Surfboards/Mike Pechonis; Cocoa Beach Surf Museum; ConservArt, George Schwartz; East Coast Surfing Hall of Fame; Eastern Surfing Association; Greenback Surf Club, Fort Lauderdale; International Swimming Hall of Fame, Fort Lauderdale; Mitch Kaufmann/Jacksonville Surfing Hall of Fame; Cecil Lear; Palm Beach County Surfing History Project; Miami Surf Archive Project; RICHES—University of Central Florida's Regional Initiative for Collecting the Histories, Experiences and Stories of Central Florida; Smyrna Surfari Club; Surfing Heritage Foundation; Surfrider Foundation.

Photographers:

Nate Adams, Paul Aho, Pat Altes, Tony Arruza, Bernie Baker, Gean Baron, Mark Beatie, Mickey Boucher, Donald Cresitello, Bill Davis, Cliff Del Santo, Jeff Divine, Tom Dugan, Rod Faulds, Walker Fischer, Ryan Gamma, Dick Graham, LeRoy Grannis, Kathy Hughes Griffith, M. E. Gruber, Ben Hicks, Tom Hodge, Darrell Jones, Kris Kerr, Nic Lugo,

Alan Margolis, Brad McCann, Rich McCarey, Augustine McCarthy, Nic McCue, Kem McNair, Greg Meischeid, Dick "Mez" Meseroll, Eric Olsen, Larry Pierce, Simone Reddingius, Jack Reilly, Savey Photography, Tom Servais, Chad Shindoll, David Silver, Jesse Sinclair, Cat Slatinsky, Craig Snyder, David Stahl, Brad Styron, Sykes Studio, John Tate, David Taylor, Osiris Torres, Lance Trout, Jonathan Utz, Bruce Walker, Pete Ward, Tom Warnke, Terry Williams, Jimmy "Jimmicane" Wilson, Scott Winer, Beth Anne Wright, Sonny Yambor.

Photography and vintage materials lenders:
 Paul Aho, David Carson, Jim Cartland, Mark Castlow, Dick Catri, Mike Clancy, Cocoa Beach Surf Museum, Croul Publications, Delray Beach Historical Society, East Coast Surfing Hall of Fame, Skipper Eppelin, Bud Gardner, John Grannis, Greenback Surf Club, Dave Grover, Carmen Irving, Mitch Kaufmann, Patty Light/The Gaulden Reed Estate, Chris Lundy, Mimi Munro, Oceanside Surf Club, Pat O'Hare, Palm Beach County Historical Society, Palm Beach County Surfing History Project, Scott Peterson/Greenback Surf Club, Karina Petroni, Possum's Reef Surf Club, Donald Reid, Juan Rodriguez, Rich and Phil Salick, Fred Salmon, Roy and Pam Scafidi, Smyrna Surfari Club, Surfing Heritage Foundation, Mike Tabeling, Lance Trout, Pat Valluzzi, Virginia Valluzzi, Tom Warnke, Bill Whiddon/Miami Surf Archive Project, Angela Whitman, George Williams, Sharon Wolfe, Women of the Waves, Buddy Wright, Frieda Zamba.

Student employees and interns, community volunteers, exhibition design and production community volunteers:
 Jeff Adams, Craig Chapman, Janet DeVries, Joe Gilberti, Darrell Jones, John MacDonald, Phil Marinelli, Richard Munson, John Parton, Mike Pechonis, Montana Pritchard, Brandon Tarpley, Greg Tindall.

University Galleries student employees and interns:
 Elizabeth D'Antonio, Kristina Forman, Jeanie Giebel, Daniel Rodriguez, Andrew Santaro.

Student interns and volunteers:
 Amanda Carroll, Janet DeVries, Samantha Fox, Elizabeth Hodapp, Matthew Perez, Alex Robinson, Chelse Sander, Mitch Screen.

Exhibition panel/media station design and production team:
 Craig Snyder, Media Station Coordinator; Maja Buljovcic; Danielle Myers; Andrew Santaro; Lee Sutherland; Momcilo Tasic; Tom Warnke.

Exhibition installation:
 Joshua Davis, Denise Moody-Tackley, Richard Tackley.

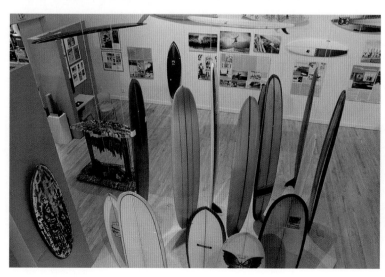

Surfing Florida: A Photographic History exhibition, Schmidt Center Gallery, Florida Atlantic University, March 2012. Photo by Paul Aho.

Sources

A number of key publications and historical resources provided names, dates, subtext, and context for much of the historical content of *Surfing Florida*. Chief among them are Matt Warshaw's pioneering *The Encyclopedia of Surfing*, as well as his monumental tome *The History of Surfing*. Other significant print resources include *The Perfect Day: Forty Years of* Surfer *Magazine,* edited by Sam George; Nat Young's *The History of Surfing* and *The Complete History of Surfing*; Drew Kampion's *Stoked! A History of Surf Culture;* and the Laguna Art Museum's exhibition catalogue *Surf Culture: The Art History of Surfing*; *Eastern Surf Magazine*; Surfline.com; the Association of Surfing Professionals site aspworldtour.com; and innumerable other websites, including LegendarySurfers.com for early historical context, and angelfire.com for regional recall in the Space Coast.

I am grateful to the many individuals who shared their knowledge and personal histories through informal interviews and formal oral histories, and to the many other sources culled together to produce this first history of surfing in and from Florida. *Surfing Florida* is backed by and responsive to academic standards.

It warrants mentioning that academic interest in the sport and history of surfing is on the rise. As *Surfing Florida* grew out of a University Galleries program at Florida Atlantic University, I wish to acknowledge use of Douglas Booth's research at University of Otago, New Zealand, while recognizing Southern Cross University, Australia; University Victor Segalen, France; University of Plymouth, U.K.; Edith Cowan University, Australia; and North Island College, Canada, some of the institutions offering surf sports management or surf science degrees.

Colburn, Bolton, Ben Finney, Tyler Stallings, C. R. Stecyk, Deanne Stillman, and Tom Wolfe, ed. *Surf Culture: The Art History of Surfing.* Madera, CA: Ginko Press, 2002.

George, Sam, ed. *The Perfect Day: Forty Years of* Surfer *Magazine.* San Francisco: Chronicle Books, 2001.

Kampion, Drew. *Stoked! A History of Surf Culture.* Layton, UT: Gibbs Smith, Publisher, 2003.

Warshaw, Matt. *The Encyclopedia of Surfing.* Orlando: Harcourt Books, 2003, 2005.

———. *The History of Surfing.* San Francisco: Chronicle Books, 2010.

Young, Nat. *The History of Surfing.* Layton, UT: Palm Beach Press, 1983; 2nd ed., Gibbs Smith, Publisher, 2006.

———. *The Complete History of Surfing: From Water to Snow.* Layton, UT: Gibbs Smith, Publisher, 2008.

Introduction

Aho, Paul, and Rod Faulds. Interview with Dudley Whitman, Whitman Family Museum, Bal Harbor, Florida, February 2008.

Cohen, Kenny. "Class of 1965." Cocoa Beach High School Alumni Association, April 3, 2011, http://cbhsalumni.org/celebrities/celebrity_cohen_k.html. Accessed September 8, 2013.

Cumming, J. Bruce, Jr. "A Brief Florida Real Estate History." Appraisal Institute, September 6, 2006, http://www.clas.ufl.edu/users/thrall/class/g3602/floridarealestatehistory.pdf. Accessed September 8, 2013.

"Dick Catri." Surfline.com, August 2000, http://www.surfline.com/surfing-a-to-z/dick-catri-biography-and-photos_781/. Accessed September 8, 2013.

"Event Program Guide." Cape Kennedy Sur-
farama, April 17, 1965.
"Frontline Evangelism Training Led by Jack
'Murf the Surf' Murphy." *Riverside House*,
http://www.riversidehouse.org/newsletter/
tag/jack-murphy/. Accessed July 14, 2009.
Funderburg, Joseph "Skipper." "Surfing
Discoveries—1907 North Carolina Surfing
Post Card Discovery." Slapdash Publications,
http://www.carolinabeach.net/surfing_his-
tory_changed.html.
"Jack Murphy." East Coast Surfing Hall of
Fame, http://www.eastcoastsurfinghallof-
fame.com/Pages/96murphy.html.
"Jack Roland Murphy (Murph the Surf)." Crime
Files, http://www.citvasia.com/crimeFile.
aspx?t=2&id=33.
Kahn, Jordan. "Surfing's Lost Chapter: How
Did Daytona Beach Become Florida's First
Surf City." *Daytona Beach News-Journal*, July
27, 2008.
Lynch, Gary, Malcolm Gault-Williams, and Wil-
liam K. Hoopes. *Tom Blake: The Uncommon
Journey of a Pioneer Waterman*. Corona Del
Mar, CA: Croul Family Foundation, 2001.
U.S. Census Bureau. "Percent of the Total Popu-
lation Who are 65 Years and Over." Geo-
graphic Comparison Table, 2009 Population
Estimates, http://factfinder.census.gov.
U.S. Department of Commerce. "1980 Census
of Population and Housing." 1981, http://
www.archive.org/stream/fwsobsusfi-
831501usfi/fwsobsusfi831501usfi_djvu.txt.

Chapter 1. Florida Surfing Origins

"Beach Combings." *Panama City Pilot*, August 4,
1921, p. 4.
Bernard, H. A. "Seabreeze and Daytona Beach."
Daytona Gazette-News, August 28, 1909, p. 2.
"The Day's Local Roundup." *St. Petersburg
(Florida) Evening Independent*, February 28,
1918, p. 7.
"Daytona Beach." *DeLand News*, September 3,
1909, p. 3.

Chapter 2. Unlikely Beginnings

"Atlantic Tropical Storm Tracking by Year."
Unisys Weather, http://weather.unisys.com/
hurricane/atlantic/, May 23, 2012.
East Coast Surfing Hall of Fame, http://www.
eastcoastsurfinghalloffame.com/.
Lumadue, Richard T. *An Institutional Autopsy at
Flagler's Kirkside: St. Augustine, Florida: His-
tory and Demise of the University Foundation

in America's Oldest City*. VDM Verlag, June
18, 2009.
Dharma Mum (Gayla Schaefer). "Mother
Ocean: Hall of Fame Profile of Mimi Munro."
Surf Guru, http://www.surfguru.com/
surfing-hall-of-fame/mother-ocean—
hall-of-fame-profile-of-mimi-munro.
Ottum, Bob. "Riding the Wave of the East
Coast's Surfing Boom." *Sports Illustrated*,
July 19, 1966.
Wilkinson, Jerry. "History of the Railroad."
Keys Historeum, http://www.keyshistory.
org/flagler.html.

Chapter 3. Florida's Maritime History

Buker, George E. *Blockaders, Refugees, and
Contrabands: Civil War on Florida's Gulf Coast,
1861–1865*. Tuscaloosa: University of Ala-
bama Press / Fire Ant Books, 2004.
Corbin, Alain. *The Lure of the Sea: Discovery of
the Seaside in the Western World, 1750–1840*.
London: Penguin Books, 1995.
Hoffman, Paul E. *Florida's Frontiers*. Blooming-
ton: Indiana University Press, 2001.
Tanner, Helen Hornbeck. "The Land and Water
Communication Systems of Southeastern
Indians." In *Powhatan's Mantle: Indians in the
Colonial Southeast*, ed. Gregory A. Waselkov,
Peter H. Wood, and M. Thomas Hatley,
27–42. Lincoln: University of Nebraska Press,
2006.

Chapter 4. Creating the Sunshine State

Aron, Cindy S. *Working at Play: A History of
Vacations in the United States*. New York:
Oxford University Press, 2001.
Bramson, Seth. *Speedway to Sunshine: The Story
of the Florida East Coast Railway*. Erin, ON:
Boston Mills Press, 2003.
Bush, Gregory W. "'Playground of the USA':
Miami and the Promotion of Spectacle."
Pacific Historical Review 68, no. 2 (May 1999):
157–87.
Davis, Jack R., and Raymond Arsenault, eds.
*Paradise Lost: An Environmental History
of Florida*. Gainesville: University Press of
Florida, 2005.
Fernandez, Susan J., and Robert P. Ingalls.
Sunshine in the Dark: Florida in the Movies.
Gainesville: University Press of Florida,
2006.
Hollis, Tim. *Selling the Sunshine State: A
Celebration of Florida Tourism Advertising*.

Gainesville: University Press of Florida, 2008.

Mormino, Gary R. *Land of Sunshine, State of Dreams: A Social History of Florida*. Gainesville: University Press of Florida, 2005.

Parks, Arva Moore. *Miami, the Magic City*. Tulsa: Continental Heritage Press, 1981.

Stronge, William B. *The Sunshine Economy: An Economic History of Florida since the Civil War*. Gainesville: University Press of Florida, 2008.

Chapter 5. Miami and Broward County

Aho, Paul. George Miller oral history. DVD, University Galleries, Florida Atlantic University (FAU); RICHES Program, History Department, University of Central Florida (UCF); Deerfield, Florida, June 2010.

Austin, Tom. "Inside Look: Miami Surf Archive Project." *Ocean Drive*, July/August 2011.

Benjamin, Scott. "Roby on Roby." Musicradio 77 WABC, www.musicradio77.com/robytribute.html.

George, Paul. "Dudley Whitman: A Profile." *South Florida History* (Historical Museum of Southern Florida) 36, no. 3, 2009.

González, Gaspar. "Stanley Whitman's Wonderful Life." *Miami New Times*, October 19, 2000.

Houston, Ross. "DACSA Communicator." Dade County Surfing Association 1, no. 2 (summer 1972).

"Journey to the Arctic Circle." *PDN*, March 4, 2010, http://www.pdnphotooftheday.com/tag/norway.

Smiley, David. "Surfer, Horticulturist William Whitman Dies." *Miami Herald*, June 1, 2007.

Warshaw, Matt. "Surfing: A History." *New York Times*, May 30, 2008, http://topics.blogs.nytimes.com/2008/05/30/surfing-a-history/.

Chapter 6. Palm Beach County and the Treasure Coast

Beard, Justin. "John McKinney's Legacy Lives On." *TCPalm,* Scripps Interactive Newspaper Group, February 3, 2011, www.tcpalm.com/news/2011/feb/03/mckinneys-legacy-lives-on.

Gibson, Terry. "Mayday, Mayday: Historic Swell Hits Florida and North Carolina." Surfline, May 11, 2007, http://www.surfline.com/surf-news/historic-swell-hits-florida-and-north-carolina-mayday-mayday_9137/photos/1/.

Hayes, Ron. "Celebrating Our History: Longboard Legacy." *Coastal Star*, March 3, 2011.

Salmon, Fred. "Surfin' the Ship." *Palm Beach Post*, March 3, 2009.

Uhrig, Robert E. "Construction of Nuclear Power Plants: A Workshop on 'Nuclear Energy Renaissance.'" Addressing the Challenges of Climate Change and Sustainability, May 8, 2008, Athens, Greece, http://ipta.demokritos.gr/Documents/UHRIG.pdf.

Weiland, James. "Local Surfing Legend Talks about Snagging His Second Cover of ESM." News Channel 5, October 22, 2010, http://www.wptv.com/dpp/sports/recreation_sports/surfing_blog/long-time-local-surfer-snags-cover-of-esm.

Chapter 7. The Space Coast

"Aerial." Surfline.com, http://www.surfline.com/surfing-a-to-z/aerial-history_732/.

Aho, Paul. Bruce Walker oral history. DVD, University Galleries, Florida Atlantic University (FAU); RICHES Program, History Department, University of Central Florida (UCF); Satellite Beach, July 22, 2010.

Aho, Paul, and Rod Faulds. Interview with Dick Catri. Melbourne Shores, Florida, November 2008.

Anderson, Andy, ed. "Campbell (Florida)." Surfing Heritage Foundation, Stoked-n-Board, Surfboards by Brands, A-Z, http://stokednboard.surfingheritage.org/pdf/Campbell_Fl.pdf.

Barilotti, Steve. "Master of His Destiny: Slater Wins Pipe Masters, Triple Crown, and the World Title, All in One Glorious Afternoon." *Surfer*, April 1996.

Bennett, Dennis. Dick Catri oral history. DVD, University Galleries, Florida Atlantic University (FAU); RICHES Program, History Department, University of Central Florida (UCF); Satellite Beach, June 2010.

———. Sharon Wolfe-Cranston oral history. DVD, University Galleries, Florida Atlantic University (FAU); RICHES Program, History Department, University of Central Florida (UCF); Satellite Beach, June 2010.

Bennison, Tobi. "Boardrider of the Month: Sharon Wolfe-Cranston." The Beachside Resident, http://thebeachsideresident.com/2011/03/boardrider-of-the-month-sharon-wolfe-cranston/, March 2011.

"The Big Issue: Special Collectors Edition, Fifty Greatest Surfers of all Time." *Surfer*, August 2009.

"Cocoa Beach Trivia." Boardheads2.com, http://www.angelfire.com/fl/boardheads2/trivia1.html.

Dixon, Peter L. "The Young Men from Florida." In *Men Who Ride Mountains*: *Incredible True Tales of Legendary Surfers*. New York: Bantam Books, 1969.

East Coast Surfing Hall of Fame Newsletter 1, no. 1, summer 2004, http://www.cityof-cocoabeach.com/citylife/SurfingNewsletters/2004/SurfingHallNewsletterVol1Issue11.pdf.

Eberwein, Bill. "Cocoa Beach Alumni." http://cbhsalumni.org/celebrities/BillEberwein_71.pdf.

Freeman, Bob. "Canaveral Pier, My 1st Sessions." Bob Freeman's Surfing Memories, http://www.bobfreemansurf.com/pierstry.htm.

Gillogly, Brian. "The Second Coming of Gary Propper." *Surfer's Journal*, winter 1994.

Haworth, Ron. "Surf Spray." *Honolulu Star-Bulletin*, March 31, 1966.

Joy, Alex. "John Holeman, Boardrider of the Month." *Beachside Resident*, September 4, 2011, http://thebeachsideresident.com/2010/12/boardrider-of-the-month-john-holeman/.

Mesanko, Greg. "Grog." AllAboutSurf.com, July 26, 2004, http://www.allaboutsurf.com/articles/grog?pg=1.

Pruett, Matt. "Sebastian Inlet: America's Ultimate Surf Park." Surfline, July 13, 2007, http://www.surfline.com/surf-news/americas-ultimate-surf-park-sebastian-inlet-spot-check_10105/.

Slater, Kelly, with Phil Jarratt. *Kelly Slater: For the Love*. San Francisco: Chronicle Books, 2008.

"The Story behind the 'Heated' Photograph." *Hometown News*, July 13, 2013, http://www.myhometownnews.net/index.php?rate=2&id=94683&article_rate=Rate!&action=submit&address=Your+email+address&words=&where=2&go=Search.

Thompson, Mike. "Waves over Puerto Rico." *Today*, September 8, 1968.

Chapter 8. Daytona and New Smyrna Beach

Aho, Paul. Members of the Smyrna Surfari Club (Gordon Smith, Doug Feindt, Bud Wright, Ross Pell, Skipper Eppelin, Ron Dreggers, Jimmy Lane, Randy Richenberg, David Coffee, and Mike Martin) oral history. DVD, University Galleries, Florida Atlantic University (FAU); RICHES Program, History Department, University of Central Florida (UCF); New Syrmna Beach, Surfari Clubhouse, July 21, 2010.

"Best Surf Towns: No. 9, New Smyrna, Florida." *Surfer*, April 5, 2009, http://www.surfermag.com/features/best-surf-towns-no-9/.

Brower, Ryan. "Jeremy Johnston Wins Coastal Edge ECSCS." *TransWorld Surf*, August 29, 2010, http://surf.transworld.net/1000113356/photos/jeremy-johnston-wins-coastal-edge-ecscs/.

Cote, Justin. "Eric Geiselman Lands the Cover of *TransWorld Surf*." *TransWorld Surf*, August 2, 2010, http://surf.transworld.net/1000110690/features/eric-geiselman-lands-the-cover-of-transworld-surf/.

Cumiskey, Kate. *Images of America: Surfing in New Smyrna Beach*. [Mount Pleasant, SC]: Arcadia Publishing, 2010.

Dixon, Chris. "New Smyrna Inlet Jetty." *Surfer*, July 22, 2010, http://www.surfermag.com/features/smyrnainletjetty/.

Florida Department of Environmental Protection. "Ponce de Leon Inlet Management Study Summary of Findings Report and Recommended Implementation Plan." Submitted by Taylor Engineering, Inc., March 1994, http://bcs.dep.state.fl.us/bchmngmt/p-deleon.pdf.

Geiselman, Eric. "Contest Results for Eric Geiselman," www.ericgeiselman.com; also http://ericgeiselman.blogspot.com/.

Kahn, Jordan. "Surfing's Lost Chapter: How Did Daytona Beach Become Florida's First Surf City?" *Daytona Beach News-Journal*, July 27, 2008.

Kerr, Kris. "Man Took Photo of Attacking Shark before Punching It." *Huffington Post*, September 10, 2010, http://www.huffingtonpost.com/2010/09/10/man-punches-shark_n_711981.html.

Mouchel, Johann. "Who Is Jeremy Johnston . . . a Sober, Competitive, Career Destroyer." *Freaksurf Magazine*, http://www.freaksurf-mag.com/interview-with-jeremy-johnston-406.html.

"Ponce de Leon Inlet, Florida, Volusia County, Navigation Study, Final Feasibility Study with Final Environmental Assessments,"

http://www.saj.usace.army.mil/Divisions/
Planning/Branches/Environmental/DOCS/
OnLine/Volusia/PonceDeLeonInlet/
NavStudy/5-CoverLetter_and_ToC.pdf.

Ponce de Leon Inlet Lighthouse Preservation
Association. "History of the Ponce de Leon
Inlet Light Station." Ponce de Leon Inlet
Lighthouse and Museum, http://www.pon-
ceinlet.org/history.cfm.

Pruett, Matt. "Breeding Grounds, New Smyrna
Beach." Surfline.com, http://www.surfline.
com/surf-news/breeding-grounds-new-
smyrna-beach_53606/.

———. "Gorkin Flip." *Eastern Surf Magazine*,
http://www.easternsurf.com/flash/features/
airsickness/text/19.swl.

———. "Nobody Knows: Inside the Other
Inlet." LostEnterprises.com, http://1991.
lostenterprises.com/prod/newsArtical.
php?ID=1025 (originally published in *Eastern
Surf Magazine*, January 21, 2007, www.east-
ernsurf.com/nsb118.html).

Reed, Gaulden, and Patti Light. *Once Upon a
Wave (Stories from a Man Who Spent 76 Years
of His Life Surfing)*. LightWaves Publishing,
2008.

"UCF's Amy Nicholl named NSSA 'Captain
of the Year.'" Surfersvillage, April 5, 2011,
http://www.surfersvillage.com/surf-
ing/51242/news.htm.

"Volcom Pipeline Pro: Day 2 Photos and
Highlight Videos." *TransWorld Surf*,
January 30, 2010, http://surf.transworld.
net/1000095438/photos/volcom-pipeline-
pro-day-2-photos-and-highlight-videos/.

Zimmerman, Steve. "Geiselman Boys Carry On
Family Tradition." *Hometown News*, May 12,
2006, http://www.myhometownnews.net/.

Chapter 9. Northeast Florida

"Asher Nolan Wins Quiksilver Pro New York
Trials Event." Surfersvillage, September 4,
2011, http://www.surfersvillage.com/surf-
ing/53229/news.htm.

Caldwell, Alicia. "Female Athletes Gaining
Notice on the Waves." *St. Petersburg Times*,
June 3, 2003, http://www2.ljworld.com/
news/2003/jun/03/surfer_girls/?print.

Carroll, Nick. *Fearlessness: The Story of Lisa An-
dersen*. San Francisco: Chronicle Books, 2007.

Coen, Jon. "The Real Surf City: Asher No-
lan Wins the Unsound Pro in New York."
Surfline.com, http://www.surfline.com/surf-
news/article.cfm?id=1507.

"The Cove Movie: Synopsis." The Cove Movie,
http://www.thecovemovie.com/the_cove/
synopsis.htm.

Fitzroy, Maggie. "Beaches' Surfing History
Rides a Wave of Interest." *Florida Times
Union*, June 7, 2008, http://jacksonville.com/
tu-online/stories/060708/nes_286860079.
shtml.

"Frieda Zamba." Surfline.com, http://www.
surfline.com/surfing-a-to-z/frieda-zamba-
biography-and-photos_952/.

"Frieda Zamba—Biography." World Champions
of Surfing, a Virtual Surf Museum, IDW
Publishing, http://www.worldchampionsof-
surfing.com/frieda-zamba-biography/.

Heller, Peter. "Return to the Killing Cove."
Men's Journal, July 30, 2009, http://www.
mensjournal.com/return-to-the-killing-cove.

Kaufmann, Mitch. "You Should've Been Here
Yesterday: 'Hanging 10': The History of Surf-
ing in the Jacksonville Beaches." Beaches
Museum and History Park. June 12–Septem-
ber 28, 2008.

"The Last Qualifier: Gabe Kling Interview."
TransWorld Surf, January 10, 2011, http://
surf.transworld.net/1000122716/features/
the-last-qualifier-gabe-kling-interview/.

Leifermann, Henry. "Zamba the Great: Forget
Gidget. Meet Frieda, Who Caught a Wave
and Is Sittin' on Top of the World." *Palm
Beach Sun Sentinel*, June 1, 1986, http://
articles.sun-sentinel.com/1986-06-01/fea-
tures/8602020247_1_today-frieda-zamba-
professional-surfing-surfing-magazine/3.

"Lisa Andersen." Surfers' Hall of Fame, July 20,
2002, http://www.hsssurf.com/shof/?p=22.

Longenecker, Bill. "Wavelengths: History of
Surfing at the Beaches Exhibit a Wonder-
ful Journey." *Florida Times-Union*, http://
jacksonville.com/tu.online/stories/070508/
nes_299773458.shtml.

McGregor, Nick. "Category Five Jim-
micane: The Jimmy Wilson Portfolio."
Eastern Surf Magazine, http://www.
easternsurf.com/index.php?option=com_
k2&view=item&id=18:category-five-
jimmicane&Itemid=129.

Nunn, Kem. "Frieda Zamba Rides High on
Surfing's New Wave: The Three-Time World
Champ Revolutionized Women's Pro Surf-
ing." *Los Angeles Times*, November 1, 1987,
http://articles.latimes.com/1987-11-01/
magazine/tm-17557_1_frieda-zamba.

Ocean Preservation Society, http://opsociety. org/home.htm.

Petroni, Karina. "Projects." KarinaPetroni.com, http://www.karinapetroni.com/projects. html.

"Shawn Patrick Balbier Jr." *Palm Beach Post,* Obituaries, June 18, 2009, http:// www.legacy.com/obituaries/palmbeach-post/obituary.aspx?n=shawn-patrick-balbier&pid=128575125.

Standora, Leo. "Shark Attack in Stuart, Florida: Kiteboard Surfer Stephen Schager Dies after Swarm Attacks." *New York Daily News*, February 4, 2010, http://www.nydailynews. com/news/national/shark-attack-stuart-florida-kiteboard-surfer-stephen-schager-dies-swarm-attacks-article-1.193337.

Thompson, Lorraine. "Beyond Surfing: Pedro Menendez High School Grad Lauren Hill Chose College over Professional Surfing." StAugustine.com, May 25, 2008, http:// staugustine.com/stories/052508/commu-nity_052508_076.shtml.

Wavemasters.org, http://www.wavemasters. org/.

Wicker, Collin. "Major Eye Injury Won't 'Stop' Local Surf Pro: Barclay Needs Two Surgeries, Help from Local Surf Community." StAugustine.com, August 19, 2006, http://stau-gustine.com/stories/081906/surfer_ban-ter_sb0819.shtml.

Chapter 10. The Emerald Coast, Florida's Panhandle

Aho, Paul, and Rod Faulds. Interview with Yancy Spencer III, Pensacola, Florida, 2008.

Blanc, Jerry. "An Old and Almost Forgot-ten Interview with Mark Foo, 1988–89." *Independent Surfer*, April 18, 2011, http:// www.stumbleupon.com/su/298MA9/www. theindependentsurfer.com/lead-article/an-old-and-almost-forgotten-interview-with-mark-foo/.

"Brian Waters: Pensacola Surfing and Board Building Icon." *Independent Surfer*, April 18, 2011, http://www.youtube.com/ watch?v=UMTxt4kO_84.

"Hurricane Gordon Preliminary Report." Na-tional Hurricane Center, 1995, http://www. nhc.noaa.gov/1994gordon.html (retrieved October 4, 2007).

"The Last of the Centaurs?" *TransWorld Surf*, May 12, 2010, http://surf.transworld.

net/1000105097/features/the-last-of-the-centaurs/.

Light, Patti. "I Am Legend: Yancy Spencer III." *Eastern Surf Magazine*, no. 144, May 2010.

McCarthy, Jessica. "First SUP and Surf Contest on Gulf Coast." Navarrepress.com, http:// navarrepress.com/news/16/3469-first-sup-and-surf-contest-on-gulf-coast.

National Park Service. "Fort Pickens." Gulf Islands National Seashore, http://www.nps. gov/guis/planyourvisit/fort-pickens.htm.

Pasch, Richard. "Hurricane Gordon, 8–21 November 1994." National Hurricane Center, January 10, 1995, http://www.nhc.noaa. gov/1994gordon.html.

Prodanovich, Todd. "Sterling on Winning the Battle of the Blogs and Reaching a Cross-roads in Life." Surfermag.com, October 13, 2011, http://www.surfermag.com/features/ sterling-spencer-interview-2/.

"Rick Bullock: Surfboard Builder, Surfing Memories, and Being from Pensacola." *In-dependent Surfer*, April 4, 2011, http://www. youtube.com/watch?v=L4IertFRD8Q&list=U UK8kk3kpozhPr3ZZnZos_WQ&index=12.

"RIP: Yancy Spenser III: 'Godfather' of Gulf Coast Surfing Passes Away at 60." Surfline. com, February 15, 2011, http://www. surfline.com/surf-news/rip-yancy-spencer-iii_52539/.

Smith, Chas. "Jordy v2.0." *Surfing Magazine*, May 6, 2011, http://www.surfingmagazine. com/blogs/jordy-v2-0/.

"Sterling Spencer." Billabong.com, http://www. billabong.com/us/team-rider/surf/351/ sterling-spencer.

"Unraveling the 'Human Boardslide' with Ster-ling Spencer." *Surfer*, http://www.surfermag. com/features/sterling_spencer_controver-sial_web_clip_human-boardslide/July 22, 2010.

"Waterboyz Factory." Waterboyz, http://www. waterboyz.com/factory.

Chapter 11. The Southern Gulf

Aho, Paul. E-mail correspondence with David Stahl, June 2013.

———. Interviews with Chris Lundy, Juan Rodriguez, Joe Nusso, and Pete Lopez, 2009–2010.

Baker, Tim. "Chris Lundy's Creative Connec-tion." *Surfer's Journal* 4, no. 6 (winter 2005).

"Hurley Opens Boardshort Specialty Store in Hossegor." *Action Sports Business Europe*,

July 7, 2011, http://www.surfersvillage.com/
surfing-news/52423#.UivhPBazv2M.

"Inspiration." Surfing Heritage Foundation, Stoked-n-Board, http://stokednboard.surf-ingheritage.org/pdf/Inspiration_Fl.pdf.

Klinkenberg, Jeff. "Surf Madness: A Sunny, Happy Sickness." *St. Petersburg Times*, October 24, 1978.

McCurdie, Jim. "Surf's Up: For Old Guard, Riding Waves Continues to Be a Way of Life: A Look at Recreation and Outdoor Life in Orange County during the Summer." *Los Angeles Times*, July 2, 1986.

"Mike McGill." McGill's Skateboard Shop, http://www.mcgillsskateshop.com/mcgill.html.

Neely, Jeff. "Looking West." Gulfster.com, http://www.gulfster.com/Lessern/LookingWest.html.

Putnam, Bob. "Skateboarding Glory Rolls through Tampa Event." *St. Petersburg Times*, March 11, 2006.

Weiss, Werner. "Cypress Gardens: Before and After LEGOLAND Florida." Yesterland, October 21, 2011, http://www.yesterland.com/cypressgardens.html.

Chapter 12. Travel and Wanderlust

George, Sam. "Sacred Hunger: The Story of Surf Exploration." *Surfer* 41, no. 10.

Gilovich, Dave. "Sea of Darkness." Surfline.com, August 17, 2009, http://www.surfline.com/surf-news/sea-of-darkness-documentary_29650/.

"Interview: Jeff Divine." Surfermag.com, July 10, 2010, http://www.surfermag.com/features/jdintrvu/.

Ponting, Jess. "Consuming Nirvana: An Exploration of Surfing Tourism Space." Ph.D. thesis, Graduate School of the University of Technology, Sydney, Australia, January 2008.

Whitman, Dudley. "Comanche to an Out Island." *International Surfing*, September 1969.

Yates, Larry. "Forgotten Island of Santosha." *Surfer*, May 1974.

Chapter 13. Expatriates

"Betty Depolito." Around Hawaii: Oceanic Time Warner Cable's Community Website, http://www.aroundhawaii.com/banzai-betty-blog.html.

"Dawn Patrol with Sea Pony: Jenni Flanigan."
JettyGirl, http://www.jettygirl.com/features/jenni.flanigan.html.

Joy, Alex. "Boardrider of the Month: Connie Arias." *Beachside Resident* 6, no. 4 (June 2010), http://thebeachsideresident.com/2010/06/boardrider-of-the-month-connie-arias/.

Kristy Murphy's Siren Surf Adventures, http://www.sirensurfsupyoga.com/SirenSurfAdventures/.

Chapter 14. Shapers and the Surfboard Industry

Brzostek, Arsen. "Profile: Juan Rodriguez of One World Surfboards and Products: Juan's World." *Surfer's Path*, October 19, 2007, http://surferspath.mpora.com/uncategorized/profile-juan-rodriguez-of-one-world-surfboards-products.html.

"Campbell Surfboards." Surfing Heritage and Culture Center, http://www.surfingheritage.org/2011/01/campbell-surfboards.html.

"Controversial Surfboard Maker Back in Jacksonville Beach." *Florida Times-Union*, January 14, 2009, http://jacksonville.com/community/shorelines/2009-01-14/story/controversial_surfboard_maker_back_in_jacksonville_beach.

Freeman, Bob. "Bob Freeman's Surfing Memories: Surf Reporting/Broadcasting." Bobfreemansurf.com, http://www.bobfreemansurf.com/surfrpt.htm.

"History of the FISH Courtesy of Swaylocks." Surfermag.com, Swaylock's Surfboard Design Discussion Forum Archive, July 13, 2004–September 14, 2010, http://forum.surfermag.com/forum/showflat.php?Number=516582.

Hunter, Josh. "Eastern Surf Magazine Celebrates 20th Anniversary." *TransWorld Surf Business*, January 17, 2011, http://business.transworld.net/55254/features/eastern-surf-magazine-celebrates-20th-anniversary/.

"Juan Rodriguez Wins First Florida Shape-Off at Surf Expo." *Surfer's Path*, January 17, 2008, http://surferspath.mpora.com/news/events/juan-rodriguez-wins-first-florida-shape-off-at-surf-expo.html.

McGregor, Nick. "I Am Legend: Larry Pope." *Eastern Surf Magazine* 19, no. 145 (June 2010).

———. "Inside Pope's Cathedral." *Surfer's Journal* 18, no. 3, summer 2009.

Pruett, Matt. "Backlighting: How The Daytona State College School of Photography Enlightened Florida's Brightest Young Surf Lensmen." *Eastern Surf Magazine* 19, no. 145 (June 2010).

"Ricky Carroll Wins Tribute to the Masters Shape-Off." *Surfer's Path*, October 15, 2008, http://surferspath.mpora.com/news/industry/ricky-carroll-wins-tribute-to-the-masters-shape-off.html.

"Steve Forstall." *Independent Surfer*, March 4, 2010, http://www.youtube.com/watch?v=2jVBPBVWnCg.

"Surf Expo: About Surf Expo," http://vimeo.com/user845469.

"30 Years with Bob Mignogna." Surfingmagazine.com, November 6, 2003, http://www.surfingmagazine.com/news/110703_mignogna/.

Chapter 15. Religion and Surfing's Spiritual Core

Caruso, Mandy. "Healing Waters." *Surfer's Path* 50 (August/September 2005): 124–29.

Colburn, Bolton, Ben Finney, Tyler Stallings, Craig R. Stecyk, Deanne Stillman, and Tom Wolfe. *Surf Culture: The Art History of Surfing*. Corte Madera, CA: Ginko Press, 2002.

Fournlander, Abraham. *Abraham Fournlander's Collection of Hawaiian Antiquities and Folklore*. Vols. 4–6 of *Memoirs of the Bernice P. Bishop Museum*. Ed. Thomas G. Thrum. Honolulu, 1916–1920.

Hamilton, Bethany, Sheryl Berk, and Rick Bundschuh. *Soul Surfer: A True Story of Faith, Family, and Fighting to Get Back on the Board*. MTV, 2004.

Hening, Glenn, and Bron Taylor. "Surfing." In *Encyclopedia of Religion and Nature*, ed. Bron Taylor, 1607–12. London: Continuum International, 2005.

Houston, James D., and Ben Finney. *Surfing: A History of the Ancient Hawaiian Sport*. Rev. ed. Rohnert: Pomegranate Art Books, 1996.

Kampion, Drew. *The Book of Waves: Form and Beauty on the Ocean*. Santa Barbara, CA: Arpel Graphics/Surfer Publications, 1989.

———. *Stoked! A History of Surf Culture*. Salt Lake City, UT: Gibbs Smith, 2003.

———. *The Way of the Surfer*. New York: Harry N. Abrams, 2003.

Kotler, Steven. *West of Jesus: Surfing, Science, and the Origins of Belief*. New York: Bloomsbury, 2006.

Leuras, Leonard. *Surfing: The Ultimate Pleasure*. New York: Workman International, 1984.

Lynch, Gary, Malcolm Gault-Williams, and William K. Hoopes. *Tom Blake: The Uncommon Journey of a Pioneer Waterman*. Corona Del Mar, CA: Croul Family Foundation, 2001.

"Nature=God: It's Official: Surfing Is a Religion." *Surfing Magazine* 44 (July 2008).

"The New Aquatic Nature Religion." *Drift Magazine* 1, no. 3 (August 2007): 14–21.

Shifren, Nachum. *Surfing Rabbi: A Kabbalistic Quest for Soul*. Los Angeles: Heaven Ink Publishing, 2001.

Taylor, Bron. "Aquatic Nature Religion." *Journal of the American Academy of Religion* 75 no. 4 (2007): 863–74.

———. "Surf é religião." *Almasurf Revista* 25, no. 68: 28–43 (May 2012).

———. "Surfing into Spirituality, and a New, Aquatic Nature Religion." *Journal of the American Academy of Religion* 75 no. 4 (2007): 923–51.

———. "Surfing Spirituality." In *Dark Green Religion: Nature Spirituality and the Planetary Future*. Berkeley & Los Angeles: University of California Press, 2010.

Warshaw, Matt. *The Encyclopedia of Surfing*. New York: Harcourt, 2003.

Young, Nat. *A History of Surfing*. Sidney, Australia: Palm Beach Press, 1983.

Chapter 16. The Right to Surf

Hill, Lauren, and J. Anthony Abbott. "Representation, Identity, and Environmental Action among Florida Surfers." *Southeastern Geographer*, 49, no. 2 (summer 2009).

"Loss of Surfing Habitat." Sustainable Surf, http://sustainablesurf.org/eco-education/loss-of-surfing-habitat/2013.

Oram, Wendy, and Clay Valverde. "Legal Protection of Surf Breaks: Putting the Brakes on the Destruction of Surf." *Stanford Environmental Law Journal* 13 (1994): 401.

Playford, Adam. "County Kills Singer Island Breakwater Project, Siding with Environmentalists." *Palm Beach Post*, March 22, 2011.

Sullivan, Jennifer A. "Laying Out an Unwelcome Mat to Public Beach Access." *Journal of Environmental and Land Use Law* 18 (2002–2003): 331.

"300-Ft. No-Surf Zone Plan around Flagler Beach Pier Has Surfers Angling for Battle." FlaglerLive.com, October 24, 2011, http://flaglerlive.com/30029/no-surfing-flagler-pier/.

Chapter 17. Competitions

Aho, Paul. E-mail correspondence with Michael O'Shaughnessy, January 12–June 12, 2013.

Booth, Douglas. "Ambiguities in Pleasure and Discipline: The Development of Competitive Surfing." *Journal of Sport History* 22, no. 3 (fall 1995).

———. "From Bikinis to Boardshorts: Wahines and the Paradoxes of Surfing Culture." *Journal of Sport History* 28, no. 1 (spring 2001).

Borte, Jason. "Ten: Ain't No Moun-Ten High Enough: A Decades-Long Look Back at Kelly's Ten World Titles." Surfline.com, November 6, 2010, http://www.surfline.com/surf-news/aint-no-moun-ten-high-enough—a-decades-long-look-back-at-kellys-ten-world-titles_49336/.

"History: Contest Results: 1966 World Championships, San Diego, California, October 1966." Surfresearch.com.au, http://www.surfresearch.com.au/0000h_contests.html.

"Hobgood Twins 1st and 2nd at Globe Sebastian Inlet Pro." Surfersvillage, January 12, 2006, http://www.surfersvillage.com/surfing/19864/news.htm.

Hodge, Tom. "World Small Wave Championships." *Surfing East Magazine* 2, no. 5 (1967).

Misetch, Yvonne. "Kelly Slater Wins Hurley Pro at Trestles over Owen Wright in Historic Final." Quiksilver.com, September 21, 2011, http://blog.quiksilver.com/surf_blog/kelly-slater-wins-hurley-pro-at-trestles-over-owen-wright-in-historic-final/.

"Surfing East Grand Prix of Surfing." *Surfing East Magazine* 2, no. 5 (1967).

"35 Years of the Easterns." Eastern Surfing Association, http://www.surfesa.org/content/view/33/35/.

"2012 ASP World Tour Schedule and Ratings." Association of Surfing Professionals, North America, www.aspnorthamerica.org.

Chapter 18. Land, Sea, and Air

Aho, Paul. Bruce Walker oral history. DVD, University Galleries, Florida Atlantic University (FAU); RICHES Program, History Department, University of Central Florida (UCF); July 22, 2010.

Bolster, Warren. *The Legacy of Warren Bolster: Master of Skateboard Photography*. N.p.: Concrete Wave Editions, 2004.

Cassimus, James. "Freeboarding: Wakesurfing into the '80s." *Action Now*, October 1981.

Graves, Lewis. "The Kids Are Alright." *Surfer*, December 1979.

"Larry Bertlemann." *The Surfer's Journal: Biographies: Jeff Hakman and Larry Bertlemann* (DVD), 2005. http://www.youtube.com/watch?v=cIlVUVZs2YA.

"Moments in Time." *Sidewalk Surfer*, December 1996.

Powell, George. "Alan Gelfand Interview." *Powell Skateboards Team Zine*, spring 1999.

Redondo, Don. "History of the Skateboard." *Thrasher*, June 1989.

Snyder, Craig. "Getting Around." *Quarterly Skateboarder*, October 1965.

———. Interviews, phone calls, and e-mail correspondence with Steve Anderson, Jeff Duerr, Rick Furness, Alan Gelfand, Scott Goodman, Jim Goodrich, Betsy Gordon, John Holeman, Matt Kechele, Ron Leiter, Dan Murray, Frank Nasworthy, Bert Parkerson, Kevin Peterson, Paul Schmitt, Lance Smith, Scott Starr, and Bruce Walker, 2004–2011.

Vickers, Lu. *Cypress Gardens, America's Tropical Wonderland: How Dick Pope Invented Florida*. Gainesville: University Press of Florida, 2010.

Chapter 19. Florida Surf Rock, Then and Now

"The Aerovons." Limestone Lounge (message board), http://limestonelounge.yuku.com/topic/648/THE-AEROVONS#.TzaV9vlnDXg.

Alton, William. "Interview with Guy Harvey Lead Singer Adam Perry." BeachedMiami.com, November 3, 2010, http://www.beachedmiami.com/2010/11/03/interview-guy-harvey-lead-singer-adam-perry/.

"Balsa Bill," http://www.balsabill.com.

"Beach Day." Kanine Records, http://kaninerecords.com/beachday.

Blair, John. *The Illustrated Discography of Surf Music 1961–1965*. 4th ed. Corona Del Mar, CA: Popular Culture Ink, 2008.

Dugo, Mike, Interview with Ron Chassner. *The Gents Five/Leaves of Grass*, www.60sgaragebands.com, http://home.unet.nl/kesteloo/gentsfive.html.

Chidester, Brian, and Domenic Priore. *Pop Surf Culture: Music Design, Film, and Fashion from the Bohemian Surf Boom*. Santa Monica, CA: Santa Monica Press, 2008.

Crowley, Kent. *Surf Beat: Rock 'n' Roll's Forgotten Revolution*. New York: Backbeat Books, 2011.

Cunningham, James. Interview with Jeffrey M. Lemlich, July 14, 2012.

"Dr. Martino: About." Facebook, https://www.facebook.com/drmartinoband/info.

Dugo, Mike. "The Gents Five/Leaves of Grass." Interview with Ron Chassner, www.60sgaragebands.com, http://home.unet.nl/kesteloo/gentsfive.html.

———. "Sand Trippers." Interview with Bob Melton, 60sgaragebands.com, http://www.60sgaragebands.com/sandtrippers.html.

Fisher, Reed, "Video: Guy Harvey's 'The Rope' Is Mostly Safe for Work." Broward/Palm Beach New Times Blogs, November 15, 2010, http://blogs.browardpalmbeach.com/countygrind/2010/11/video_guy_harveys_the_rope_has.php.

Fong-Torres, Ben. *Hickory Wind: The Life and Times of Gram Parsons*. New York: St. Martin's Publishing, 1998.

Gillespie, Blake. "Guy Harvey 7": Drunk at the Dog Park, Admiring the View." *Impose*, February 24, 2012, http://www.imposemagazine.com/bytes/guy-harvey-7.

Glover, Bo. "The Roemans: An Interview with Bo Glover." Beyond the Beat Generation: The Undiscovered Area of 60's Underground, http://home.unet.nl/kesteloo/roemans.html.

"Gold Dust Lounge," http://www.golddust-lounge.com/.

Lemlich, Jeffery M. *Savage Lost, Florida Garage Bands: The 60s and Beyond*. Plantation, FL: Distinctive Publishing, 1992.

"Surfer Blood." *Surfing Magazine*, April 23, 2010, http://www.surfingmagazine.com/sounds/sounds-surfer-blood/.

"Florida Rocks Again!" Garagepunk Hideout, http://garagepunk.com/profile/FloridaRocksAgain.

Wilkening, Matthew. "Surfer Blood Interview: SXSW," March 14, 2010, http://www.spinner.com/2010/03/14/surfer-blood-interview-sxsw-2010/.

Paul Aho grew up in Ocean Ridge, Florida, and began surfing in 1964. A former competitive surfer, Aho now heads the Paducah School of Art and Design in west Kentucky, where he serves as dean and teaches digital photography. His career as an artist includes recognition as a two-time recipient of the South Florida Cultural Consortium's Visual and Media Artists Fellowship, an extensive exhibition history, and a career that includes significant educational and administrative positions in service to arts and community.

W. Rod Faulds, project director of the *Surfing Florida* exhibition, is director of University Galleries at Florida Atlantic University.

Tom Ankerson is director of the Conservation Clinic at the Center for Governmental Responsibility at the Levin College of Law at the University of Florida.

James E. Cunningham is associate professor of music at Florida Atlantic University. An ethnomusicologist, Cunningham is also an active performer with a number of professional recordings.

Fred Fejes is graduate director and professor of media studies at Florida Atlantic University.

Mark Long is a lecturer of history at University of Central Florida.

Craig Snyder is a writer, photographer, and independent historian. He is the author of *A Secret History of the Ollie* and also cofounder of the Skateboarding Heritage Foundation.

Bron Taylor is professor of history at the University of Florida. Among his publications are *Dark Green Religion: Nature, Spirituality, and the Planetary Future* and *Ecological Resistance Movements: The Global Emergence of Radical and Popular Environmentalism.*

Scott Edwards is a historic preservationist within the Compliance and Review Section of the Florida Department of State Division of Historical Resources.

Top to bottom: Lance Trout, North Shore, Oahu, 1978. Photo by Dick "Mez" Meseroll/ESM.

Tom Dugan, Florida. Photo by Dick "Mez" Meseroll/ESM.

Bruce Walker, Marsh Harbor Ferry, Bahamas, 1980s. Photo by Bruce Walker.

Dick "Mez" Meseroll, Bahamas. Courtesy of Dick "Mez" Meseroll/ESM.

Paul Aho, Hurricane Arlene, Fox Hill, New Hampshire, July 1971. Photo by Linda Carruthers, courtesy of Paul Aho.

Slide archives. Photographs by Darrell Jones.

Nate Adams is a top surf photographer and photo editor for *Eastern Surf Magazine*. Owner of OpticalTranquility.com, he shoots action sports and other subjects as well as surfing.

Paul Aho began surfing in Palm Beach County in 1965. Like many surfer-photographers, he has documented events as they occurred, including his travels around the world.

Pat Altes captured the emergence of New Smyrna Beach as a hotbed of talent in the 1970s and 1980s. He also wrote a number of magazine features on surf travel and on the region's leading talent for East Coast publications during that time.

Tony Arruza is a commercial and fine art photographer based in West Palm Beach who also photographs people, locations, and water sports for corporate clients and magazines. He has traveled extensively to surf and photograph.

Bernie Baker is a North Shore icon, wearing hats as surf photographer, contest director, and journalist. He is a senior staff photographer for *Surfer* magazine, has been a Hawaiian regional judge for the Association of Surfing Professionals for over thirty years, and is competition director for Hawaii's Triple Crown of Surfing.

Gean Baron, father of 1960s competitor Linda Baron Grover, documented the sports development in Daytona Beach in those early days. Much of his archive appears in a new documentary by Will Lucas, *Surfing at Summer's End*, which showcases stories by and about a generation of surfers.

Mark Beatie spent four years in Hawaii shooting for *Surfer* magazine in the early 1960s before returning to California, where he established himself as a noted studio and travel photographer. He was also a teacher and board member of the Brooks Institute of Photography in Santa Barbara.

Mickey Boucher was among the first surfers in New Smyrna Beach and captured some of its earliest moments on film.

Donald Cresitello is a chief photographer for *Eastern Surf Magazine*. He spent years in the Space Coast in the 1980s, refining his photography skills at Sebastian Inlet and capturing the development of high-performance surfing in Florida.

Bill Davis is a surfer and avid surf photographer whose focus centers on central and northern Palm Beach County.

Cliff Del Santo started surfing in Lake Worth in 1962 and began documenting the sport on film a decade later. A team rider for Nomad and then Fox surfboards, he also assisted with ESA Florida competitions in the early 1970s.

Jeff Divine is one of surfing's top photographers, and his overview extends from 1970 to the present. He is also photo editor for *The Surfer's Journal*, arguably the sport's finest publication.

Tom Dugan was a Gilgo Beach local before becoming a top Florida surfer with an equal affinity for photography. Dugan shot for West Coast interests and served as photo editor of *Swell* magazine and then as coproducer of

U.S. Surf, a 1980s glossy East Coast magazine, before cofounding *Eastern Surf Magazine* with Dick Meseroll in 1991. Dugan and Meseroll were inducted into the East Coast Surfing Legends Hall of Fame in 2006.

Rod Faulds is director of University Galleries at Florida Atlantic University and project director for *Surfing Florida: A Photographic History*. He is also an avid surfer and an artist-photographer.

Walker Fischer is a Daytona-based photographer whose early work captured surfing's boom years of the 1960s in North Florida and beyond.

Kirby Fukunaga, a Hawaiian-born surfer, writer, and photographer, spent fifteen years as a pro surfer in Japan before returning to Oahu. He is the founder of Go-Naminori.com, a surf-related site that links Japan and Hawaii and generates over a million page views a month.

Ryan Gamma is an accomplished surf and commercial photographer who trained at Daytona State College's noted School of Photography. He is also a former photo editor for *Eastern Surf Magazine*.

Dick Graham cofounded *International Surfing* magazine on the West Coast with photographer Leroy Grannis in 1964. With his roots in photography, Graham also captured the top stars and events of the longboard era, including the top East Coasters.

LeRoy Grannis was a pioneer surf photographer whose family had roots in Florida but whose career captured the golden days of surfing in California and Hawaii. The subject of much industry and media acclaim for his work, in 2006 Taschen published *LeRoy Grannis: Birth of a Culture* as a limited-edition monograph of his work. Grannis died in February 2011.

Kathy Hughes Griffith was regional director of the Gulf Coast district of the Eastern Surfing Association in the 1980s and documented the sport and surfers of the region during those years.

M. E Gruber was an early surf photographer who focused on Palm Beach County but whose work spanned the state between the 1960s and 1970s. Since his death, Gruber's enormous slide archive has been granted to the Palm Beach County Surfing History Project, a nonprofit organization dedicated to preserving the surf history of the county and the state.

Ben Hicks is a South Florida fine art photographer whose work focuses on surfing, nature, and landscape. Hicks has traveled extensively in pursuit of his subjects and is a contributing photographer for *Eastern Surf Magazine*.

Tom Hodge photographed East Coast surfing from the Northeast to Central Florida during the longboard era and into the shortboard revolution, with a particular eye for the competition scenes in New Jersey and Cocoa Beach.

Darrell Jones, a former senior photographer for *Surfer* magazine, has more cover shots to his credit than any other photographer in the publication's history. Based in Miami, Jones documented Florida's leading surfers at home and around the world in the 1970s, and his work accompanied a number of *Surfer* travel features written by Florida surfers.

Kris Kerr is a surf and water sports photographer from New Smyrna Beach. A serious action photographer, Kerr is perhaps best known for his 2010 water shot of a shark, whose attack he deterred by punching it in the snout at New Smyrna Inlet. The failed attack and the photo put Kerr and the story in the national news.

Nic Lugo is a South Florida photographer who has emerged as a leading talent in the sport's highly competitive industry. While focus has been on the Palm Beaches, he is a constant travel companion with many of the state's top surfers to locations around the world.

Allan Margolis was among the top photographers capturing Central Florida in the 1970s. He also produced the video *Waves We Live By*, featuring Florida waves and Space Coast surfers. He was also involved in a number of surf-related industries and business interests.

Brad McCann, a leading surfer from Florida's Panhandle, studied photography in Daytona in the 1970s and put his skills to work documenting the northern Gulf, as well as his travels elsewhere.

Rich McCarey, a friend of inaugural aerialist Matt Kechele, was an amateur photographer who captured the first known photo of Kechele's revolutionary "Kech air" in 1979.

Augustine McCarthy photographed beach culture and other activities in Sarasota in the 1970s.

Nic McCue is a contemporary photographer based in Pensacola who has documented the region's vitality as a surfing community. Notably, he has documented the extraordinary talents of the Spencer family.

Kem McNair is a noted artist, musician, and photographer from New Smyrna Beach. Having begun surfing in the 1960s at an early age, he was one of the best surfers in the state in his youth and remains an extraordinary talent.

Greg Meischeid, a top Space Coast surfer in the early 1980s, was on hand to photograph the action as well. Perhaps his most notable photograph is a shot of pioneer aerialist John Holeman performing the first known 360 aerial in 1980.

Dick "Mez" Meseroll abandoned a career as a senior staff photographer at *Surfer* magazine to cofound *Eastern Surf Magazine* in 1991. Meseroll and cofounder Tom Dugan are legendary among surfing's photographic elite and have helped launch the careers of many of the East Coast's best surfers and photographers.

Eric Olsen documented the Space Coast surf scene during the 1970s with an eye toward the broadest community of notable surfers, amassing an outstanding archive singularly representative of the time and place.

Larry Pierce photographed the sport in Hawaii during the middle 1970s, capturing the masters of the era on Oahu's North Shore. He has since turned his lens to skiing.

Simone Reddingius began surfing in the early 1980s and started shooting the sport's leading figures around the same time. She was particularly active shooting the top female surfers, and her work was showcased in a Jetty Girl story *Eighties Ladies: A Special 1980's Photo Feature*. She lives in Maui.

Jack Reilly is a Californian artist originally from the southern Gulf. Upon moving to New Smyrna Beach in the early 1970s, he produced Creation surfboards and put together a team of the region's top riders.

Savey Photography was a commercial photography studio serving New Smyrna Beach in the 1960s.

Tom Servais is a Florida-born surf photographer now based in California. He has been instrumental in capturing the sport since the shortboard revolution, has provided many of the sport's most iconic photographs, and has a veteran's access and portfolio that comes only with decades of experience.

Chad Shindoll is a contemporary surf, wedding, and portrait photographer living and working in New Smyrna Beach.

David Silver captured the 1960s surf boom, including its best surfers, in the coastal communities of North Florida, and Jacksonville Beach in particular. He also made one of the state's first and few early surfing movies, *The Enchanted Sea,* which premiered in August 1965.

Jesse Sinclair is a California photographer whose subjects include Florida expatriate pro and shaper Pat Mulhearn.

Cat Slatinsky is a photographer and surf coach from Imperial Beach, California, who now lives in Honolulu. She is also an avid surfer and stand-up paddleboarder.

Craig Snyder is a writer, photographer, and historian. The author of *A Secret History of the Ollie*, a comprehensive history of the sport of skateboarding, he is also contributed chapter 18, "Land, Sea, and Air," to the present volume.

David Stahl, an early southern Gulf surfer, launched his career with an article and photographs on surfing in Sarasota for *Surfer* magazine in 1966, later landing work as a contributing photographer for *Surfing* and *Tracks* magazines. Other key publications include *National Geographic, Vogue, Yachting, Smithsonian,* and *Outside* magazines, among others.

Brad Styron is a fine art photographer and graphic artist who lived and worked on Florida's southwest Gulf during the late 2000s before heading back home to Emerald Isle, North Carolina, where he continues to capture the sport.

Sykes Photography was a commercial photography studio serving Neptune Beach and North Florida in the 1930s.

John Tate is a Broward County surfer and photographer whose key work captured the 1970s and '80s in South and Central Florida, compiling an impressive slide archive of the era's best surfers.

David Taylor is a contemporary photographer whose work focuses on New Smyrna Beach and its surfers. His photographs are regularly featured in online galleries like surfline.com and magicseaweed.com.

Osiris Torres is a noted photographer with roots in Puerto Rico, a favorite go-to place for many Floridians, and for even more northern Atlantic surfers during the winter months. Torres has captured many of the East Coast's best surfers in the island's often significant surf.

Lance Trout learned to surf in Sarasota, Florida, but left for Hawaii during the 1970s shortboard revolution, where he photographed the sport's leading surfers as a freelancer until joining *Surfing Magazine* as a staff photographer from 1977 to 1980.

Jonathan Utz was an active member of the extraordinary skateboard community in South Florida in the 1970s, and he was on hand to capture some of the sport's defining moments.

Bruce Walker, like many other noted Space Coast surfers, has roots in Miami Beach. Beyond his success in the surf and skateboard industries, and his former role as U.S. Amateur Team Coach, he is an outstanding photographer who has more recently turned his eye to video work.

Pete Ward was a Cocoa Beach local who surfed and photographed his friends and other surf boom talent of his generation in the early 1960s.

Tom Warnke began surfing in the early 1960s in Palm Beach County. He quickly assumed a leadership role in the development of amateur competitive surfing and later in issues related to environmentalism and beach access, locally and through his work for Surfrider Foundation.

Terry Williams is a Treasure Coast surfer and wife of George Williams. The two have traveled extensively, allowing Terry the opportunity to capture their exploits in Puerto Escondido and elsewhere.

Jimmy "Jimmicane" Wilson is associate photo editor of *Surfing Magazine* and is among the sport's top photographers. While based in California, his roots are in North Florida, and he is an adamant and vocal supporter of East Coast surfing.

Scott Winer is a contemporary surfer and photographer whose travels and images include extensive stays at Cloudbreak in Tavarua, Fiji.

Beth Anne Wright is the wife of pioneer New Smyrna surfer Bud Wright. She took photos of surfers in the region in the 1960s.

Sonny Yambor is a New Smyrna surfer deeply involved in the sport since the 1960s, having documented many of its key moments and the growth of the Smyrna Surfari Club. In addition to other activism, he and Mike Martin were instrumental in presenting the Aloe Up Cup in 1988 and 1989.